ARTS
AND
ARTISTS

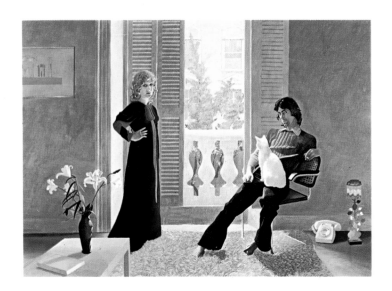

ABOVE *Mr and Mrs Clark and Percy* (1970-71), a double portrait in acrylic on canvas, seven feet high by ten feet wide, by British painter David Hockney (born 1937).

ENDPAPERS *Procession in the Piazza San Marco*, by the 15th-century Venetian painter Gentile Bellini.

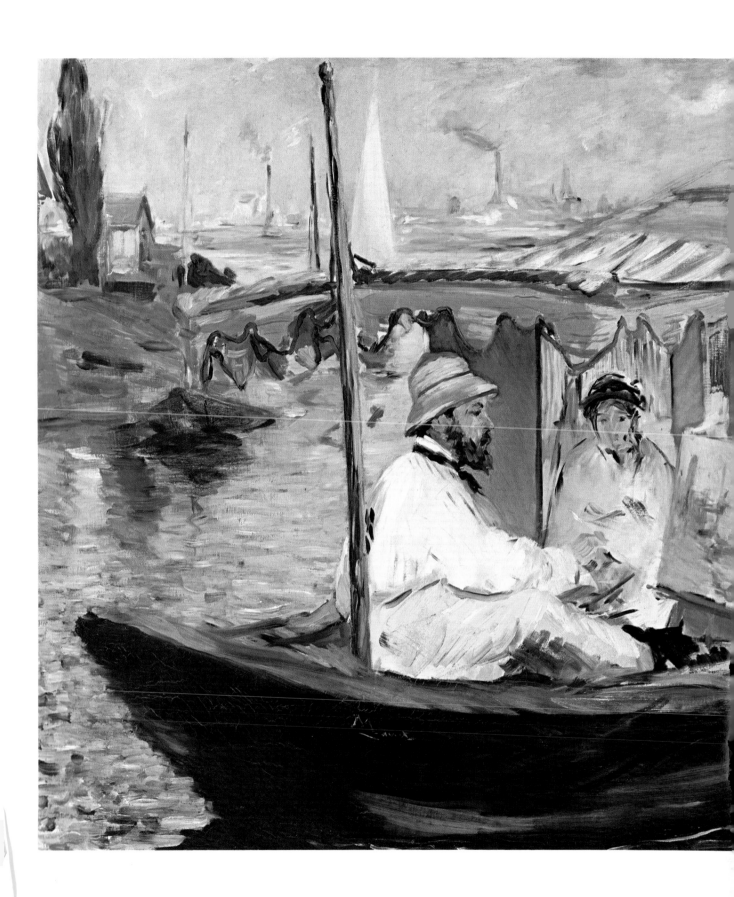

ARTS
AND
ARTISTS

JEREMY KINGSTON

Bloomsbury Books
London

Editorial Coordinator: John Mason
Art Editor: John Fitzmaurice
Editor: Nina Shandloff
Designer: Gill Mouqué
Research: Pat Vaughan, Diana Korchien, Frances Vargo

This edition published 1989 by
Bloomsbury Books an imprint of
Godfrey Cave Associates Limited
42 Bloomsbury Street, London WC1B 3QJ
Printed in Hong Kong by Regent Publishing Services Ltd.
ISBN 1870830 38 6

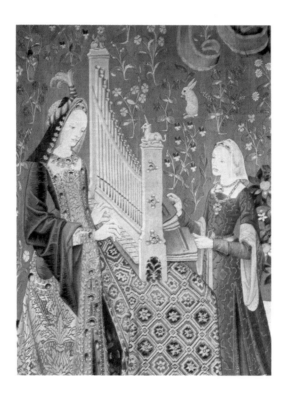

ABOVE French tapestry showing
two women playing a portable
organ popular in Europe during
the late Middle Ages. One
operates the bellows (right)
and the other presses the keys.

PREVIOUS PAGES *Monet Working
on His Boat at Argenteuil*
(1874) by Monet's friend,
benefactor, and fellow
Impressionist Édouard Manet.

INTRODUCTION

Art defies precise definition simply because it has so many
and such various forms. The aim of this book is to help
the reader to explore a range of arts, from painting to
drama, sculpture to film making, music to architecture. In
addition to chapters on each of these arts, other chapters
describe the contributions of individual artists. Devoting a
double-page spread to each of 70 artists, these chapters
show the human aspect of the subject. Spanning the
achievements of painters from Giotto to Jackson Pollock,
architects from Brunelleschi to Le Corbusier, composers
from Monteverdi to Stravinsky, and film makers from
D. W. Griffith to Satyajit Ray – this book is filled with a
wealth of artists whose lives and work are clearly described
and fully illustrated. The book as a whole can be read
as a study in some depth of the ways in which individual
artists have developed techniques of self-expression in a
wide range of media over the centuries.

CONTENTS

Chapter 7

THE ART OF MUSIC

The language of music is a specialized set of
symbols arranged in particular patterns so that it
can be played to sound as its composer wished.
These patterns, and the instruments they are meant
for, have evolved through the centuries.

Chapter 8

THE GREAT COMPOSERS

Music is an aural art, and writing it requires an
acute perception of what the marks on a page will
sound like when played or sung. But whether meant
for a patron, church service or personal expression,
music must always communicate.

Chapter 9

THE ART OF THEATER

Drama is the translation of a playwright's
intentions into living, breathing theater, and this
means that the actor and director assume great
importance. But the development of the playhouse
itself has also been a strong influence.

Chapter 10

THE GREAT DRAMATISTS

From the classical Greek traditions of comedy and
tragedy to realistic innovation and experimental
theater, great dramatists have shown us how we
appear to others. Cutting across language barriers,
they "are not of an age but for all time."

Chapter 11

THE ART OF FILM

In a short time this aspect of photography has
acquired the stature of an art form from its
beginnings as a scientific novelty. The use of
sound, color, and animation has made storytelling
and documentary possible on a massive scale.

Chapter 12

THE GREAT FILM MAKERS

The history of film is one of individuals, people
who seized their opportunities to communicate with
a wide audience through a new medium whose rules
were as yet unwritten. These directors have each
made their own mark on 20th-century culture.

Chapter 13

ENJOYING THE ARTS

People need time to appreciate and enjoy the arts,
both in the historical sense of determining a work's
lasting power and in the more personal sense of
listening, looking, feeling, and watching. Display
and preservation fulfill this need.

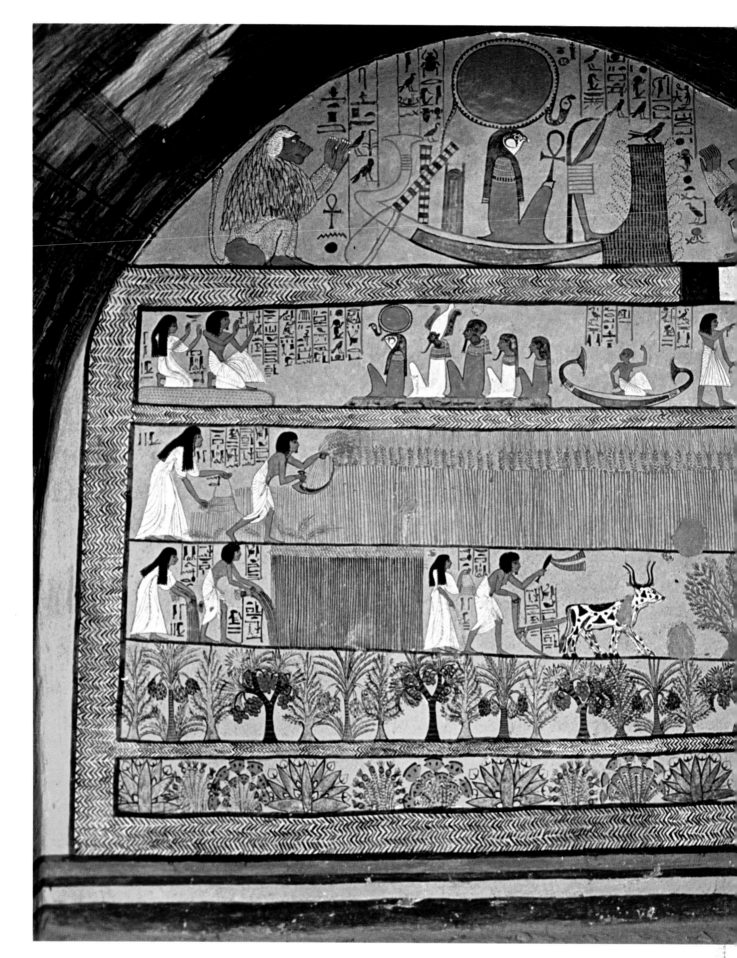

8

Chapter 1

THE CREATIVE SPIRIT

The story of art through the ages is the story of humanity's continuing search for appropriate forms to express its experience of the world and the aspirations of the human spirit.

Art forms are many and wonderfully various. Color and shape, sound and movement can all be used by the artist to shape his or her creative vision. The finished work can be beautiful or it can be harsh; some modern art is purposely intended to have an unsettling or disagreeable effect. At its greatest, art can inspire a sense of awe at the stupendous power and intricacy of the universe. It can discover and lay bare the order that underlies all things.

Through their work artists share their experience and in so doing affect the way other people experience the world. This power to awaken in others a sense of personal involvement is a main reason for art's enduring value within human societies. Communities without art are unknown; therefore art must be universal.

OPPOSITE Egyptian wall painting from the tomb of Senejem at Thebes, dating from the 14th or 13th century BC – the XIXth dynasty. The artists depicted daily life alongside the final journey of the pharaoh, in a boat piloted by the god Horus.

Early Artists

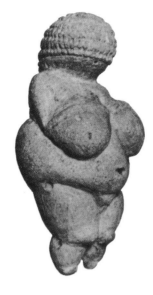

ABOVE the Paleolithic figurine known as the "Venus of Willendorf," found in Austria. It measures $4\frac{1}{8}$ inches and is one of the earliest sculptures of a human being, probably intended to represent the Mother Goddess.

BELOW Paleolithic drawings of dappled horses from the Pech-Merle grotto.

The human urge to create goes back to earliest times. People drew lines in soft clay, traced shadows cast on rock walls, and sketched the outlines of their hands. The first finished works of art so far discovered date from the upper Paleolithic Age – toward the end of the last Ice Age, some 20,000 years ago – but their quality suggests that human artistic talent developed earlier still.

Primitive people sought their first security and shelter in caves. In the deepest caverns they left wall paintings and carvings – both testimony to their emerging intellectual powers and pictorial records of their thoughts and activities. The principal finds are at Altamira in northern Spain and Lascaux in western France. They are pictures and scratches made on the ceilings and walls of caves originally fashioned by nature from subterranean deposits of sandstone and limestone.

Early people hunted and danced. They maintained and increased their tribes. They feared the unknown. And they recorded their activities and concerns with remarkable artistry and technical skill. They were not seeking an audience, nor were they engaged in decoration or merely filling idle hours. With ocher, oxide, chalk, and charcoal they were making *magic*. They believed that by creating an image of an animal they would acquire a mysterious power over the real thing. Their art was the result of a ritual act with a functional purpose.

These first artists were primarily hunters and most commonly depicted animals. In superb colors, chiefly red, yellow, black, and brown, they made realistic likenesses of bison, bears, horses, and deer. Often the vigor and movement of these creatures has been perfectly captured. People depended on animals for food and clothing, and by making pictures of the beasts, sometimes with arrows in their sides and blood flowing from them, it was hoped that the real animal would succumb as readily.

At Lascaux the paintings frequently include

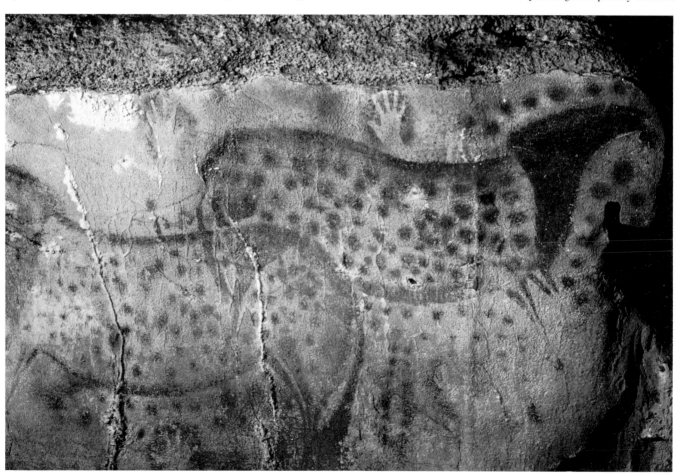

strange lattice shapes, often found by the feet of the animals. These may represent simple traps, but they are often associated with curious human-looking figures drawn, unlike the animals, in a nonrealistic style. The "traps" may be for catching hostile spirits, presumably dead ancestors.

Aesthetic feeling, a sensitivity to beauty and form, appeared at an early stage in the development of human beings, who must have been moved by such natural phenomena as sunsets, rainbows, and flowers. Prehistoric collections have been found of shells and stones of pleasing shapes and colors. Strings of polished canine teeth and flint tools, carefully finished beyond strictly functional needs, emphasize the obvious concern for beauty felt by many different groups of prehistoric peoples.

Primitive art was intended by its makers to have a direct appeal. Background landscape is seldom indicated, and the emphasis instead is on the human and animal figures. These are generally shown from the side. But this straight-forward approach was linked to a sturdy artistic sensibility. These early people brought to their art an awareness of the symmetry and sense of rhythm they had observed in living creatures. Often their records of nature were deliberately

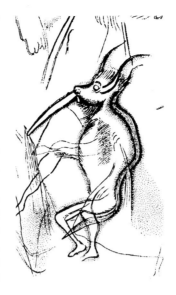

ABOVE the flute-playing man-bison figure found among cave drawings at Trois Frères in southern France.

BELOW a horse pierced with arrows, from prehistoric cave paintings at Lascaux. The black pigment was made from charcoal and the red from ocher, a kind of iron ore, ground to a powder.

reduced to simple forms made up of basic shapes and regular patterns. Among the most striking objects are small figurines in which features of the female body are greatly exaggerated. These are an expression of the Mother Goddess cult and a realization of the idea that women were the source of life who thus provided an essential continuity.

Around the magical artistry of primitive people developed patterns of activity, communication, and response from which evolved *rituals*. Both the flute-playing man-bison found in a cavern in France and the skirted woman dancing in an initiation ceremony in a Spanish cave are engaged in rituals which themselves mark the beginnings of a more complex culture and the breaking of new ground in many different arts.

Because much modern speculation about the earliest artists is based on observations of the art of primitive tribes living now, the real intentions of these prehistoric artists can still only be suggested. One of the cave pictures in Spain, for example, shows a man near a tree with a bees' nest, surrounded by angry bees. Although it is tempting to imagine that the artist meant the picture to be funny, people looking at it today can only speculate.

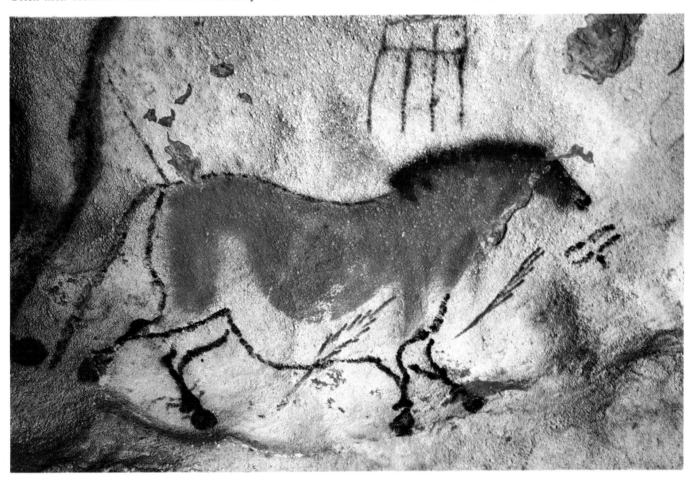

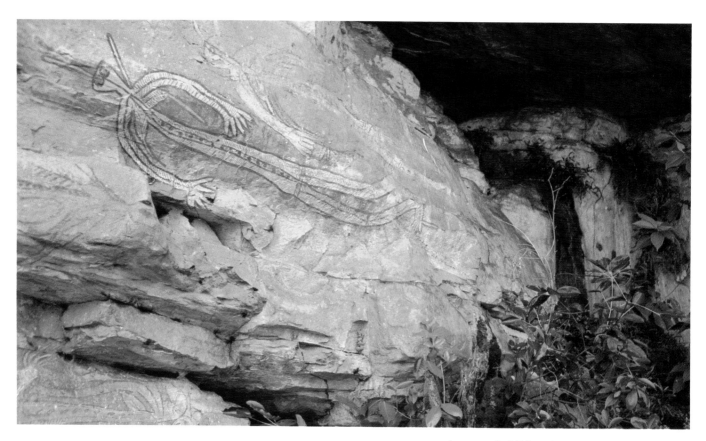

Ritual
and Magic

Art was first used in magic and ritual, formal ceremonies or observances performed for a solemn purpose, usually religious. People shaped or painted in order to propitiate supernatural forces, insure the defeat of enemies, encourage continuation of the species, and overcome hostile forces.

Elements of magic and ritual have survived in the arts of primitive peoples today, and there are even traces of it in sophisticated societies. In parts of Africa, South America, Polynesia, and the Arctic, magic remains the principal function of the arts. Tribesmen and women still create pictures and figures which are meant to gain them power over a source of danger or to placate those gods or spirits whom they believe rule over natural forces. Rain gods and fertility goddesses are still worshiped through a variety of forms and cults. In Africa some women still carry a doll on their backs to promote their

ABOVE two human figures painted on the wall of a cave at Nourlangie Rock in Arnhem Land, Australia. The "X-ray" technique, including the internal structure of living things as part of the drawings, is a feature of aboriginal art.

RIGHT bronze ritual food vessel (called a *ting*) from the Shang dynasty, excavated in 1950 at Anyang, Honan. It is inscribed "Father chi" in a reference to the ancestor and the day (*chi*) of the ten-day cycle on which the offering would be made.

chances of childbearing. Some Australian aborigines "insure" rainfall by painting roughly outlined human figures with eyes and nose but no mouth. These figures, called *wondjina*, are thought to attract rain. They lack mouths because it is believed that these would provide an outlet for such a large volume of rain water that floods might result.

Objects made for ritual purposes are among the earliest artistic works to have survived. The elaborate funeral rites observed in ancient China

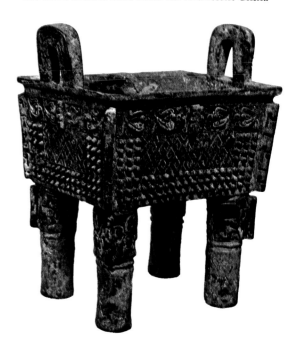

during the Shang dynasty (1766-1122 BC) required many different kinds of ceremonial vessel in which to prepare and offer food and wine to the ancestral dead. These ritual vessels, first made in pottery but later magnificently cast in bronze, show an already highly developed aesthetic sense in both shape and ornament.

In many cultures representations of everyday objects were buried with the dead to assist them in their journey to the "other world" or sustain them in their new existence there. The treasures unearthed from the tomb of Tutankhamen in Egypt show the artistic heights such funerary wares could reach, but even the humbler burial places of 5th-century Greece have disclosed painted terra cotta figures of youths and mourning women that are miniature works of art. Statuettes of this type took the place of the human sacrifices that had accompanied earlier burials.

In modern industrial societies the role of magic as a function of the arts has largely disappeared. But ritual has extraordinary powers of survival in every type of society, including the most sophisticated. Often it evolves into forms and practices whose original purpose is

BELOW limestone statuette of Chac Mool, rain spirit of the ancient Maya of Central America, found in the ruins of their city Chichen Itzá. It was made sometime between the 10th and the 17th century AD by craftsmen who had no hard metal tools but were skilled in shaping soft stone with harder stone.

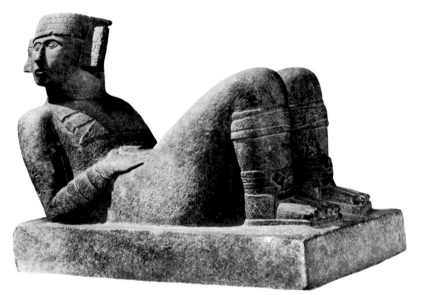

obscure. Fertility dances on the threshing floors of ancient Greece and the revels that marked the festivals of the wine god Dionysus developed into classical drama. Pagan and Christian rituals, and a mixture of both, have dictated the layout of villages in parts of Africa and the Americas even though the rituals themselves no longer attract serious celebrants. In some places religious processions have developed into military parades, and our modern calendar is filled with references to feast days and harvest holidays.

Many activities closely attended by ritual in one form or another still require help from the

arts today, including religious observances, state functions, political meetings, and sporting occasions, all of which have developed over the ages or been borrowed from older institutions.

Churches have always been influential patrons of the arts, and even in our own time this has led to some notable achievements. The British architect Sir Frederick Gibberd (born 1908) designed the Roman Catholic Metropolitan Cathedral at Liverpool, a circular building that has been described as the most modern cathedral in the world and superbly suited to the needs of contemporary worship. He also drew up the plans for the Central London Mosque in Regent's Park. The French painter Henri Matisse (1869-1954), though himself lacking religious conviction, designed the vestments and interior decoration for a convent chapel at Vence, near Nice.

In this kind of work the artist's personal feelings may be subordinated to other requirements. The individual style that is the creator's signature remains, but the artist's function is to decorate, record or commemorate. He or she fulfills the artistic demands of social or religious systems that are not necessarily representative of the creator's own beliefs.

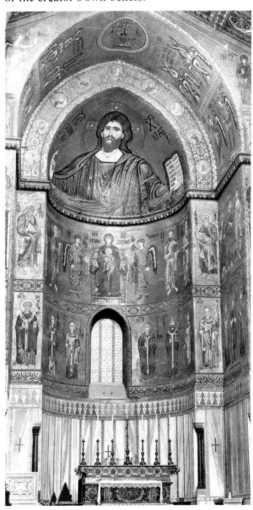

RIGHT Monreale Cathedral in Sicily. Most of the wall and ceiling area is covered with mosaic figures, dominated by the representation of Christ. The work was completed in 1189 AD by a Byzantine-trained workshop, and their subjects include an Old Testament cycle, the miracles of Christ, his life, and the lives of Saints Peter and Paul. The mosaic decoration is one of the largest and richest still in existence.

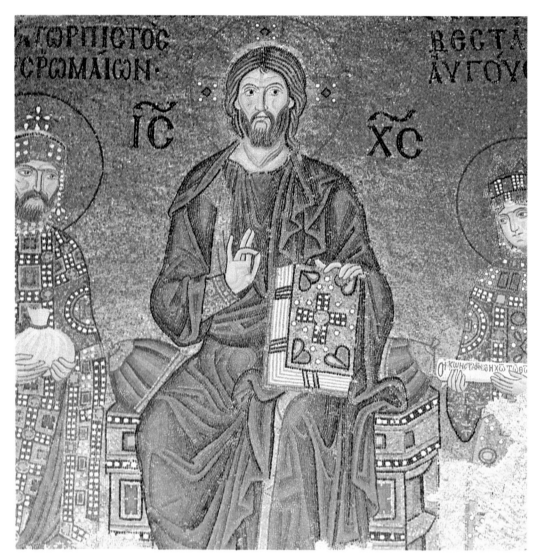

Different Times, Different Styles

Humanity's changing attitudes toward spiritual ideals can be seen in these portraits of Christ, which span the ages from 3rd-century Rome to 17th-century Italy.

No authentic portrait of Christ exists, so the Christ face we know is entirely an achievement of the human imagination. The early Christians, following in the Jewish tradition, were not interested in his physical appearance, but the pagan converts of the 3rd and 4th centuries, who were used to marble statues of their former gods, wished to see Christ with their own eyes

RIGHT *Christ Crowned with Thorns*
by Guido Reni, whose expressive
style was influenced by Raphael
and other Italian Renaissance
painters.

and to contemplate scenes of his miracles. Since no true portrait existed, artists turned to the mythical or heroic types of the time – Orpheus and Alexander the Great, for instance. The Roman catacombs contain numerous examples of Christ as a youth of divine beauty.

When Christianity became the state religion, the image of the boy-savior began to give way before that of Christ the teacher, a dignified figure with a long beard. This image was gradually dehumanized to become the stern enthroned Judge of the World, the superhuman Christ of the Byzantine icons. This rigid figure remained the strongest influence for many centuries, although the artists of different parts of medieval Europe introduced their own national styles, making the figure less or more ethereal, for a while emphasizing his transcendent power, at other times presenting a more lifelike figure.

The shock and fear resulting from the appearance of the Black Death in 14th-century Europe altered the mood of all the arts. Pictures of Christ began to emphasize the suffering he underwent on the Cross, and he became a figure of pity. The Renaissance revived interest in true portraiture, and depictions of Christ then became more lifelike, though they were still very different from one another. The Christ of Leonardo da Vinci is a dreamer whereas Michelangelo's Christ is reminiscent of a muscular Greek god.

Paintings of Christ by two Italian artists who were near contemporaries show how individual tastes can produce portraits far apart in style and mood. Guido Reni (1575–1642) in *Christ Crowned with Thorns* emphasizes the aspect of pathos with a theatricality of color and expression which today might be considered overdone. Caravaggio (1573–1610) in his *Supper at Emmaus* defies the conventions of his time with a naturalistic portrait of a youth, even showing the crooked part in his hair (see page 36). But the work of Spanish-born painter Jusepe de Ribera (1591?–1652) makes its impact in a different way. *The Lamentation over the Dead Christ* appeals to the universal human experience of suffering: Ribera's pale, thin, long-limbed Christ looks like a physically tortured youth who nonetheless retains his faith in his own calling.

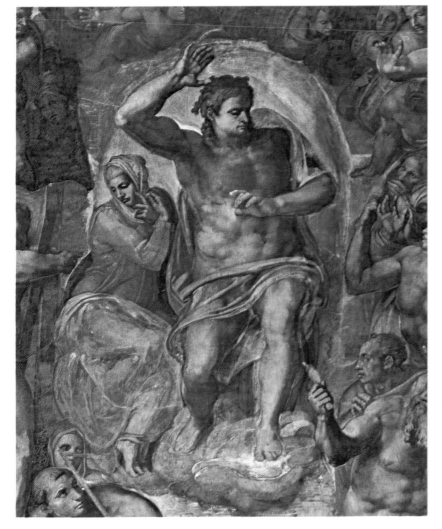

LEFT detail showing Christ in
judgment from Michelangelo's
Sistine Chapel frescoes. Both
Christ and the Virgin Mary,
who sits enthroned beside him,
have the full fleshiness of
Greek gods and goddesses.

15

Artistic
Creativity

The source of an artist's creative power is never easy to define. Michelangelo spoke of the essence of the sculptor's work as "liberating the figure from the marble which imprisons it." The 19th-century Norwegian playwright Henrik Ibsen used a more aggressive image to describe his mood while writing his first successful play, *Brand*. He compared himself to the scorpion he kept in an empty beer glass on his table. "From time to time the brute would ail; then I would throw a piece of ripe fruit in to it, on which it would cast itself in a rage and eject its poison into it; then it was well again."

Great artistic geniuses are not, of course, the only people who feel the stirrings of creativity. At one time or another nearly everyone sees or hears or senses something that he or she feels the urge to preserve in paint, words or music. It has been said that love makes poets of us all. But artists appear to be *compelled* to preserve their visions or insights and therefore to train not only their receptivity but also their technical abilities.

A work of art is the expression of a complex of ideas stimulated by the artist's perception and experience. The inspiration is influenced by the setting, era, philosophy, and activity which determine the quality of life around the artist. A distillation of all these things is then presented with individual vision. It is a kind of magical accident, touched with premeditation.

However spontaneous or precocious his or her talent, no artist can communicate a personal vision without training. Each must learn the fundamentals of the craft before beginning to experiment with new means of expression. This training does not have to be supplied by art schools or musical academies – neither Gauguin nor Van Gogh, to give only two examples, received any formal training. It is through the constant practice of their craft that aspiring artists discover their vision and develop their ability to express it.

Most artists employ at least some of the conventions of their art, probably to a greater extent than they realize. The greatest innovators

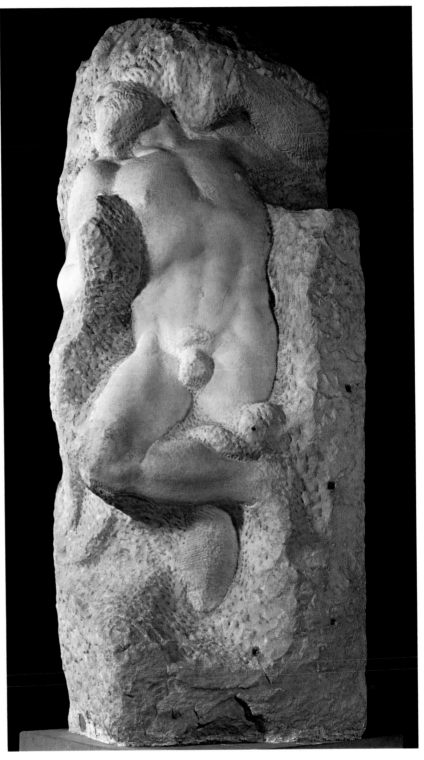

ABOVE *Awakening of the Imprisoned Slave*, an unfinished work of sculpture by Michelangelo now in a small museum in his adopted hometown of Florence.

in art, such as Paul Cézanne (1839-1906) or Pablo Picasso (1881-1973), have begun their careers along conventional lines. Before they become innovators, in fact, all artists are imitators, although even then they do not imitate nature itself but interpret it. If they find their customary interpretations are no longer capable of expressing their vision – a vision that may still be indistinct, or little more than a persistent dissatisfaction with current achievement – then

the artist's creative powers must face the supreme challenge. The time for experiment has come, and a new interpretation or means of expression must be sought. So Beethoven in the second movement of his *Ninth Symphony* introduced singers into a symphonic work for the first time. So Cézanne distorted the shape of an apple to achieve the balanced composition he wanted.

After an artist has achieved a new style – a new way of interpreting the world – his or her subsequent works may appear simple and inevitable. Popular films have encouraged us to believe that artists swiftly dash off a symphony or paint a Sistine Chapel ceiling. In reality the creation of an original style is nearly always accompanied by doubt, anxiety, and false starts. Michelangelo's remark about liberating the figure in the marble makes his great sculptures appear deceptively straightforward. It should be remembered that his acts of liberation were often the results of laborious effort expended at intervals over a period of many years.

Admirers of individual painters sometimes come to prefer the unsureness and spontaneity of their preliminary sketches to the mellower quality of their finished work. Such a preference is, of course, permissible, though when applied, as it sometimes is, to a great master like the British painter John Constable (1776–1837), it is due to a misunderstanding of the artist's intention. What is really being prized in such a case is the moment of creativity itself, what has been called "the inspired stammer that precedes the grammatical sentence."

It was to capture that moment of unconscious creativity that the American Jackson Pollock

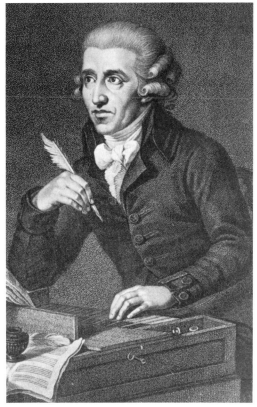

RIGHT Franz Joseph Haydn, one of the most influential composers of the 18th century. He worked for an aristocrat as a court musician for most of his life, and his output was therefore regulated by the constant demands of his patron.

(1912–56) produced his action paintings in the 1940s. He spread enormous canvases on his studio floor and dripped paint onto them from swinging cans or brushes. His pictures are thus a record of the almost dancelike process used in creating them. Action painting is now a style of the past, but in its time the loops and blobs scattered rhythmically across the surface of Pollock's canvases had a stimulating and liberating effect upon his contemporaries.

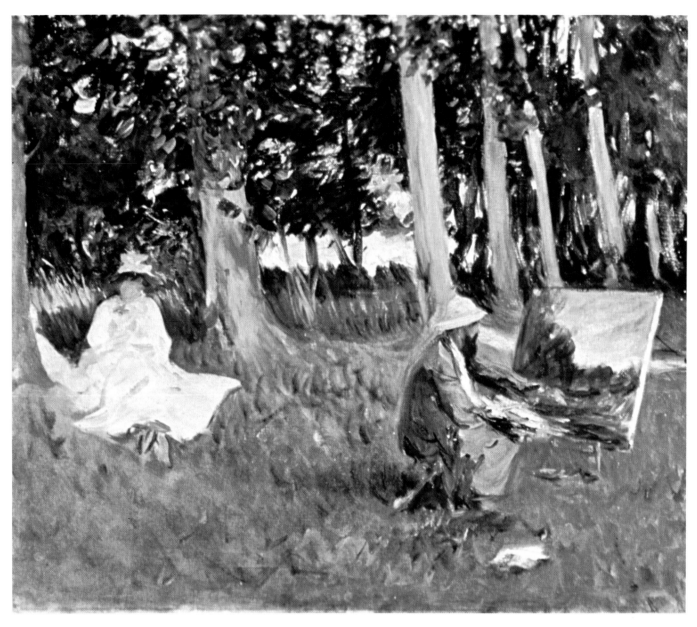

Artists
at
Work

An artist may work like a mad person in a frenzy of swift creativity or proceed slowly and patiently with painstaking care. In whatever form the inspiration comes, the artist must be ready to improvise. As he or she works to give substance to vision the initial idea will inevitably be altered. Some parts will be discarded and others added. If the idea is vigorous and stimulating it acquires

ABOVE *Claude Monet Painting at the Edge of a Wood* (about 1887), by John Singer Sargent. An American trained in Paris, Sargent became a friend of Monet's in the early 1880s, and he shows the strong Impressionist influence in his own handling of paint.

a life of its own, which the artist will not resist but allow to grow and assume its own shape, whether in paint, stone, sound or language. The artist must be flexible and try not to impose preconceived notions on every area of the composition. If an idea is truly new an artist can never predict exactly how it will turn out – and if its "wish" to grow is frustrated the result will be lifeless.

In this respect artists are in the same position as creative scientists or any other thinkers in not knowing where they are going until they have arrived. All they have at the beginning is an indistinct impression of what they are aiming for, but the details remain unclear until they start to tackle them, little by little. Gradually the nature of what they are trying to do reveals itself. It is a process summed up by Picasso in his phrase, "I do not seek, I find."

The workings of artistic creativity are still not known for certain, but it seems that the artist often enters a state of wakeful dreaming. Alert yet passive, he or she awaits the flow of inspiration as it emerges from the unconscious levels of the mind. The unconscious is not only a fertile source of images but, more significantly for the artist, it is also a region where opposites are felt as unities and contraries coexist. The ability to perceive this principle of unity allows the artist – most obviously the visual artist – to achieve balance and order in the most complex compositions.

The artist can find inspiration anywhere, though it does not always come when bidden. A painter may wish to capture the particular expression of a face or try to balance two interesting shapes against one another. A sculptor may want to create a form whose shape alters in a certain way as the observer moves around it. Composers may begin with only a chord or phrase, or even with the interruption of a phrase. In the slow movement of Beethoven's *Hammerclavier Sonata* the pianist's right hand abruptly breaks the melody by jumping more than an octave from a CEG chord to a high B. Beethoven's

RIGHT the composer Igor Stravinsky conducting a rehearsal. Composers devote a great deal of time not only to composing and writing down their ideas but to helping players understand how to interpret them.

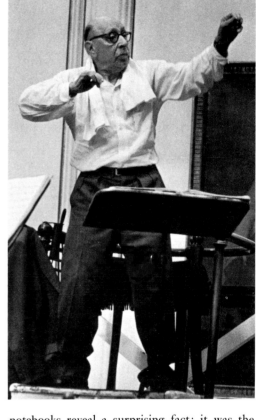

BELOW RIGHT Picasso at work. This scene was shot as part of a film, *The Mysterious Picasso*, that the French director H. G. Clouzot made in 1956.

BELOW Marc Chagall (born 1887), perhaps best known for his paintings, also sculpts, designs sets for ballets and operas, and has produced stained-glass windows, mosaics, and tapestries.

notebooks reveal a surprising fact: it was the idea of the break that came to him first, before he composed the melodies that fit on either side of it.

To appreciate a work of art it is not necessary to know precisely what inspired it (and of course there is often no way of telling). Nor is it essential to know in what manner the artist carefully built it up from the first outlines to the final achievement. Artists generally wish their audience to consider the finished work rather than the laborious attempts and altered versions. But a familiarity with the type of preparation that lies behind a completed work can lead to greater understanding of the fascinating process of creation.

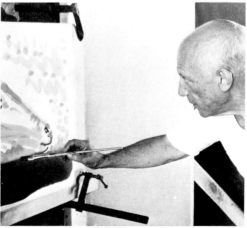

Progress of a Painting

Unusually detailed preliminary studies were made by the British painter John Constable for his large paintings. *The Leaping Horse*, completed in 1825, was preceded by three of these – two small studies in pencil and wash and a full-sized oil on canvas. Constable described the subject in a letter to a potential purchaser: "Scene in Suffolk, banks of a navigable river, barge horse leaping on an old bridge, under which is a floodgate and an eelery, river plants and weeds, a moorhen frightened from her nest – nearby in the meadows is the fine Gothic tower of Dedham."

The moorhen does not feature in either of the studies, in the first of which the horse is standing while the rider scrambles onto its back. In the second study the scene is one of greater activity. A riderless horse jumps the barrier across the tow path, the leaning willow tree is more erect, and in the background a man is poling a barge. In the full-size sketch Constable has combined elements from the two studies and added several other features – a rider on the horse, another figure on the barges, and more timber in the

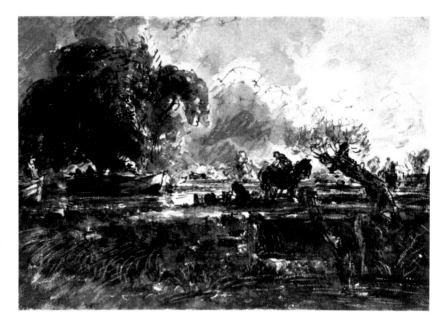

foreground. Traces of overpainting indicate that at one time a willow was in that area of the composition now occupied by the cow at the water's edge.

In the finished picture Constable reintroduced the central willow. He also kept the willow by the horse, and it was in this state that he sent the painting to London to be shown at the Royal Academy Exhibition. Not until it was returned from the Academy six months later did he make the last important change, writing to his wife afterward: "Got up early – set to work on my large picture – took out the old willow stump by my horse – which has improved the picture much – almost finished . . ."

ABOVE *First Study for "The Leaping Horse"* (1824) in pencil, pen, and wash. It was bequeathed to the British Museum in 1888 by Constable's daughter Isabel.

LEFT second study for the painting, to which Constable has added action and a human figure.

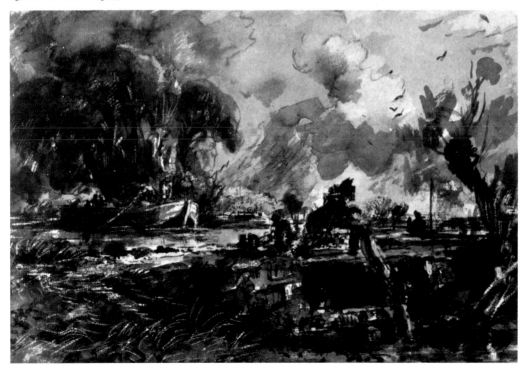

RIGHT Constable's full-size oil "sketch" for *The Leaping Horse*. The painting is one of the most complex of the artist's major works.

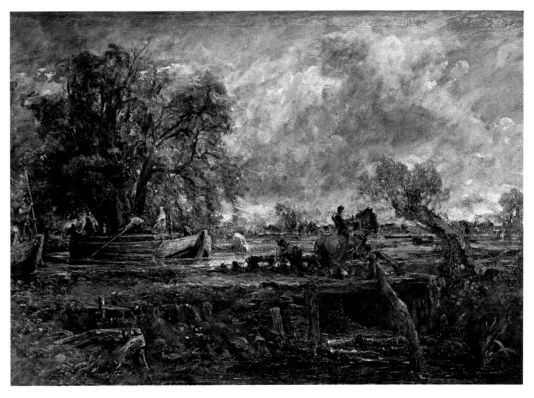

BELOW the finished oil painting officially titled *Landscape* (*The Leaping Horse*), first exhibited at the Royal Academy in 1825 by the artist.

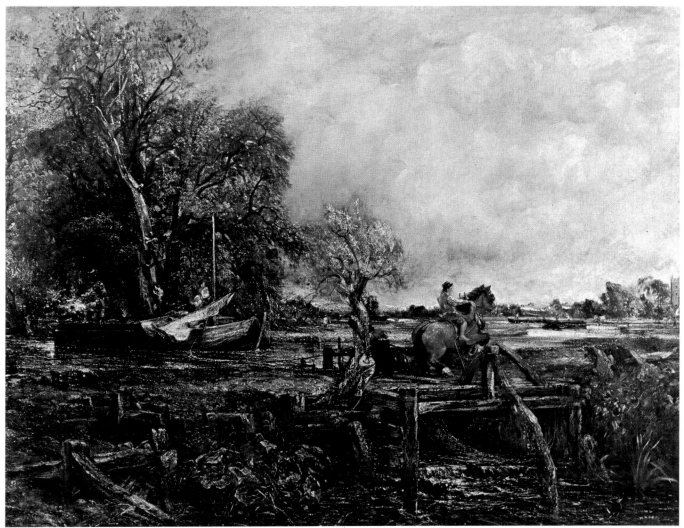

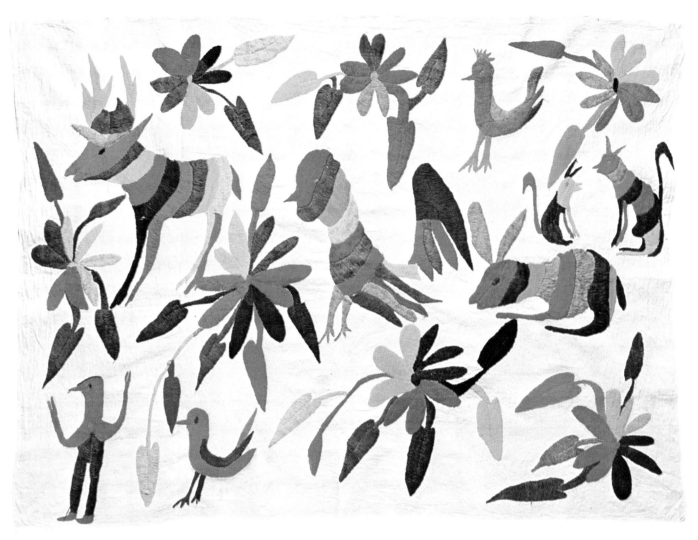

Folk
Art

Folk art is fundamentally the simple art of rural peoples. It has its own traditions, related to the more self-conscious and theoretical traditions of the cultural centers but nonetheless distinct from them. Though this art represents the group taste of unsophisticated people, it should not therefore be viewed with condescension. The folk artist is rightly called an artist, but he or she is a maker rather than a creator, a selector rather than a composer, and an adjustor rather than an inventor. Because they cater for people with a set notion of what they want, these artists do not strive for novelty for its own sake. The work of the folk artist therefore tends to be conservative.

ABOVE a rainbow profusion of fairy-tale creatures and plants, inspired by both fantasy and observation of nature, cover this embroidered cloth from Tenango de Doria in Hidalgo, Mexico.

The house builder with no architectural aspirations builds traditional houses. A village carpenter, less concerned with elegance than the cabinetmaker of more sophisticated communities, makes strong, simple furniture, the finish and decoration of which are often of a high standard and have a direct appeal. The painter who makes a traditional picture of a sacred object is providing the kind of art a conventional neighbor would like to look at rather than necessarily obeying the dictates of a personal artistic vision.

While most recognized masterpieces of sculpture and painting are strictly nonutilitarian, folk art usually involves the decoration of objects for everyday use, which is the role of *applied* art. The patterns employed can sometimes be traced back centuries to far flung cultures. Some Mexican *serapes* (a type of shawl) have woven frets remarkably similar to those that were traditional in ancient Greece. The use of strong, pure colors, rhythmic patterns, and firm outlines is nearly universal in folk art. Surfaces tend to be crowded with detail and contrasting colors. On large flat areas historical scenes are popular,

sometimes portrayed in stylized form. To the sensitive connoisseur of art, the effect of folk art is often charming rather than moving or exciting.

Folk art is not self-conscious. It is an integral part of rural life. Although it may appear simple, folk art often demands a high degree of technical skill. Frequently this skill is associated with divine inspiration – the folk artist may believe that in the act of creation human beings are daring to approximate the divine prerogative. Although meticulous in the detail of the work, the artist feels that people cannot attain perfection because this is the province of God. In acknowledgment of this a flaw may be incorporated into the art object. This can be an unfinished part, a break in the symmetry or some

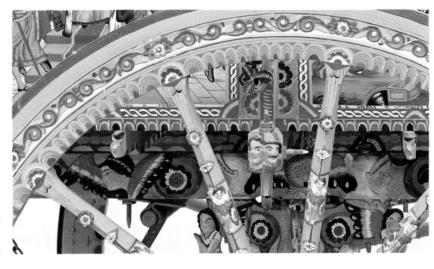

ABOVE delicate carving and ornate painting characterize this Sicilian cart, every inch of which is colorfully decorated.

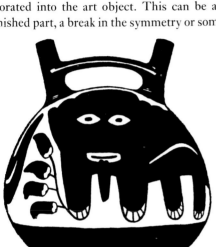

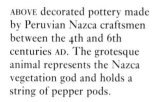
ABOVE decorated pottery made by Peruvian Nazca craftsmen between the 4th and 6th centuries AD. The grotesque animal represents the Nazca vegetation god and holds a string of pepper pods.

other deliberate "mistake," such as Finnish and Oriental weavers leave in their work. These slight imperfections are deliberately left in order to safeguard the artist from the retributive wrath of God, who may be outraged by human pretensions to creation.

In the 20th century some of the elements of folk art, notably its abstraction of form, stylization, and color, have influenced the development of modern art. The dramatic figures of African tribal sculpture, whose impressive qualities were introduced to industrial societies by their own artists, have become highly prized among collectors, and the motifs of folk art have often influenced styles of fashion and interior design.

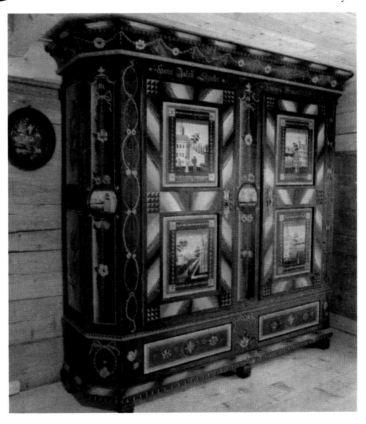

LEFT painted Swiss country furniture from the 1820s, now in a local museum in Urnäsch, a small town in the north-eastern canton of Appenzell.

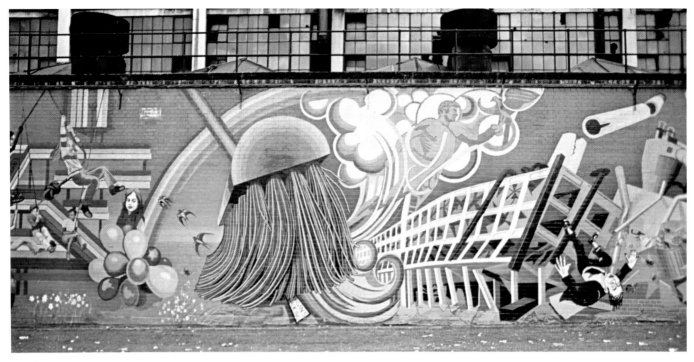

Art for a Mass Audience

Mass art is popular art produced in large numbers and communicated by books, newspapers and magazines, posters, movies, television, and radio. It is the art of industrial societies as folk art is that of nonindustrial cultures and primitive peoples. It is made *for* the masses, not *by* them, and its roots are in democracy and the industrial revolution. At the same time that democracy produced a receptive mass of people with an awareness of culture and a common education, industry produced the means of mass production and mass communication.

The painter's brush and the potter's wheel have not changed fundamentally for thousands of years, but today they are supplemented by relatively new technical devices which have not only created new art forms but also influenced artists to work in new styles. Perhaps the beginning of this partial but important revolution in the world of art came with the inventions of printing and techniques of woodcutting and etching some centuries ago, although these crafts could hardly be called mechanical today.

New methods of graphic reproduction and the discovery of new sources of power resulted in a great cultural breakthrough. The camera, sound recording, moving pictures, radio, and television followed.

It has become possible to make and reproduce mechanically artwork of reasonable quality and finish. The new art industry has produced its own kinds of artists – movie directors, cameramen, production designers, and so on. In music, new instruments and processes have given a new range and purpose to a long-established art form. Applied art flourishes in a wide range of old and new commodities.

A principal example of mass art – posters, basically intended to advertise a product, service or entertainment – has attracted notable practitioners in such artists as the Frenchman Henri

ABOVE mural painted by Brian Barnes on the side of a factory wall in Battersea, south London. It was 250 feet long and took two years to complete. This section shows a giant broom sweeping away local factories and high-rise apartment buildings, the first steps in a policy of improving the Battersea area which the artist felt would be the result of the Labor party winning office from the local Conservatives. In fact, the Tories won and tore it down.

LEFT cover for a record album made in 1979 by the Japanese Yellow Magic Orchestra. The design of artwork and photography for album covers has become a modern art form.

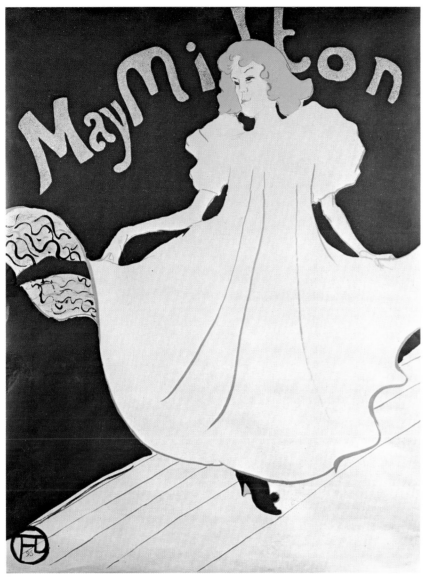

adorned with cubist motifs. Advertising effectively exploits surrealism, pop art, op art, and other modern artistic styles.

The influence can also be felt in the opposite direction. A recent and striking example of this trend is pop art, in which an accurate rendering of a design such as the label on a can of tomato soup is presented by an artist as a work of art.

The mass art industry caters to a popular demand for relief from boredom and an escape from drab realities. In meeting this demand the industry is not always cynical, and perhaps it does its limited best. The values of a mass-minded society are relatively vague and uncertain, and even when the public claims to know what it likes and wants, mass art can have the effect of blunting people's sensitivity to what is really significant in the wider art world.

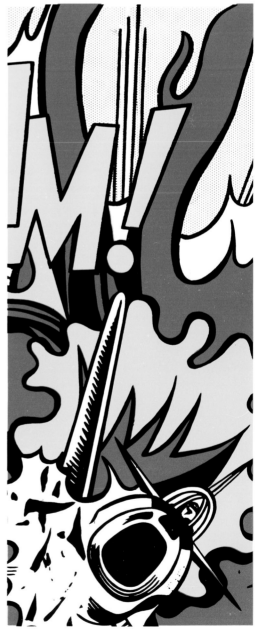

de Toulouse-Lautrec (1864–1901) and Picasso. Facsimiles of their posters find ready sale. Miniature mobiles based on the inventions of the American sculptor Alexander Calder (1898–1976) have become a popular home decoration, though sometimes they are made of materials which have only a relatively short life. Photographs in popular magazines can also be of high quality in terms of composition and reproduction.

Whereas folk art is almost static in its reliance on tradition, mass art reflects the constant changes in fashion. This dynamism is imposed not only by the insatiable demand of the public for novelty, however trivial, but by the extreme competitiveness of the mass art business. On the other hand, a tendency toward conservatism does exist in the constant exploitation of successful formulas.

For its tentative steps in new directions mass art follows the lead of art. A public which rejects cubism in art may be happy to wear products

ABOVE theater poster by Henri de Toulouse Lautrec, whose documentation of the bohemian life of Paris' Montmartre led to his first public recognition.

RIGHT a detail from *Whaam!* by Roy Lichtenstein (born 1923). In contrast to many modern abstract artists, Lichtenstein unashamedly adopts well-worn comic-strip devices on a dramatic scale in order to create startling and colorful images.

Chapter 2

THE ART OF PAINTING

Painting is more than producing a combination of lines, shapes, and colors on a two-dimensional surface. It is one way in which people communicate their vision of life, joy, sorrow, anxieties, and beliefs.

Artists are able to bring a clearer insight to this task than most people and can convey their vision ably by means of a sure technique. They seem to understand the essential nature of what they see – whether this be a human face, a tranquil landscape, a dramatic scene or a piece of fruit – more profoundly than the rest of us, and they feel an irresistible urge to convey this understanding in a pattern of color and form.

Such is the genius of the truly creative painter that his or her work becomes more than merely a statement of personal reactions. When a painting is a work of art it takes on a meaning, life, and vitality of its own regardless of whether it is realistic or abstract.

OPPOSITE *The Dinner Table : A Harmony in Red* (1908) by the French painter, sculptor, and graphic artist Henri Matisse. The effect is reminiscent of Islamic decorative art.

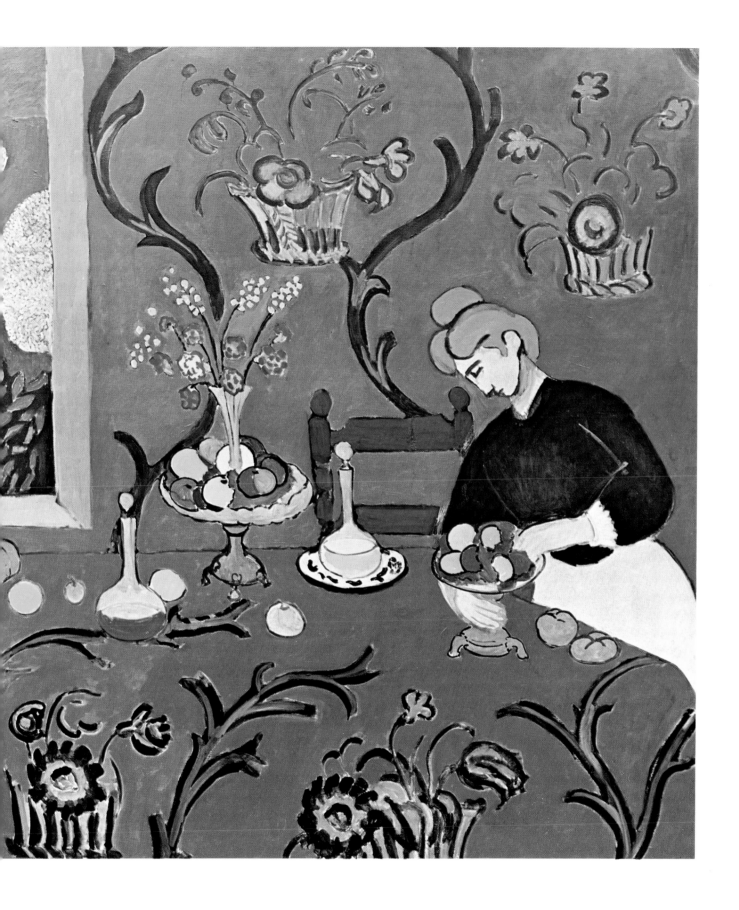

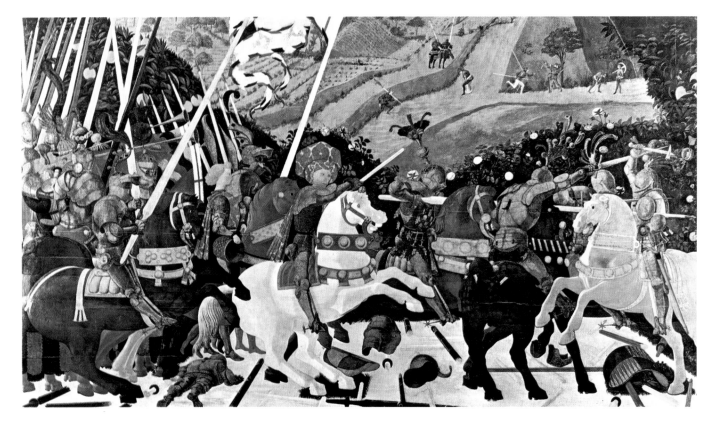

The Third Dimension

ABOVE *The Rout of San Romano* by Paolo Uccello (1397–1475), one of the earliest experimenters in perspective. The broken lances carry the eye toward the background.

experimented with problems of perspective, the development of this technique was suspended for hundreds of years when Western European art was dominated by the two-dimensional "Byzantine manner." Byzantine art, which dates

Because painting is basically a two-dimensional art – the flat foundation on which it lies has length and breadth only – artists have striven to create the illusion of a third dimension and thereby give their subjects depth, solidity, and space. In Western art the problem of *perspective* was resolved in part by the application of the science of optics, which allows the relationship of objects before the eye to be plotted with accuracy. The angles of sight serve as a guide. The apparent smallness of distant objects led to the establishment of a convention of rendering near objects larger than those further away. The "fading" of distant objects also helps create an illusion of depth. The use of warm colors (reds and yellows), which seem to advance, and cool colors (blues and greens), which seem to recede, is another device used to lend depth to the composition. Shading can also give the illusion of roundness and solidity.

Although painters of ancient Greece and Rome

ABOVE *Flagellation of Christ* by Piero della Francesca, in which three anonymous figures in the right foreground are mysteriously remote from the torture of Christ within the building, set further back in depth.

from the 5th to the 15th century, was closely associated with Christian ideology, and its finest expression was in the mosaics and paintings which decorated church buildings.

The basis of the Byzantine style of painting lay in the rejection of the natural human figure

as a suitable subject and a refusal to create illusions or make pictures seem lifelike. Human figures and other objects were presented *schematically*, that is, through outlines filled with color and decoration. Convention demanded that bodies be shown frontally, full face.

This style dominated European art until certain 13th-century Italian painters, stirred by a renewed interest in the ancient past and its naturalism, made a break with the tradition. One of these innovators was Cimabue (about 1240–1302), a Florentine painter and mosaicist. He began to break away from Byzantine forms and conventions to give more volume and animation to his figures through a freer use of line and movement. Giotto (about 1266–1337), believed to have been a pupil of Cimabue, used foreshortening (painting something shorter than it really is to make it look three-dimensional) and careful placing of figures to create a feeling of space. His human figures are the first since Roman times to have a sculptural sense of three-dimensionality.

Almost a century later a short-lived genius named Tommaso Guidi (1401–28), who became known as Masaccio ("Hulking Tom"), appeared in Florence to revolutionize 15th-century art. He used perspective lines that receded to a vanishing point, a single source of light, and the shading device of *chiaroscuro* (light and shadow).

This illusion of the third dimension remained an accepted painterly convention for over 400 years until early in the 20th century, when Pablo Picasso and Georges Braque (1882–1963) invented cubism. On a single flat canvas surface they presented several separate facets of an object as they might be observed by a spectator moving around it. Since that time several painters have turned away completely from this concern with solidity of shape and instead have created abstract, two-dimensional paintings.

But even in these the interaction of "warm" and "cool" colors serves to break up the flat surface, an effect that can be seen most obviously in the extreme abstraction of op (optical) art, where the picture plane seems to bulge and sway before the viewer's very eyes.

Size and Setting

No painting exists in isolation from its surroundings. A ceiling, wall or recess, a flat or uneven surface, each sets pictorial limits and requires special treatment. There are pictures for the community and pictures for the private viewer. Primitive people, the Egyptian, Greeks, and Romans usually painted for a communal purpose, generally religious. But pictures for the private enjoyment of wealthy families were painted on the walls of Roman villas, and paintings of the dead survive on the inside of Egyptian mummy cases for the dead person's spirit to view.

The magic of pictures painted on the walls and ceilings of caves was probably enhanced by isolation and darkness, lit as they were only by the flickering light of torches. The vast, magnificently painted walls and vaults of Romanesque churches, and the scale and brilliance of the great religious ceiling paintings of Renaissance artists, overwhelmed the worshiper with a sense of the glory of God.

At the other end of the scale are the illuminations of medieval manuscripts, painted by trained monks with intricate and painstaking detail around the initial letters of devotional works. These brilliantly colored pictures reinforced the Christian message and were intended to be looked at in the simple seclusion of a monastic cell.

The delicate miniatures commissioned by princes and nobles to adorn calendars or books of hours were similarly painted for close inspection – although the sole purpose of these charming views of medieval life was to give pleasure. The tiny details were probably painted with the aid of a magnifying glass and may even

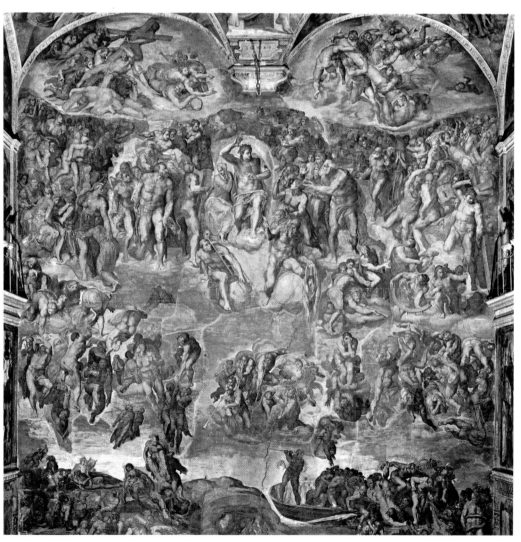

LEFT the Final Judgment scene from Michelangelo's Sistine Chapel series for the Vatican. Overwhelming in scale and complexity, these paintings were meant to impress their viewers.

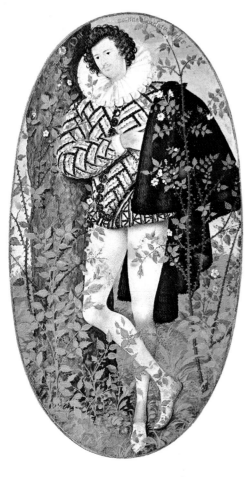

LEFT Nicholas Hilliard's *Portrait of a Young Man*, a miniature painted about 1588. This token includes roses, a favorite symbol in Elizabethan poetry. Hilliard's subjects included the Queen herself and courtiers.

splendidly confident figures can then be seen to be a human skull, a grimly sardonic reminder of death.

Paintings were often hung in relatively dim churches or in rooms that were poorly lit, so the painter took account of this when choosing colors. Modern artists are acutely aware of the fact that their paintings will hang among others on the well-lit walls of public and private galleries, either in their own show or with other artists' works. The competitive aspect of group exhibitions has in recent years encouraged artists to paint larger canvases with bolder color schemes and simpler compositions.

In addition to questions of space, the medium used also often influences the size of a painting. Watercolors, which dry quickly and are therefore almost impossible to correct, are generally small. Murals are, by definition, usually larger in order to decorate or otherwise exploit wall spaces. Oil paints are adaptable to anything from a miniature to a theatrical backdrop. Mosaics have also been used on scales ranging from the miniature to the monumental, though the most successful use of the medium has been architectural decoration. Modern synthetic mediums, even more than oil, lend themselves to such a variety of styles that they can be used for everything from miniatures to murals.

BELOW *The Ambassadors* (1533), by Hans Holbein the Younger. On the left is Jean de Dinteville, French ambassador to England, and on the right is Georges de Selve, ambassador to the Vatican. Between their feet, on its edge, is the skull.

have been designed to be examined in the same way. Miniatures later became an art form of their own and in the 16th century were widely used for portraiture and given as presents. The British miniaturist Nicholas Hilliard (about 1547–1619) advised those who wished to follow him in this rigorous art to use the brush as though it were a fine pen, applying paint in minute dabs and letting each one dry before applying the next.

With the Renaissance the artist was liberated from the almost exclusive patronage of the church by a demand for "private" art from the rising middle class. People of wealth began to commission paintings of themselves, their families, and of events, real or imagined, as well as traditional religious subjects. These pictures for private display were often made in portable form on panels of wood or on stretched fabric. Frames came later.

Artists often made paintings to be seen in a fixed setting, sometimes even at a particular angle. The full significance of the double portrait known as *The Ambassadors* by the German painter Hans Holbein the Younger (about 1498–1543) can only be grasped when it is viewed from the right of the picture. The unintelligible white shape in front of the two

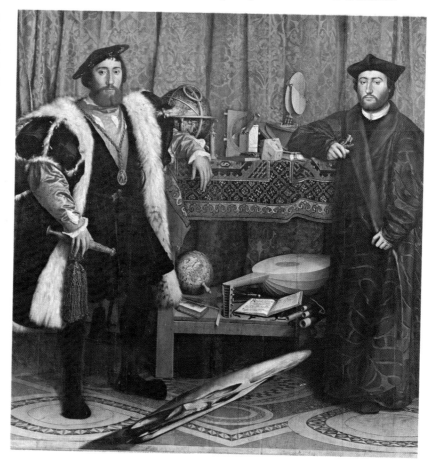

Drawing and Draftsmanship

Although drawings may be seen as works of art in themselves, they are also the first step in many great paintings. In the process of organizing a picture and studying its shapes and effects, an artist often begins by drawing, the most convenient and revealing medium for experiment in form and composition. Because the use of line is invaluable to an artist, competent draftsmanship is inseparable from good art.

BELOW cartoon for *The Virgin and Child with St Anne and John the Baptist*, by Leonardo da Vinci. This is not the study for the *Virgin and St Anne* (in the British Museum) in which the figures have all but disappeared under a succession of "second thoughts," but it also shows the process of working out ideas.

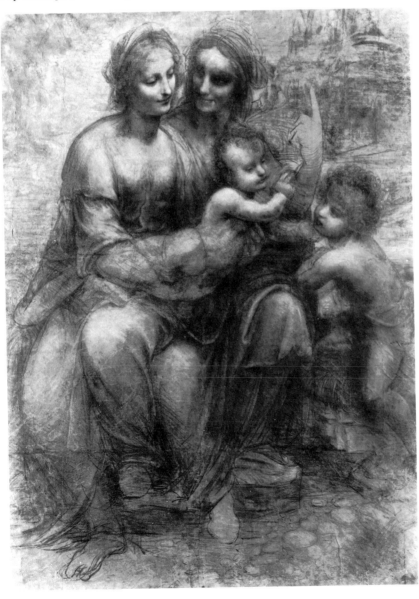

At the first stage in the preparation of a painting an artist must decide how to interpret the essence of the subject. This involves thinking about the composition of the various elements the work will include and searching for the rhythm and line which will reveal most expressively the artist's highly personal concept of the subject.

Artists may also study the anatomical features of a figure, the structure and texture of certain natural forms, and the varying effects of light. With pencil, charcoal or chalk they may make a number of preliminary drawings, some the vaguest of sketches, in their search for the perfect way to fill and form the picture. The experimental drawings of Leonardo da Vinci, Michelangelo, Rembrandt, and other masters reveal their detailed preparations and the individuality of their techniques. Leonardo (1452–1519) pioneered the use of the sketch as a means of sorting out ideas, by placing different facial expressions or different body positions on top of previous versions, until in the end the drawing sometimes resembled a dark, impenetrable cloud. In the case of his preliminary study for the *Virgin and St Anne*, in which heads, hands, and elbows had all but vanished beneath the succession of "second thoughts," Leonardo had to trace the line he eventually chose through the paper to the other side with a stylus.

From the Renaissance onward artists also made drawings not intended to be sketches for paintings but finished works in themselves. They also made drawings of their own paintings as a record of their work. Some drawings, made by artists of other people's paintings that they admired, are now the only record of works since destroyed by fire, war or the other fatal accidents to which paintings are subject.

Among the great draftsmen was the French painter Jean Dominique Ingres (1780–1867), whose purity of line was matched only by his academic correctness. Ingres was a classicist rather than a naturalist, and his work was greatly influenced by the art of ancient Greece and Rome. For a large part of his working life the predominant style of art was the bold exuberance of the romantic movement. Ingres, however, held tenaciously to his belief that there was something animal about color whereas line was essentially spiritual.

The Frenchman Edgar Degas (1834–1917) was influenced by Ingres and wanted to be a "colorist through line." Like Ingres, Degas subordinated color to form, especially in his early works. His paintings, although filled with liveliness and apparent spontaneity, are carefully composed to reflect his original vision.

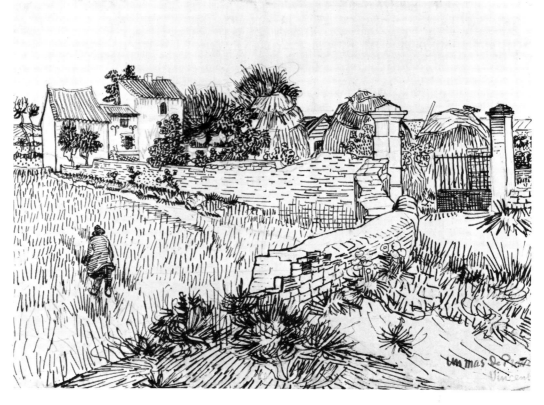

RIGHT *Farmhouse in Provence*, a
pen-and-ink drawing by
Vincent Van Gogh. The
choppy strokes suggest that all
nature is bristling with life,
and each blade of grass seems
to thrust itself aggressively
from the earth.

In all his periods and styles Picasso's ability
as a masterful draftsman is evident. In the
swiftly executed, economical lines of his post-
cubist period he was able to capture the form
and a sense of the solidity of his subjects even
when he restricted himself to an outline drawing.

The lines of the wood engravings by the
German master Albrecht Dürer (1471–1528)
are unmistakably his own, resembling only his

own drawings in charcoal or pen and brush. The
style of an artist's drawing, then, is as individual
as handwriting. No matter what tool or surface
is used, an artist's distinctive style can usually
be recognized.

LEFT woodcut by Albrecht
Dürer, done in his character-
istically fine detail and
crowded with symbolic figures.

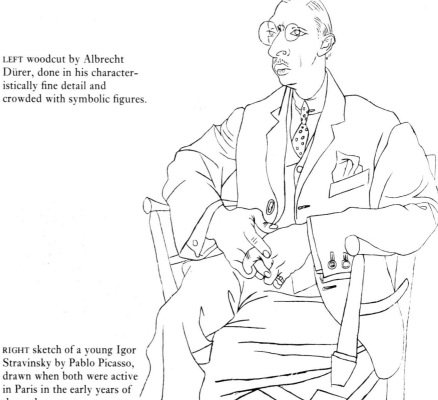

RIGHT sketch of a young Igor
Stravinsky by Pablo Picasso,
drawn when both were active
in Paris in the early years of
the 20th century.

33

Color

The use of color dates from earliest times, when cavemen and women used it realistically, applying it to rough stone walls with their fingers, a brush, a pad, and what was possibly a primitive form of spraying. Egyptian art developed some odd color conventions: men were always tinted a darker shade than women. Christian artists also used color symbolism, cloaking the Virgin Mary in blue, for example, as a token of purity. These styles of coloring, with their rules to which all painters conform, can be compared to the art of heraldry, in which the different bearings on a coat of arms must be shown according to precise laws in order to make their meaning clear.

This convention was superseded by one in which painters created a quality of *atmosphere* through color harmony. Colors were carefully blended but also interacted to establish balance. Painters considered how the light within their pictures should fall on the objects shown and regulated the colors accordingly, scaling their brightness up or down according to their relative positions. Generally speaking, their intention was to make the rectangular picture "an open window" giving onto a view of the real world. Color was an essential element in this endeavor because it could help give definition to forms. Leonardo da Vinci used color to shape the play of light and shadow "in such a manner that things which are flat appear to be round. To sacrifice shadow to mere splendor of color is to behave like a babbler, who cares more for high-sounding language than for the significance of what is said."

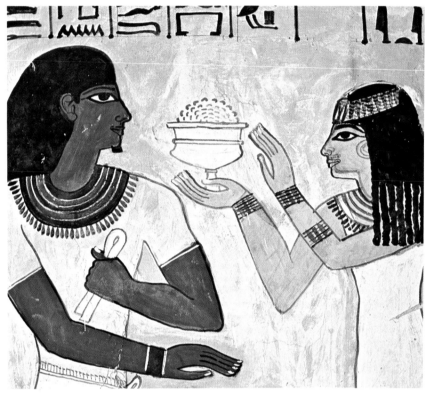

BELOW fresco from the tomb of Sennufer in Thebes, showing the Egyptian pharaoh being served by his wife.

The French painter Edouard Manet (1832-83) and his followers, who came to be known as the Impressionists, became dissatisfied with the paintings popular in the 19th century, all of which were painted from start to finish in the studio. Manet noticed how facial features became indistinct when seen in direct sunlight, and he tried to capture this effect with novel combinations of color that outraged his contemporaries. His younger colleague Claude Monet (1840-1926) went out into the open air to paint what he saw there, gleaming and trembling in the brilliant light of midday. In the pictures of the Impressionists paint is applied in small patches of pure color so that the forms in the background of their compositions dissolve away under the effects of the sunlight.

The Dutch painter Vincent Van Gogh (1853-90), who used brilliant color, said that instead of producing an exact replica of what he saw he used color to express his excitement about the

FAR LEFT *Virgin and Child with Two Angels* by the 15th-century Florentine painter, goldsmith, and sculptor Andrea del Verrocchio. Mary is cloaked in blue, a tradition signifying the purity of the virgin birth.

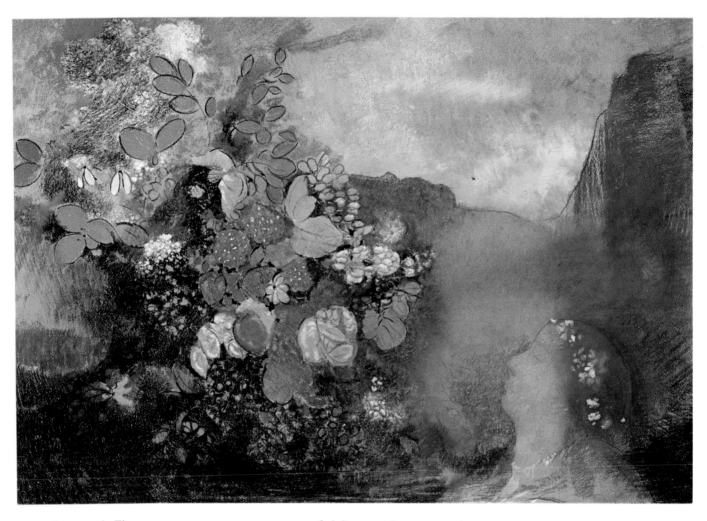

ABOVE: *Ophelia among the Flowers* (1905–8) by Odilon Redon, whose use of color in both pastel and oil produced languid, dreamlike effects.

BELOW *Barges on the Thames* (1906) by André Derain. His explosive colors – exaggerated, intensified, and outlined like a child's – mark him as a Fauve.

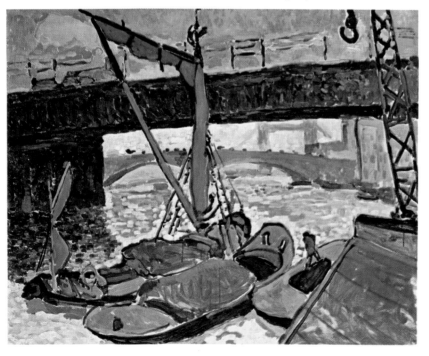

subject. The Frenchman Paul Gauguin (1848–1903) spread his rich, pure colors over flat areas. His countryman Odilon Redon (1840–1916) used iridescent effects to invest his still lifes of flowers with a glistening appearance of reality, but Redon also painted highly imaginative subjects such as plants with human heads, phantoms, and figments from dreams, visions, and nightmares. His works were characteristic of the symbolist movement in art and poetry.

Early in the 20th century the Fauves ("wild beasts" of art), working temporarily as a group in Paris, carried Van Gogh's ideas a stage further. The violent color of the objects in their paintings no longer related to the objects in the world outside. Townscapes became bright red, bridges acquired shades of blue and purple, and faces were given fresh green accents.

Though Picasso used colors both in absolute harmony and in almost brutal dissonance to achieve particular emotional effects, his subject matter was always recognizably based on some familiar object. The abstract artists of our own day have divorced their paintings from any figurative content in order to concentrate solely on exploiting the possibilities of color and form.

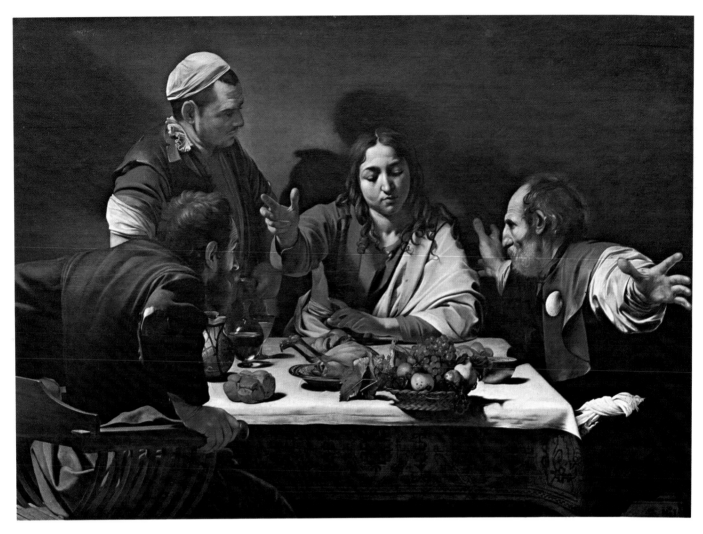

Light Effects

An appreciation of the nature, qualities, and effects of light is essential to the artist, at least in Western painting. By contrast in Eastern paintings – even when the sun or moon is part of the picture – there is seldom any attempt to indicate the source of light on the scene or to show shadows or highlights.

The basic observation of what light, or the absence of light, does to a scene or figure is apparently simple, even obvious; but the techniques of reproducing it demand great skill. Shapes and forms of objects are defined by the effect of light, which is variable, upon them. This phenomenon has been the object of close

study and experimentation by painters through the ages. They cannot reproduce the strength of light in nature, but can only translate it. Because composition and line alone do not suggest light, the chief instrument is color, and all the color values that arise from the play of light depend on each other. The degree of white, which represents the combination of all the colors in light, modifies the effect of all other colors used. The artist must observe the assembled objects not only individually but in their relationship to the whole.

To render three-dimensional forms painters lighten or darken colors, employing different *tones* to give the impression of roundness to objects. To do this successfully they must study colored shadows and understand exactly the different values any single color has as opposed to another. The successful contrast or opposition of colors in varied lights and in correct proportion produces harmony and gives life to a picture.

Colors absorb and reflect different elements of the light they receive. Thus the basic or "local" color of an object is altered by the play of light on it. A red car looks darker in the shade

different areas. All objects – including paint itself – undergo these modifications of color by light. For this reason painters often prefer to mix and apply their colors in daylight from a neutral northerly direction.

Texture, too, is rendered by the play of light on different surfaces. A shiny surface – a glass, mirror or brass candlestick, for example – throws back light. A dull or uneven one – red bricks or black velvet – will swallow light to some degree. By skillful use of light effects an artist can show us how objects would feel to the touch.

Impressionism as a style was an attempt to capture a precise, never-recurring moment in time and light by recording an *impression* of an instant. It involved the abandonment of the old principles of modeling in precise detail. It also meant rejection of the contrast between light and dark, the device known as chiaroscuro, with which painters had previously expressed form.

Akin to painting in their effect and closely associated in many of their techniques are the art forms of *mosaic* and *stained glass*. The first takes advantage of the reflection of light by having small pieces of colored glass, stone, ceramic or other material set against an opaque surface in pictorial patterns. The second uses the passage of light through colored glass fragments which are framed and held together by strips of lead. Makers of both mosaic and stained glass therefore actually use light itself rather than reproduce its effects.

than in bright sunshine. A white boat moored at the water's edge – unless all its planes receive direct sunlight – will in fact have greenish gray shadows near the water line caused by the reflection of the water. Unless this greenish gray is painted in, the boat will not look natural. The green of leaves on a tree acquires varied tints according to the amount of light falling on

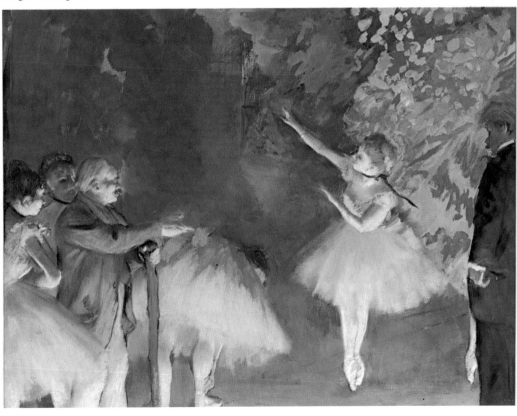

RIGHT *Ballet Rehearsal* by Edgar Degas, done in pastel and gouache, a mixed technique that allowed a compromise between texture and surface pattern. Never actually an Impressionist himself, Degas was nonetheless as interested in the effects of light as they were – his pictures of the Paris Opéra ballet dancers are filled with the suggestive, illusory look of the gas lights used in the 1870s and 1880s.

Elements
of Composition

If a work of art is to be successful the painter must compose a balanced and harmonious arrangement of shapes and colors. Some gifted artists have an instinctive feeling for composition, but many painters work according to conventional academic rules, sometimes with almost mathematical precision.

The Golden Section is the basis of one such set of rules. It is represented by the ideal proportions to be seen in the scale of Greek temples and medieval cathedrals and is discernible even in plant life. It is not certain to whom the concept first occurred, but in the 6th century BC the Greek philosopher Pythagoras considered the

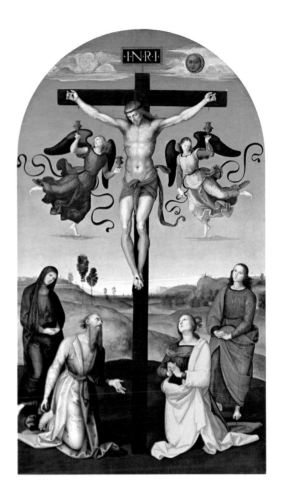

RIGHT Raphael's *Altarpiece: The Crucified Christ with the Virgin Mary, Saints, and Angels*, painted for the Gavari Chapel in the Church of San Domenico at Città di Castello. One of his earliest works, it is precisely balanced in accordance with the Golden Section.

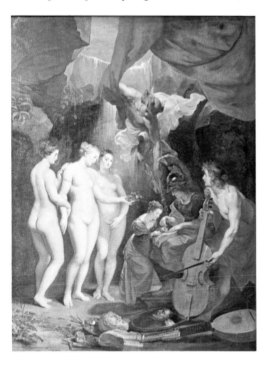

LEFT *The Education of Marie de Medici* by Peter Paul Rubens, part of his Medici cycle painted about 1622 and now in the Louvre. The nude figures and dark setting create a spiral base for the composition.

problem of cutting a stick into ideal proportions so that the ratio of the smaller part to the larger was the same as that of the larger part to the whole. The point at which this occurs, which can be determined mathematically, was seen to lie between a half and a third of the way down the length of the stick.

This ratio became a standard means of producing harmony of proportion. From this basic

principle a Golden Rectangle, which itself could be divided or enlarged by the established ratio, was produced. This logical system of geometry was developed further in order to guide architects and painters in the proportions of their designs. The device was frequently used by Piero della Francesca (about 1416–92) who divided his fresco of *The Resurrection* by the longitudinal line created by the lid of Christ's tomb, and vertically divided his *Flagellation of Christ* by the line of a column. The Italian Renaissance artists Raphael (1483–1520) and Titian (about 1487–1576) also used the Golden Section in carefully balanced constructions.

The arrangement of pictorial elements, however, remains a matter of individual taste, temperament, and competence. Some artists accept and exploit a triangle as a basis of good composition, whereas others prefer a spiral. The Flemish painter Peter Paul Rubens (1577–1640), who liked a fluid form and rich color, used a flowing, curvilinear system. Leonardo da Vinci effectively combined triangular and curvilinear systems in many of his works. In his *Virgin and Child with St Anne* (see page 65), in the Louvre Museum in Paris, the three figures and the lamb grasped by the Christ child can all be enclosed in a triangle, the base of which runs across the bottom of the picture while the apex is formed by St Anne's head. To soften what might otherwise be a stiff composition,

Leonardo used flowing, rhythmic lines over and around the figures and made a subtle play of color harmonies and balanced masses. In *The Last Supper* he arranged the disciples in four roughly triangular groups and posed Christ as a single triangle in order to focus attention on his face at its apex.

Albrecht Dürer, an incomparable draftsman, excelled in linear composition. In his paintings the contours and outlines rather than three-dimensional effects or chiaroscuro dominate the design. The same preference was shown much later by Toulouse-Lautrec, who used a crisp line to present colorful vignettes of 19th-century Parisian life. Rubens and the Dutchman Rembrandt van Rijn (1606–69) filled their canvases with rounded shapes, skillfully unified through a sense of balance and rhythm. By the opposition of forms enclosed in shifting curves, Rubens often achieved dramatic movement in scenes of battles or stories taken from mythology. Rembrandt used contrasts of light to give inner life to his subjects.

Experimentation in pure composition is the reason for the concentration of many artists on the *still life*. Objects are assembled and moved around in relation to each other and to the background until the artist finds a satisfactory arrangement, in light as well as form, to serve as a model. Paul Cézanne frequently painted still lifes, coordinating color and form in deceptively

BELOW *Still Life with Apples and Oranges* (1895–1900) by Paul Cézanne, who carefully composed his pictures by first analyzing the forms and then harmonizing the colors, volumes, and shapes. Cézanne's still lifes numbered over 200, and each one involved a laborious search for that perfect balance of design.

simple compositions of apples, jugs, and bottles.

The interplay of simple shapes in planes of flat color to create a balanced whole has preoccupied many modern painters. The emotive power in the result lies in the pure geometry and color, and atmosphere is absent. But whatever the style, every artist constructs his or her pictures as a composition of areas of different colors which together form a unified whole.

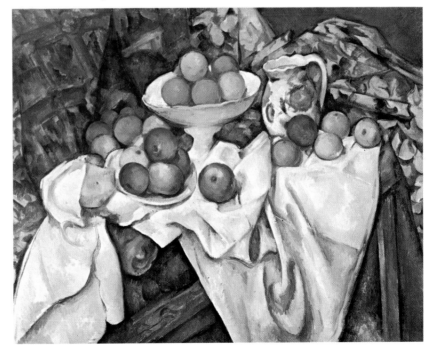

Methods and Materials

Artists use several methods of applying color to a surface, with differing effects. They choose the technique that best suits their abilities and pictorial intentions. The main difference between the various techniques lies in the substance used to bind the powdered colors and fix them to the particular surface.

BELOW RIGHT watercolor study by John Constable.

BELOW *The Baptism of Christ*, part of an altarpiece painted in tempera by Piero della Francesca for a priory in Sansepolcro, his hometown.

Until the development of techniques of oil painting in the 15th century, the medium in general use was *tempera*, which is still used today. It is made by mixing pigments with a solution of egg white and water and is applied by brush. Its characteristic quality is a luminous opacity. It dries quickly, but the pigment is more brittle than oil. *Oil*, which supplanted tempera, has a greater flexibility. It can be brushed on thickly (impasto) or thinly (glaze). It is easily removed by reworking the surface, and it has a particular richness. Colors can be mixed together to obtain a large number of different shades. However, oil paints dry slowly. They are usually applied to a canvas or wood surface, but they can be used on other materials.

Watercolors are bound with vegetable gums into small "cakes." When applied to a surface,

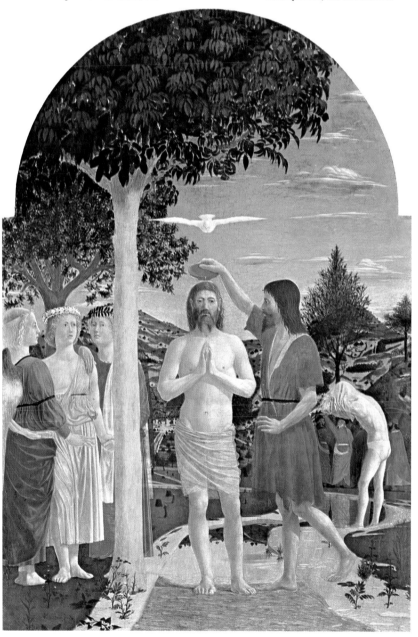

usually paper, they dry quickly and thus allow little correction if the delicacy of the transparent colors and the spontaneity with which they are brushed on are not to be lost. *Fresco* is a very old technique of painting in water-soluble colors on large surfaces, usually interior walls. In true fresco painting the colors are brushed onto wet plaster; they are absorbed and dry out quickly to become a part of the wall surface. Only small areas at a time can be worked, and the painter must work swiftly and accurately. The Italian Michelangelo (1475–1564) was a master of this technique, which flourished from the 14th to the 16th century. *Dry fresco*, painting on dry plaster, does not penetrate the surface and has a tendency to flake off.

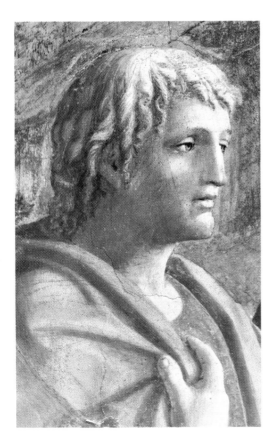

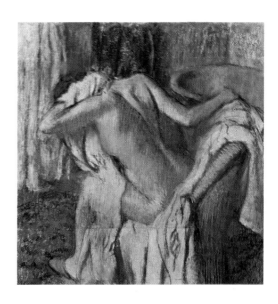

LEFT detail from *The Tribute Money*, one of the series of frescoes Masaccio painted for the Brancacci Chapel in Florence. The flat fresco technique restricts the artist to a limited variety of textures.

RIGHT *After the Bath: Woman Drying Herself*, one of many pastels by Edgar Degas on the subject of women bathing, washing their hair or dressing themselves. As his eyesight weakened with advancing age he concentrated on working in this medium, and his handling became broader and freer.

Acrylic paints can be used on almost any surface.

Pastel crayons, consisting of dry powdered colors mixed with just enough gum arabic to bind them, are allowed to set in molds the size and shape of a finger. They are used like pencils, and the finished picture is sprayed with a fixative agent so that the pigment will not smudge or rub off. Edgar Degas was a master of this medium, as were the 18th-century French artists Quentin de La Tour (1704–88) and Jean Baptiste Siméon Chardin (1699–1779). Chardin produced two self-portraits and one of his wife in pastel (all now in the Louvre) that are masterpieces of acute analysis and breadth of artistic vision and understanding.

A new medium combining the transparency and quick-drying qualities of watercolor with the thick, plastic advantages of oil is the recently developed *acrylic* paints. They may be put on in thin glazes with a water-dipped brush or in thick impastos with a brush or palette knife.

BELOW *Alpha-Phi* (1961) by the American painter Morris Louis, who died in 1962. He began by staining unsized canvas with layers of liquid acrylic paint before moving to regular stripes of pure color.

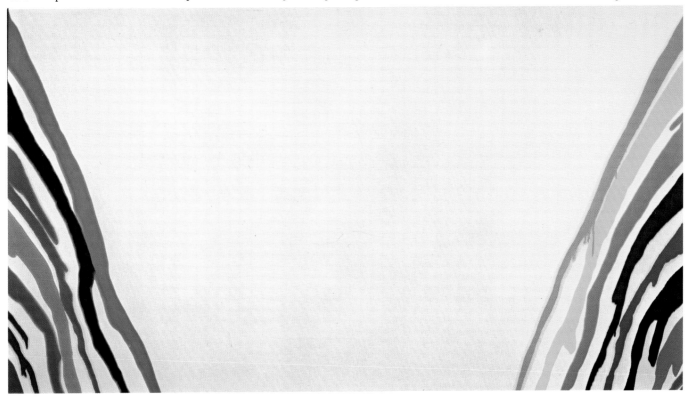

Narrative Painting

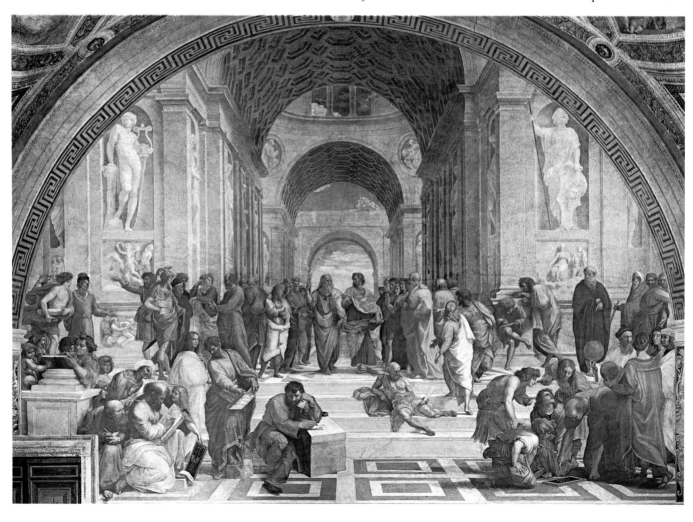

Although every picture does not necessarily tell a story, the narrative style of painting has a long and distinguished history. Religious art, when not portraying holy figures or stark symbolism, tended to present simple pictorial accounts of events in religious history or in the realm of the spirit. Ancient Egyptian and Roman artists often painted epic tales. Elsewhere and in later times the depiction of major historical events and works on social themes became common in secular art.

European painters of the 16th and 17th centuries, schooled for the purpose, made notable contributions to national and social

ABOVE RIGHT *The Last of England* (1860) by Ford Madox Brown, depicting the determination of 19th-century emigrants to the New World.

BELOW *The School of Athens.*

records. Raphael produced important paintings in the "grand manner" usually characteristic of such works. In the Vatican palace in Rome he

painted the ceilings and walls of the sequence of rooms now known as the Raphael Stanze. The mural known as *The School of Athens* shows the learned men of antiquity. In it Plato (sometimes thought to be a portrait of Leonardo da Vinci) is pointing upward to heaven, and Aristotle's hand is held palm downward, signifying their spiritual and earthly philosophies.

In Spain Diego Velázquez (1599–1660) painted tributes to monarchs and their courtiers and to his country's military achievements. Narrative painters proliferated in the 18th and 19th centuries. Pictorial history and social comment had become a profitable activity by this time.

But an excess of academicism and the depiction of extremely elaborate subjects on vast canvases in a manner that became trite in its opulence eventually brought a reaction against narrative painting. Today storytelling has been largely relegated to hack painters, although an artistic curiosity of World War II was the use of professional artists in the battlefield and on the home front. Their work, commissioned by governments, recorded the events and captured the atmosphere of combat with all the horror and compassion aroused in the participants.

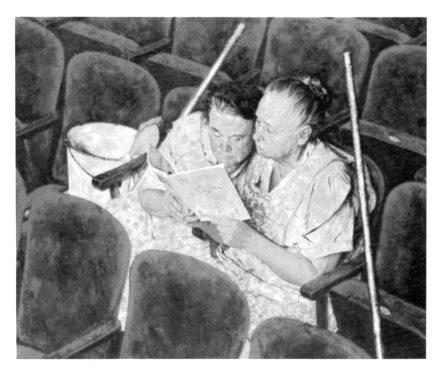

ABOVE Norman Rockwell's telling picture of two cleaning women taking a break in a deserted theater.

BELOW *Rocket Firing Typhoons at the Falaise Gap, Normandy, 1944,* Frank Wootton's painting of a World War II attack.

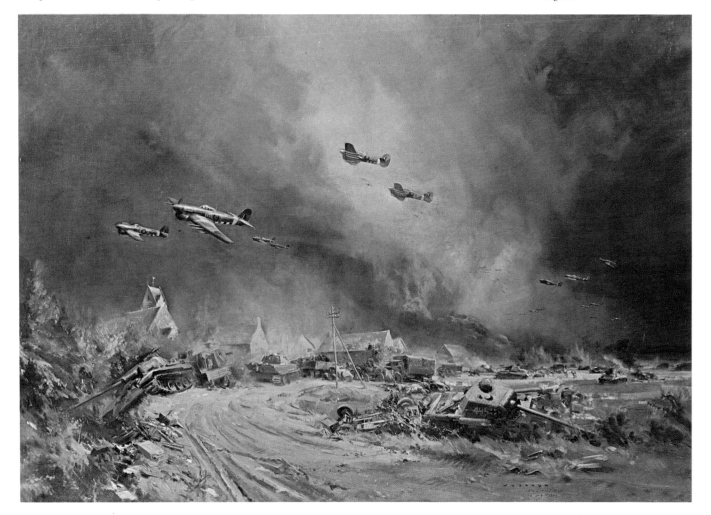

The Nude

The nude human body, in its basic form, anatomical structure, possible movement, and infinite variation of shape and expression, offers the artist a ready study in nature and a model for all natural form. A knowledge of the body's structure and the ability to render it with fluency are basic facets of the training of every serious artist.

The nude was the main element in the art of ancient Greece. The Greeks were proud of their bodies and often represented the naked torsos of their young athletes, gods, and goddesses. For them the accurate rendering of the human figure was part of the pursuit of truth.

The Romans might not have accepted this particular argument in favor of the nude (Roman statues of the gods are nearly always robed), but they filled their private houses with naked bronze youths and maidens. The rise of Christianity brought with it a total rejection of the unclothed body; nakedness represented paganism and sinful lust, and for nearly a thousand years the only figures ever shown naked were Adam and Eve and the Christ child. After 1400 the nude was rediscovered for art by the Renaissance movement in Italy. On the ceiling of the Sistine Chapel Michelangelo

RIGHT *Bather of Valpinçon* (1808) by Jean-Auguste-Dominique Ingres, a calmly satisfying example of classical draftsmanship. His nudes were ideal images for a painter whose notion of beauty was of something large, simple, and continuous, enclosed and amplified by an unbroken outline.

BELOW *Venus and Mars* by Sandro Botticelli, an allegorical suggestion that love (here fully clothed) can tame the god of war, here represented as an innocent youth.

painted 20 colossal nude youths – the Ignudi – and an Adam represented as coming to life at the commanding touch of the hand of God. Michelangelo's vision is of a gracefully muscular Adam very different from the hunched, starved figures of earlier Christian art.

The image of Venus, goddess of love, was restored to life at the same time. Sandro Botticelli (about 1445–1510) painted her birth in an unforgettable manner, and numerous Renaissance painters showed her in a particularly

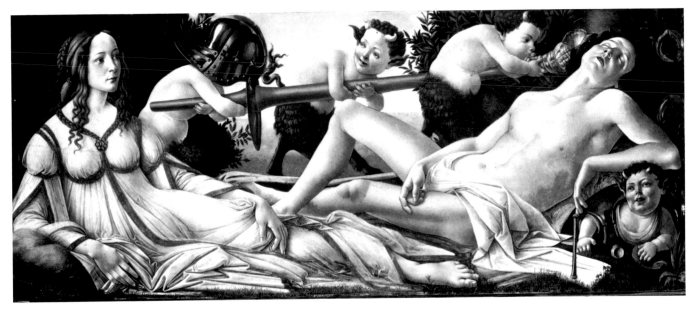

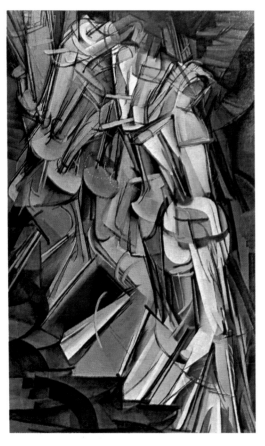

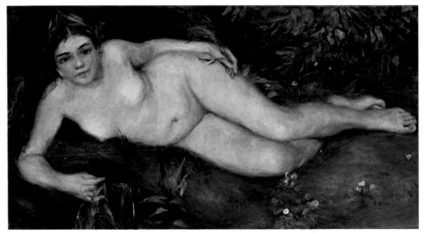

LEFT *Nude Descending a Staircase, No. 2* (1912) by Marcel Duchamp. Based on a multiple-exposure technique borrowed from photography, the nude is here reduced to a descending machine.

BELOW *Water Nymph*, one of the many nudes that Renoir painted during his long creative life. They reflect the cheerful serenity he found in working from nature.

popular pose for the female nude – reclining on a bed gazing drowsily out of the picture at the spectator. Among the masters of this convention were the great Venetian painters Giorgione (1477–1510), Titian, and Jacopo Tintoretto (1518–94). The relish with which these artists showed the luscious curves and flesh tones of the female body influenced their treatment of biblical subjects, too, as can be seen in the seductive lines of Tintoretto's *Susannah and the Elders* (about 1550).

Leading painters of the Italian Renaissance dissected human bodies to study the way muscles worked and to discover the exact skeletal structure. They were acting in opposition to the traditional respect for the inviolability of the body after death, however, and this practice excited bitter recriminations. These artists included Leonardo da Vinci, Michelangelo, and Raphael, and their sketches and calculations show the painstaking care that went into their studies.

German Renaissance painters showed a similar interest in representing the nude, at first in the classical manner and later in more personal styles. In Spain El Greco (1541–1614) portrayed nude male figures in inspired, elongated forms that increased the drama of his religious compositions.

During the next three centuries artists con-

BELOW sketch of a young girl by the Austrian expressionist painter Egon Schiele (1890–1918). He was profoundly affected by Freudian psychology, which he applied to portrait painting.

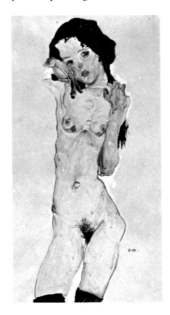

tinued to study and paint the human body. Rubens, who had a boisterous appetite for life, painted superbly vital women, plump and lustrous, whether illustrating a tale from the Bible or a scene of pagan joy. By the 18th century painting of the nude had declined into an art for princes in the pretty and artificial world of the French painters Jean Fragonard (1732–1806) and François Boucher (1703–70). The 19th-century painter Ingres brought solidity back into the form with such nudes as his *Bather of Valpinçon* and *The Large Odalisque* (voluptuous nude), both seen from the back.

Later in the 19th century the French painter Pierre Auguste Renoir (1841–1919), after moving away from the style of the Impressionists, painted his female nudes in lyrical color "like beautiful fruit," frequently placing them in a setting of sea or river bank. No one since Renoir has ever painted such warm, desirable, lifelike flesh.

The painting of the nude has continued into the 20th century. The Italian painter Amedeo Modigliani (1884–1920) drew female forms in long, sinuous lines of great elegance. Grave and unsmiling, his nudes have a haunting air of melancholy. Henri Matisse, principal artist of the Fauve group of French painters, continually returned to the subject of the nude throughout his long life. Matisse painted several groups of dancing or bathing nudes in which a sense of movement is communicated with a superb economy of line and strong juxtapositions of color. He also painted a great number of female nudes in repose – reclining, sprawling or otherwise at ease. Picasso attacked the image of the female nude with calculated violence in order to express emotional suffering, but the starting point of the composition always remained recognizable; in the work of many other modern painters, however, this subject among others has vanished under the influence of abstraction.

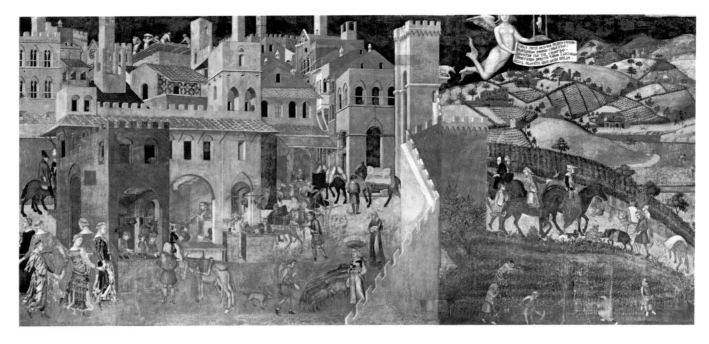

Landscape Painting

ABOVE *The Effects of Good Government in City and Countryside*, some of the panoramic scenes that make up Ambrogio Lorenzetti's enormous fresco for the Siena town hall.

In Japan and China landscapes and seascapes have long been favorite subjects of artists and often dominate any human figures that may appear in a scene. In the West, however, for centuries, landscapes were found only in the

BELOW *The Avenue, Middelharnis* (1689), by Meindert Hobbema. The Middelharnis province of south Holland lies on the north coast of the island of Over Flakee.

backgrounds of religious pictures or as miniature, though detailed, illustrations of medieval manuscripts. Perhaps the oldest surviving examples of landscape used as an essential component of composition are the series of frescos in the Siena town hall by the 14th-century Italian painter Ambrogio Lorenzetti (active 1319–47). Their theme is the contrast between *Good and Bad Government* (the title of the series), and they show such country activities as hawking, fishing, and bird-catching against a background of dense foliage, reminiscent of tapestry. The landscapes painted by the Flemish Limbourg brothers for the Duke of Berry's *Très Riches Heures*, a book of hours produced around 1405, also rank among the earliest of their kind, as do the surviving panels of his altarpiece of the Redemption by the Swiss Konrad Witz (about 1400–1444). His only signed and dated work is the painting in Geneva's Museum of Art and History, *The Miraculous Draft of Fishes* (1444), in which the brilliantly clear view of fields and hills beyond the fisherman's boat is recognizably a particular point on the shore of Lake Geneva. These seem to be the earliest examples of artists being inspired to depict the true look of a real place.

But landscape painting for its own sake remained a rarity until the growth of a group of landscapists in Holland during the mid-17th century, who widened the whole horizon of art. The pioneers included Jan van Goyen (1596–1656) and Salomon van Ruysdael (1600–1670), and a whole school specializing in landscape succeeded them, notably Salomon's nephew Jacob van Ruisdael (about 1628–82) and Aelbert Cuyp (1620–91). The ability of these painters

to capture the effect of light on buildings, forest trees, and coastal waters exerted a powerful influence on later artists. One of the last of this school was Meindert Hobbema (1638-1709), whose *Avenue, Middelharnis* (1689) in the National Gallery, London, has become, through reproduction, one of the best known of all paintings.

In Italy and France artists took up landscape as a subject but did not see it in the simple natural way of the Dutch. Instead they idealized it in a classical style. Foremost among these painters was Nicolas Poussin (1594-1665), who carefully balanced buildings and trees to give a strong, almost architectural structure to his compositions. Claude Lorrain (pseudonym of Claude Gellée, 1600-1682), another Frenchman who spent most of his life in Italy, also included classical architecture in his graceful paintings of a vanished "golden age." The views he painted almost always fade into a remote, hazy distance. The point was eventually reached when a real landscape in nature could be described as "picturesque," meaning like a painting, by admiring viewers.

By the 18th century landscape painting was practiced widely only in England, where leading artists produced naturalistic romantic pictures. In the next century John Constable and J. M. W. Turner (1775-1851) added to the British reputation in this field with pictures that were full of feeling and light. In France Jean Baptiste Camille Corot (1796-1875), who did not win full recognition until after his death, idealized his atmospheric landscapes with a more delicate touch than his French forebears. Many of his works gave the effect of being viewed through a hazy screen. He did not hesitate to leave out of his paintings any topographical details which did not happen to suit his composition.

Paul Cézanne applied to landscapes his theory of rendering volume and space through color, which he used with a geometrical precision, and ignoring the traditional system of linear perspective. Vincent Van Gogh, using a brush heavily loaded with strong color, brought a dramatic vitality to the features of his landscapes. His agitated *Crows over the Wheatfield* (1890), a view of the fields near Auvers-sur-Oise, a small village in north central France, was painted during the last months before he committed suicide. His vision of nature became lighter and more lyrical than in his earlier paintings of sun-baked southern landscapes, and the northern light required paler tones.

The Fauves brought an even more brilliant coloring to their landscapes, and the works of André Derain (1880-1954) and Georges Braque in this style are particularly remarkable. Both subsequently toned down their colors and changed their style of painting. In the great experiment of cubism, Braque and Picasso produced landscapes in which they attempted to translate the forms of nature into a "new realism" based on Cézanne's geometrical system.

More recently, painters have not found great stimulus in rustic landscapes. The strong patterns of roofs and chimneys have inspired some painters to produce "townscapes," while others have nourished an inner vision of dream landscapes that are sharply colored, mysterious, and at times alarming.

BELOW *Crows over the Wheatfield* (1890), one of Van Gogh's last landscapes, reflecting his depression and unease in the dramatic brushwork.

The Artist
as Observer

Artists are close and tireless observers of human beings and the world around them. The perceptive artist's eye does not content itself with surface appearances but delves deeper, into the very nature and structure of the object under scrutiny. Painters have a great curiosity and capacity to assimilate observations. It is the knowledge gained in this way, combined with perception, experience, and instinct, that they draw on in order to create images that do not imitate but interpret life.

Many of the early cavemen and women rendered the movement of their animal subjects with extraordinary accuracy. The successful "freezing" of a bison in the act of charging or of a running deer demanded close study. Medieval

artists also studied their subjects with a discerning eye. Giotto, who saw people in the round, moved away from the tradition of rendering them as if they were flat. Later Uccello was so intrigued by problems of perspective that he spent long nights studying "that sweet thing." In Renaissance Italy, movement, expression, and background were depicted with an obvious

LEFT *Tall Grasses*, one of Albrecht Dürer's beautifully detailed studies of plant life. It is almost photographically faithful to reality.

RIGHT *The Anatomy of the Horse*, a book by George Stubbs, includes this drawing of the structure of a horse. This English artist, born in Liverpool, became known for his fastidious attention to anatomical detail and gained a reputation as one of the greatest of animal-painters.

appreciation of nature and truth.

Leonardo da Vinci and Michelangelo conducted research into the physical structure of human beings by dissection of bodies and first-hand examination. Leonardo's study of the movement of water and wind was no less dedicated, and he now is celebrated as an ingenious inventor of mechanical devices. His intellectual curiosity knew no bounds, and his unequaled vision was reflected in all of his works.

In the course of the 16th century the continuing rediscovery of the natural world gave rise to a style known as *genre* painting. Genre paintings depict subjects and scenes from everyday life, usually devoid of satiric or moral comment. Pieter Brueghel the Elder (about 1525-69) is famous for his depictions of Flemish peasant life, but it was not until the 17th century that genre painting became widely popular. When it did, the Netherlands became its greatest center. The Reformation had deprived Dutch artists of religious patronage, for Protestant churches did not commission works of art in as great numbers as the Catholics. Artists were therefore forced to turn to other subjects. They showed ordinary people in taverns, women performing household tasks, homely interiors, and still lifes. From the 1600s also come the familiar, exquisitely precise

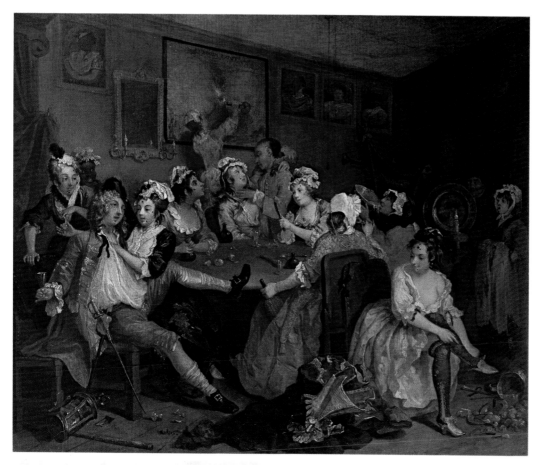

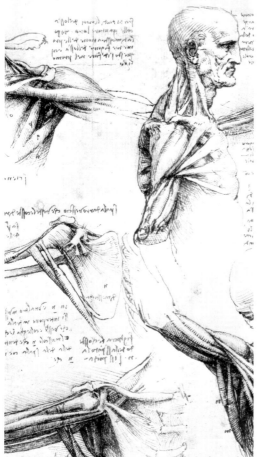

paintings of tulips and other flowers. Sometimes
these are shown singly for purposes of record,
but they are frequently arranged in massed
groups of different kinds of flower that reveal a
sensitivity to pattern as well as to color and detail.

In England, through close observation of large
city populations in their squalor and of the
nobility in their elegance, William Hogarth
(1697-1764) – whose apprenticeship had been
in silver engraving – painted well-studied por-
traits and narrative scenes with all the care for
detail of an engraver combined with the spirit
of a satirist. Later George Stubbs (1724-1806),
also a noted portraitist, published *Anatomy of
the Horse*, the result of many years' study.

The Impressionists literally saw the world
in a new light and made a break with tradition.
They flattened volumes and lightened color in
their effort to record instantaneous impressions.
Camille Pissarro (1830-1903), though always an
acute observer, often depicted houses as masses
of bright color and vibrating spots of light.

The surrealists claimed metaphysical inspira-
tion and painted fantasies and dreamlike visions
which established disturbing new relations
between objects. Later still, in nonobjective
art, paintings were produced through a con-
scious effort not to recall or evoke any reality
except that of color relationships.

Artist and Patron

Apart from earning a certain respect, perhaps amounting to reverence, for their special skills, it is unlikely that prehistoric artists received any reward for their labors. In the ancient world, when portraits of individuals had come into vogue and rich people commissioned reproductions for their homes of the public pictures they admired, craftsmen-painters were undoubtedly paid for their work. And in the Middle Ages, when religious patronage offered the only market for their hard-earned skills, painters worked in close association with their fellow craftsmen and depended largely for their living on what were, in effect, anonymous group contracts.

By the 14th century kings and noblemen in Europe had enlarged the painter's clientele and earning potential. Paintings and books were freely commissioned, and artists of high reputation were much sought after and often imported from some distance. In France the Duke de Berry,

ABOVE portrait of Lorenzo the Magnificent, most illustrious of the Medici dynasty that ruled Florence for more than three centuries. Famous for his unstinting patronage of the arts, his protégés included da Vinci and Michelangelo.

brother of Charles V, was a particularly avid and generous collector of art, giving his patronage both to individual artists and to *guilds* into which groups of artists formed themselves in order to protect the interests and skills of their crafts. These guilds operated an apprentice system that insured the continuity and quality of their craft.

Individual artists of more than average talent began literally to make a name for themselves by putting their signatures on works of art they executed. Commissions now came in more steadily, not only from the religious establishment and the courts, but from merchant guilds and individuals anxious to be recorded in this increasingly fashionable way.

During the Renaissance private demand for works of art increased almost everywhere on a considerable scale. The studios of the more able and successful practitioners became centers for training greater numbers of young artists. Inevitably individuals of rare talent and occasionally artists of genius emerged from this widening of the craft. Painters' status was further enhanced by the opportunity given them by their patrons, both religious and private, to work in the grand manner. An imposing concept, well executed, was bound to bring credit to both artist and sponsor. Artists gained a new sense of personal and artistic independence and came into their own, able to name their own fees and choose their own subjects.

In the 17th century Rubens received com-

LEFT *Rubens and His Second Wife in their Garden*, painted soon after his remarriage, when in 1635 Rubens and his wife went to live at the château he bought in Elewijt to enjoy the lifestyle of the landed gentry.

missions on such a scale that he employed large numbers of assistants to work on paintings that he had first roughed out and later finished with a masterly touch. He became very wealthy and eventually worked in a palace of his own. Rembrandt, who also obtained many commissions from public bodies and private individuals, nevertheless died in lonely poverty. Jacob van Ruisdael prospered, but Frans Hals (about 1585–1666), a clear-sighted Flemish master of portraiture, died destitute in a poorhouse.

In the 19th century many creative painters rebelled against the conservative attitudes of the Academy, and their attitudes led to the popular image of the artist as a starving nonconformist rather than a gifted craftsman. Today commissions from public bodies are still occasionally forthcoming, and there is renewed patronage by the state. Business firms, for reasons of advertisement and prestige, have also entered the market. But it is still the private buyer who, by and large, provides artists with their living.

In an increasingly organized world the painter is often encouraged and guided by a middleman, the dealer, who usually runs an art gallery through which paintings are shown and sold either to members of the public or to museums. In spite of the constant need for new talent, the competition for attention is extremely demanding, and most contemporary artists must turn to teaching or some other similar source of steady income in order to support their artistic activity.

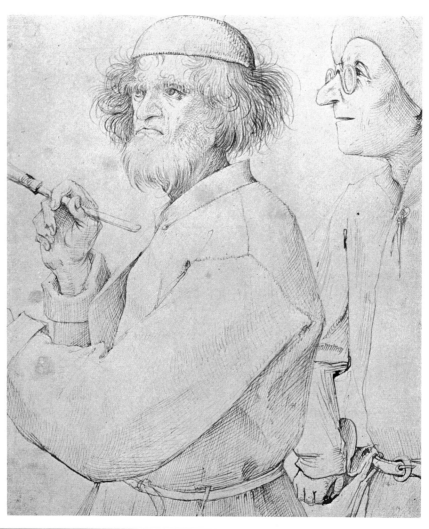

ABOVE drawing by Pieter Brueghel the Elder entitled *Master and Pupil* (about 1565). Brueghel himself was apprenticed to a leading Antwerp artist and was received as a master into the Antwerp painters' guild in 1551.

LEFT *Teamwork* by David Wynne, commissioned in 1958 by the Taylor Woodrow Group for its international head office outside London. It shows four men pulling together on a rope and is an example of artistic patronage by big business for the sake of prestige.

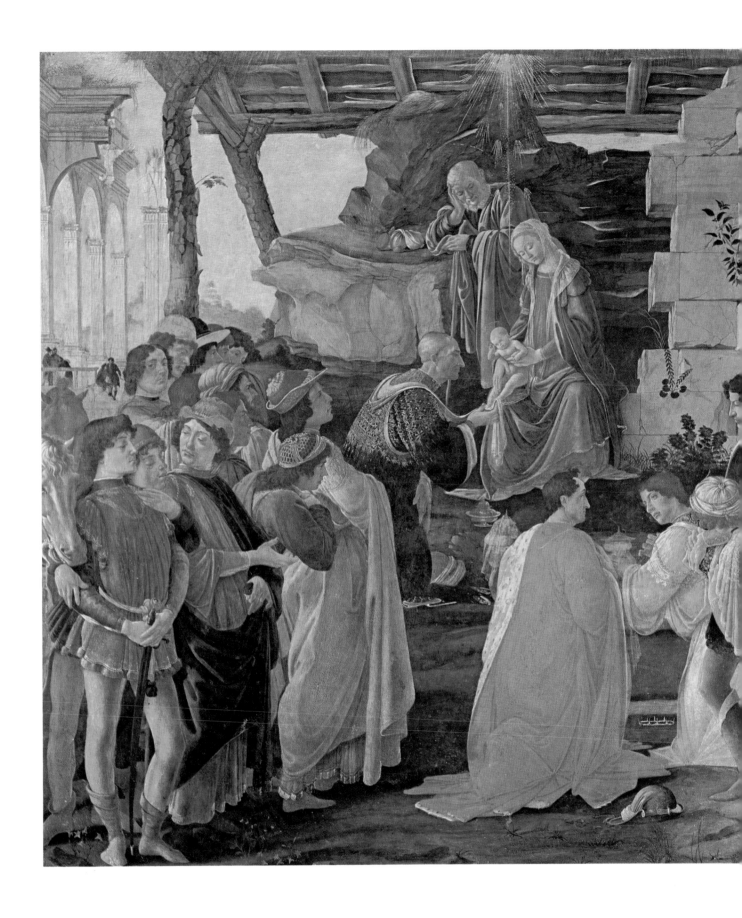

Chapter 3

THE GREAT PAINTERS

Great painters may have as little in common with one another as an overpowering need to paint. The Japanese artist Hokusai was known as "the old man mad about painting." The aged Renoir, stricken with arthritis, had brushes strapped to his wrists so that he could continue his beloved art. Painters of genius sprang from widely different social backgrounds – peasant homes, the ranks of the minor aristocracy, the homes of businessmen with no interest in art, and families with a strong artistic tradition. There is no fixed characteristic by which to predict the career of any artist.

Painters must have a clear eye and a sure hand, but above all they need imagination. It is the intensity of that imagination that distinguishes the great painters from the rest – an intensity that we, the spectators, can share when we look at their paintings.

OPPOSITE *The Adoration of the Magi* (about 1475), painted for the Medici, citizen-kings of Florence, three of whom are depicted among the worshipers. The figure in yellow at the far right is a self-portrait of Sandro Botticelli.

Giotto

1266?-1337

His contemporaries called him "the greatest master of painting." One early historian of Florence wrote, "Before Giotto's day we see that painting was dead. But he rescued it from a state in which it was capable only of depicting laughable caricatures." He was praised by the poet Dante in the *Divine Comedy*, and a critic who knew Giotto di Bondone personally suggested a reason for this: "He, more than any other, depicted people and actions from life."

This was the aspect of Giotto's work that struck his contemporaries most forcibly. Painters before him, their names mostly unknown, had copied the motifs and style of their predecessors, and the stiff conventions of Byzantine painting had thus been handed down through many generations. Cimabue, Giotto's teacher, had tried to break free of the constricting mold, but it was Giotto who succeeded. He looked upon people, their expressions, and their actions as his main subject matter. He thought deeply about how to produce scenes in paintings so that they would look real. The events they depicted, whether taken from the Bible or from

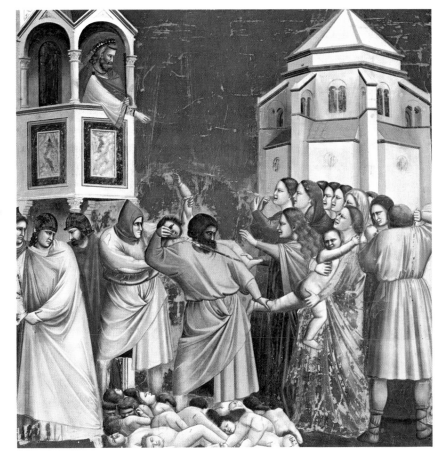

ABOVE *Massacre of the Innocents*, one of the scenes from the Scrovegni Chapel in Padua. Giotto's classic, ordered vision of the world is reflected in his plain but subtle figures who, no matter how unsophisticated, are always dignified.

the life of the great humanist St Francis of Assisi (only recently dead), seemed to be both of this world and also to have a greater, spiritual reality.

Giotto was born at Colle di Vespignano in the countryside 14 miles from Florence, the son of a poor peasant farmer. According to legend,

BELOW detail from *The Last Judgment* (west wall, Scrovegni Chapel), believed to be a self-portrait of Giotto himself. He has been called the first great creative personality of European painting, and his characteristic wit was cherished by his contemporaries as much as the undoubted genius of his painting.

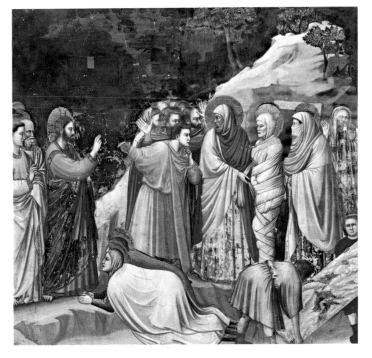

LEFT *Raising of Lazarus*, also from the Scrovegni or Arena Chapel, Padua. The series of frescoes, which completely decorate the interior in three tiers, were planned for in the construction of the chapel, unusual for the period.

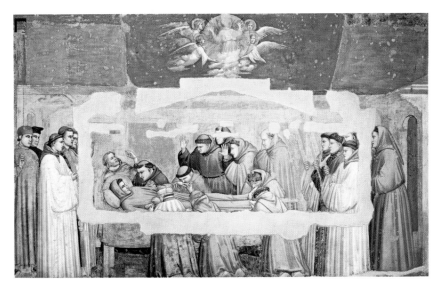

ABOVE *The Death of St Francis*, a scene from the Bardi Chapel series of frescoes in Florence.

Cimabue was traveling from Florence to Vespignano when he came upon the boy Giotto guarding his father's sheep and drawing one of them by scratching with a stone on a smooth rock. Astonished at his skill, he asked whether the boy would like to become his pupil. Giotto's father gave his consent, and so Giotto went to Florence.

Little is known of his early years as a painter. He mastered Cimabue's style and absorbed the

RIGHT the Bardi Chapel in the Church of Santa Croce, Florence. The life of St Francis of Assisi is illustrated in a magnificent series of frescoes that are among Giotto's best-preserved works. He also decorated three other chapels in the church.

traditions of Roman fresco painting and Gothic sculpture, both of which aimed for objective representation and apparent solidity of form. From about 1290 he was working in Assisi, where he probably executed some of the fresco cycles on the life of St Francis that decorate the Upper Church of San Francesco. Scholars disagree as to how many of these frescoes Giotto actually painted, but the resemblances between these and his mature work are very slight.

In 1304 he was summoned to Padua and began work on the first of his undoubted masterpieces, the frescoes of the Scrovegni Chapel, also known as the Arena Chapel because it stood on the site of a Roman amphitheater. The fortune of the Scrovegni family was founded on moneylending, and the chapel was presumably built to expiate the sin of usury that hung over the family name.

Onto the smooth walls and barrel vault of the chapel Giotto painted 40 scenes from the life of the Virgin Mary and the life and death of Christ. The scenes flow along the walls in three bands, and the perspectives of architecture are convincingly shown. There is always a feeling of space around and between the figures. Their gestures define the space and also supply the dramatic and emotional links in the narrative.

This can be clearly seen in the many scenes in which figures stare fixedly at one another – the Virgin and the newborn Jesus; Jesus kissed by Judas; the Pietà, in which the Virgin's earlier gaze is echoed and movingly transformed by grief. In this last scene, entitled *The Lamentation*, St John flings back his arms in a gesture that is unusual yet vividly expressive of sorrow while in the sky above angels sob piteously.

The sense of communication between figures as expressed by the eyes was one of Giotto's supreme achievements. The *Massacre of the Innocents*, the *Raising of Lazarus*, and the *Mocking of Christ* (where people crowd around to tug at his beard) are examples of his economy in the number of figures which, combined with the use of telling detail, gave his contemporaries the impression of eyewitness accounts.

Giotto painted other frescoes in Padua, Naples, and Bologna, all of which are lost. Fortunately many of the frescoes he painted in the 1320s in the Church of Santa Croce, Florence, have survived, although they were covered with whitewash and were only restored in the mid-19th century. The series in the Bardi Chapel, the best preserved, is devoted to the life of St Francis, but it is painted in more muted colors than the earlier cycles. Through its expressive details Giotto reveals a mastery of characterization and realism that would not be equaled for another hundred years.

Jan van Eyck
1370?-1441

Above the round mirror in the bedroom where Giovanni Arnolfini stands holding the hand of his bride, Giovanna Cenami, the painter has placed an inscription: "Johannes de eyck fuit hic 1434" (Jan van Eyck was here, 1434). So precisely and vividly has van Eyck painted the innumerable minute details of the room in which they are exchanging marriage vows that we must believe that he was. In fact, two people (probably the witnesses) are reflected in the mirror as standing in the position of the viewer, and one of them must be the artist. For the double portrait is a record of an actual occurrence. Arnolfini was a wealthy Italian merchant from Lucca, in Bruges to sell silk to the Duke of Burgundy. He wears a beaver hat and fur-trimmed gown – and never before has the fur in a painting seemed so furry. Never before has a green dress looked so richly green, and one can imagine holding its heavy folds, as Giovanna does, and feeling their weight. The hairs of the little dog in the foreground are astonishingly silky. The oranges on the chest, the apple on the window, the brass chandelier with its single burning candle – all are intensely lifelike. As a record of the world about us, painting could hardly advance further – and in a sense it never has. Yet the domestic setting, however persuasively realistic, is also full of subtle symbolism conveying the ideals of marriage. The painting is both a remarkable portrait and a major imaginative masterpiece.

Jan van Eyck was born in Maeseyck in Limburg, in eastern Flanders, as the younger of two brothers. Little is known of Hubert van Eyck, though he was also a painter. Flanders at this time was part of the extensive dominions of the dukes of Burgundy, and from 1425 Jan was in the service of Philip the Good, the duke who made Burgundy into one of the major powers of Europe and helped to bring about the flowering of 15th-century Flemish art. Jan's role was wider than that of a court painter. He was frequently sent on "certain distant and secret journeys" for the duke, who evidently saw the advantage of having as his confidential agent an

BELOW *The Marriage of Giovanni Arnolfini and Giovanna Cenami*, van Eyck's famous painting "documenting" the wedding of these two Italians. The script in which the artist inscribed his name is a type common in legal documents and contracts.

unobtrusive painter with remarkable powers of observation. He traveled to France, Portugal, England, and Spain, twice on business connected with marriage negotiations. He also painted decorations for the palace of Count John of Holland, in The Hague. Eventually he settled in Bruges, at that time one of the wealthiest trading centers in Europe.

At this time the Italians were beginning to give a greater verisimilitude to their paintings by the scientific application of perspective. Van Eyck and his fellow Flemish painters were aware that objects diminish in size as they recede from the observer, but their own study led them to consider the fall of light as the factor that gave shape to solid forms. Light touched all objects in a picture, and through the play of light and shadow on them their three-dimensional appearance emerged.

The newly discovered material of oil paints

enabled the Flemish to represent an illusion of the effects of light to a degree impossible for an Italian painter working in fresco. Onto a panel of wood carefully prepared by first covering it with a polished layer of *gesso* (powdered chalk and size) the painter applied layer upon layer of pigment bound with oil. Each layer hardened to a transparent glaze. Light could permeate these glazes and make the colors glow instead of reflecting back off an opaque surface. Some colors – vermilion is one – are always opaque, but when a layer of transparent glaze was painted over it the color became superbly rich. It was the combination of meticulous observation and their mastery of oil painting technique that gave van Eyck, his colleagues, and their successors – Rogier van der Weyden, Hugo van der Goes, Hans Memling – their unique character.

Hubert van Eyck left the large altarpiece of the St Bavo Cathedral in Ghent, *Adoration of the Lamb,* unfinished at his death, and Jan completed

BELOW *A Man in a Turban* (1433), presumed to be a self-portrait of the artist. On the upper edge of the frame are inscribed the words "Als ich can," said to refer to a Flemish proverb: "As I can, but not as I would."

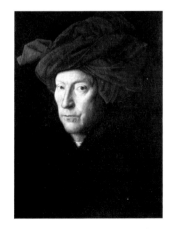

it in 1432. The extent of his contribution is doubtful, but the cypresses and orange trees are definitely the work of someone who has seen them growing (presumably in Portugal). The *Adam* and *Eve* panels are Jan's, and on the outside of the altarpiece he painted an *Annunciation* in which the Virgin is placed, not against the usual gold background, but within a typical Flemish room with a view of the town visible through the windows.

Similar views appear in many of Jan van Eyck's paintings. In the background to the *Madonna with Chancellor Rolin* (about 1436) can be seen a flower garden, and beyond a parapet is an astonishingly busy and detailed landscape. The Virgin, though sometimes shown wearing a crown, is never given a halo. Nor are St George or St Donatien, who flank the Virgin and Child in the *Madonna of Canon van der Paele* (1436) in Bruges. Not even the Christ child wears a halo. This contributes to the naturalism of the works.

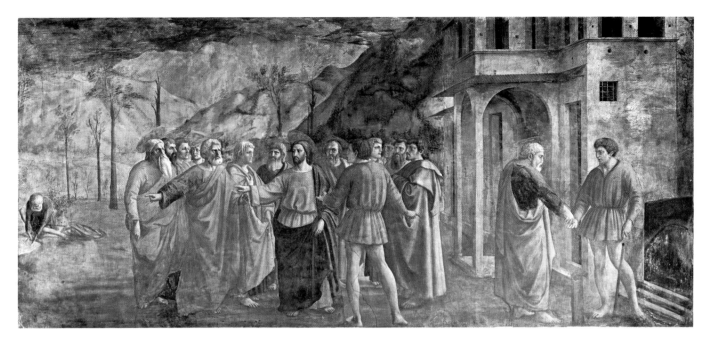

Masaccio

1401-1428

Painting, like the other arts, honors those of its practitioners who died young. The earliest and one of the greatest of these was Tommaso di Giovanni di Simone Guidi – known as Masaccio, a nickname that means roughly "Clumsy Tom." He was born in what is today the town of San Giovanni Valdarno in the Tuscan province of Arezzo, the son of a lawyer. When he was 16 he went to Florence, where he joined the painters' guild in 1422. He painted in Florence and Pisa and in 1428 traveled to Rome, where almost immediately (some said by poison) he died.

Masaccio's single-mindedness became proverbial. He cared nothing for the clothes he wore, the food he ate, the room in which he lived nor the money he received. He lived absolutely for his painting. His loss was deeply mourned at the time and seemed all the greater as his fellow artists began to assimilate the discoveries he had made in his eight years of creative life.

He was the first painter since the death of Giotto to fully understand and master his predecessor's achievements and to build from them. He learned from the sculpture of his friend Donatello and was familiar with the perspective drawings of another friend, the

TOP *The Tribute Money*, from the Brancacci Chapel in the Church of Santa Maria del Carmine in Florence. With the opportunity to work on an epic scale, the young artist fully mastered a revolutionary realism and left a monument that served as a school for painters including Leonardo, Raphael, and Michelangelo.

ABOVE *Enthroned Madonna and Child*, originally the central panel of a polyptych. The throne shows the classical influence of Brunelleschi.

RIGHT detail from the Brancacci fresco *St Peter Healing the Sick*, in which the young man on the far right is presumed to be Masaccio.

architect Filippo Brunelleschi (about 1377–1446). These influences, combined with Masaccio's own genius and dedication, were to bring about a revolution in painting.

The polyptych he painted for the Church of Santa Maria del Carmine in Pisa in 1426 was dismantled and dispersed in the 18th century, and to date only 11 sections have been identified in various museums and private collections. The most significant in terms of reconstruction are the central panel, *Enthroned Madonna and Child*, and the *Crucifixion*, which originally formed the lofty summit. In this the figure of Christ, intended to be seen from below, is foreshortened upward so that his collarbone projects in silhouette against the face above. The distraught Mary Magdalene stretches out her arms as St

John turns away to weep; only the Virgin stands staring at her dead son, hands crossed in prayer – a figure of determination and grandeur. A similar grandeur can be seen in the *Enthroned Madonna*, although the face has been spoiled by overcleaning. Her quality of monumentality is enhanced by Masaccio's use of architectural columns on the throne. The Virgin looks as though she is the height of a building, and the intensity of the shadows gives a further massive solidity to the form. The naked child stuffs grapes (symbols of the Passion) into his mouth from the bunch held for him by his impassive mother. It is a curiously disturbing image.

Masaccio's greatest and most influential achievements were the frescoes he painted in the Brancacci Chapel in the Church of Santa Maria del Carmine and the *Trinity* in the Church of Santa Maria Novella, both in Florence. All the frescoes in the Brancacci Chapel, painted between 1424 and 1428, represent scenes in the life of St Peter. The room is dominated by Masaccio's masterpiece, *The Tribute Money*, illustrating a little-known incident in the New Testament. It was particularly relevant to the Florentines, because at the time it was painted they were being urged to pay taxes toward defending themselves against a Milanese army. In the center the tax gatherer demands his tribute and Christ points out to St Peter where to find it. To the left Peter is taking the money from the mouth of a fish, and to the right he is handing it to the taxman.

The cloaked figures make an unforgettably powerful group, rugged and monumental, their faces strongly individualized (though reflecting the artist's fondness for long noses). The light falling from the right places them clearly in space, while in the distance Masaccio painted the first credible landscape since Roman times. Plains and riverbanks lead to hills and, in the distance, a cloud-filled sky. His brushwork showed an ease and freedom that had not been seen for a thousand years. A modern critic has written, "It represents not hairs but hair, not leaves but foliage, not waves but water, not physical entities but optical impressions." Such a method anticipates the aims of Impressionism by nearly 500 years.

Elsewhere in the chapel Masaccio painted other scenes which have this novel sense of life and real emotion. Leonardo, Michelangelo, Raphael, and many others came later to study the figure of a nude youth shivering with cold as he waits for St Peter to baptize him, that of a man drying himself with a towel, and the muscular youth kneeling in the water. There is a tragic poignancy in the figures of Adam shielding his eyes and Eve crying out in despair in *The Expulsion from Paradise*.

One of Masaccio's last works was the *Trinity* for the Church of Santa Maria Novella in Florence. It amazed his contemporaries by its revolutionary use of linear perspective. The foreground figures are set against a barrel vault that recedes with such accuracy and gives so convincing an illusion of depth that the true wall seems to have dissolved away through the power of Masaccio's brush. A few weeks after completing it, at the age of 28, he was dead.

BELOW Masaccio's *Trinity*, in which a flat wall is made to look like a barrel vault. His interest in architecture led him to take great care over the structure that frames the figures.

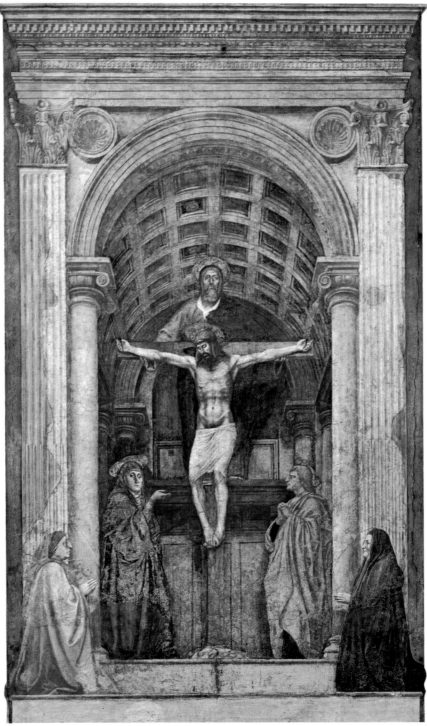

Piero della Francesca

1420?-1492

Piero della Francesca (dei Franceschi) worked mainly in the smaller Tuscan towns of Arezzo, Urbino, and Sansepolcro. A celebrated painter in his own time and also well known as a theorist of perspective, his later fame was overshadowed by that of the great generation of painters who came immediately after him. Not until the late 19th century did his reputation recover, and it now stands far higher than in his lifetime. His ability to place solid objects and figures in a believable space is unrivaled – a modern critic has called him "the first cubist" – and above all he understood how light can give a three-dimensional form to objects as well as enhancing the emotional content of a scene.

He was born in the small town of Borgo San Sepolcro, east of Arezzo, and the bare, hilly landscape of the area can be seen in several of

RIGHT *St Michael*, one of the flanking saints from the polyptych painted for a Sansepolcro charity, originally the altarpiece of the Church of San Agostino. Three of the other saints are known to have survived.

BELOW *The Nativity*, in which cold blues and silver-grays – tones not used again until Vermeer – suggest the sunless early morning. This painting remained in the possession of the artist's family for many years.

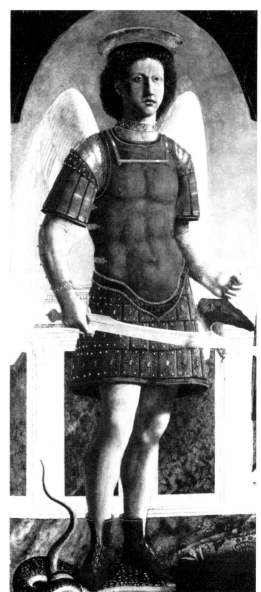

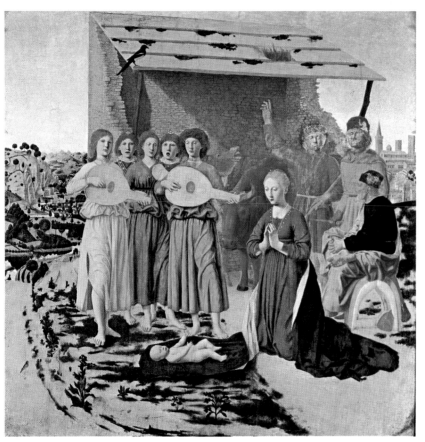

his paintings – for instance, *The Baptism of Christ* (about 1440-45) and *The Nativity* (about 1480). His father was a shoemaker, but nothing else is known of Piero's early years until 1439, when he was about 20 and working in Florence as assistant to Domenico Veneziano (about 1410-61). Here he would have been able to study the achievements of Giotto, Uccello, and Fra Angelico (about 1387-1455). But he soon returned to his hometown, which he loved, and began work on the very large polyptych (23 pictures in all) for the charity of the Confraternity of the Misericordia. This altarpiece was to occupy him from 1445 to 1462.

The smaller pictures are by assistants, but the *Crucifixion*, central *Madonna*, and flanking saints show Piero's hand. An unusual feature of the contract was that he undertook to inspect the work after ten years and to make good any damage. The probable reason for this was that

he used a mixture of tempera and the new oil paints recently introduced into Italy from Flanders. A tradition claims that the figure with his face tilted up, to the left of the Madonna, is a self-portrait.

About this time Piero also painted *The Baptism of Christ*, and here we can begin to see his special interest in perspective. The landscape recedes convincingly behind the figures toward the distant hills, and the recession is assisted by the subtle harmony of color. The red of the foreground angel is repeated in the strange red hat of the man in the background (the hat is virtually the same shape as the angel, only upside down); the green of the man's cloak makes him almost one with the grass beyond. Piero built up his compositions as carefully as geometric diagrams. The lower arc of a circle traces a line across the shoulders of the man taking off his shirt and through John the Baptist's arm, the top of Christ's loincloth, and the profile of the angel on the left. The sturdy figure of John is balanced by the equally sturdy – though different in form and color – vertical line of the tree. In a painting that lacked pictorial depth this composition might seem mere patterning, but Piero has combined two-dimensional patterning with the illusion of three-dimensional space.

Another characteristic of Piero's can be seen in the *Flagellation of Christ*, painted in the late 1450s when he went to Urbino to work for Duke Federico da Montefeltro, whose highly cultured court was called "the light of Italy." For scenes as potentially dramatic as the *Baptism* and the *Flagellation*, the figures are remarkably still. Unlike the painters most liked by the Florentines, Piero seldom shows violent movement. Only twice did he paint battles – and one of those was the Emperor Constantine defeating a rival without a sword being drawn. Instead he captures crucial movements of an event and "freezes" them at the moment that best expresses their significance.

In the *Flagellation*, where three anonymous figures in the foreground are mysteriously separate from the torture of Christ within the building (which is painted according to the most precise mathematical principles), Piero may have intended to represent the sufferings of the church at that time. After a thousand years of precarious existence, the eastern Christian empire of Constantinople (Byzantium) had just fallen to the Turks. The three foreground figures may recall the earlier sufferings of Christ, as in a dream. Some scholars have seen in the bearded man a resemblance to the Constantine, founder of Constantinople, of the great cycle of

BELOW *Madonna of Mercy*, central panel of the altarpiece for the Confraternity of the Misericordia. The Madonna holds her blue cloak around the members of the organization in an image of heavenly protection.

frescoes painted by Piero about this time in Arezzo. There, in the choir of the Church of San Francesco, he painted the *Legend of the True Cross*, a cycle of frescoes ranging from the death of Adam to the reign of Constantine. This commission, on which his fame chiefly rests, occupied him from 1452 to 1466. Again, the scenes are quietly dignified, beautifully composed and lit, and are typical of Piero's art at its best. He lived until 1492 but painted nothing after about 1480, although he wrote a treatise on proportion. In fact, he may have gone blind.

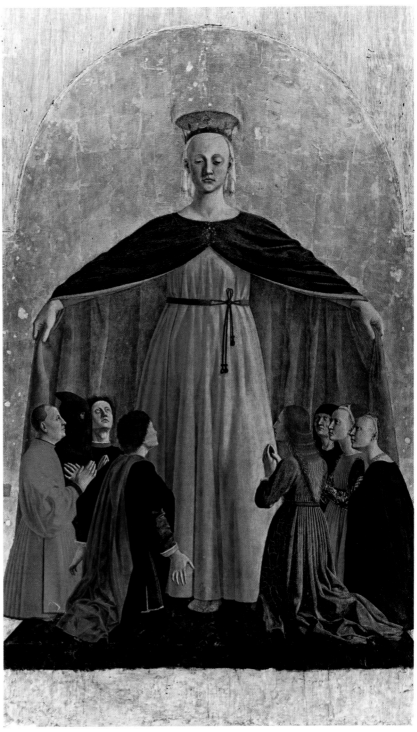

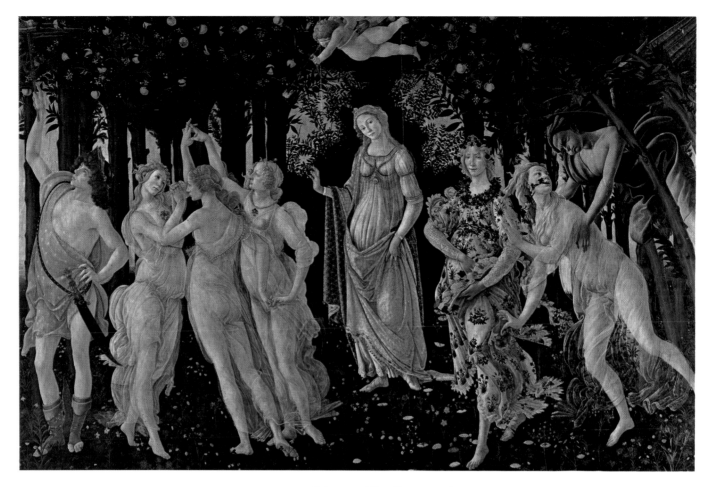

Sandro Botticelli

1445?-1510

It is said that a weaver once moved into the house next door to Botticelli and set up eight looms that rattled both buildings so much that the painter was unable to work. When he asked his neighbor to control this nuisance, the weaver replied that in his own house he could and would do whatever he liked. Botticelli thereupon had an enormous rock carried up to the top of his own house, which overlooked his neighbor's, and balanced it on the wall so that at any time it might fall and wreck the weaver's house and all his looms. When the terrified weaver protested, Botticelli answered that in his own house he was doing what he liked. This story suggests that Sandro Botticelli possessed a certain robust wit, a quality perhaps slightly surprising considering the grave and ethereal beauty of his most

ABOVE *Primavera, The Allegory of Spring*. Painted for the villa, at Castello, of Lorenzo di Pierfrancesca dei Medici, unruly young cousin of Lorenzo the Magnificent, it may have been part of the boy's tutors' attempts to improve his behavior. Venus was considered the goddess of moderation by Florentine humanist scholars, who profoundly influenced Botticelli at this time. His Venus, modestly draped, stands at the center of his composition. To the right the wind god Zephyr pursues the frightened nymph Chloris, who at his touch changed into the goddess Flora. Blind Cupid is shooting a burning arrow at one of the three Graces, and on the left the god Mercury disperses the clouds of ignorance with his wand. The painting is an elaborate allegory showing that passion can be transformed into wisdom.

famous mythological paintings.

Although he is the best known of the early Renaissance painters, details of his life and development are few and far between. His name was not really Botticelli. He was born Alessandro dei Filipepi, the fourth son of an elderly Florentine leather tanner. His elder brother Giovanni, a pawnbroker, was nicknamed Il Botticello ("little barrel"), and it is assumed that this nickname followed the younger brother when he entered the workshop of the painter Fra Filippo Lippi (about 1406-69).

By the time he was 25 he was running a workshop of his own. He painted a number of portraits, mainly head-and-shoulders views of youths, and an enormous quantity of Madonnas. Many are the joint work of Botticelli and his assistants and are notoriously difficult to date. His paintings show his characteristically precise outlines, careful finish, and a somewhat dreamy beauty. Even the mythological figure of *Fortitude* (about 1470), painted for the Merchant's Guild as his first substantial commission, has a wistful look. Her blonde hair, smooth brow, and pointed chin were features of Botticelli's work – in *Judith and Holofernes* (about 1469), in numerous angels and nymphs, and of course in both the male and female figures of *Primavera* ("Allegory of

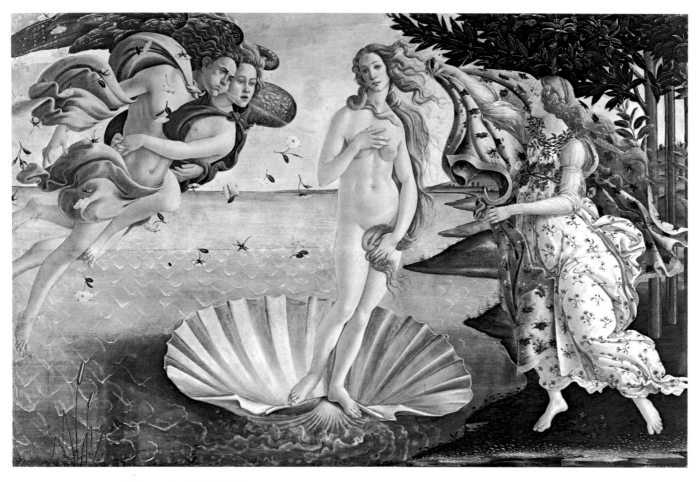

ABOVE *Birth of Venus*, the most famous of all Botticelli's pictures. A work of magnificent elegance and great delicacy, it shows the artist at the peak of his powers.

LEFT *Mystic Nativity*, the only painting signed by Botticelli. The interpretation of this subject is unusual and implies that Botticelli painted it for himself.

BELOW self-portrait of the artist at about the age of 30, a detail from his painting *Adoration of the Magi* (see pages 52–3).

The painting is an elaborate allegory showing that passion can be transformed into wisdom. But one does not have to be aware of the philosophical content to admire the harmonious lines and otherworldly beauty of the work.

About five years later Botticelli painted his *Birth of Venus* for the same villa. Her neck may be too long and her shoulders impossibly slanted, but somehow these defects, if such they are, do not matter: she is the personification of grace as she floats toward us, blown by the embracing winds.

Botticelli paid a bitter price for the mythological beauties he painted in his youth. In the 1490s the friar Savonarola came to Florence, and Botticelli was converted by his vehement sermons denouncing luxury, greed, paganism, and tyranny. A more tragic note became evident in his paintings, and after Savonarola was burned at the stake he painted less and less. One of his last works, dated 1501, is the *Mystic Nativity*, in which a tight circle of angels dances with joy at the birth of Christ while other angels eagerly embrace mortals. It may express Botticelli's hope that justice, as preached by Savonarola, would return once more to the world. In this Botticelli was disappointed, and his last years were spent in poverty.

Spring"), which he painted in 1477–8.

Attempts to explain the full meaning of this unforgettably beautiful and complex work have led to acrimonious disputes among art historians.

Leonardo
da Vinci

1452-1519

If there is any single painting that everyone can recognize and name, it is probably the *Mona Lisa* (1503-6). This haunting portrait is known for an enigmatic smile that on closer inspection proves not to be a smile at all but a seemingly direct gaze that just avoids meeting the eye of the onlooker. The woman has an elemental, ageless quality, maternal yet guarded, and not a little alarming. Beyond her lies a landscape as mysterious as herself, precisely seen yet somehow "wrong," as in a dream. The discontinuity of the horizon, which seems to be higher on the right than on the left, gives an almost stereoscopic quality to the composition that counterpoints the eerie stillness of the Mona Lisa herself.

Leonardo painted her portrait when he was about 50 years old. She is presumed to be "La Gioconda," the young wife of Francesco del Giocondo, a Florentine official, but although

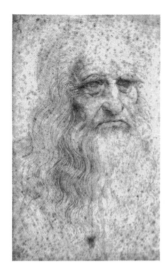

ABOVE self-portrait drawn when Leonardo was 60 years old. He has been called, by a modern commentator, "the most relentlessly curious man in history."

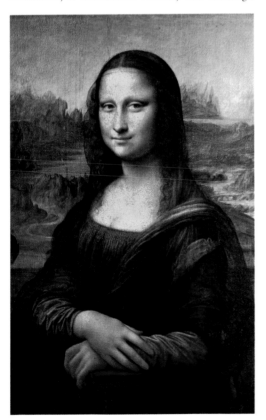

LEFT the unmistakable *Mona Lisa* (1503). There is a close resemblance between her features and those the artist used for his drawings of the Virgin and St Anne (opposite page).

this is one of the few paintings that Leonardo actually finished, he never parted with it. It was with him when he died on his estate at Cloux near Amboise in France, a favored guest of the French king Francis I, and Leonardo left the painting to his patron.

We do not see the painting as he left it. Age has discolored the watery sheen of the eyes, the rosy nostrils, and the red lips that contemporaries spoke of in awe. But we can still marvel at the subtle modeling, the way tone merges into tone and plane into plane, and the way the arrangement of head, bust, and hands leads our eyes around the figure. All is composed to give a roundness and the illusion of reality. As Leonardo wrote in his notebooks, "The painter strives and competes with nature."

Leonardo turned down commissions to paint popes, great lords, and courtiers in order to work – for three years – at this painting of the second wife of an obscure Florentine citizen. The source of her fascination for him must have been her smile, which became the famous "Gioconda smile." For Leonardo the smile was an indication and expression of the inner life of a person. The almost unknowable workings of the mind, like the mysterious powers of nature that so obsessed him, could be understood only in part. When other figures in his paintings have a similar smile the meaning is the same – the mystery of creation or the mystery of nature. The enigmatic effect is achieved by Leonardo's invention of *sfumato*, an almost imperceptible transition of tones that gives a blurry softness to contours. The corners of the eye and of the mouth are indistinct. Something is left to the imagination of beholders, who can never be certain in what mood the Mona Lisa surveys them.

Born in the small village of Vinci outside Florence, the illegitimate son of a notary, Leonardo was reared in his father's house and studied painting in Florence. At the age of 28 he was commissioned to paint an *Adoration of the Magi* (1481), but two years later he left it unfinished and offered his services to Ludovico Sforza, Duke of Milan. For him he painted two versions of *The Virgin of the Rocks* and, between 1495 and 1497, the *Last Supper*. The next few years saw him in Florence again in the service of Cesare Borgia, the notorious son of Pope Alexander VI who was the inspiration for Niccolò Machiavelli's *The Prince*.

In the *Last Supper* Leonardo broke with an artistic convention that required Judas to be separated from the other Apostles. By choosing to picture the tense moment when Christ says, "One of you will betray me," he shows human

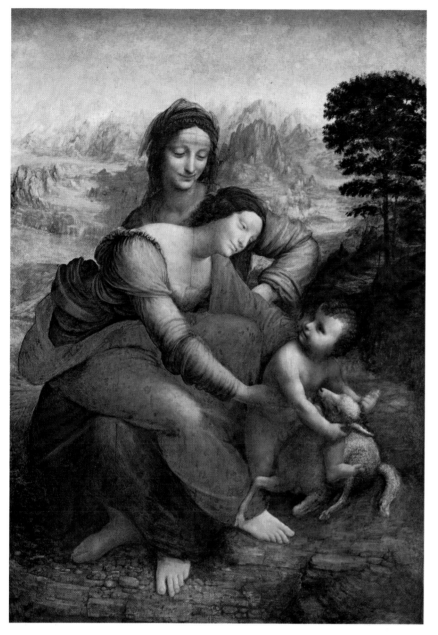

individuals in the throes of agitated emotions. Centuries of damp have wrecked the details, particularly of the faces, but the painting still possesses a moving power. The Twelve are divided into four groups of three; the variety of postures within the groups and the unifying effect of the arms and gestures focuses the eye on the central, serene, triangular form of Christ.

Supposedly one of the monks at the monastery where Leonardo was painting the *Last Supper* complained that he came in the morning, applied a few brush strokes, and went away for the day. Leonardo answered that he could not visualize the face of the wicked Judas, but would be willing to use the monk as a model.

The *Virgin of the Rocks* in the Louvre is probably the earlier of the two versions and is a more attractive composition; the pointing hand of the angel is absent in the version in London's National Gallery. But in these works and in his *Virgin and Child with St Anne* (1500) Leonardo brought rhythm into a strong, pyramidal composition of dynamism and tension. It became a model that inspired generations of artists.

Leonardo was restless and endlessly curious about the world around him. Several times he stopped painting for months, even years at a time – "out of all patience with the brush" – because it interfered with his study of geometry, hydraulics or anatomy. He believed that the artist had a significant role as transmitter of the true and accurate data of experience, acquired through keen visual observation. He developed his own "theory of knowledge" in which art and science were combined rather than separated. But it is his creative genius and intellectual force, evident in every one of his multiplicity of creations, that mark him out as one of the most revolutionary figures of the Western world.

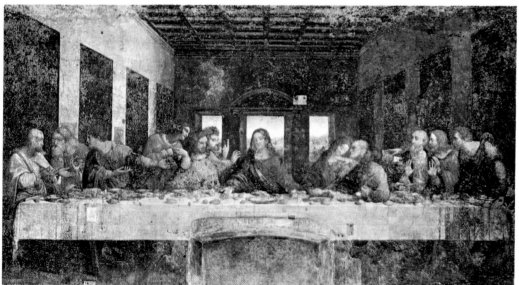

ABOVE LEFT *Virgin and Child with St Anne*, an unfinished painted panel in which Mary, seated on her mother's lap, leans forward to restrain the Child from trying to climb onto a symbolic lamb, which has replaced the young St John of the cartoon in London's National Gallery (see page 32).

LEFT Leonardo's *Last Supper*, a fresco from the dining hall of the monastery of Santa Maria delle Grazie. It could be said to be the first painting of the High Renaissance, though it now exists only as a noble ruin.

Albrecht Dürer

1471-1528

Albrecht Dürer brought the discoveries of the Italian Renaissance across the Alps to northern Europe. His father, Hungarian by birth, had come to Nuremberg in Bavaria to set up as a goldsmith. He prospered, married the daughter of his employer, and changed his name to Dürer, a variation of the German word for Ajtos (Hungarian for "door"). Albrecht was his third son.

At the age of 12 Albrecht Durer did the first of the many self-portraits he would continue to draw or paint throughout his life, second only to Rembrandt in number and variety. In those he painted in his 20s he indulged his fondness for splendid clothes and romantic trappings. The *Self-Portrait* of 1493, now in the Louvre, shows a handsome young lover holding a thistle, a symbol of conjugal fidelity. In the *Self-Portrait* painted four years later and now in the Prado, Madrid, he is the elegant, Italianate artist who was then winning an international reputation for his series of 16 large visionary woodcuts of the Revelation of St John entitled *Apocalypse*, published in 1498. During his life he produced 250 woodcuts in addition to 1000 drawings,

ABOVE *Adoration of the Magi*, in which the king with curly golden hair is a self-portrait of Dürer. The elaborate setting of ruined arches and a city on a distant hill frames a scene in which the kings are more interesting figures than the Virgin and Child.

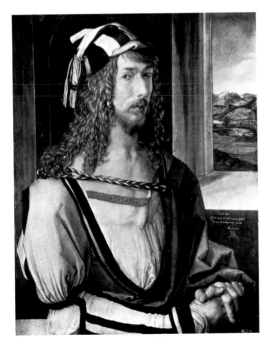

LEFT *Self-Portrait* (1498). Dürer at the age of 27 presents himself not as a humble craftsman but as an elegant, fashionable, and even vain painter, described by Leonardo as being "dressed in the clothes he fancies."

approximately 100 engravings, and about 70 paintings.

After finishing his apprenticeship he spent four years traveling around northern Europe studying the work of other artists and supporting himself by making and selling woodcuts. Six months after returning to Nuremberg he set off again, this time to the south. He had immersed himself in the long-established Gothic tradition and now felt the lure of the newly rediscovered classical and humanist world.

Italy, and particularly Venice, came as a revelation to him. He met the painter Giovanni Bellini (about 1430-1516), already a master of oil painting and the founder of the Venetian school. From him Dürer learned the rich potential of color and how the interpenetration of light and form could give reality to a landscape. His discovery of what could be done with perspective and color is evident in the watercolors of Alpine towns that he painted on the journey back to Nuremberg.

Back home in 1507, he incorporated what he had learned in numerous woodcuts and engravings; their novel qualities of fluency, rhythm, breadth of detail, and sense of space transformed German art. He was later to be acclaimed as the inventor of etching. He began to paint portraits, and when he made his second journey to Italy ten years after the first it was as someone who could speak with foreign artists on equal terms.

One of the most arresting of his portraits is a half-length view of Oswolt Krel in which Dürer

BELOW *Knight, Death, and the Devil* (1513), one of Dürer's greatest copperplate engravings. Enigmatic and complex, it achieves a high level of intensity combined with a richness of conception and mood not equaled by any of Dürer's artist contemporaries or predecessors. Copperplate engraving is the technique of making prints from copper plates into which a design has been incised with a cutting tool called a burin.

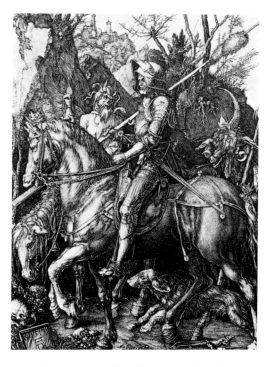

superbly conveys the desperate, barely controlled energy of his subject. He enhances the tension by placing the sitter against a blood-red curtain.

In the central panel of his altarpiece *Altar of the Three Kings* (1504) called *Adoration of the Magi*, Dürer's German heritage is evident in the face and dress of the Virgin and in his self-portrait as the most richly dressed of the Magi. Elsewhere the Italianate influence can be seen in the glowing colors, the background detail, and the almost excessively ruined arches. A masterly feeling for space binds the composition together. His diptych figures of *Adam and Eve*, painted soon after his second visit to Italy, are the first life-size nudes in German art. They are characterized by great simplicity and grandeur.

His most expressive portrait drawing was of his mother, made during 1513 and 1514. To these years also belong Dürer's greatest copperplate engravings: the *Knight, Death, and the Devil*; *St Jerome in His Study*; and *Melencholia I*.

ABOVE and ABOVE RIGHT diptych of Adam and Eve, dated 1507. The two figures stand calmly in relaxed classical poses against dark, almost bare backgrounds. Hanging from the Tree of Life behind Eve is a plaque with Dürer's familiar signature.

Striking and enigmatic, they show the classical perfection for which he strove.

Dürer's sure eye for the details of the natural world stayed with him to the end of his life. His notebooks contain numerous watercolors and gouaches of birds, small animals, and plants as well as landscapes that possess an astonishingly modern feeling, suggestive of Cézanne. But the upheavals of the Reformation inevitably affected the subject matter of his religious paintings. His last large-scale work of this kind was the *Four Apostles*, which he presented to the city of Nuremberg in 1526, two years before his death. The colors and the faces, full of character, are superbly handled. With this magnificent pair of paintings Dürer attained his final and certainly his highest level of achievement as a painter. His versatility and ability to reflect on his own creative activity, combined with his undoubted artistic skill, made him the foremost German painter, engraver, and designer of the Renaissance period in northern Europe.

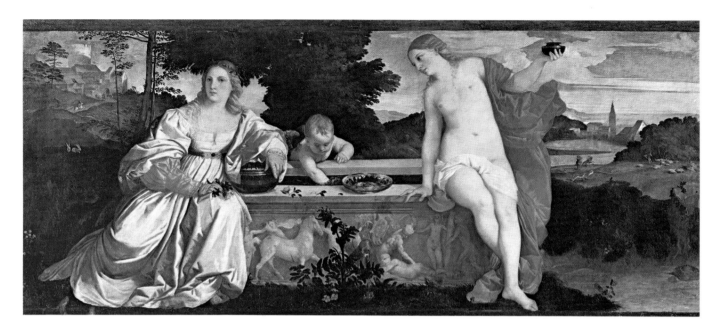

Titian

1488?-1576

ABOVE *Sacred and Profane Love.* Set in a landscape of extraordinary beauty reminiscent of Giorgione, the allegory involves twin Venuses who symbolize the forces of nature (the clothed woman on the left) and eternal and divine love (the nude on the right). Titian made few drawings, preferring to work on the actual canvas itself.

(1477-1510). After that painter's tragically early death Titian completed some of his unfinished paintings. For several years he continued to paint in a Giorgionesque manner, placing idealized figures in magical, timeless landscapes. But gradually his own style developed: the two Venuses on either side of a fountain in the painting known as *Sacred and Profane Love* (1512-15) are no longer idealized beauties but have the definite sensual look of flesh-and-blood women.

The Venetian school of painters, of whom Titian was the greatest, were renowned above all for their sense of color. The brilliant light that came shimmering off the city's lagoon blurred the edges of shapes but added a special radiance to colors. This geographical fact distinguished the painters of Venice from those of Florence, who emphasized the importance of good draftsmanship and design. For the Venetians, design provided only a rough outline upon which painters brushed their colors in layer after layer, glaze upon glaze, to produce brilliant depths and a luminous glow that can still be relished after 400 years.

Tiziano Vecelli, who became known as Titian, was born in the Alpine village of Pieve di Cadore 70 miles north of Venice. When he was only nine years old he was apprenticed by his father to a painter of mosaics in Venice. Most of his long life was spent in that rich and beautiful city, but he never forgot the landscape of his native village. The rocky hills and rushing streams of Cadore appear in the backgrounds of many of his paintings.

He studied for a while with Giovanni Bellini, the greatest Venetian painter of the day, and later collaborated with Giorgione of Castelfranco

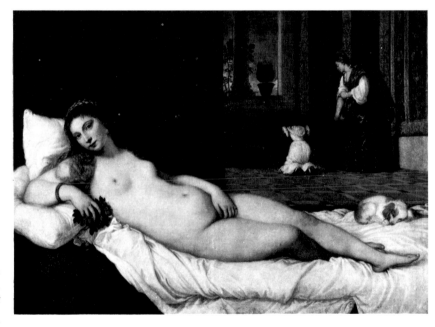

ABOVE Titian's *Venus of Urbino*, an ideal rendering of the female body. Variations on this theme recur throughout Titian's career.

In 1519 Titian began work on a revolutionary *Madonna* for the Pesaro Chapel in the Venetian monastery of Santa Maria dei Frari. The customary style in such paintings was to place the Madonna in the center between balanced groups of saints and worshipers. Titian boldly placed her to one side on a throne set at an angle,

arranged the other figures in small groups elsewhere, and gave an unprecedented sense of movement to a traditionally static scene.

By this time he had become Painter to the Republic of Venice and was also working for several of the independent princes of northern Italy. The Venetian commissions were for portraits and battle scenes, but the princes wanted scenes of revelry. For the Duke of Ferrara he painted *Bacchus and Ariadne* (1520–23) and for the Duke of Urbino a sublimely beautiful *Venus* (1538–9) reclining on a couch. This pose was first conceived by Giorgione and has been popular with painters ever since. But Titian was the first to make a significant change: Giorgione's Venus lay sleeping in a landscape, but Titian brought her into a bedroom and opened her eyes. She gazes sleepily at the spectator with an unmistakable air of invitation in Titian's version.

Years later he painted a much more erotic nude, *Danae with Nursemaid* (1553–4), for King Philip II of Spain. Danae leans back against soft pillows, knees raised, looking up voluptuously at the approaching Zeus, who is disguised as a

ABOVE detail from a self-portrait of the artist. Recognized early in his own lifetime as a supremely great painter, his portraits record his interest in human nature.

BELOW *Danae with Nursemaid*, a lovely woman visited by Zeus disguised as a shower of gold. The play of light and shadow creates the atmosphere.

shower of gold. Titian stayed faithful to a pose for many years once he had found one that satisfied him. Several versions of both these nudes exist.

He painted for many years for Philip's father, the Holy Roman Emperor Charles V. Charles was so pleased with Titian's first portrait of him that in 1553 he knighted the painter, an unprecedented honor for an artist. There may be no truth in the story that the emperor once stooped to pick up a brush Titian had dropped, but the tale accurately reflects the extraordinary friendship that grew up between these two remarkable men.

In his old age Titian's eyesight weakened and his hand trembled when he held a brush. However, he continued to paint, covering the canvas with rapid, broad brush strokes and creating blurred stripes that could only be seen as definite shapes when the spectator stood well back from the canvas. These explorations in technique were regarded as an old man's folly during his lifetime, but many great painters, notably Rembrandt and Van Gogh, studied them in the centuries after his death.

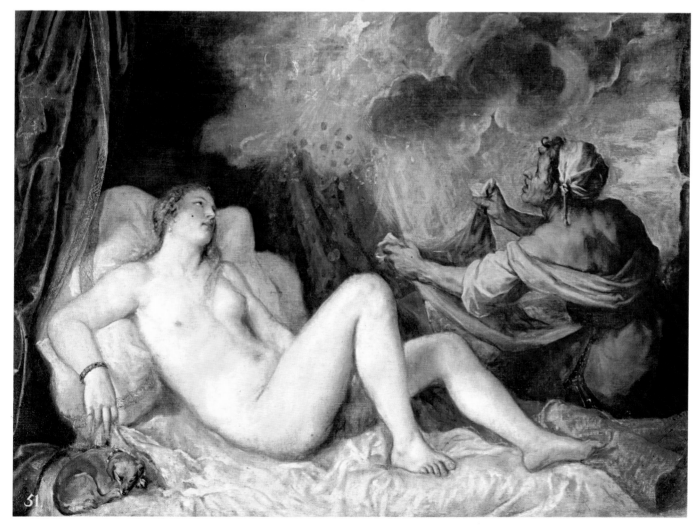

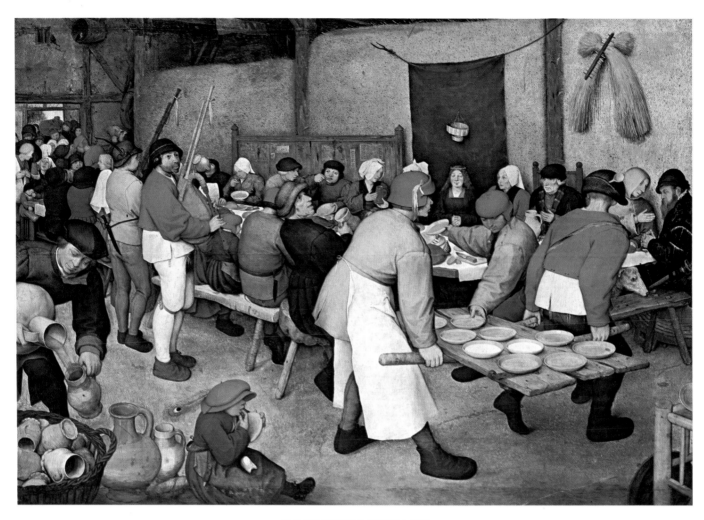

Pieter Brueghel the Elder

1525?-1569

Brueghel is the great Flemish painter of panoramic landscapes and detailed peasant scenes. In his rustic pictures something is usually going on in every corner of the canvas. *The Corn Harvest*, one of a series of paintings known as "Labors of the Months" (1565), encourages the spectator's eye to wander over the composition finding small vivid scenes within it – the villager bringing refreshment up the narrow path through the corn while the others carry stooks away to the village; the group tucking away their midday meal in the shadow of a tree. In the distance can be seen houses, churches, and the hay wain, and in the foreground a pitcher of drink is kept cool amid the corn. In the well-known *Children's*

TOP *The Wedding Feast* (1568), showing Brueghel's "pleasure in observing the manners of the peasants . . . which he then rendered . . . in watercolor as well as in oil, in both of which mediums he was extraordinarily talented," according to an early biographer. "It was amazing to see the attention he paid to the details of the peasants' dress and his care to get their movements and attitudes exactly right, and the steps of their dances."

ABOVE self-portrait of Brueghel in a detail of *Wedding Feast*.

Games (1559 and 1560) a town square is the setting for over 200 children rolling hoops and throwing marbles.

Brueghel's exact date of birth is unknown and so is his birthplace, although it is thought to have been in the neighborhood of Breda, now in the Netherlands. In 1551 he entered the painters' guild in Antwerp and shortly afterward left on an unusually extensive tour of Italy. He not only spent time working in Rome but went on to Reggio in Calabria – drawing the town in the midst of an attack by the Turks – and visited Sicily. He returned to the Netherlands by a circuitous route through the Alps, where the scenery made a lasting impression on him. His first biographer commented, "It was said of him, when he traveled through the Alps, that he had swallowed all the mountains and rocks and spat them out again, after his return, onto his canvases and panels." The remainder of his life was spent first in Antwerp and then in Brussels, where his satirical engravings brought him wide fame. Knowledge of his paintings, however, was restricted to a small circle of friends and patrons.

Crowded though Brueghel's compositions are, their structure is strong. In *Hunters in the*

Snow, the January episode of his months cycle (of which only five survive), the line of dogs, hunters, trees, and flooded fields carries the eye effortlessly toward the mountains on the horizon, where the stark black cross formed by a bird in flight brings the eye back to the foreground.

There is also a grim side to Brueghel's vision. *Dulle Griet* ("Mad Meg"), painted in 1562, shows the personification of covetousness striding up to the mouth of Hell with a bag of loot. The horrifying army of skeletons and profusion of monsters and other lurid horrors in *The Triumph of Death* (about 1562) places him in the direct tradition of the Dutch caricaturist and fantasist Hieronymus Bosch (about 1450-1516).

Pieter Brueghel has been variously described as a pessimist, humorist, peasant, intellectual humanist, Catholic, and Protestant. What is certain is that he was a moralist with definite ideas of right and wrong. Even the pictures popularly considered simple genre scenes, such as *The Wedding Feast* (1568) and *Peasant Wedding* (about 1567), are probably intended also as parables against lust and gluttony.

Brueghel painted several biblical subjects and two versions of *The Tower of Babel* (1563 and undated). The larger, dated picture includes the figure of Nimrod on a tour of inspection, but both show the tower structure as the size of a mountain, dwarfing the city and harbor at its foot. Its immense size is emphasized by the

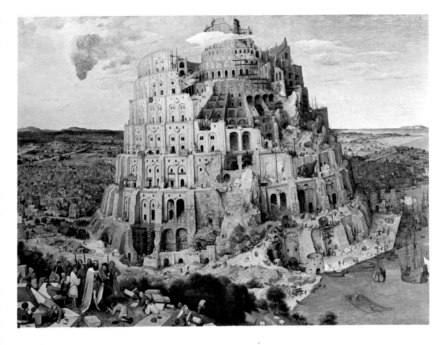

ABOVE *The Tower of Babel* (1563). Nimrod, wearing a crown and carrying a scepter, stands at the lower lefthand corner watching stonemasons.

BELOW detail from *The Fall of the Rebel Angels* (1562), in which Brueghel returned to the unreal world of Bosch to denounce human wickedness as a dark army of demons.

antlike people who swarm over every level in their tasks. The detailed building operations indicate a closeness of observation, which is not surprising. Almost all our visual knowledge of peasant life in the mid-16th century we owe to the work of "Peasant" Brueghel. His witty exposition of human shortcomings and seemingly inexhaustible narrative inventiveness have made him one of the most popular painters of any period or country.

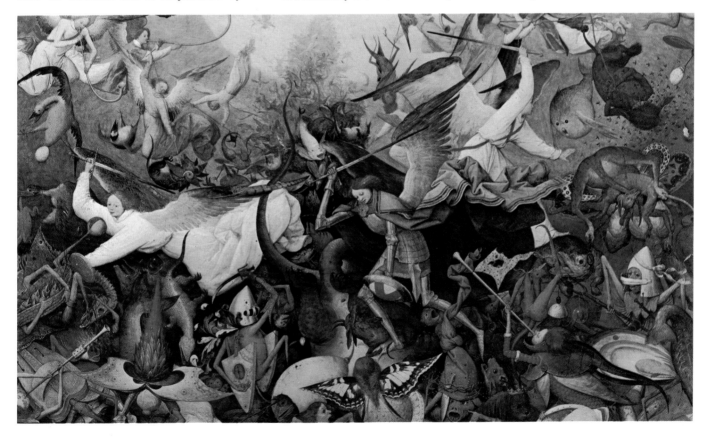

Caravaggio
1573-1610

Caravaggio was the stormy rebel of Italian painting, both in his life and in his art. Born Michelangelo Merisi in the village of Caravaggio near Milan in northern Lombardy, he was orphaned at the age of 11 and was apprenticed to a painter in Milan. He went to Rome when he was about 20, and for the next few years he moved from workshop to workshop helping other artists finish their paintings and trying to sell his own. He slept wherever he could find a bed and

RIGHT *John the Baptist*, one of the paintings that feature a seductively beautiful boy as a model.

BELOW *The Crucifixion of St Peter* (1601), painted before Caravaggio had reached the age of 30. The men are plain working people, muscular, stubborn, and tenacious, and their faith is simple but strong.

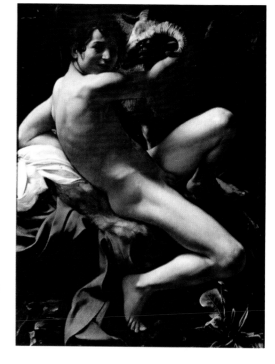

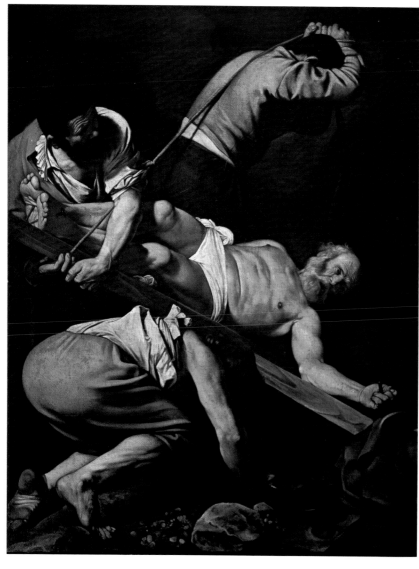

mingled freely with the cosmopolitan society of the city's decaying neighborhoods.

His abilities were eventually recognized by Cardinal Francesco del Monte, a prelate of great influence in the papal court, in whose palazzo he went to live for a time. His cycle of paintings of St Matthew for the Contarelli Chapel of the Church of San Luigi dei Francesci in Rome (1598-1601) made his reputation. But after he left the relatively stable environment of the Cardinal's household he was continually involved in street brawls until one day, after a game of tennis in which he disputed the score, he killed his opponent and had to flee from Rome.

He took refuge in Naples in 1607 and then in Malta where he was received as a celebrated artist. He was even received into the Order of the Knights of Malta, but three months later he was expelled and fled again, first to Sicily and then to Naples again in 1609, where he was nearly killed in a tavern. On his way back to Rome, where a papal pardon was about to be granted, he landed at Porto Ercole only to be arrested by mistake, imprisoned, and released just in time to see his ship sailing away with all his possessions. Beside himself with rage, he tried to pursue it along the coast until he collapsed with malignant fever. Within a week his pardon came through and the ship was found with all his possessions safe. But it was too late. Caravaggio was dead at the age of 36.

His first paintings in Rome were of adolescent boys who gazed soulfully at the spectator; some are thinly disguised as the Greek god Bacchus,

but all share the same dreamily erotic appeal. These are all small pictures, no doubt because Caravaggio could not afford large canvases. He was later commissioned to paint larger paintings of John the Baptist, whom he presented as a seductive youth. These caused no scandal, however, presumably because they were painted for the private delight of his patrons and were not on public view.

It was a different matter with his paintings for churches – although here there was no question of sexual impropriety. It was his lack of respect for the venerable persons of the saints to which the monks and devout members of the congregation objected. Accustomed to seeing the Apostles as distinguished figures with noble expressions and spotless robes, these critics were outraged when Caravaggio portrayed them as puzzled old men with worn clothes and the faces of peasants. The painter's answer was that the Apostles *were* peasants. His critics were unimpressed, and on at least two occasions com-

To make his subjects seem more relevant, Caravaggio includes figures wearing contemporary dress. His backgrounds are nearly always plain, as in *The Supper at Emmaus* (1596–8), in which no background details are allowed to distract from the central subject of the figures grouped around a table. One disciple's jacket is torn and the other (whose outstretched arms are a masterly piece of painting) has the weatherbeaten look of a workman; the Christ figure is beardless and rather plump, and he has a crooked part in his hair.

Caravaggio's realism was to influence a whole generation of painters, as was his bold use of light and shadow. His scenes of martyrdom seem illumined by sudden shafts of light that throw deep shadows across some objects while brilliantly emphasizing others. These isolated objects – a hand, a knife, a straining back or a skull – give tremendous force to the composition and express through very few images the mood of the whole painting.

BELOW LEFT *David with the Head of Goliath*. Disconcertingly realistic in detail, the painting gains interest through the fact that Goliath is a self-portrait of the artist.

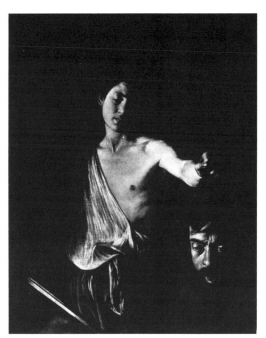

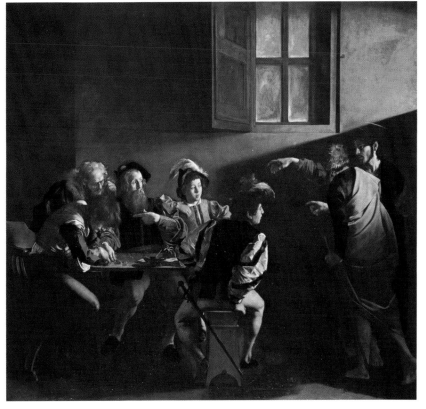

missioned paintings were rejected and he had to try again.

What Caravaggio was trying to do was push past the accumulations of tradition and to imagine what it must have felt like to be, for example, a tax gatherer suddenly called to follow Christ. In his astoundingly dramatic picture on this subject in the Church of San Luigi dei Francesci, *The Calling of St Matthew*, the future saint points disbelievingly at himself; to the right of the composition stands Christ, rendered more commanding by being partially obscured by St Peter, his face and outstretched hand caught in a shaft of light.

ABOVE *The Calling of St Matthew* (1598–1601), part of a cycle covering the life of St Matthew for the Contarelli Chapel in the Church of San Luigi dei Francesci in Rome. This commission established him, at the age of 24, as a "renowned painter" with important clients.

Peter Paul Rubens

1577-1640

Of all the great painters it is probably Rubens who stirs the least interest today, with his vast stretches of canvas the size of whole walls and entire ceilings covered with muscular brown gods and plump pink goddesses tumbling over each other in allegorical riot. Not only do such energetic panoramas fail to arouse enthusiasm in the modern spectator, but they look faintly ridiculous as well.

Take, for example, the paintings commissioned by Marie de Medici, widow of Henry IV of France, to decorate two galleries in her newly built Luxembourg Palace. Between 1622 and 1625 Rubens sketched and he and his assistants painted 22 enormous canvases devoted to significant events in the queen's life. Her birth is compared to the Nativity of Christ and her marriage to the betrothal of the Virgin Mary. Mythological beings accompany her at every turn. When she steps onto French soil, naked sirens pull on the ship's ropes, Neptune rides his seahorse nearby, and above the queen's head an angel hovers blowing a golden trumpet.

And yet, while a lack of sympathy for such works as these is easy to understand, it would be a pity if that blinded us to the very real qualities of Rubens' painting. There was a reason for the enormous success he gained during his lifetime. Kings, queens, and cardinals ordered pictures

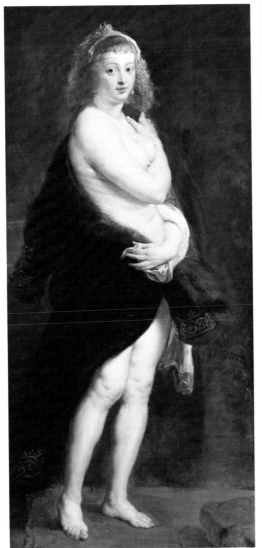

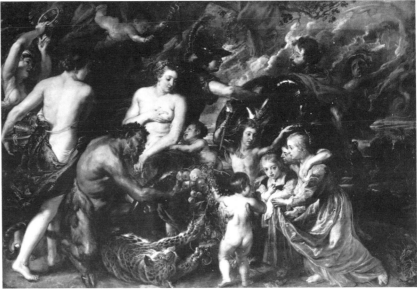

ABOVE *Minerva Protects Pax from Mars* (1630), an allegory showing the goddess of wisdom (helmeted, center) leading the god of war away from the naked goddess of peace, who is surrounded by a satyr offering the fruits of peace, a tamed wildcat, and the young god of marriage.

LEFT *Hélène Fourment in a Fur Wrap* (1638–40), the girl Rubens married when she was only 16 after having been a widower for four years. He was infatuated with her sweetness and beauty and she became the theme and inspiration for his later mythological paintings and the model for many intimate portraits.

from him not merely because he could furnish them with an elevated image of themselves. His paintings are also astoundingly alive. We may not find his Graces and goddesses as beautiful as his 17th-century contemporaries certainly did, since fashions in human pulchritude change. But with what astonishing realism did Rubens paint their swelling breasts, thighs, and buttocks! The flesh dimples where a hand grasps it: the wrinkling and puckering of skin had never before been shown so convincingly. His flesh tints give a vivid sense of blood pulsing beneath the skin, and because of this his paintings have a strong – and calculated – erotic appeal.

Rubens' father, a Flemish Calvinist, was exiled to Germany during the fight against Spanish Catholic rule, and Peter Paul was born there. At the age of 10 he was sent to a Latin school back in Antwerp, but soon a shortage of money prompted his family to send him to a

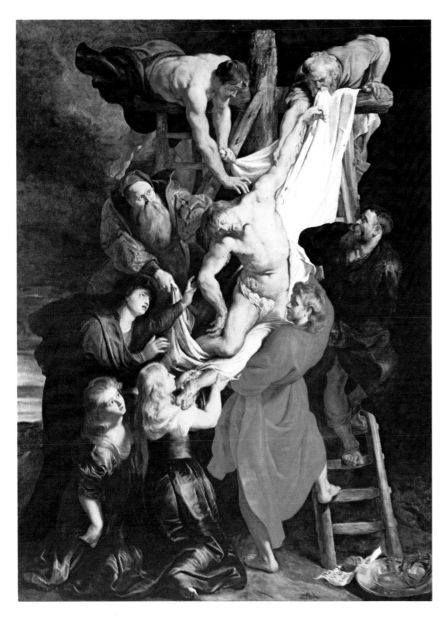

ABOVE *Descent from the Cross*, center panel of the altarpiece Rubens painted for Antwerp Cathedral. The lighting is reminiscent of Caravaggio.

BELOW *An Autumn Landscape with a View of Het Steen*, probably painted in the early morning of a fall day in 1636 on Rubens' estate.

Protestant Dutch and the Catholic Flemish, but by showing the god Mars in his armor trampling on the blessings of Peace. Episodes in the lives of classical heroines were also always in demand, especially if they offered opportunities to display several naked bodies. Requests for altarpieces and eventful religious subjects poured into his Antwerp studio as well. Such was Rubens' fertility of imagination that these commissions frequently resulted in masterpieces such as *Descent from the Cross* (about 1612) for the cathedral in Antwerp, in which the heads of no fewer than eight figures frame the strong diagonal of the winding sheet around the pallid body of the dead Christ. Rubens wrote in 1611 that the demand to work in his studio was so great that he had had to refuse more than 100 applicants who wished to become his pupils.

Rubens also painted family portraits of his first wife, his children, and a great many of his second wife, Hélène Fourment. Sometimes she is Venus or Bathsheba, but more often she is just herself. Infatuated with her beauty, Rubens immortalized her with his brush.

Also for his own pleasure he painted landscapes, which are remarkable for moving away from simply using nature as a dramatic background for other events. Rubens painted the rich effects of sunlight upon the earth and was one of the first artists to paint outside. In a painting such as *Autumn Landscape with a View of Het Steen* (1635-7) – painted at the country house he bought in 1635, five years before his death – the eye is led from the foreground to the distant horizon without any necessity for a change of focus between the fore and middle ground, a technical problem that many landscape painters have had difficulty overcoming. If his allegorical works led finally to a dead end, his sensitive portraits and landscapes and his mastery of the glowing colors of oil paint belong in the mainstream of European art.

kinsman, a minor painter, who taught him the rudiments of his profession. At the age of 23 he left Antwerp for Italy and stayed away for eight years before returning to become court painter to the Spanish regents of Flanders. For the rest of his life he drew on his memories of the Italian paintings he had studied, exactly reproducing the attitude of a Titian nude or else adapting it by twisting the torso and giving it the Rubens touch of life.

Allegory was the international language of his age, and when he wished to demonstrate the horrors of war, which as a scholar and diplomat he feared, he did so not by painting scenes of the war then raging between the predominantly

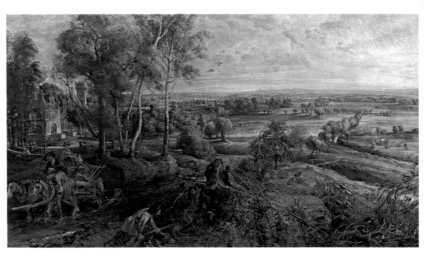

Diego Velázquez
1599-1660

It is no simple task for artists to paint official portraits and keep their integrity of vision. Flattery of the subject and pomposity in the treatment are two of the traps that lesser artists fall into only too easily. King Philip IV of Spain was fortunate to have as his court painter for nearly 40 years Diego Rodriguez de Silva y Velázquez, whose eye for features and character never lost its clarity.

Velázquez was born in Seville. Both his parents seem to have belonged to the minor aristocracy. He was apprenticed to a painter and passed the necessary examination at 18; a painting from this time shows a quite exceptional gift for the realistic painting of everyday objects. This is the *Old Woman Frying Eggs* (1618), in which he painted the various pots and dishes from above as though to emphasize their internal as well as their external form. The woman's spoon and the gourd and flask in the boy's hands are similarly painted with a precise attention to their shapes. Sharply outlined against the dark shadows of the kitchen, these inanimate objects seem to possess as intense a life as the human figures. *The Waterseller of*

ABOVE *Old Woman Frying Eggs*, an early genre painting in which Velázquez characteristically suppressed any comment and became a recorder of whatever was placed before him.

Seville (1619) is another example of his superbly realistic painting: the man's brown cloak and his grayish-brown pitcher have a timeless quality that turns the composition into a great still life, despite the fact that three figures are included in it.

Velázquez also painted a few religious and mythological subjects. He was not, however, a painter of dramatic moments, and his pictures with subjects taken from religion or mythology such as *The Coronation of the Virgin* (1641-2) and *The Forge of Vulcan* (1630) are chiefly noted for the realistic portraiture of the models. It was

LEFT *Philip IV Hunting Wild Boar* ("*La Tela Real*"). The subject is a form of boar hunt commonly practiced by the Spanish kings in which the game was chased inside a canvas enclosure or *tela*. This type of narrative painting of royal activities was one of the duties of a court painter.

in this area that Velázquez excelled – in painting objects he could study from life.

At the age of 23 he went to Madrid hoping to paint the king's portrait. Nothing came of this attempt but the following year he tried again. He painted a portrait that aroused such general praise and so pleased the king that it was decreed that in future no one else should paint the royal portraits. Henceforward, Velázquez was a courtier as well as painter, and in King Philip's service he rose high, eventually becoming chamberlain with responsibilities for many court functions.

Except for the young children, the royal family were a physically unappealing bunch. Velázquez does not glamorize the king. He looks and paints what he sees. He does not emphasize the king's physical peculiarities, but he does not deny them. If he cannot make him majestic, he gives him dignity.

His only historical painting is *The Surrender of Breda* (1634–5), the Dutch city besieged by Spanish forces in 1625. Here Velázquez had to rely on his imagination, but he did so to moving effect. True to his fondness for sobriety (few people in his paintings ever smile) the soldiers on both sides look solemn. The arms of the two commanders are cleverly silhouetted against the lightest area in the composition. The other faces,

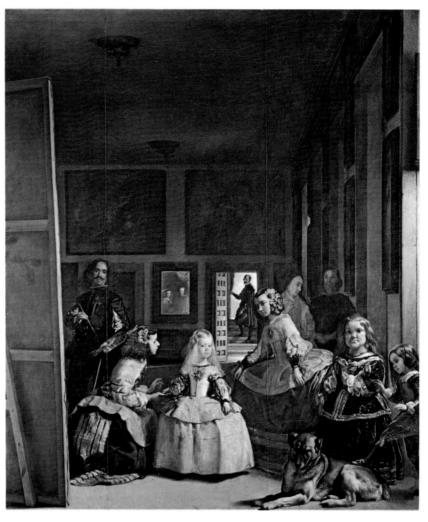

ABOVE *Las Meninas*, in which the painter (in shadow at left) employs a trick effect of a mirror reflecting the king and queen, who stand where the spectator would be to look at the picture. Velázquez may have been inspired by van Eyck's Arnolfini marriage portrait (see page 56), then in the Spanish royal collection. But here the people in the room – the blonde Infanta Margarita Teresa, her maids, a boy who caresses a dog with his foot, a nun, a man at an open doorway – are not the posed subjects of a group portrait, but shown in a natural moment of action as an "impression" of court life.

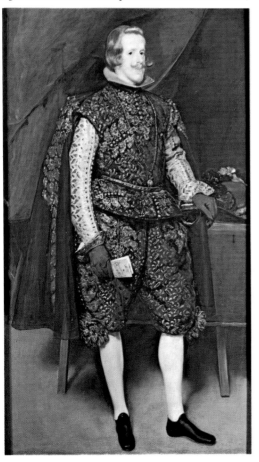

LEFT *Philip IV of Spain in Brown and Silver* (1631–5), one of the many portraits Velázquez painted of the king of Spain. In this one he wears the badge of the Order of the Golden Fleece.

though not individual portraits, have the air of realism. Even the prominent rump of the horse adds to the realism of the scene, the sense that this is how it must have been.

On a visit to Italy from 1649 to 1651 he painted a masterly portrait of Pope Innocent X (1650) and the celebrated *Toilet of Venus* (1651), known as *The Rokeby Venus*. But his major artistic activity continued to be producing paintings for the royal family of Spain. In the last of these, painted in 1656 and generally known as *Las Meninas* (Maids of Honor), he introduced himself at an easel, staring out of the picture at what a mirror behind him reveals to be the king and queen, who are looking in on the scene. It is an astonishingly bold conception for a painting, particularly a royal painting, but Velázquez was now one of the king's most trusted friends. Three years later the king created him a knight of the coveted Order of Santiago, and Velázquez went back to this painting and added the red cross of the Order to his costume. Nothing is known about how the idea for this unique painting originated, but it was probably meant to be kept for the private enjoyment of an intimate circle.

Rembrandt

1606-1669

Rembrandt's paintings are works of inexhaustible richness. He brings a sublime insight to his interpretation of biblical scenes, while his portraits – notably the self-portraits, of which he painted over 60 – show the profound sympathy for the human condition that makes him the greatest of portrait painters, unwavering in his determination to observe and record the truth.

Rembrandt Harmenszoon van Rijn was born in Leyden, the son of a prosperous miller. He spent a short time at Leyden University study-

ABOVE *Saskia van Ulenborch* (1635), Rembrandt's first wife, who bore him four children. She is dressed in the then popular Arcadian fashion.

ABOVE RIGHT *The Adoration of the Shepherds* (1646). During the 1640s Rembrandt's work became more introspective, quiet, and structured than his more dramatic earlier work. Soft light suffuses the subject.

ing Latin before becoming the pupil of a local painter. After further study in Amsterdam he returned to Leyden and established a considerable reputation as a portrait painter. He moved permanently to Amsterdam in 1631, by which time his fame had spread throughout the Netherlands. In 1632 he painted the first of his three great group portraits, *The Anatomy Lesson of Dr Nicolaes Tulp*. In the following year he married Saskia van Ulenborch, and the eight years of their life together was a period of great happiness for him.

He painted Saskia many times in the elaborate costumes he delighted to introduce into his paintings. The play of light on armor was another favorite motif, allowing him to contrast the metallic sheen with the different textures of flesh and cloth or leather. During these years he developed his etchings to great perfection.

Around the time that he completed the next of his dramatic group portraits – the *Company of Captain Frans Banning Cocq*, better known as *The Night Watch* (1642) – his mother, his sister, Saskia, and three of their four children all died. This series of personal tragedies was followed by financial setbacks. The magnificent house that he had bought in the most fashionable part of Amsterdam was dragging him inexorably into debt. His emotional life, too, was unsettled. Sometime after 1649 Hendrickje Stoffels, the nurse he employed to look after his son Titus, became his mistress. The birth of their daughter Cornelia embarrassed several of Rembrandt's former friends. In 1656 the inevitable happened – he was declared bankrupt.

Hendrickje became his model as Saskia had been, but a greater depth of feeling is evident in his portraits of Hendrickje. Sometimes she is

Bathsheba or one of the other heroines of biblical history, but usually she is just herself, painted sitting on a bed or stepping into a pool holding up her dress, a woman of no special beauty but a real thinking and feeling human being. She was intensely loyal to Rembrandt. When his house and all his possessions were sold at auction (for far less than their real value) she and Titus, then aged 17, concocted a scheme to save Rembrandt from total financial ruin. They set themselves up as art dealers with Rembrandt as their assistant; any money he earned would go into the company and he would thus be spared the demands of his creditors. Due to the success of this arrangement, the last ten years of Rembrandt's life saw the creation of many of his finest works.

It was at this time that he painted his last group portrait, *The Sampling Officials of the Drapers' Guild* (1662). He uses no dramatic effects as in *The Night Watch*, but the six attentive faces are painted with such expressive power that it would be hard to find a more successful group portrait in the history of art.

This was also the period of his greatest self-

ABOVE *The Sampling Officials of the Drapers' Guild* (1662).

BELOW LEFT *A Woman Bathing in a Stream* (1665), a tender portrait of Hendrickje Stoffels.

BELOW *Self-Portrait Aged 63* (1669), Rembrandt's last, painted the year he died. It was the culmination of his lifelong effort to analyze his own personality in paint.

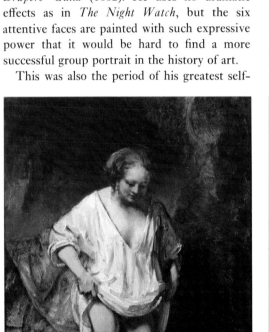

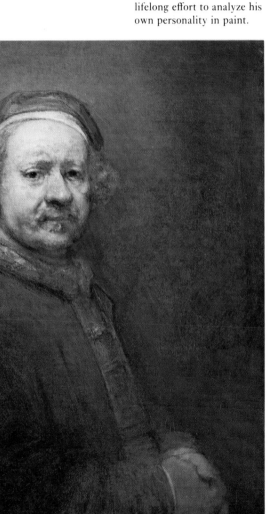

portraits. He painted these throughout his life, and they show him changing from an alert and eager youth to a stricken but unbroken old man 40 years later. After first Hendrickje and then Titus died (at the age of 27), Rembrandt's self-portraits reveal the desolating effect these latest blows had had on him. But he summoned up all his strength and painted one more. This is our final vision of a wise man and supremely talented painter.

Jan Vermeer

1632-1675

The 17th-century painter most closely associated with clarity and precision through the use of light is Jan Vermeer of Delft. Ironically, his life is almost totally obscure. If, as some art historians suggest, his painting of *The Artist in His Studio* (1665) is a self-portrait, it is ironically

RIGHT *The Kitchen Maid* (1658), one of Vermeer's simpler attempts to depict the down-to-earth world of bakers, grocers, and other tradesmen within which he lived. The woman's serenity is spiritual.

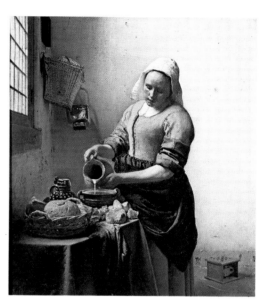

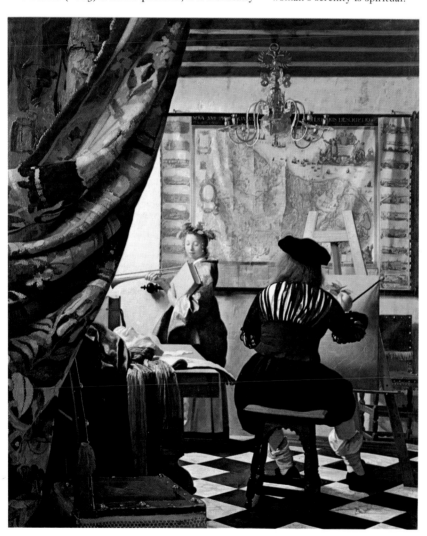

appropriate that he painted a rear view of himself that kept his face hidden.

The facts of his life are soon told. He was born in Delft, where his father was an innkeeper, and lived all his life there, dying at the age of 43. He was highly regarded by his fellow painters, who

ABOVE *Allegory of Painting* (*The Artist in His Studio*), in which Vermeer is appropriately shown seated at his easel. Even his two known landscapes were painted through a window rather than outside.

twice chose him as the president of the local guild. Nonetheless, he was chronically short of money and supported himself and his family as an art dealer rather than by the sale of his own paintings – many of which were used to pay off debts to local shopkeepers. Less than 40 paintings by him are known, and this relatively low output may account for his poverty. When he died, bankrupt, he left his wife with 11 children to support. His paintings were long thought of as experimental and were not widely appreciated, so that for nearly 200 years after his death he was virtually forgotten.

He was one of the very greatest of the naturalistic painters; some would say he has no rival. Only at the beginning of his career did he choose dramatic subjects, and these paintings are not his most successful. In a typical Vermeer the figure – nearly always a woman – has been captured in a moment of absorption in some everyday event. She is reading a letter, making lace or pouring milk. A clear light falls steadily upon her from an unseen source to one side – Vermeer has never been surpassed in his ability to render the subtle alteration of tones brought about by light. The colors can be strong, particularly in the early paintings, but they are more often "cool" – pale blues, lemon yellow, and dove gray. Harmoniously placed in the composition, these colors, altering where the light and shadows fall upon them, build up a totally convincing sense of air and space in which the figure is placed.

A third factor contributes to the astonishing serenity of a Vermeer painting – a delicately stressed pattern of verticals and horizontals relate the figure and foreground objects to the walls of the room. The feeling that the figure and the background fit and are part of one another

is an important source of the sense of peace and satisfaction his pictures give.

Vermeer's subjects are frequently the interiors of well-to-do middle class homes, furnished with musical instruments, rich materials and, in his last paintings, checked tiled floors that suggest an increasing interest in perspective effects. In the *Young Woman Reading a Letter* (1662–3) the sense of life in the still, rapt figure is intensified by the placement of her face against the "dead" parchment map that covers part of the wall beyond her.

In his beautiful *The Kitchen Maid* (1658) the same strong sense of form inhabiting space is brought about by means of color and light effects. He also places the two central verticals of the maid and the milk being poured from her pitcher against the short diagonal of the table coming

forward and the longer diagonal that crosses the picture space from the basket (high up in the lefthand corner) down to the foot warmer on the bottom right.

Only two of Vermeer's landscapes have come down to us. The smaller of these is *The Little Street* (1658), a composition that shows great originality in not presenting the whole façade of the house. The *View of Delft* (1660) – probably one of the best-loved landscapes in the world – is outstanding for its rendering of light and atmosphere. It owes its achievement of space to the subtly different textures in the different areas of the painting – the wide area of the cloud-filled sky, the various mellow tones of the buildings (lit by a gleam of sunlight in the distance), the grained and highlighted textures of the boats, and the horizontal sheen of the

BELOW *The Little Street* (1658), in which Vermeer's almost photographic interest in the look of the world around him is combined with his personal involvement in it to create a masterpiece of observation.

ABOVE *Young Woman Reading a Letter* (1662–3). Vermeer's interiors are lit from a side window, but the natural brightness is muted by the setting and has a pearly, dispassionate quality. The people seem to lose their individuality and become timeless, caught where they stand like a scene under glass. Vermeer's artistic experiments were ignored in his own time.

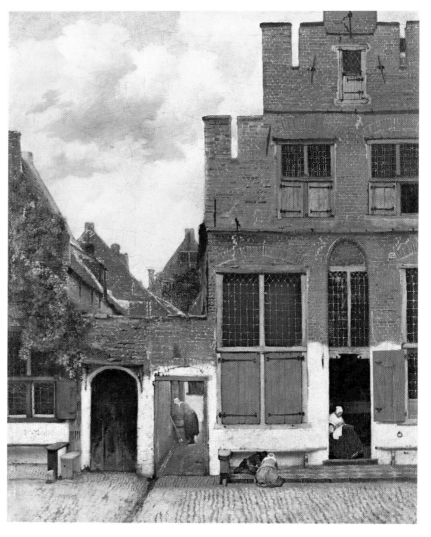

water. Vermeer used none of the receding diagonals and curving paths that were the traditional devices for giving depth to a panorama. Yet his achievement is convincing, beautiful, and profound. His landscapes, no less than his interiors, have the clear, still intensity of a vision.

Claude Lorrain

1600-1682

Natural scenery is the principal subject in landscape painting. Figures may be included in the composition but they are subordinate to the mood of the landscape. Art historians divide this art into several branches – the landscape of symbols, the landscape of fact, the landscape of fantasy, and the ideal landscape – and the undoubted master of the last of these is the Frenchman Claude Gellée.

It is only just appropriate to call him a Frenchman: he was born in the village of Chamagne near Nancy in the independent duchy of Lorrain; orphaned at an early age, he made his way to Rome and worked there as a pastry cook. Except for one return visit to Lorrain in his 20s, the remaining 70 years of his life were spent in Italy, most of them in the vicinity of Rome.

Little is known of his early years. His contemporaries referred to him as Il Lorenese ("the

man from Lorrain"), but he signed himself Claude, with or without his surname. Largely self-educated, he displayed the thrifty bourgeois qualities of shrewdness and industry and by the end of his life had accumulated a fortune.

Ideal landscape painting seeks to present natural scenery as more harmonious and beautiful than the reality. For Claude the source of inspiration was the countryside around Rome, the *campagna*, then more wooded than it is today. It is an area rich in associations with antiquity. Representations of ideal landscape even before Claude's time are reminiscent of theatrical scenery, with tall trees at the side of the foreground like stage wings framing a distant view. Claude took these compositional elements and produced numerous subtly different variations on them; the keynote of his work was the treatment of atmosphere and light. He specialized, as an early biographer commented, on "those conditions of nature that produced views of the sun, particularly on seawater and over rivers at dawn and evening."

Until he was in his 30s he worked, fairly obscurely, on frescoes. Even after turning to canvas painting he continued to be virtually unknown, but by the age of 33 he had developed the main elements of his style and was painting his first landscapes with mythological titles. By the time he was 38 he had become the leading landscape painter in Italy.

BELOW *Seaport: The Embarkation of the Queen of Sheba* (1648). This seaport view was painted for the Duc de Bouillon, one of Claude's many aristocratic patrons.

BELOW *Landscape* (about 1638), one of Claude's drawings for his *Liber Veritatis*. Most were executed in pen and brown ink wash, and the artist considered the *Liber* both a valuable copyright protection and a work of art in its own right. Louis XIV of France tried to buy the book after Claude's death, but the terms of his will made this impossible.

At about this time he began work on his *Liber Veritatis* or "Book of Truth," in which he carefully drew copies of his paintings (195 in all) with details of the dates and the patrons for whom they were painted. The purpose of this book was to protect himself against forgers of his style. It now constitutes an invaluable record of his artistic development. About 250 of Claude's paintings and more than 1000 drawings are known to have survived.

Almost all his works possess a similar compositional structure. Something tall, generally a feathery tree, occupies one side of the picture space, and its shadow falls across the dark greenish-brown foreground; the planes beyond it contain other groups of trees or some architectural feature, one of which is on the opposite side to the foreground tree; the last plane is the astonishingly luminous blue distance which Claude, unique for his time, painted directly from nature.

In his seaport views he follows the same principles, making use of palace façades, ships, and distant cliffs. What might in lesser hands have become a formula does not with Claude because of the delicacy of his brushwork and his precise observation of architecture, trees, and rigging. In *Landscape: David at the Cave of Adullam* (1658) a further unity is achieved by the frequency of pointed objects – David's crown, spears, narrow pyramids, the pointed tents, and

RIGHT *Landscape: Hagar and the Angel* (1646), describing the Old Testament story of Abraham and his servant girl, whom he cast out with their infant son Ishmael.

BELOW *Landscape: David at the Cave of Adullam* (1658). The subject comes from the Book of Samuel, and involves three men who risk their lives breaking through the ranks of the Philistines to bring David water from the well of Bethlehem. The picture was painted for Prince Agostino Chigi, the young nephew of Pope Alexander VII.

even the peaked cloud. When he painted water the effect of sunlight on the waves is beautifully realized. He was the first artist to use the sun as the visible source of the light in his paintings. Just above the horizon, rising, or more often setting, its light spreads through the whole landscape from horizon to foreground, bringing to the composition a spatial unity and imparting a wistful poetic tone to a view of nature more harmonious than any real view could ever be.

Jacob van Ruisdael

1628?-1682

ABOVE *The Jewish Cemetery.* The strong central focus of the composition is the group of three tombs – actual tombs in the Portuguese Jewish burial ground at Oudekerk, near Amsterdam. But Ruisdael placed this group in an imaginary setting – a landscape of ruined church, faint rainbow, and bleached dead tree – that makes the painting symbolic of the brevity of life.

Two generations of Dutch painters developed the neglected art of landscape painting into a major school. The French painters Nicolas Poussin and Claude Lorrain had created an ideal classical landscape based on the Roman *campagna*. The painters of the Netherlands discovered that nature could be interesting in all its aspects. The greatest of them approached their subjects with an almost religious sense of awe, but their paintings were seldom simple acts of representation. They selected and rejected elements for the sake of the composition in order to draw an expressive value from the landscape.

Jan van Goyen and Salomon van Ruysdael, born at the beginning of the 17th century, used a relatively restricted palette to render atmosphere faithfully. The succeeding generation, feeling a need for something more arresting, liked to make some object the focus of the composition and relate everything else to it. The foremost painter of this generation was Jacob van Ruisdael, son of a Haarlem artisan and nephew of Salomon (who spelled his surname differently).

Nothing is known of Jacob's youth or apprenticeship, though he was presumably trained or at least guided by his uncle. Evidently he was a precocious artist, because he became a member of the Haarlem guild when only 19 years old. In his 20s he was painting in the border region between Holland and Germany, where he saw mountains for the first time, but by 1660 he had settled in Amsterdam where he remained until his death. At one time it was thought that he died poor and insane in the Haarlem workhouse,

but this has since been verified as the fate of his cousin and namesake, the son of Salomon. Jacob the painter became moderately well-to-do and charged a good price for his paintings.

Frequent subjects in his early years were the dunes and groups of trees outside his native Haarlem. From the beginning he seems to have had an unusually strong feeling for trees. He analyzed their form and color and used a heavier paint than was customary to depict them, thus giving the foliage a far greater sense of life. The trunks are strong and often gnarled; they appear strongly rooted in the earth. While others of his generation were trying to adapt Claude's Italian-ate treatment of trees to the northern landscape,

Ruisdael avoided the great Frenchman's tendency to "generalize" trees. A Ruisdael tree remains individual, even heroic.

His travels into Germany increased his repertoire of motifs: deep forests, ruined castles, and rushing streams began to make an appearance in his paintings. Often they have a decidedly melancholy air. Some of his most attractive pictures show a marsh or pool in a forest clearing where the whitened bark of the dead trees is no less real than the thriving clumps beyond them. These paintings were probably intended to be reminders of mortality.

His masterpiece in this style is the *Jewish Cemetery* (about 1660), of which two versions exist. It had a powerful effect on the German poet Goethe, and during the 19th-century romantic movement Ruisdael's woodland views became quite popular.

His repertoire was extensive. He painted many wide panoramas of the Dutch landscape, showing flat fields beneath an expanse of cloud that obscures but is itself lit by the sun. Always

ABOVE *The Shore at Egmond-aan-Zee* (1675). In the distance on the right is the tower of Egmond church, engulfed by the North Sea in 1743.

LEFT *A Waterfall*, contrasting the stillness and solidity of the trees with the dramatic rushing of the water.

BELOW *Two Watermills*, a scene van Ruisdael painted several times. The figure in the red jacket is working the sluices.

these clouds relate to the forms of objects on the land beneath. In the *Windmill at Wijk bij Duurstede* (about 1665), for example, they complement the angularities of the mill's sails. His shore scenes and the views of Haarlem and Amsterdam in the distance are among his greatest paintings. In contrast to the forest views they have a simplicity and restraint of composition, but the subtle balance of cloud and land give them a majestic strength. In capturing so perfectly the face of the Dutch landscape he justly earned the title he has been given of "the portrait-painter of Holland."

Jean-Antoine Watteau

1684-1721

At first sight the world of Watteau resembles an infinitely graceful park. Its privileged inhabitants, in their costumes of pale shimmering silk, move idly across the grass or recline in small groups to exchange pleasantries of love. It is a world where it is always afternoon.

RIGHT portrait of Watteau by François Boucher, 20 years his junior, who began as an engraver of Watteau's work. He typified the rococo style of decoration and was a protégé of Madame de Pompadour.

This is a true impression as far as it goes, but Watteau's vision penetrated beyond the surface charm of his figures and the landscape in which they so elegantly move. There is a sadness in their postures and their frequent backward glances;

ABOVE *Fêtes Venitiennes* (1718). Because Watteau reused the same drawings of figures over and over again from sketches in big bound notebooks, his portraits look similar.

the pale colors are the hues of a world that is passing all too quickly. Life is short, the pictures seem to say, and filled with sorrow.

Watteau was born in Valenciennes close to the frontier of what is now Belgium. The town became part of France only six years before his birth, so his contemporaries spoke of him as "Vatteau the Flemish painter." When his father, who was a successful tile maker, discovered that his son possessed a talent for drawing the street traders near their home, he paid for him to be trained under a local painter. But after three years he stopped paying the fees and Antoine, aged 18, penniless and without decent clothes, made his way to Paris.

Paris was then reacting to the oppressive splendor of Louis XIV's Versailles. The lighter, more graceful baroque art of the *rococo* was evolving, and it was this spirit that Watteau absorbed. He expressed it so perfectly that he can be thought of as one of its creators. In reaction to the formalistic art of Versailles he studied the paintings of Rubens, particularly the Marie dei Medici cycle in the Luxembourg Palace, of which he made many drawings. He painted scenes for the theater and studies of traveling actors, possibly finding in their wandering life some correspondence to his own restless temperament. The figures in his paintings are frequently wearing fancy dress or carnival costume, and even when wearing contemporary clothes they seem to be acting out a role on a stage. In *A Lady at Her Toilet* (1720) the woman is obviously conscious of her audience.

In 1712 Watteau was accepted by the Académie as a painter of *fêtes galantes* – outdoor courtly entertainments – and the first version of *The Embarkation for Cythera*, painted that year, was his reception work. Cythera was a legendary

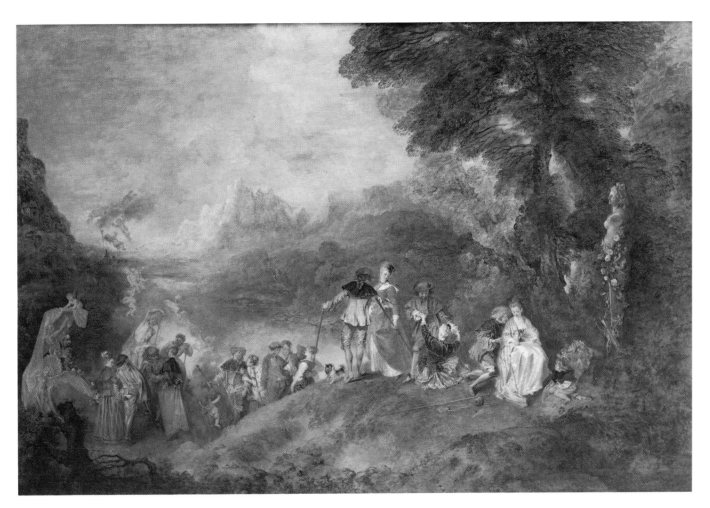

island of love, and Watteau's painting shows the end of a day of dreamy pleasure. The suggestion of time passing is very poignantly conveyed.

Louis XIV died in 1715, the rococo received official patronage at court, and Watteau entered his years of success. He lived in the houses of his wealthy friends and drew their parks and guests, bringing them together in harmonious landscapes with such titles as *The Love Duet* (about 1715), *Fête in a Park* (1716–17), and *Dance in a Park* (about 1718). In the last Watteau included a portrait of himself playing the bagpipes.

He was a severely self-critical painter and destroyed many of his pictures, yet his studio was surprisingly dirty. A friend and early biographer described his oil pot as "filled with filth and dust mixed with all the colors that dropped off his brush." Partly because of this neglect, many of his paintings have deteriorated.

Success came to Watteau only in the last six years of his life, and toward the end he was too frail to work for any length of time. He died of tuberculosis at the age of 37. After his death a friend financed the publication of four superb volumes of his drawings, an unprecedented tribute to an artist that presented his enormous range of graphic work to a wide public. Though

ABOVE *Embarkation for Cythera*, the finished version of 1717. The statue of Venus has been hung with a garland of roses and the lovers are preparing to depart. Three couples are rising to their feet to join the others, already assembled by the golden boat. The couple on the brow of the hill, in the center of the painting, are the pivot of the composition. As he pauses and she turns to look back with a sad smile of regret, the feelings of nostalgia and loss are emphasized by the russet autumnal tones.

the number of his paintings is relatively small, his achievement was to have a powerful influence on European art up to the end of the 18th century. His *Embarkation for Cythera* remained the most important French contribution to painting for over half a century.

RIGHT *Gilles* (1720–21), one of Watteau's last works. Portrait of a clown dressed in white, it was painted as a signboard for the Théâtre de la Foire.

Francisco de Goya

1746-1828

The career of Francisco José de Goya y Lucientes falls neatly into two almost equal parts, divided by the unidentified illness that left him totally deaf at the age of 47. Before this he had been a highly successful portrait painter, somewhat experimental but basically conventional. He continued to paint portraits for the remainder of his life, but after his mysterious illness he also gave expression to the macabre and fantastic elements of his personality in the works for which he is now especially famous.

He was born near Saragossa, Spain, the son of a not very successful gilder. As an apprentice in the studio of a local painter he helped produce the countless religious paintings required by village churches, but his powers took a long time to develop. At the age of 30 he began painting cartoons for the royal tapestry works in Madrid, but the fear of failure and a dread of poverty made his early designs surprisingly timid.

Gradually his confidence increased, and his study of the paintings of Velázquez in the royal collection improved his technique. Eventually

his skill at portraiture led to his appointment as Painter of the Royal Household in 1789. He was then 43 years old. In addition to portraits of the royal family he painted a succession of aristocrats and their children, and he became a friend of the Duke and Duchess of Alba. How close his relations were with the duchess has been a matter of endless debate, partly because of his paintings of her such as the *Clothed Maja* (about 1797) and

ABOVE portrait of a court lady, Doña Tadea Arias de Enriquez. It specifically identifies the subject with her coat of arms.

ABOVE LEFT detail of a Goya self-portrait, one of many. He claimed "three masters: Velázquez, Rembrandt, and Nature."

the *Naked Maja* (about 1798).

Across the Pyrenees France was in the throes of the Revolution, and liberal Spaniards welcomed the new French ideas. But in 1808 Napoleon's troops invaded Spain and drove out the reactionary Bourbon king, Ferdinand VII, and the atrocities committed by the French soldiers split their loyalties. The reactionary Catholic church rallied the peasants to the

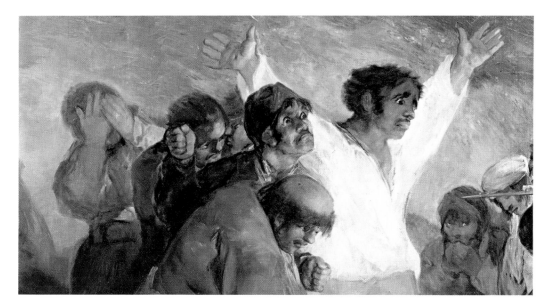

"defense" of Spain: to support the liberal cause of reform became synonymous with being an enemy of Spain. Goya shared this dilemma. The curious illness that struck him in 1793 may have been psychosomatic, the consequences of the first throes of what became a "moral and professional crisis."

The effect on his work was immediate. He painted pictures of catastrophes in order, so he wrote to a friend, "to make observations that are normally given no place in commissioned works, where caprice and invention cannot be developed." He also made two series of etchings called *The Caprices* (1799) and *The Disasters of War* (1810-14). His masterpiece, commemorating the execution of 400 Spaniards by the French outside Madrid, is *The Third of May, 1808* (1814). In the light of the lantern the central figure holds his arms open like a man crucified against the steely line of the execution squad's rifles (there is even the mark of what might be a nail in one palm).

The mysterious *Colossus* (about 1808–12) was also painted at this time, a vision of a giant on the edge of the world with his back turned to fleeing human and animal refugees. Some of the figures are mere twists or blobs of paint. As his black moods and a recurrence of the same strange illness settled upon him, Goya retired to a house outside Madrid, the *Quinta del Sorda* ("House of the Deaf Man"), where he painted his so-called *Black Paintings* – scenes of misery, mystery, and witchcraft. In 1824 there was a fresh wave of reaction which forced him, at the age of 78, to leave Spain and settle in voluntary exile in Bordeaux, where he died four years later.

So wide ranging are the subjects of his paintings that, although it would have astonished the aristocratic sitters for his portraits, the years

ABOVE *Colossus*, subtitled *Panic*, clearly alluding to the fear generated by war, here personified by the huge figure of the Colossus looming over a dark despairing world in which monsters of brutality, uncaring of the plight of humanity, bring about an irrational new world of horror and pain.

1790–1825 in Spain can truly be called "the age of Goya." He achieved an outstanding breadth of style with techniques that included painting with reeds and dabbing paint onto canvas with a sponge, and this pre-Impressionism greatly influenced Manet. He has been called the last of the Old Masters and, simultaneously, the first of the moderns, but his vision remains both starkly compelling and unmistakably his own.

Hokusai
1760-1849

ABOVE *In the Mountains of Totomi Province*, a woodblock print from *Thirty-Six Views of Mount Fuji*. Fuji peeks through from behind the triangular pattern of the large piece of timber and its supporting framework.

Hokusai is celebrated in the West primarily for his picture of the most famous wave in art. The brilliant dark blue water rises up above two boats and from the crest of the wave the spray, like angry claws, descends upon the crouching boatmen. In the distance, almost resembling another wave, rises the perfect cone of Mount Fujiyama, in quiet contrast to the constantly moving and menacing sea.

The Breaking Wave off Kanagawa is one of a series of woodblock color prints called *Thirty-Six Views of Mount Fuji* (1826-33) and belongs to that period of his life when Hokusai was creating his great landscapes. Together with his *Kwachō* (flower-and-bird) prints, they are the

LEFT self-portrait in brush drawing by Hokusai as an old man. He once wrote that "from the age of six I had the habit of drawing the forms of things." He was a perennial eccentric in a society of conformists, and in an age when most people of his class lived out their lives in the houses where they were born, Hokusai changed residences no less than 93 times.

works on which his high reputation in the West is largely based. But in his youth Hokusai Katsushika had painted very different subjects. Landscape was considered one of the master arts of painting, only to be attempted by persons of refined and preferably noble birth. Artists of the lower classes – Hokusai's father was a maker of engraved mirrors – were expected to cater for the taste of the lower classes. The *Ukiyo-e* school evolved for this purpose. The name means "Pictures of the Fleeting World," and the pictures recorded the life of the streets and teahouses. Theatrical prints were enormously popular, as were *bijin-e* (beautiful-woman pictures).

Hokusai began his career as a wood engraver, carving the blocks for designs created by other artists. (It was not the custom in Japan, any more than in Europe at the time of Dürer, for artists to engrave their own designs.) Separate blocks were carved for applying the various colors, and sometimes as many as 12 blocks were used for a single print. A very high degree of skill was required from engravers and color printers, and without doubt their achievements during Hokusai's time have never been approached anywhere else in the world.

Hokusai soon took up designing, and almost from the start of his career he revealed an eagerness for new and untried methods of composition. To his exceptional flair for design was allied a sense of humor, and he liked to select odd expressions and curious actions for the figures in his pictures. After achieving prominence with his theatrical prints and book illustrations, he helped to create a new form of artistic expression known as *surimono* – exquisitely designed New Year's cards, picture calendars, invitations, and

greeting cards. When he wished to do so he could depict natural forms perfectly, but he did not hesitate to adapt them for the sake of the composition.

At about this time he was commanded to perform in the presence of the Tokugawa Shōgun, effective ruler of Japan. It was a contest in which each artist had to make a painting on the spot, and Hokusai won by painting on a large screen the blue curves of a river and then forcing a cock, whose feet he had dipped in red paint, to run over it. He described the result as the river Tatsuta in the fall with red maple leaves floating down it. Hokusai became famous for tricks of showmanship of this kind.

The views of Fuji are superb compositions; some, such as *Fuji in Clear Weather* and *Fuji Above the Lightning*, have an eloquent simplicity, but even in the more elaborate pictures every detail makes its precise contribution to the pattern. Much use is made of a brilliant dark blue new to the painters of the time. The gradations of color, looking as if they could only have been produced by a brush, are all achieved by the incredibly skillful inking of successive blocks. When these prints arrived in Europe, often as padding in packing cases, they acted as a liberating force on the French painter Édouard Manet and his Impressionist friends, who saw in the Japanese simplifications and unfamiliar patterns a way to free themselves from the meticulous realism of mid-19th-century European art.

For the last 20 years of his life Hokusai signed himself Gwakyō Rōjin – "old man mad about

RIGHT *Waves and Birds*, a "blue print" dating from about 1825. Hokusai devoted the decade of the 1820s to the production of *Kwachō* prints.

painting." At the age of 75 he wrote: "Although from about 50 I have often published my pictorial works, before I was 70 none is of much value. At the age of 73 I was able to fathom slightly the structure of birds, animals, insects, and fish, the growth of grasses and trees. Thus perhaps at 80 my art may improve greatly; at 90 it may reach real depth, and at 100 it may become divinely inspired. At 110 every dot and every stroke may have a life of its own." He died, brush in hand, in his 90th year.

LEFT *The Breaking Wave off Kanagawa*, unmatched for sheer breathless force by any other Hokusai composition. The color scheme is forcefully simple: aside from the boats and sky, everything is blue and white, the deep blue of the ocean being carried over into Mount Fuji. The white sections are simply unprinted.

91

J. M. W. Turner

1775 - 1851

Joseph Mallord William Turner is one of those artists who begin, like Goya, as painters of talent but only become painters of genius in middle age. He was born in London near Covent Garden, the son of a barber. Little is known of his mother except that she died insane when he was 29 years old. From the age of ten Turner was brought up by his maternal uncle in the countryside outside London.

During his lifetime the English artistic world was dominated by the Royal Academy, and the main market for artists' work was the annual Summer Exhibition. From an early age Turner was determined to succeed in this world of academic art. He became a student at the Royal Academy Schools at the age of 14 and his first exhibit (a watercolor) appeared the following year. Except during the critical years that followed his first visit to Italy in his 40s, he always exhibited paintings there annually.

In Turner's day the Academy regarded pure landscape as a relatively low-ranking category of artistic endeavor. Accepting these standards, Turner painted seascapes with ships in the style that had been made popular by Dutch artists and idealized landscapes in the style of the French painter Claude Lorrain, to which he attached titles from mythology. But as his interest in the effects of atmosphere, sunlight, and particularly the appearance of storm and blizzard increased, the mythological and biblical deluges came to be supplanted by scenes of natural catastrophe. Even in his late paintings, where the subject has been almost entirely dissolved in color, the painting never becomes completely abstract. In his *Norham Castle, Sunrise*, painted between 1835 and 1840, the pale color scheme and diffused sunlight spreading through mist have washed away any recognizable outline of the castle – but the cow in the foreground anchors the composition to the real world. Turner probably felt that his works would only move a spectator when the swirling, dissolving shapes could be associated with natural forces. Nonetheless, it is a wonder that he did not encounter more critical abuse during his lifetime. The oils he painted in the 1830s are far less comprehensible than the works of the Impressionists that were viciously attacked 40 years later.

Turner possessed an unusual visual memory. Over 250 sketchbooks bear witness to his phenomenal activity, and the pace of his creation

BELOW *Norham Castle, Sunrise*. Turner first saw the castle, on the river Tweed, during his first tour of the north of England in 1797, when he made a single pencil drawing. This version, developed from a "color beginning" in watercolor, is very thinly painted with diluted washes of oil paint floated over a white ground. The blue castle is more thickly painted, while yellow and white impasto suggest flickering sunlight. His use of color is revolutionary in being suggestive rather than simply descriptive.

BELOW *Self-Portrait* (detail), painted when Turner was not yet 25 years old. He trained himself as a topographical draftsman for engravers and by copying other artists' works.

soon proved too great for him to wait for an annual exhibition. He opened his own gallery and exhibited there some paintings less likely to appeal to academic tastes. It was at the Academy, however, that in 1812 he exhibited *Snowstorm: Hannibal and His Army Crossing the Alps*, the first of his paintings with a vortexlike composition that draws the spectator into its depths as into a whirlpool.

In 1819, after years of painting what he supposed were "Italian" landscapes of mist and twilight, he visited Italy for the first time. The brilliant light overwhelmed him, and though he made the enormous number of 1500 watercolor sketches in three months, on returning to his London studio he experienced great difficulty translating any of them into oil paintings. Not until a second visit ten years later did he discover a technique to express this new vision, but he was then able to produce for many years large shimmering views based on his Venetian sketchbooks. A contemporary critic praised the "almost impossible effects produced on principles directly opposed to those generally adopted, his lights merging in depths, his depths thrown deeper by his lights."

But while the critics praised these paintings, they increasingly complained of the eccentricities of his more imaginative works. The brilliant colors of his *Ulysses Deriding Polyphemus*, painted in 1829 immediately after his second Italian visit, were denounced as "coloring run

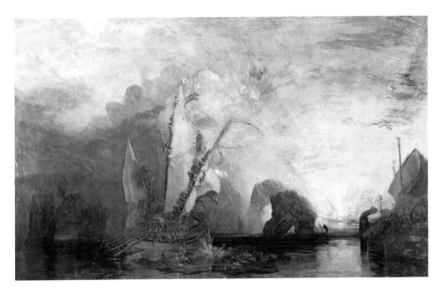

mad." The superbly exciting *Snowstorm: Steamboat off a harbor's mouth making signals in shallow water* (1842), in which the boat is at the center of a whirling vortex of browns, blues, and yellow, was said to be a mess of "soapsuds and whitewash." This remark provoked Turner, who had witnessed this particular storm, into saying, "I wonder what they think the sea is like? I wish they'd seen it."

Whirling spray, mist, steam, and storms are the subjects Turner made especially his own – along with, of course, sunlight. As he lay dying he is reputed to have muttered to whoever would listen, "The sun is god."

ABOVE *Ulysses Deriding Polyphemus*, based loosely on an incident in Homer's *Odyssey* in which the Greek hero puts out the eye of a giant cyclops. One 19th-century critic called this "the *central picture* in Turner's career."

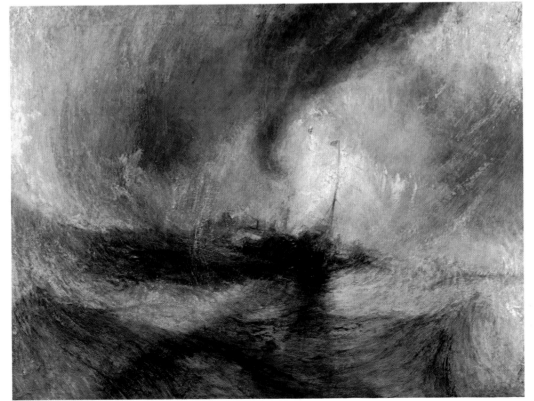

LEFT *Snowstorm: Steamboat off a harbor's mouth making signals in shallow water*, one of the most extreme works exhibited by Turner during his lifetime, a culmination of his efforts to demonstrate the weakness of humanity in the face of nature.

BELOW *Turner on Varnishing Day* (about 1846) by S. W. Parrott. In the 1830s and 1840s Turner painted many of his pictures as they hung on the walls of the Royal Academy during "Varnishing Days."

Eugène Delacroix

1798-1863

"I am like a man dreaming!" Delacroix wrote back to a friend in Paris after the first day of his visit to North Africa. He was the first European artist of any stature to visit the Muslim world and was overwhelmed by its color, vigor, and customs. The cultural shock was wholly beneficial, bringing together as it did two warring parts of his nature – the romantic and the searcher for historical truth. For the next 30 years he was to draw on his North African experiences.

Ferdinand Victor Eugène Delacroix was born at Charenton-Saint-Maurice on the outskirts of Paris, the son of a minor politician, although there is a tradition that he was actually the son of the great statesman Talleyrand. After studying at the École des Beaux Arts he reacted against the neoclassical school of painting then in the ascendant and turned instead for inspiration to the rich color and movement of Rubens and, after a visit to London in 1825, to the paintings of Turner and Constable. His technique became freer and more supple, and his choice of subject related him to the rising romantic school. *Dante and Virgil in Hell* (1822), his first large-scale work, announced his lifelong fascination with the idea of heroic figures threatened by danger. The muscular bodies of the damned are obviously influenced by Michelangelo. Its vigorous composition impressed a youthful politician, Louis Thiers, who was later in a position to give Delacroix valuable state commissions. His next major work was *The Massacre at Chios* (1824), inspired by an incident in the Greek War of Independence. The composition is loosely that of a double pyramid, and though the painting has faults it is full of impressive details, particularly the figure of the Turk on his rearing horse.

In 1827 his *The Death of Sardanapalus* created a sensation when it was exhibited at the Paris Salon. A critic hitherto favorable to Delacroix exclaimed, "He has been carried away beyond all limits." There had never been a composition depicting so many beautiful women wearing such glittering bracelets (but little else), dying so violently among such exotic finery,

heaps of gold, and horses rearing in their death agonies. It is one of the masterpieces of romantic painting. After the sensation of its exhibition this enormous painting (12 feet high by 18 feet long) surprisingly disappeared from sight for almost a century before reappearing to be bought for the Louvre in 1921 – when it caused a second scandal.

Two other paintings exhibited in the same year were the allegorical *Greece Expiring on the Ruins of Missolonghi* (1827) and the *Execution of the Doge Marino Faliero* (1826-7), but they were almost the last he painted in his youthful romantic manner. After the Revolution of 1830 he painted *Liberty Leading the People* (1830) and was awarded the Legion of Honor by the new government, suitably grateful for the vivid impression this painting had made on the public. But after this he turned away from romantic scenes and the stagey historical subjects they relied upon, seeking instead an environment where the exotic was an accepted part of the everyday world. This he found in North Africa – where he also discovered the sense of continuity with the past that satisfied the part of his nature

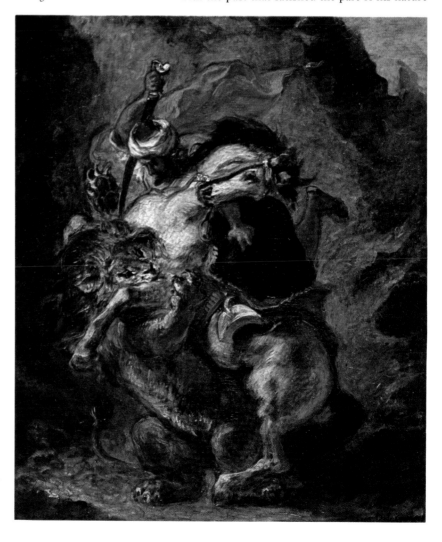

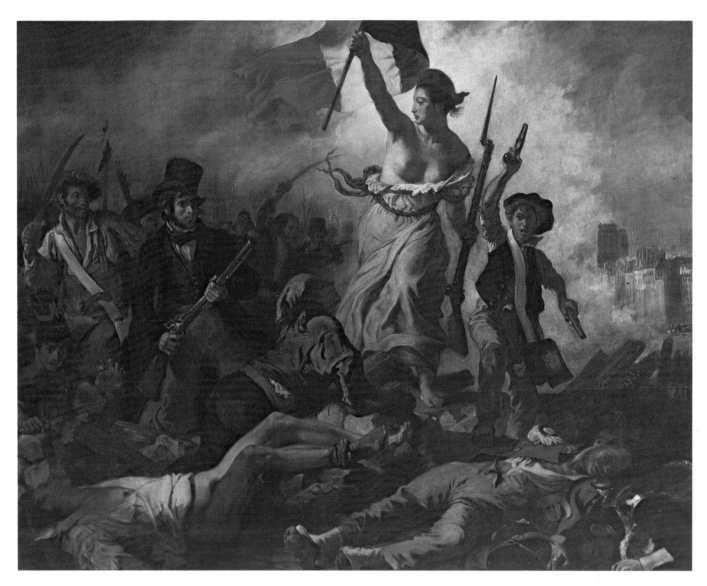

still responsive to order and the classical tradition. He managed to penetrate a harem and, back in Paris, painted *Women of Algiers in Their Apartment* (1834), a composition that is sumptuous and yet reposed. His zest for exotic subjects never left him, but he preferred to place them in the contemporary – though perhaps a foreign – world.

While the neoclassicists emphasized the importance of line, the one necessity for Delacroix was color. "In nature all is reflection, and all color is an exchange of reflections." Renoir claimed he could smell the incense the *Women of Algiers* were burning as soon as he came close to the picture, and Cézanne added, "The color of the red slipper goes into one's eyes like a glass of wine down one's throat." And in Delacroix's fast-moving scenes of galloping Arab horses, the outlines are often unclear, having, in his own words, "the shaggy look of a tapestry seen from the back." His work was the precursor of Impressionism.

ABOVE *Liberty Leading the People* (1830), a rare example of Delacroix painting a historical picture in contemporary dress. It was stored in the basement of the Louvre after 1848 on the grounds that it could not be exhibited while France was not a republic. The scene was based on the artist's own observations.

RIGHT *Women of Algiers in Their Apartment* (1834). King Louis Philippe bought this painting at the 1834 Salon for 3000 francs. The clothing confirms that the women were Jewish, and the way Delacroix painted them reveals the wonder and enchantment he felt when he entered their dark, sweet-scented room.

In his last years, when not producing large-scale murals for public buildings, he continued to paint scenes of struggle and slaughter, these involving wild horses, tigers, and lions. Significantly, he also painted large baskets of flowers. The conflict in his nature had not been resolved. His great admirer, the poet Baudelaire, aptly described him as "a volcanic crater artistically concealed beneath bouquets of flowers."

Edouard Manet

1832-1883

Delacroix suffered the angry disapproval of the Paris art critics for a year or two. When Turner painted his snowstorms the public was puzzled, though they bought his other work. Manet's paintings, however, brought him storms of abuse year after year. He was called an incompetent, a plagiarist, and a man without talent or taste.

He was the first of the modern masters – a man

ABOVE portrait of Manet by his colleague Henri Fantin-Latour (1836-1904), a detail from the group portrait *Homage to Manet (The Studio at Batignolles)*, painted in 1870. His friend Degas, after Manet's funeral in May 1883, quietly commented, "He was greater than we ever thought."

balcony *had* a nose, but if it *looked* as if there was nothing between her eyes and her nostrils, then that was how he painted her. When Gustave Courbet (1819-77), the great realist painter, saw Manet's *Olympia* (1863) he complained, "It is so flat; there is no modeling; you would imagine she was the Queen of Spades in a pack of cards, coming out of her bath." When this work was exhibited at the Salon it evoked such an uproar from the public that it had to be rehung out of reach of attack.

A few months earlier he had painted the picture now called *Le Déjeuner sur l'herbe*. Of this revolutionary painting one critic wrote, "Monsieur Manet has the qualities needed to have him refused unanimously by every hanging committee in the world. His shrill colors penetrate the eye like a steel saw, his characters are sharply punched out with a crudity which no compromise can soften. He has all the sourness of a green fruit that will never ripen." "Monsieur

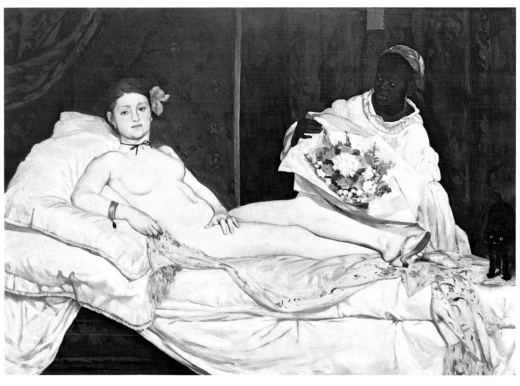

LEFT *Olympia* (1863), a painting Manet first considered too daring to submit to the Salon. It was accepted the next year (1865), but its reception confirmed his fears. One critic wrote, "People throng in front of Manet's putrid *Olympia* as they would in front of a body in the morgue. This is art fallen so low that it is not even worthy of censure."

born, as Matisse said, "to simplify art." He reacted against the fussy details of the romantic painters and the historical school, wanting to paint pictures of the world about him. But he felt little enthusiasm for the works of the realist school, whose paintings of laborers were set in carefully naturalistic backgrounds. Both in subject matter and in manner Manet's art was new. He painted in the open air, where familiar colors look different and bright sunlight alters the modeling of figures, making solid objects look flat. He knew that a woman on a sunlit

Manet," wrote another, "wishes to achieve fame by shocking the bourgeoisie."

This charge of shocking the bourgeoisie was to be leveled against one artist after another, in all fields of art, over the years to come. Yet Édouard Manet himself was born into a solid middle-class family. His father was chief of staff at the Ministry of Justice and his mother the daughter of a diplomat. Édouard was allowed to study painting, but the master his father chose for him was a leader of the historical style he detested. He found better teachers in the

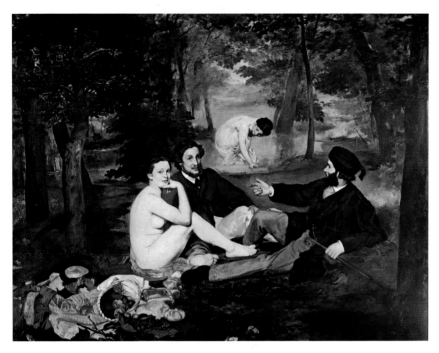

Louvre, where he copied the paintings of Goya and Velázquez. From Velázquez he learned to simplify the planes and colors of a picture. He also learned to dispense with a background, and a painting like *The Fifer*, rejected by the 1866 Salon, is a boldly simple composition of primary colors against a gray background.

But the chief lesson he learned from his study of the Spanish painters was the pleasure of

ABOVE *Le Déjeuner sur l'herbe* (*Luncheon on the Grass*). Considered indecent by Napoleon III, the subject was taken from a composition by Raphael. The shapes are expressed in flat colors rather than by sharp outlines.

LEFT *The Fifer* (1866), a young band boy of the Imperial Guard. The background is not really firm enough to provide support, but his figure seems so solid that his steady stance alone gives the illusion of a base. The economy of Manet's style may have owed something to photography, at which he was a keen amateur.

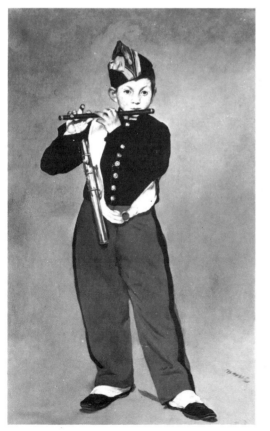

RIGHT *The Balcony* (1868–9). Berthe Morisot, who was introduced to Manet after he had admired one of her paintings, posed for the sitting figure at the front. The subject and treatment were inspired by Goya's *Majas on a Balcony*.

painting for its own sake: choice of subject was immaterial. Subjects of everyday life presented themselves, and if they did not he could adapt the Old Masters. When walking one day with friends by the Seine he noticed some women bathing and said, "It seems I must do a nude. All right, I'll do one . . . in the transparent air, with people like those we can see over there." His choice of subject infuriated a public who were only prepared to see a nude woman in the context of a mythological or historical scene. His *Déjeuner* showed a contemporary woman who had taken off her clothes and sat down beside contemporary men. As for his manner of painting, they were angered by his lack of interest in traditional modeling. He liked to paint areas lit by strong light or in strong shadow using as few halftones as possible.

When Manet painted a historical scene it was of contemporary history, such as *The Execution of the Emperor Maximilian of Mexico* (1867). Though the execution squad was Mexican, Manet painted them in French uniforms to show his opinion of where the responsibility for the tragedy lay.

Under the influence of Monet and other Impressionists he lightened his palette, and it was in this style that he painted his last great work, *A Bar at the Folies-Bergère* (1882). By this time he was tired of the continual struggle to win acceptance and his health was deteriorating. Ironically, it was only after a posthumous exhibition held nine months after his early death that his work began to gain prominence and his artistic reputation was assured.

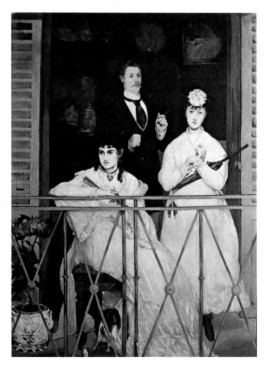

Claude Monet
1840-1926

In April 1874 a group of French painters, angered by the stiffly traditional standards of the Paris Salon, exhibited their paintings in the studio of the writer, photographer, and balloonist Nadar in the Boulevard des Capucines. Critics and spectators roared with contemptuous laughter at the canvases dabbed with color. One newspaperman stopped in front of a view of boats with a red sun casting its reflection on the misty water, painted in 1872. He read the title – *Impression: Sunrise* by Claude Monet. In his scornful review of the exhibition he seized on this title and castigated the artist for daring to foist on the public something he admitted to be a mere *impression*. The name stuck. The painters themselves adopted it, and they have been known ever since as Impressionists.

It was apt that a work by Monet should have given its name to the group because, though not the oldest of the painters involved, he was the moving force behind them. Renoir later said, "Without Monet, we would all have given up." Renoir and other members of the group, such as Degas, Cézanne, and Pissarro, later moved away from Impressionism but Monet remained close to its first principles throughout his life.

In their search for a greater naturalism the Impressionists "invented" a new way of seeing. As a student Monet had rejected the conventional form of art teaching, which consisted largely of drawing plaster casts in the light coming through a north window. He led a group of fellow students out into the forest of Fontainebleau where they painted in the open air. They were not the first painters to do this, but it was not something students were expected to do. Monet insisted on changing the rules. What he wanted was to catch the fleeting impression of sunlight on objects. Though born in Paris he had lived most of his life near Le Havre in Normandy, and it was this out-of-doors world he wanted to capture in paint – as it actually was at the moment of seeing it, not worked up in the studio afterward from sketches.

Impressionism was born in the village of Argenteuil on the Seine during the early 1870s.

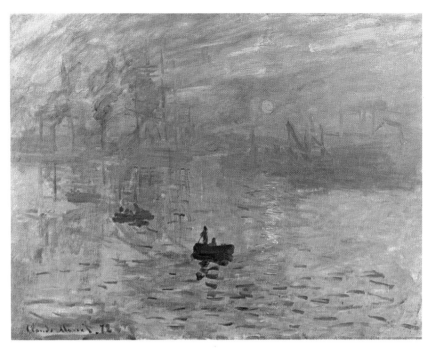

ABOVE *Impression: Sunrise*, the painting that gave its name to the Impressionist style of painting.

BELOW self-portrait of Monet painted when he was in his 70s during World War I. By this time Monet was almost blind and suffering from the loss of his second wife and his son Jean, but he struggled on and built himself a new studio.

RIGHT *Cathedral at Rouen*, one of a series Monet painted between 1892 and 1894. It fits into a sequence covering dawn to dusk, with the dominant colors gray, white, iris or, as here, blue. The thick texture of the surface was painted over again from memory in the studio to give the effect of shadows and points of light on old stonework.

It was a period of appalling poverty for Monet; his family were too poor to aid him financially, and he once tried to kill himself. But he found artistic release in trying to portray the reflection of an object in moving water as a medley of bars and dots of color. He and Renoir began to apply paint in small, brightly colored strokes, first in pictures of boating scenes and then in landscapes and other compositions. They gradually did away with the precise outlines of an object – which do not really exist anyway – and concen-

trated on its appearance in terms of color, brightened or dulled by the presence or absence of direct sunlight. Monet realized that shadows too are colored, and the surface of his paintings began to dance with myriad dabs of pure color, sometimes so densely placed that the spectator must stand back from the picture in order to comprehend it. So absorbed was he by light on water that he fitted out a small secondhand boat as a floating studio so as to be able to study its effects in all its moods.

Although Monet hated living in towns, and he is known primarily for his depictions of nature, he could also turn city life into a picturesque landscape pulsing with activity and color. In 1873 he painted a scene of carnival on the Boulevard des Capucines in Paris; in 1876 it was the Tuileries Gardens bathed in a golden sunset; and between 1876 and 1878 Monet painted ten versions of the Gare Saint-Lazare, full of puffing steam and noisy trains. These

BELOW *Poppies* (1873), one of Monet's most successful pictures of the countryside, in which the brilliant red of the flowers contrasts with the green of the meadows. The paint is applied so thickly that the flowers seem to grow.

outstanding technical achievements, dealing with wholeheartedly contemporary subjects, constituted the first of Monet's many "series" of pictures of one subject, in which the real point is the effect of changing light on an object. Later examples were the *Haystacks* (1889-93) and the *Poplars* (1890-91). He then spent many months painting in Rouen from a first-floor room overlooking the cathedral. The paint in the *Rouen Cathedral* series (1892-4) has a stippled effect, like the surface of old stonework. His most famous series is the *Water Lilies*, painted in the garden he planned and built around his house at Giverny. He painted 48 of these between 1904 and 1908, and in 1915 he took up the subject again. Despite failing eyesight he continued to paint almost until his death. These last paintings, some very large, in which subject and form have virtually dissolved into blurred areas of bright color, have been called precursors of mid-20th-century abstract art.

Vincent Van Gogh

1853-1890

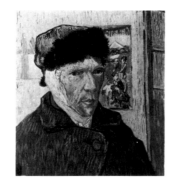

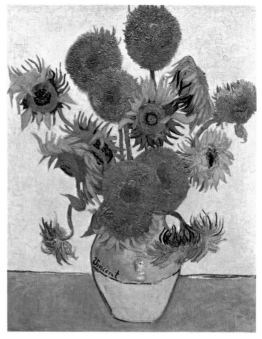

The tragic mental anguish of Vincent Van Gogh, possibly triggered by a form of epilepsy, is brilliantly reflected in the twisting forms and bright colors of his paintings. No artist before him had ever painted cypresses as writhing flames, but now it is difficult to look at one without thinking of him. The sunflowers, stubby hedges, cornfields, and yellow chairs of his paintings glow with the intensity of a fever. Printed reproductions of his more famous paintings sell by the thousand now, and that would have pleased him; he once wrote to his devoted younger brother Theo that nothing would make him happier than that people should hang prints of his works in their homes or workshops. During his lifetime he sold only one picture, and that was to a fellow artist.

Vincent Willem Van Gogh was born in Groot Zundert, a small village in the southern Dutch region of Brabant. His father was a Protestant clergyman and Vincent was deeply religious, feeling a particularly deep sympathy for poor and suffering people. At the age of 16 he began training with an uncle who managed the Goupil art gallery in The Hague, and three years later he was sent to the firm's London branch. There an unhappy love affair precipitated a nervous breakdown and a burst of religious enthusiasm. A succession of brief jobs in England and Holland was followed by two years as a lay missionary in the Borinage, a coal-mining district near Mons in Belgium, where he shared the harsh, poverty-stricken life of the miners. He was dismissed in 1880 for interpreting Christian doctrines of selflessness too zealously.

He had been drawing since an early age, and the relief it brought him during this period of despair proved to be the turning point of his life. Suddenly aware of his creative powers, he wanted to study everything about drawing. At the age of 30 he started to paint. His first compositions were the traditional Dutch subjects – landscapes, still lifes, and figures – painted in dark and somber colors. His portraits of peasants of this time are distinguished by a profound respect and sympathy.

ABOVE *Self-Portrait with Mutilated Ear* (detail), which Van Gogh painted in Arles in January 1889 after his quarrel with Gauguin. Behind him is one of his Japanese prints.

RIGHT *Sunflowers* (1888), probably painted while Van Gogh was in Arles. The canvas is signed "Vincent."

BELOW *The Potato Eaters* (1885), painted by lamplight on the spot. "I have tried to make it clear how those people, eating their potatoes under the lamplight, have dug earth with those very hands they put into the dish and it speaks of manual labor." The color, influenced by Delacroix, Van Gogh termed a "green soap color." (Collection State Museum Kröller-Müller, Otterlo, the Netherlands)

For five years he lived in Holland, supported by his parents. During a winter in Antwerp he discovered Rubens and became fascinated by the bright colors and flat modeling of Japanese prints. In 1886 he arrived in Paris to stay with Theo, who was working at Goupil's Paris headquarters. Theo introduced him to Toulouse-Lautrec, Gauguin, and the new Impressionist group of painters including Pissarro, Degas, and Georges Seurat (1859-91). Under the influence of these exciting new developments in modern art Van Gogh's style and palette altered, and during 1887 he painted several typically Impressionist subjects – street scenes, restaurants,

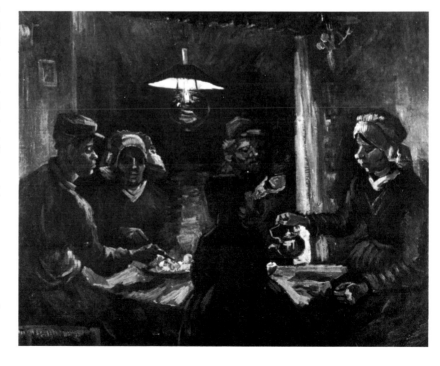

flowers, and people in boats. He combined the shimmer of water or sunlight with a distinctly un-Impressionist definition of outline or used planes of color as the basis of a composition, such as in *The Wheatfield*. Van Gogh left Paris in the spring of 1888 and went south to the small town of Arles, near the mouth of the Rhone river. There, in the burning Provençal sunshine, he painted with a feverish desperation.

One of his first subjects was *The Bridge of Langlois* (1888), a drawbridge near Arles that may have reminded him of similar bridges in Holland and in Japanese art. The reeds and grasses are painted with a forceful energy in long strokes of pure color. Throughout that summer in Arles his colors became increasingly strong and he developed an obsession with the sun, painting it rising, large and golden, above the cornfield in *The Sower*.

His yellows glow as if with internal heat – the celebrated *Sunflowers* in their pale unmodeled vase are a feast of different yellows superbly brought together. As the year progressed, night scenes and the moon came to fascinate him. He surrounded stars with halos as in *The Night Café* (1888), in which light and dark are marvelously contrasted.

By this time his technique of applying paint in separate brush strokes – learned from the Impressionists – had become a potent means of conveying the intensity of his emotions. He jabbed the paint onto the canvas and often made no attempt to smooth it over but left it rough, standing up in ridges where it reflected light and cast shadows in all directions.

For two months at the end of 1888 Paul

BELOW LEFT *The Chair and the Pipe* (1888–9), a picture of the artist's own chair in daylight. It was begun two or three weeks before Van Gogh's breakdown in Arles.

BELOW *The Night Café* (1888), which depicts the Place du Forum in Arles. Van Gogh contrasted the hot, sulfurous yellow of the café's gaslight with the cool, natural blues of the starry night sky. (Collection State Museum Kröller-Müller, Otterlo, the Netherlands)

Gauguin shared his "yellow house" studio, but this attempt to found a community of Impressionist artists failed because of their differences in temperament. In the mental breakdown that followed – expressed in his paintings of empty chairs – Van Gogh mutilated his left ear and was taken to the hospital. Gauguin left. In the spring of 1889, fearful of losing his sanity completely, Van Gogh asked to stay at a mental home in Saint-Rémy-de-Provence, where his paintings alternated between an enforced calm and an even greater turbulence. Trees, rocks, and the sky itself heave like waves in his work of that year.

In May 1890, oppressed by loneliness, he returned to Paris and was sent by Theo to stay in the small town of Auvers on the river Oise, where the local doctor was also an artist and collector. For a time his condition seemed to improve, but in the two paintings of wheatfields he completed in July the black crows might have been harbingers of death. At the end of the month, in despair at ever being cured, he shot himself and died two days later.

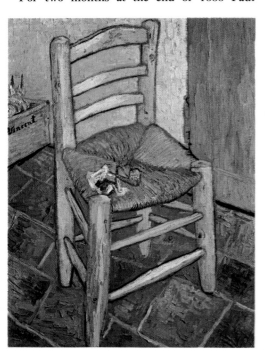

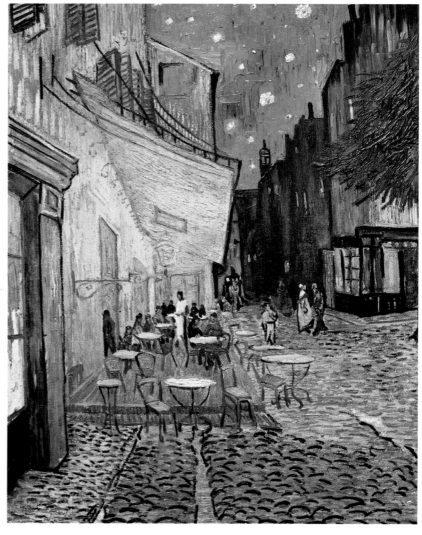

Paul Cézanne

1839-1906

Although considered by many to be the father of modern painting, Cézanne would probably disown almost all the modern art that has since been produced. He was not a typical revolutionary. Born in Aix-en-Provence in southern France, the only son of a domineering, self-made banker, Paul had a difficult childhood and never gained the approval or respect of his father. As a result he was always extremely sensitive to criticism, subject to violent but contradictory emotions, and distrustful and defensive toward even his closest friends.

When he first arrived in Paris, after persuading his father to allow him to study art, he painted erotic or pathetic subjects in somber tones, applying the paint thickly with a palette knife. He was first influenced by both Courbet's realism and Delacroix's use of color. But under the influence of the Impressionists, notably his friend Camille Pissarro, his colors became lighter, and the compact brush strokes of this period herald his later manner. He sent three works to the first Impressionist Exhibition of 1874; of these, it is not difficult to understand why *Modern Olympia* was singled out for particular abuse. It was a parody of Manet's *Olympia*, and in it the Negress lifts a sheet off the bed to expose the other woman's nakedness while a spectator (perhaps Cézanne himself) looks on. The color is intense, the brushwork thick and spirited. Critics called him a victim of *delirium tremens* ("the shakes").

He stopped exhibiting with the Impressionists after their third show in 1877, having by then decided that they were losing more than they were gaining by their concentration on light and color. He felt they were overemphasizing surface appearances and neglecting solidity and structure. Cézanne wanted to keep a sense of substance but he did not wish to suggest form by means of traditional perspective, and he rejected the old method of suggesting it by the use of darker tones. He wanted to keep the bright palette of the Impressionists but to use it to compose works that were more organized and stable than theirs could ever be.

He moved with his family to the isolation of Estaque, on the Mediterranean coast near Marseilles, and then back to his birthplace of Aix. There he labored over his canvases while staring at the sea, a fishing port or the mountains, and eventually he found a way of achieving a three-dimensional quality using color alone. He applied facets of color in a mosaiclike pattern of varying shapes and sizes, carefully graduated in tone so that they built up to suggest the form

ABOVE self-portrait of Cézanne dating from about 1880. He said that he wanted "to make of Impressionism something solid and durable, like the art of the Museums."

LEFT *Mont Sainte-Victoire*, one of more than ten paintings of this scene near his home in Provence. This version dates from 1886–8. Cézanne wrote, "The landscape becomes human, a thinking, living being within me. I become one with my picture . . . We merge in an iridescent chaos."

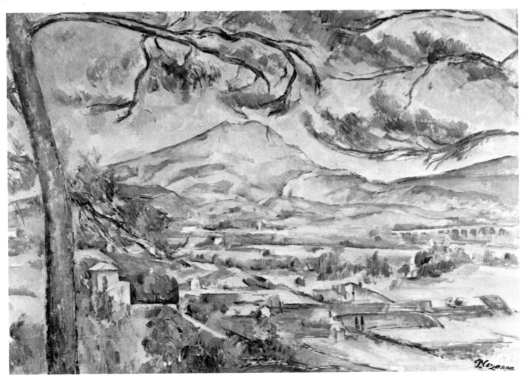

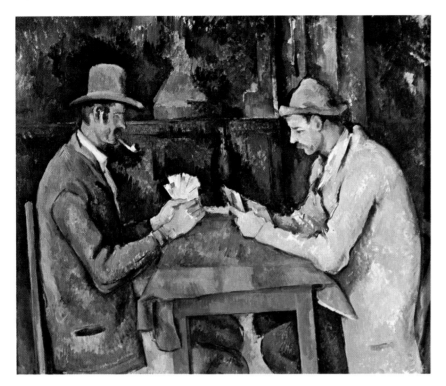

ABOVE *The Card Players* (1892), one of five pictures on this theme. All express the sober dignity of the players, unlike most of Cézanne's portraits which make no attempt to hint at the sitter's character.

lakeshore, and distant field.

This method of constructing a painting was very time-consuming. The Impressionists hoped to finish a painting in a single sitting, working very fast. In contrast, Cézanne worked so methodically that he is said to have stopped work on a portrait of the art dealer Ambroise Vollard after more than 100 sittings with the comment that he was "not displeased" with the shirt front. This was because the reality he set out to record through art kept deepening the closer he looked. Cézanne stalked nature like an elusive prey and then wrestled with the medium of paint to fix the image he saw in front of him. He painted numerous views of Mont Sainte-Victoire near Aix in which it becomes almost a mythical presence. His still lifes, numbering over 200, were organized as if they were architectural drawings, with all their elements inextricably interlocked.

By the turn of the century his achievements were being recognized by other artists. The cubists were inspired by his remark that "everything in Nature is modeled after the sphere, the cone, and the cylinder." He did not shrink from distorting shapes or altering colors if this helped the composition. His last works integrate monumental forms with landscape in his own vision of reality. But his chief legacy to modern art is best expressed in his own words: "Design and color are not distinct and separate. As one paints, one draws. The more the colors harmonize, the more the design takes form. When color is at its richest, form is at its fullest."

of the landscape, bather or bowl of apples he was studying. The direction of the brush strokes further assisted the appearance of form, and the composition was unified by the complicated interlocking of lines and planes. Perhaps the first masterpiece of his mature style was *L'Estaque* (about 1888). The opposing diagonals of branches and mountain slopes in *The Lake of Annecy* (1896) link the foreground and background as do the verticals and horizontals of tree, reflections,

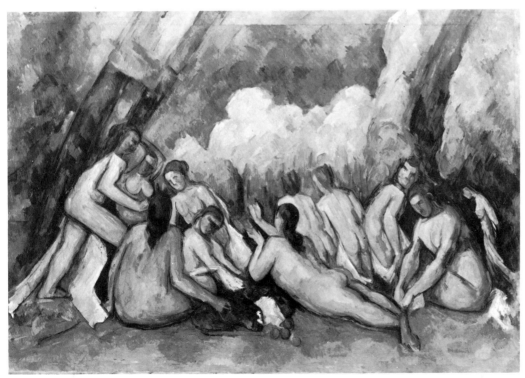

LEFT *Bathers*, one of three large pictures of a similar subject dating from between 1890 and 1905. Many smaller versions exist as well. He was trying to return to the classic tradition of the nude and explore its sculptural effect in relation to the landscape.

Edvard Munch

1863-1944

"I was walking along a road. The sun set. I felt a tinge of melancholy. Suddenly the sky became a bloody red. I stopped and leaned against the railing, dead tired, and I looked at the flaming clouds that hung like blood and a sword over the blue-black fjord and the city. I stood there, trembling with fright. And I felt a loud, unending scream piercing nature."

With these words Edvard Munch described the experience that inspired his most famous painting, *The Scream* (1893), an unforgettable image of the anxieties of modern humanity. The

RIGHT *The Sick Child* (1886), the earliest of several paintings of this subject. Munch's own experience provided the psychological driving power.

BELOW *The Scream* (1893), part of the *Frieze of Life*. Strindberg called it "a scream of dread at Nature which, flushed with rage, is about to speak through storm and thunder to those foolish, puny humans who imagine themselves gods."

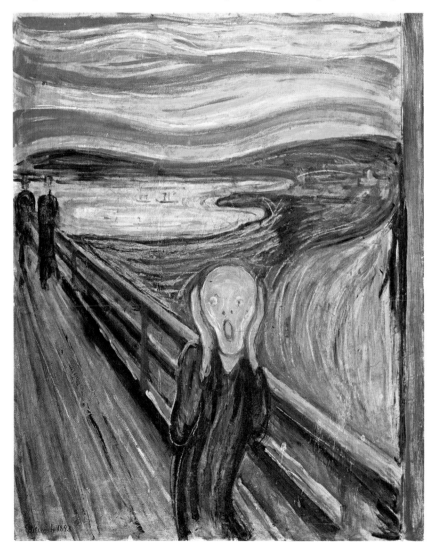

nightmarelike perspective, the wavy lines of the landscape and sky, and the lurid colors – reds and yellows reflected in the sea and the railing – all express the inner tension of the terrified figure in the foreground, whose hands are held to his or her ears and whose mouth is wide open. The scream is in nature, but it is also in each human being.

This painting is an early example of what has come to be called *expressionist* painting, in which internal states are expressed "by means of exaggeration and distortion of line and color." By simplifying all the elements of the composition, a direct and powerful emotional impact is achieved. Many of Van Gogh's paintings show expressionist tendencies, but the movement's most influential exponent was Munch. In his most memorable paintings he created a succession of images that vividly convey the emotions of despair, fear, and spiritual malaise. They evoke in the spectator the same emotions the artist himself must have felt while he was painting them.

Edvard Munch was born in Löten, Norway, one of the five children of a military doctor. His mother died of tuberculosis when he was five, which left his father a prey to melancholy and religious anxiety. Munch's elder sister died when he was 14, also from tuberculosis, and memories of her death inspired one of his earliest paintings, *The Sick Child* (1886). The girl's thin face on the pillow is turned toward the window while the mother bows her head in the grief she can no longer conceal.

The paintings Munch exhibited in Oslo were attacked by the critics, but he managed to obtain a state grant to study in Paris in 1889. For the next 20 years he traveled widely in France and Germany, painting different versions of a relatively small range of subjects – visionary experiences that seem to have come to him in

moments of heightened emotional intensity. Each summer he returned to Norway, and the undulating shoreline and great boulders of Åsgårdstrand on the Oslo Fjord are familiar features in his work.

In the 1890s he developed his characteristic style of simplified figure drawing that made use of an expressive outline and large areas of uniform color. To this period belongs the group of paintings that he called the *Frieze of Life* (1893–5), conceived, he wrote, "as a series of paintings which together present a picture of life in all its fullness, its joy and suffering." Suffering, however, predominates. The titles alone are revealing – *Melancholy*, *Puberty*, *Vampire*, *Jealousy*, *Ashes*, and *The Scream*.

Munch's reaction to women was one of fascinated fear. Sometimes he saw them as young and virginal, in white, gazing out to sea. Significantly, their faces are almost always turned away from the spectator. At other times woman is the seductress, her *art nouveau* tendrils of hair flowing over her naked body or, as in *Vampire*, across the head of her lover. In the lithograph

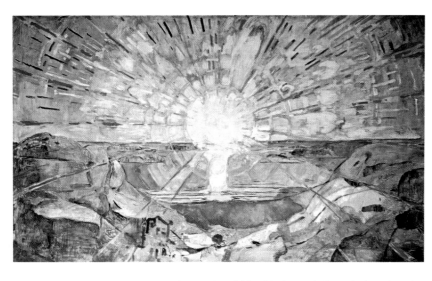

ABOVE *The Sun* (1909–11), one of three main panels of the mural Munch painted for Oslo University. The sun of the north rises over the coast of the Kragerø fjord, and its rays form the traditional triangle of Renaissance composition.

he made of his *Madonna* (1894–5), he placed a naked woman within a frame of wriggling spermatozoa while in the corner crouches a miserable fetus or homunculus. Another image of woman is the hollow-eyed figure in black, standing at one side in scenes of dancing, and suggestive of death.

Munch undeniably had a deeply neurotic personality, and in 1908 he suffered a severe mental collapse. After a year in a Copenhagen clinic he returned to Norway, but his style had altered. Though he sometimes returned to earlier themes, the anxious energy had gone and his brighter and richer colors express his more positive frame of mind. He abandoned the printmaking for which he had also become known and spent his last years painting in solitude at his home near Oslo. He bequeathed all his works to the city of Oslo.

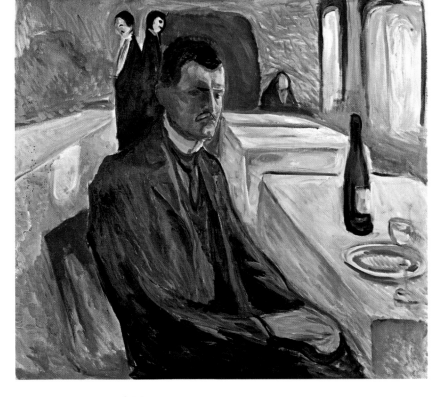

ABOVE *Self-Portrait with Wine Bottle* (1906), a record of his feeling of inner division and warfare. Munch turns his back on the two waiters and lone diner in an otherwise empty restaurant as an expression of the constant loneliness and despair that afflicted him.

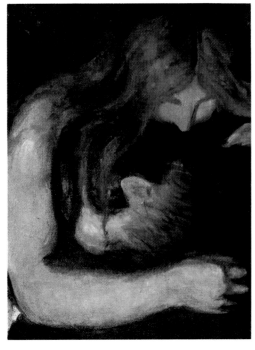

RIGHT detail of *Vampire* (1893), one of numerous examples of Munch's ambivalent attitude to women. His colors are generally restrained, yet they glow like a banked fire and communicate through an intense symbolic language.

105

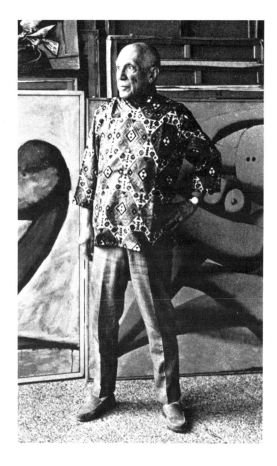

at work on it. Two figures resemble the African masks that intrigued Picasso with their strong emotive power. These sculptures pointed the way to an art that would break away from the representational tradition.

In the next few years Picasso worked with Georges Braque and the Spanish painter Juan Gris (1887-1927), experimenting with an entirely new means of interpreting form on a flat surface. They separated the elements of an object's form and painted them, including more than could be seen from a single viewpoint. To give structure to the compositions they limited their palette to a few rather drab colors and treated the subject and background with a certain uniformity. The eye traveled over a series of facets that gave the appearance both of solidity

Pablo Picasso

1881-1973

No painter has ever achieved mastery over so wide a range of styles as Pablo Picasso. At various times he has produced paintings with atmospheric effects akin to the Impressionists, nostalgic pictures of vagabonds in misty colors, and images of harsh, distressing violence; he has revitalized archaic forms, flirted with surrealism, and pioneered numerous styles of visual expression with a fertility of imagination halted only by his death at the age of 92.

Gifted even as a child in Málaga with an astonishing facility for drawing that was noticed and encouraged by his father, an art teacher, Pablo Ruiz y Picasso left Spain for the stimulation of bohemian Paris at the age of 20. In 1907, six years later, he began work on the painting that would become the turning point in modern art – *Les Demoiselles d'Avignon*. His ideas about the function of art changed greatly while he was

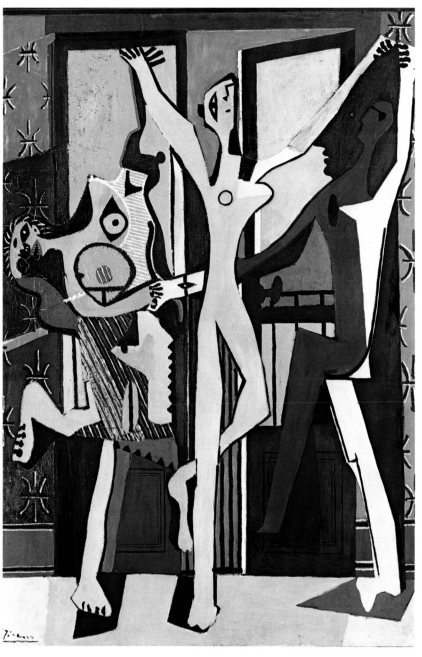

and transparence. Cubist painting was born.

As his paintings became more abstract Picasso felt the need to introduce a new reference to reality. He pasted a piece of cane seating onto a canvas; cutout paper and other materials rapidly followed. Bright color returned to give the sensation of depth, and the paintings, whatever their starting point in nature, became compositions in their own right – *collages*. Various shapes, colors, and textures were freely arranged in the picture space. *Three Musicians* (1921) is a major achievement in this style.

During World War I Picasso designed scenery for Diaghilev's Ballets Russes, and this led to an interest in classical subjects. Never content to stay with one style (as were Braque and Gris), he now produced representational paintings at the same time as his cubist works. In the 1920s his nude women became increasingly solid until, with the large canvas *The Three Dancers* (1925), violent movement erupted into his art. Hitherto his paintings had all been static in mood, but from this time the compositions involve monstrous distortion of the human figure, frenetic energy, harsh colors, and an air of foreboding. The female nude is subjected to severe pictorial violation. This period of his work culminated in the huge mural *Guernica* (1937), inspired by the destruction of this Basque town by Hitler's bombers during the Spanish Civil War. It expressed Picasso's horror of war and, unlike the "battle pictures" of other eras, conveys what war *feels* like rather than what it may look like. Details of this immense composition are perhaps

BELOW *Guernica* (1937), a huge allegorical mural in which a host of symbols express the reaction of a self-exiled Spaniard to the bloody Civil War that raged in his own country.

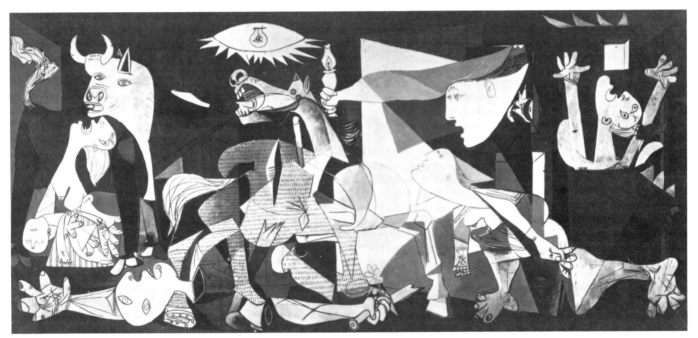

more impressive than the painting as a whole, and it is through his preliminary and subsequent versions of these details that Picasso most directly expresses the terror and misery of war.

After World War II, Picasso settled in the south of France, first at Vallauris, attracted there by the potteries, and later at the Château de Vauvenargues, situated below the slopes of Mont Sainte-Victoire, so often painted by Cézanne. His creative powers led him into other fields – sculpture, ceramics, and a wide variety of graphic work – but he always returned to his painting, working in a style generally less aggressive than that of the 1930s. He left his extensive private collection to the people of France. It is clear already that his influence on modern art has been all-pervading, but which elements of his work will prove most stimulating for late-20th-century painters has yet to be seen.

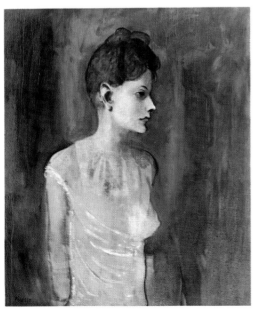

LEFT *Woman in a Chemise* (about 1905), an early picture from Picasso's Blue period when he was interested in creating specific moods through the distortion of color.

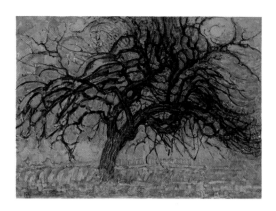

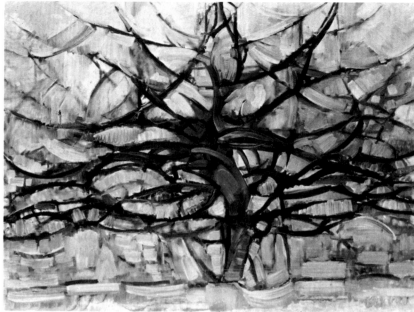

Piet Mondrian

1872-1944

"The impact of an acute triangle on a circle produces an effect no less powerful than the meeting of the fingers of God and Adam in Michelangelo's *Creation*." Thus spoke the Russian-born painter Vassily Kandinsky, one of the founders of abstract art. This modern movement was developed from cubism – which always retained a figurative element, however distorted – by artists who realized that a painting need not have an object in the outside world as a subject. Art could instead be *nonobjective*. One of the foremost of these painters was Piet Mondrian.

Kandinsky believed paintings should always express a powerful emotion, but Mondrian and other artists developed the principles of abstract art in the opposite direction. They wanted a "pure" art in which human emotions played no part – an impersonal, universal art. Mondrian's distinctive style in particular has exerted a powerful influence on 20th-century architecture, advertising, and typography.

Pieter Cornelis Mondriaan (he dropped the second "a" from his name during his early days in Paris) was born in Amersfoort, near Utrecht in the Netherlands, the son of a strict Calvinist schoolmaster. He received his first lessons in painting from his uncle, a landscape painter; he became qualified to teach art in 1892 and spent five years attending evening classes at the Academy of Fine Arts in Amsterdam where he painted landscapes and still lifes. His monumental work *Woods Near Oele* (1908) shows a new linear movement somewhat reminiscent of Munch and a vigorous use of color. In a series of

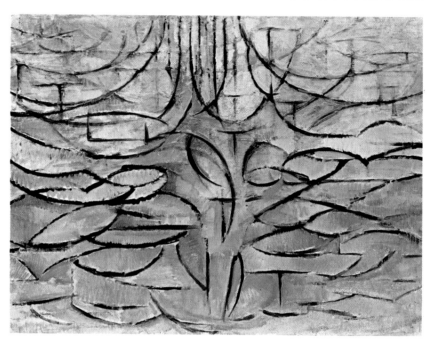

ABOVE Mondrian's break with the national tradition of Dutch painting occurred when he evolved his own vision of nature by creating a balance between the contrasting hues of red and blue and between the violent movement of a tree and the stillness of a blue sky. He thus achieved a sense of equilibrium in his representation of the natural world. Simultaneously he was striving to reduce individual forms to a general formula, as in *The Red Tree* (1908) ABOVE LEFT; *The Gray Tree* (1912) TOP; and *Blooming Appletree* (1912) DIRECTLY ABOVE.

paintings of trees such as *The Red Tree* (1908) and *The Gray Tree* (1912) he tried to lay bare the underlying structure of a tree. The spreading branches – at first painted in a manner recalling Van Gogh – were gradually reduced to an abstract web of black curves and spikes on a neutral background.

In 1912 Mondrian moved to Paris, where he found the early experiments of the cubists Picasso and Braque to be in sympathy with his own research. He differed from them, however, in penetrating beyond the figurative to the totally abstract. In his first cubist-inspired paintings such as *Still Life with Gingerpot* (1911-12), the shape of objects, notably a blue-gray ginger jar, can still be discerned. The objects are

more recognizable than in the paintings of the cubists, whose aim was to present an object simultaneously from several viewpoints. But by 1914, when he returned to Holland, the figurative element had been completely removed from his work. The curves in the compositions of this period are descendants of the ginger jar and the church windows of Domburg he had painted previously, but such titles as *Pier and Ocean* (1916) have given place to the austere *Composition in Black and White* (1917). Mondrian's aim was always to simplify shape and color.

With the Dutch painter Theo van Doesburg (1883–1931) he founded the magazine *De Stijl* in 1917, in which they argued for a new social

RIGHT *Self-Portrait*, drawn in charcoal in 1912 about the time Mondrian first went to Paris. He returned to the Netherlands in 1914 to visit his father, who was seriously ill, and then the outbreak of World War I prevented his return to Paris. During the war years he joined the Theosophical Society and helped to found *De Stijl* ("the Style").

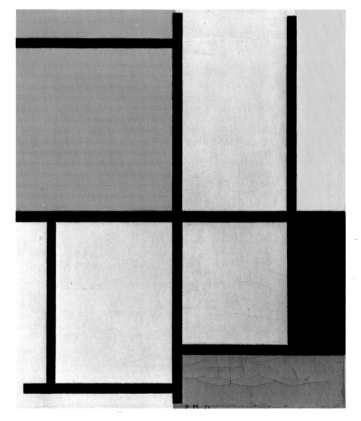

theory of art. Their belief that abstraction was the true "art of the time" influenced the establishment of the Bauhaus school in Germany, and Mondrian's own paintings began to look increasingly like architectural ground plans. By 1920 he was painting the compositions that are particularly associated with his name. Thick black lines across the canvas either vertically or horizontally, and some of the resulting rectangles are painted in primary colors.

Mondrian continued to exploit the possibilities of this style for the next 20 years and adhered strictly to its principles. In 1925 he stopped contributing to *De Stijl* magazine after van Doesburg introduced oblique lines into his compositions. Mondrian's own compositions

ABOVE LEFT *Composition* (1921), one of the first examples of Mondrian's mature style. He limited his palette to the primary colors of yellow, red, and blue as part of his effort to depict a universal harmony through the use of vertical and horizontal lines.

ABOVE RIGHT *Broadway Boogie Woogie* (1942–3), one of the last works of Mondrian during his war exile in New York. He achieved a vibrant rhythm that reflects the effect the brash American city had on him – but he nonetheless remained true to his guiding principles.

continued to be expressed within the framework of vertical and horizontal lines, where form was defined by the primary colors. In his paintings of the 1930s color is reduced to small areas on the fringes of the canvas, but the essential elements remained the same until after he left war-torn Europe for America in 1940. The quickness and exuberance of New York dazzled and confused him. His last paintings show how he assimilated the new stimuli: the black lines became multicolored and his previous sense of stillness was replaced with restless movement. Even the style of the titles changes, and his last painting, begun in 1943, he optimistically called *Victory Boogie Woogie*. It was left unfinished, however, at Mondrian's death, from pneumonia, at 71.

Jackson Pollock

1912-1956

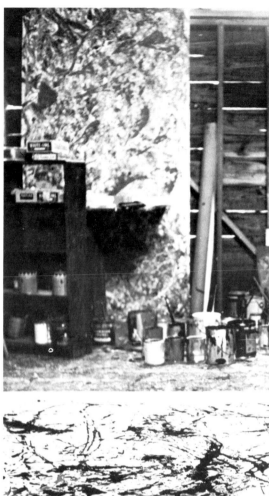

In 1940, as the war in Europe intensified, the center of the art world shifted from Paris to New York. Sculptors, architects, and painters of international reputation gathered there, and European works previously known only from photographs became available for American

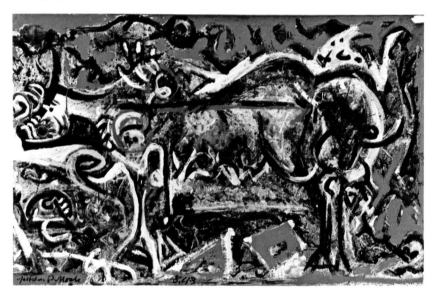

artists to study. Their presence coincided with the growth to artistic maturity of a generation of American painters. The works they produced proved sufficiently stimulating to insure that America retained its position in the years after World War II as the world's center of artistic innovation and authority. The first of these native American painters to achieve wide recognition was Jackson Pollock, who achieved celebrity as the new "wild man" of art – a fame increased by stories of his alcoholism and violent, possibly suicidal death in a car crash at the age of 44.

Paul Jackson Pollock was the youngest of five children born to an unsuccessful farmer in the small town of Cody, Wyoming. The family moved nine times in the first 16 years of his life, living in various parts of California and Arizona. In 1930 he went to New York to study painting. The few paintings that survive from the next decade are small, brightly colored abstracts in

ABOVE *The She-Wolf* (1943), a work that shows the personal way Pollock used surrealist devices, retaining fragments of Picasso's animal imagery but refusing to communicate purely through the power of symbolism.

which figurative elements make an occasional appearance. Already drinking heavily and, after 1937, undergoing psychiatric therapy, Pollock was trying to find himself both as an individual and as an artist. His compositions mark stages of his attempt to find a coherent personality.

In 1943 the millionaire art collector Peggy Guggenheim took an interest in his work and gave him a five-year contract. That November he held his first one-man show at her Art of This Century Gallery and quickly received encouraging critical attention. Later, less respectfully, he would become known as "Jack the Dripper."

He was interested both in Jungian theories of the unconscious and in ancient rituals. The sand paintings of the Navaho Indians, first encountered during his early years in the southwest, were an abiding influence. The two-dimensional quality of these pictograms, produced by pouring colored sand through the fingers onto the

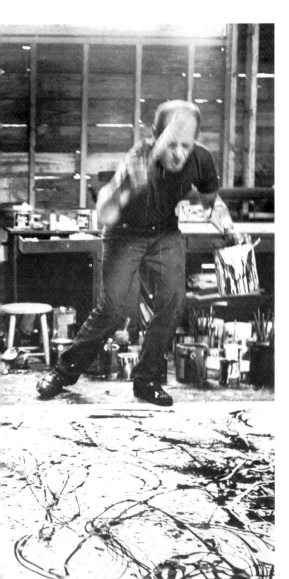

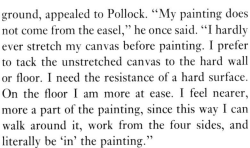

LEFT Jackson Pollock at work, photographed for a documentary film in 1950 at his studio in East Hampton, Long Island, where he painted for the last ten years of his life.

BELOW *White Light* (1954), done in oil, enamel, and aluminum paint on canvas. Pollock saw himself as the essential subject of his painting and judged his own work and that of others by its authenticity of personal expression, by which he meant the clear communication of the voice of the unconscious.

for a picture so much as an event."

Pollock's method was to squeeze paint directly from the tube or to swing a punctured paint can over the canvas as it lay on the floor. Working very rapidly he would control the flow of the paint as it fell, building the surface up in successive layers of color as nets of paint across which the eye wandered restlessly in search of a focus. In *Blue Poles* (1953) the totemlike straight lines provide a kind of resting place, but in the earlier *Eyes in the Heat* (1946) or *Lavender Mist* (1950) there is nothing on which the eye can rest.

Pollock believed that he was directly inspired by the unconscious and that paintings produced in this manner were therefore honest expressions of his own personality – hence the name sometimes given to the group of artists associated with Pollock was abstract expressionists. His impact focused attention on the American-born artists of New York, but his influence as a painter – he inspired a host of imitators – has not yet been fully assimilated.

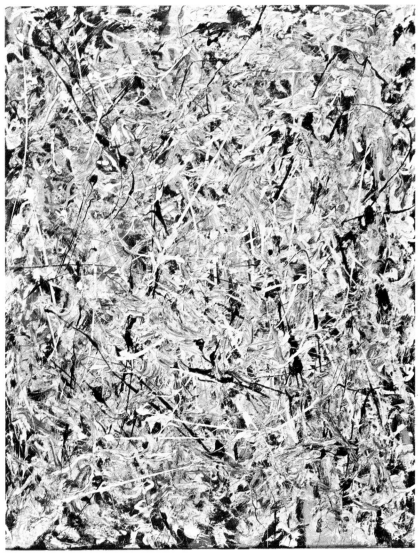

ground, appealed to Pollock. "My painting does not come from the easel," he once said. "I hardly ever stretch my canvas before painting. I prefer to tack the unstretched canvas to the hard wall or floor. I need the resistance of a hard surface. On the floor I am more at ease. I feel nearer, more a part of the painting, since this way I can walk around it, work from the four sides, and literally be 'in' the painting."

In the "drip paintings" he produced between 1947 and 1951 the lines of paint no longer indicate the contours or edges of a shape, distinguishing interior from exterior. They exist in their own right as arcs and blobs of color that trace the movement of the artist's painting arm. The painting represents nothing but itself: the act of painting is its own subject. For this reason the style came to be known as *action* painting, meaning that the painting was the equivalent of action. The canvas became "an arena in which to act . . . no longer the medium

Chapter 4

SCULPTURE AND SCULPTORS

Auguste Rodin (1840–1917) defined sculpture as the art of "the hole and the lump." Like architecture, sculpture is concerned with solid forms and space. It is the art of creating objects in the round or in relief by chiseling, modeling, carving, casting, welding, or other means. Since ancient times sculpture has been a medium for commemoration and decoration, a vehicle of history and an art form enjoyed for its own sake. It has also been the means by which a people have imagined – that is, formed an image of – their gods and goddesses, their heroes, and their demons. The great age of Christian sculpture may have passed, but modern sculptors are still using their art to produce nonnaturalistic (and for that reason sometimes more powerful) images of the invisible and only partly known forces that shape our lives.

OPPOSITE the marble *Pietà* that Michelangelo created for St Peter's Basilica in Rome when he was only 20 years old, a triumphant celebration of the sculptor's artistic genius for combining meaning with appropriate form.

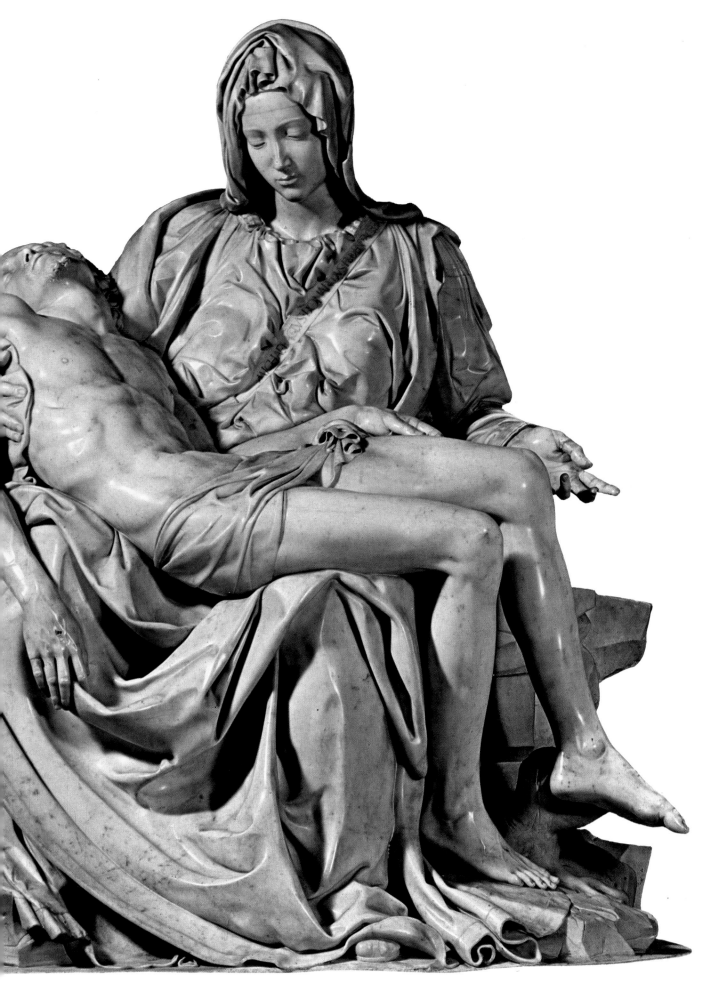

The Image
in Space

Sculpture, conceived and presented in three-dimensional form, seems to have a life and personality of its own. If it is well executed, a statue of a human being in a garden or of a god in a Central American jungle may have a startling vitality and physical presence. The toughness and solidity of most of the materials used give sculpture great powers of survival, and its physical permanence through the ages provides an invaluable record of our historical as well as artistic past.

The first sculptors produced charms people could carry for protection against evil forces and for attracting good fortune. One of the oldest known sculptured pieces, the 24,000-year-old "Venus" ivory fragment from Brassempouy, was probably a fertility amulet of a Paleolithic tribe living in what is now southern France.

Today statuettes of St Christopher, patron saint of travelers, are often carried in cars to protect the occupants. In Malta buses have small shrines at the front for the same purpose. Some Christians wear a model of the crucifix as an amulet to remind them of Christ's martyrdom.

It was not the evocation of human mortality that prompted Egyptian sculptors to make statues of the dead that were then buried with them. A sculptural likeness was believed to give the dead continuing *life* by protecting their souls. Later sculptors were not concerned with such magical considerations, though they did create statues of prominent people who had died. This was simply meant as a memorial to the individuals and their accomplishments. The Greeks and Romans, who laid the foundations for Western sculptural tradition, sought to stress human dignity, often at the expense of vitality. In the early 19th century the great German romantic philosopher and poet Johann Wolfgang von Goethe advised sculptors to "render the dignity of humanity within the compass of the human form and subordinate all nonhuman elements to it."

Sculptural art has largely concentrated on the human body. Sculptured horses, some splendidly vigorous, were added to ennoble the

ABOVE *Bartolomeo Colleoni*, a bronze equestrian statue commissioned in 1483 by the government of Venice. Verrocchio's innovation was to give the horse a sense of movement and the rider an impressive gaze that implies his position at the head of his troops.

human figures astride them, as in the famous statue of General Bartolomeo Colleoni, a great Italian warrior, in Venice. Yet a major function of this work by the Florentine Andrea del Verrocchio (1435–88) was clearly architectural, in that it was meant to be viewed along with the buildings surrounding it.

Sculpture had long been subordinated to architecture when the great Italian Renaissance sculptors Donatello (about 1386–1466) and Michelangelo set out to liberate it from the niches and sidelines to which it had been relegated. They produced sculptures that were three-dimensional forms occupying space in their own right. Donatello's bronze statue of David, the slayer of Goliath, was among the most important freestanding sculptures of the Renaissance. Michelangelo further developed the concept of sculpture as a mass in space with a succession of figures for tombs and monuments.

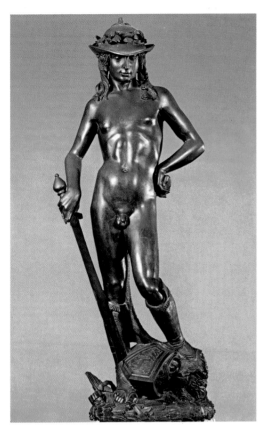

LEFT the *David* by Donatello, the first large-scale, free-standing nude statue of the Renaissance. Well proportioned and superbly poised, its air of harmonious calm gives it a classical feeling.

RIGHT *Family Group* by Henry Moore, one of his monumental sculptures set out of doors.

A century later Gianlorenzo Bernini (1598–1680) created the baroque style, characterized by passionate emotion and whirling drapery.

After the Renaissance the next striking advance in the art of sculpture was when the French sculptor Auguste Rodin, "taking his orders from nature," created realistic works from his raw material. He was not concerned with the strict anatomy of forms but with how they appeared to the human eye.

Henry Moore (born 1898), a leading British sculptor, exploits the sculptural concept of space when he "mentally visualizes a complex form from all round itself" and sees its volumes as "the space that the shape displaces in the air." He claims Aztec art as an influence. In the United States Alexander Calder carried sculptural movement into space with his *mobiles*, whose forms gyrate freely with air movements, thereby creating a constantly changing pattern.

RIGHT *Danaïdes* by Rodin, whose prime contribution to sculpture was a restatement of the sumptuous quality inherent in the human body.

Carving

In carving, sculptors systematically eliminate sections of their raw material until the form they have set out to make emerges. Stone, especially marble, is the classic material of the sculptor, but granite and basalt have been carved for centuries and were widely used by the Egyptians and Assyrians. Jade has been popular with Chinese sculptors. Wood and ivory have also been used since earliest times.

Sculptors normally choose the material at their disposal which best suits their purpose. The ancient Greeks used marble not only because it is relatively easy to work, but because its smooth surface and texture particularly suited their idealistic style. Marble is often used for human figures because its lustrous quality convincingly represents human flesh.

Most sculptors begin with sketches and then make plaster or wax models as a guide. Sculptors in stone often have assistants, and in recent

ABOVE carving of a Hittite king dating from the 8th century BC, from the Lion Gate at Malatya, now in Turkey.

LEFT Assyrian relief of the mythical Gilgamesh, half man and half god, who is the hero of a Babylonian epic poem. Found at Khorsabad in Mesopotamia, this massive figure is fashioned in the realistic manner typical of Assyria in the 8th century BC.

times some have employed masons to enlarge their completed sketches to the required scale. However, most work produced by this method has a dead, mechanical appearance.

Wood is infinitely softer and more perishable than stone. It lends itself to detail, but its grain creates problems of technique and expression. Wood splits and is liable to shrink, thus presenting constant hazards. Softwoods, from conifers, are easier to cut than hardwoods, which come from deciduous trees; but hardwoods, closer grained and more durable, can be worked into finer forms. Limewood and pearwood are both highly favored.

But no matter what kind of wood they are using, sculptors must have a precise image of the shape and form of the work they want to create before they do any cutting. Generally they draw an outline directly onto the wood. Once they begin cutting they must work carefully, not cutting too deeply. They must leave enough extra wood for the finishing details, since if they cut away too much they will be unable to complete the design.

Wood sculpture of astonishing intricacy was

carved for the churches and cathedrals of Europe. Veit Stoss (about 1447–1533) lived for most of his long life in Nuremberg, but for 12 years he worked in Poland on the great altarpiece above the High Altar of the Church of St Mary in Cracow. This masterwork, 39 feet high, illustrates scenes from the life of the Virgin Mary; the various panels possess a strong overall design while the individual figures are vividly characterized – tender or rough, ascetic or vigorous. The smaller panels and surrounding niches are all elaborately carved with foliage, smaller figures, architectural features, and angels in flight. The figures were then painted, like nearly all church statuary up to this time, although in some of his later work Stoss relied for his effects on the surface of the wood itself.

Ivory, which is actually scraped rather than carved, is often used as a sculptural medium. The statue of Zeus at Olympia, carved by the Greek sculptor Phidias (about 500–432 BC), was one of the original Seven Wonders of the World. The body was made of ivory and the draperies of gold, a type of work sometimes referred to as *chryselephantine*, and thin plates of these materials were bent and riveted to a wooden core. This colossal statue, which was 58 feet high, disappeared some time after the 2nd century AD. Ivory is more usually employed for delicate carvings, often in the form of plaques with figures shown in relief. Its texture is particularly suited for representing intricate foliage.

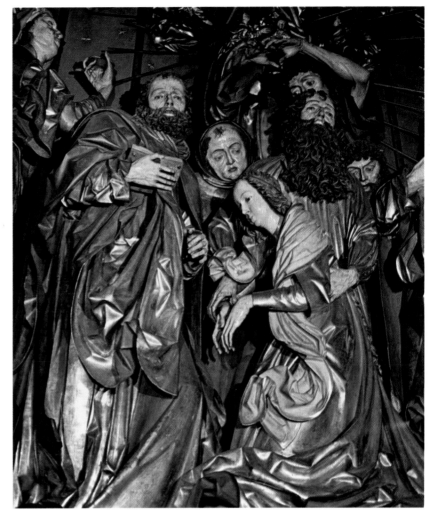

ABOVE detail from the altarpiece of St Mary's Church in Cracow (1477–89), carved by Veit Stoss in limewood and then painted. One of the greatest sculptors of 16th-century Germany, Stoss created a style based on nervous, angular forms carved in an unusually realistic manner.

LEFT carved figurine of a Canaanite girl made from solid ivory between the 14th and 12th century BC. It was found at Megiddo, south of Haifa in what is now Israel. The town is often identified with the biblical Armageddon.

RIGHT a Zapotec funerary urn dating from the 13th or 14th century. It is carved in the likeness of Cocijo, god of water and flowers, and was buried in a vault with the body as part of the ceremony performed by these Central American Indians.

Sculptors of hard materials need mallets, points, chisels, gouges of many different shapes and sizes, and a north light (so that the light varies as little as possible). As they pit themselves against stone "to liberate the subject," modern sculptors use traditional tools dating back centuries. They can also call on such relatively sophisticated aids as electric drills.

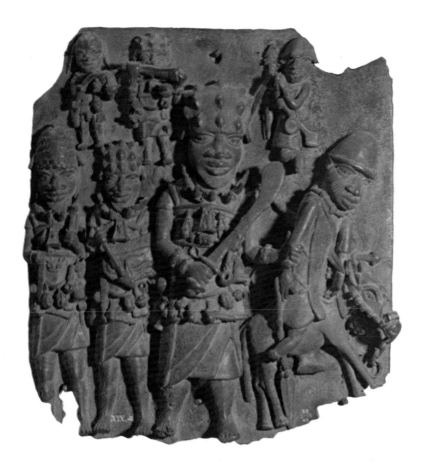

Modeling

While carvers create an image by cutting away from the material in which they are working, modelers produce their form by building up, applying and shaping materials into the images they have visualized. Clay or wax are the materials most widely used for modeling, and because they are flexible sculptors are able to invest their work with greater feeling, spontaneity, and movement than is often possible in carving. Modelers have the added advantage of being able to work and rework their material, adding or subtracting as they go along, until they have achieved a form which satisfies them.

The principal limitation of modeling lies in the fragility of the material. In the actual process of construction the work is both filled and stiffened by the use of a core of metal tubing, wood or wire called an *armature*. This is a framework in the general shape of the form to be made. Over it the clay is pressed, built upon, and finally

ABOVE warriors in bronze from a relief made in Benin, West Africa, a small kingdom that flourished from the 15th to the 18th century. The bronzes were first modeled in clay and then cast by a sophisticated technique developed by Benin's artists, who were highly regarded in their society.

ABOVE RIGHT delicate terra cotta figure of a horse from the T'ang dynasty (618–907 AD) of China. The clay would first have been molded and baked, then glazed and baked again.

shaped into the desired form. However, the sculpture will not last very long unless it is translated into a more durable material like bronze, lead or aluminum. By making a mold and taking a cast of it, an exact copy or replica of the original in hard and lasting metal can be obtained.

The process of casting is not easy and is now often done commercially. It can be carried out without affecting the original model, and a number of copies can be made from one original. The model is covered with a mold made from sand, clay or, most often, a thin paste mixture of plaster-of-Paris and water. The model must then be removed from the mold. Often the mold is made in sections, forming a *piece mold*. The sections are removed individually, the model

taken out, and the mold sections put back together again for casting. When the cast has set the mold is taken off.

One of the most popular materials for casting has long been bronze. When metal is used, however, the castings must be hollow or they are liable to crack easily. To make a hollow figure the mold is lined with wax, which is impermeable but melts when heated. The center space is filled with material like that of the mold. When heated, the wax runs out and molten metal is poured into the space between the mold and the center material.

Baking, in the sun or in a kiln, is another means of giving a measure of durability to an object modeled in clay. In the simplest technique the piece of modeled sculpture is exposed to the sun until it is hardened by the disappearance of all moisture. This is the means by which *terra cotta* (baked earth) pottery and

sculptures have been produced in all parts of the world since the days of primitive peoples. A Sumerian terra cotta statuette was found in Mesopotamia which dates from the 29th century BC. The legs are broken off below both knees but otherwise it is intact, even though it was made

with each arm separate from the body. Highly sophisticated figurines in terra cotta have survived from the 3rd century BC.

Sometimes products of this terra cotta process are glazed. A gaily colored glazed statuette of a woman, estimated to date from the 17th century BC, was found in Crete. Her ground-length skirt is shaped like a bell to give the figure durability.

The use of terra cotta declined during the Middle Ages, but it was revived as an important sculptural medium during the Renaissance. Verrocchio, the Florentine sculptor of the monumental equestrian statue of Colleoni, also fashioned a delightful child poised on a globe. The della Robbia family of Florence, of which the first and greatest was Luca (1400–1482), executed numerous popular sculptures in lead-

Stages in the creation of a bronze by Henry Moore entitled *Three-Way Piece No. 2: Archer* (1964).

RIGHT Stage 2, in which the first plaster is applied to a wooden armature. In Stage 1 the framework was labeled to show exactly where the plaster for the mold was to go.

RIGHT Stage 5, a working model of the finished sculpture in plaster. The previous two stages involved applying the plaster thickly to shape and then forming the smooth finish.

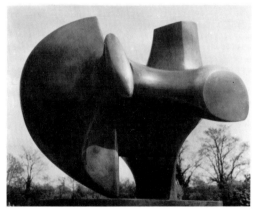

RIGHT the finished bronze set outdoors, the culmination of the sculptor's efforts and imagination. It stands 30.5 inches high and, though heavy, does not need an external prop.

LEFT Cretan statuette of a woman, possibly dating back to 1600 BC, excavated on the Greek island of Crete. It probably represents a Minoan snake goddess. The terra cotta figure gains stability from its triangular base.

glazed terra cotta.

The clay used for terra cotta must be firm enough to be modeled easily but at the same time loose enough to dry without warping or shrinking too much when baked. The clay must also be kept moist while it is modeled. Sculptors often wet their hands while working and keep damp cloths around the clay when it is put aside.

In the 18th century, age-old Chinese techniques were adopted in Europe to produce highly valued *porcelains*. Pottery and figurines in pure china clay were fired to the point of *vitrification*, or conversion into glass, and decorated with exquisite colors. Very fine ware came from the Meissen kilns on the Elbe river in East Germany, near Dresden, which became known worldwide as Dresden china.

Architecture and Sculpture

Sculpture has always added greatly to the beauty and expressiveness of architecture. Although sculpture was at one time subordinated to the dictates of architecture, sculpture as an art may be even older than architecture; its influence on the beginnings of architecture was very important.

The mystery of life and death brought forth the creation and use of magical images. People first housed these in the dark recesses of caves and later in tombs. Later still, solid monuments were built for religious veneration. First these were carved from the outside, but eventually people began to hollow them out so they could contain the revered images. Michelangelo once

RIGHT part of the façade of the ancient Hindu temple at Madurai, India, crowded with the sculptured figures of gods. They were meant to teach those who could not read.

BELOW the south porch of the Erichtheum, the temple begun about 420 BC on the Acropolis. Caryatids are sculptured female figures used as columns; in this case, two other porches have Ionic columns.

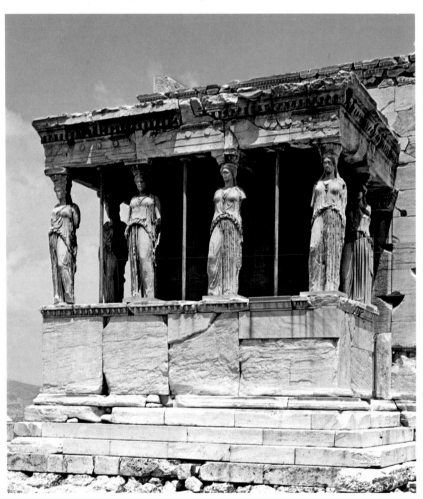

expressed a wish to carve an entire mountain into sculpture, and nowhere is this fundamental link between architecture and sculpture more clearly expressed than in ancient Indian and other Eastern temples. In the towering façades of some Indian temples Michelangelo's dream seems to have been realized, as the spectator's eye travels up past one densely filled level after another to the distant summit.

In ancient Greece space was built into temples, and statues of the gods, sometimes of colossal size, were enshrined within them. On the exterior of the building sculpture was generally restricted to covering the *metopes* (square spaces) around and on the *pediments*, triangular gables on the roof. Occasionally, as in the Erechtheum, last of the four great buildings to be built on the Acropolis in Athens, some of the columns would be replaced by giant figures known as *caryatids* that appear to bear the weight of the roof on their heads.

The full expression of architectural and sculptural unity inspired by religion is exemplified by Chartres Cathedral, 50 miles southwest of Paris, which was completed in the 12th century. On its façade alone 700 statues are integrated with the fabric of the stonework.

The combination of architecture and sculpture produced its own forms of sculptural composition. Because the pediments of such buildings as the Parthenon were triangular, the human figures in the angles at the base had to be reclining or sitting. For the medieval cathedral sculptors adapted their forms to the *tympanum* (arched panel between the door lintel and the arch above it), the *capitals* (tops) of columns, and the spaces where arches met or vaulting intersected. Such functional external structures as water spouts were fashioned into *gargoyles* in the shape of either grotesque mythological

creatures or likenesses of the people, from architects to masons, who had been involved in the building. There was often a strong element of caricature.

Apart from producing figures to fill niches upon buildings, the classical sculptor was often required to make narrative *friezes* by carving suitable horizontal spaces in order to tell a religious story. These were rendered in relief by cutting away the stone background so that the figures stood out. Both background and figures were vividly colored, as were many of the columns. The frieze of the Parthenon represented a procession in honor of the goddess Athena, whose gigantic image in ivory and gold was housed within the temple. Medieval sculptors carved scenes of religious narrative in relief

RIGHT the capital of a column in Southwell Minster in Nottingham, England, which was begun about 1110 and raised to the rank of cathedral in 1884.

LEFT statue of Ramses II (1292–25 BC) that once stood before one of the rock temples at Abu Simbel on the Nile. Four massive statues of the king, each 65 feet high, were discovered along with the temples in 1812. They have since been transported to higher ground so that the Aswan Dam could be built and the area flooded.

BELOW the highly decorated entranceway and front façade of the Old Town Hall in Bamberg, Bavaria.

characters in mythology or such abstractions as "the virtues." But often important historical figures and citizens who deserved special commemoration were included.

Sculpture and architecture are less closely associated in the modern age, and architects would be reluctant to include representations of human figures in their designs for a building. Abstract sculptural forms are sometimes used to break up what would otherwise be a plain wall space, but the most common association found today is when a piece of modern sculpture is set in the forecourt of a new building. The sculpture is often curvilinear to contrast with the strong verticals of the building behind it.

on church façades and choir screens inside the church.

During the Renaissance, sculpture was used much more extensively in secular architecture. In Germany and the Netherlands castles and civic buildings show a profusion of sculptural work that challenges the most ornate churches and cathedrals. Statuary associated with secular buildings was occasionally classical, portraying

Storytelling
in
Sculpture

The use of sculpture to deliver a message or tell a story is as old as the art itself. Symbols were incised on the walls and ceilings of the caves of primitive peoples. In Egyptian pyramids, which were in effect massive artificial burial mounds, the life story of the dead person was carved into the walls of his or her burial room. The Assyrians in the 8th century BC carved massive friezes showing famous victories in war. In the Parthenon are friezes that portray the rituals of Athenian festivals. Religious art through the centuries and secular art in more recent times have exploited sculpture for informative ends with eloquent effect.

The form of sculpture that lends itself particularly well to storytelling is continuous narrative relief. Sculptured forms of this kind are generally cut or inserted in the outer and inner walls of a building, but they have also been used on freestanding monuments like Central American *stelae*, carved monoliths of religious and historical value, which have only recently

ABOVE base of the throne of King Salmanassar III (858–24 BC), a relief depicting the king's soldiers preparing for war. It was found in the ancient city of Nimrud in what is now Iraq.

been deciphered and which have increased our knowledge of long-dead Mayan civilization.

Generally speaking, *relief* is achieved by cutting away parts of a flat surface or by building up on a flat background, so that figures remain in the foreground and at varying depths. The depth or shallowness of the carving determines whether the relief is *high* or *low* (*bas-relief*). In high relief figures and objects are often virtually detached from the background and become three-dimensional in form. *Incision*, another technique used on a flat surface, is simply carving into a surface without the effect of objects "standing out." This process was used extensively by the Egyptians in their funeral hieroglyphics and is still favored throughout the world for monumental inscriptions on tombstones.

A spectacular use of the freestanding form for narrative sculpture is in the marble group of the Laocoön, probably a Roman copy of an original Greek bronze of the late 2nd century BC. The Trojan priest Laocoön warned his fellow citizens not to bring the Greeks' wooden horse into the besieged city. The goddess Athena, who favored the Greeks, sent two snakes to entwine themselves around Laocoön and his two sons, killing all three. The agonized figures are shown in full detail along with the snakes and a background altar draped with a cloth. Their hopeless struggle is suggested in the different types of movement each figure expresses: the elder son has just been caught up, the father is still struggling, and the younger son

LEFT the marble group statue depicting the Laocoon, now in the Vatican Museum in Rome.

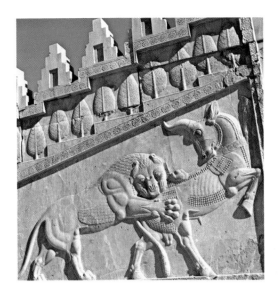

LEFT relief found in Persepolis, now in Iran, showing a lion attacking a unicorn. Many narrative scenes carved onto buildings or walls in ancient times were religious or mythological in nature.

BELOW RIGHT François Rude's *Departure of the Volunteers in 1792*, a complex work of action and patriotism that is part of the Arc de Triomphe.

BELOW altarpiece of the Church of St Ulrich (built between 1475 and 1604) in Augsburg, Bavaria, for which the sculptor created a nativity scene.

is collapsing. Three stages of a single experience have been shown within the one group.

Narrative sculpture in which movement is involved calls for the arrangement of limbs and torsos to suggest flight, elation, dance or obei-

sance as needed to emphasize the action. Trajan's Column, erected in 113 AD to commemorate the war victories of the Roman emperor Trajan, is packed with military action. François Rude (1784–1855), the most vigorous sculptural interpreter of the Napoleonic era, created his major work on this theme; the relief called *The Departure of the Volunteers in 1792* (also known as *The Marseillaise*) is part of the Arc de Triomphe in Paris. The volunteers referred to were for the Revolutionary campaign of 1792, but Rude's intention was to glorify the various Napoleonic campaigns of the early 19th century.

Crowded scenes with rather less emotional effect adorn many secular monuments and buildings dating from the Renaissance until after the turn of the 20th century. The intention was not so much to decorate as to describe the achievements of kings, soldiers or politicians. After World War I narrative war memorials proliferated, but few memorable works resulted.

During the 1930s, when the government of

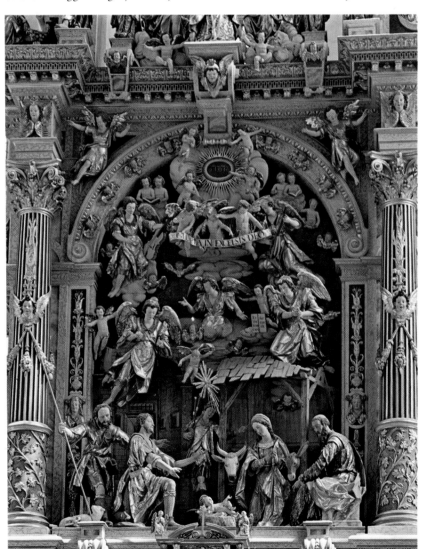

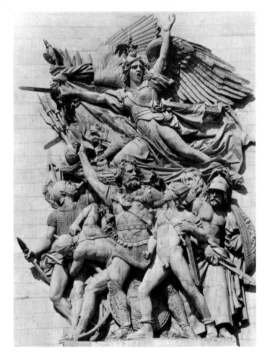

the United States commissioned a considerable amount of architectural sculpture as part of a public works program to aid the unemployed of the Depression, many public buildings were decorated with reliefs illustrating various trades and industries or telling stories of local history. Modern sculptors have been more interested in experimenting with new forms, materials, and shapes and the way they occupy space than with depicting stories or events. Sculpture as a means of storytelling appears to have gone out of fashion, if only temporarily.

The Greek Spirit

The Greek traveler and writer Lucian, writing in the 2nd century AD of his visit to the ancient city of Cnidus on the southwest coast of Turkey, described the extraordinary beauty of the statue at the town's famous shrine of Aphrodite in tones of mixed awe and delight. The great Athenian sculptor Praxiteles, working in the 4th century BC, had shown the naked goddess leaning forward about to step into a ritual bath; in her left hand she holds the garment she has just taken from her shoulders. So desirable did the goddess of love look in her small shrine, surrounded by vines heavy with grapes, that Lucian leaped onto her pedestal and flung his arms around her neck. The attendant was only mildly shocked.

The beauty and naturalism of Greek statues is their most notable feature. After many centuries of rigidly stylized statuary produced by the Egyptian and Assyrian civilizations, the early Greek statues of around 500 BC give a feeling of life stirring within the stone for the first time. A rare survivor from this early period is the so-called Apollo of Piombino, a bronze now in the Louvre in Paris. He faces us with shoulders squared and his weight evenly distributed, one foot slightly in front of the other.

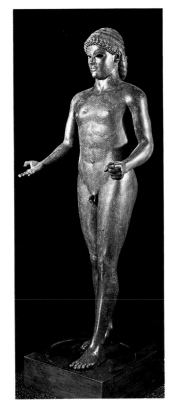

ABOVE the Apollo of Piombino, dating from the 5th century BC.

BELOW the remaining forms of the famous sculpture of three goddesses that was designed to fill the triangular pediment of the Parthenon, shrine of Athens' patron Athena.

He is definitely human, but there is still something formal about his stance. The great change actually came when sculptors first brought rhythm to their statues of the human body. This was done by means of two stylistic alterations that might seem obvious today but then had never been tried before: the head was slightly turned and the weight of the body was unevenly distributed between the legs. These two techniques, particularly the second, were responsible for an altogether freer arrangement of the body. Suddenly, within a matter of a generation, one can sense that a skeleton supports the body and muscles shape the limbs.

The first Greek sculptor of whom anything personal is known is Polyclitus in the 5th century BC, who said, "A well-made work is the result of numerous calculations, carried to within a hair's breadth." He worked out a system of deducing the ideal proportions of human bodies. He also perfected ways of positioning the limbs and balancing the lines of the hips and shoulders in a pose so as to suggest that the figure had been arrested in the process of moving.

It was said of Polyclitus that he could create the likeness of a perfect man but could not create the likeness of a god. This latter ability belonged to his contemporary Phidias, who produced a colossal seated Zeus for the temple at Olympia and a 38-foot-high gold and ivory statue of Athena for the Parthenon. These have survived only as copies, but the originals – six times greater than life size, gleaming with gold, and adorned with jewels and colored stones – must have possessed an overwhelming power. The white plaster casts and lifeless Roman copies that fill the museums of Europe cannot help but give a false impression of what Greek statues really were like. The Aphrodite of Cnidus that so aroused Lucian was exquisitely painted; indeed, it was because of this that no casts of it were taken, for fear of damaging the delicate paintwork. As a result, none of the versions that have survived can help us to share Lucian's

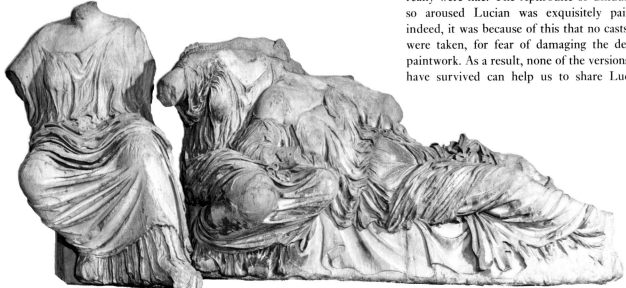

excitement. One statue that has come down to us intact gives some idea of what the ancient Greeks produced for their cities and temples – the Charioteer of Delphi. Hundreds of similar statues were erected to winners of the Olympic Games in the precincts of the great temple at Delphi. The bronze Charioteer dates from about 480 BC. The hair and lips are slightly gilded, giving an added sense of life to the face, and the eyes are marked with colored stones. It is a statue of exceptional harmony and grace.

The Aphrodite of Cnidus was the work of the last great Greek sculptor whose name we know, and it influenced a host of imitations. Their arms were held in various attitudes – sometimes across their breasts in an affected modesty. But all adopted Praxiteles' uneven hip position, giving a seductive curve to the female human figure. The last famous sculpture to survive from ancient Greece, a statue of Venus (Aphrodite) discovered on the island of Milos in the Cyclades north of Crete, had this same characteristic in addition to one new one. Her unknown sculptor has shown her with a loose garment slipping off her hips. This gave a strong base, thus doing away

RIGHT perhaps the world's best-known sculpture, the Venus de Milo, found on the tiny Greek island of Milos. The marble figure dates from about 200 BC and was only discovered in 1820.

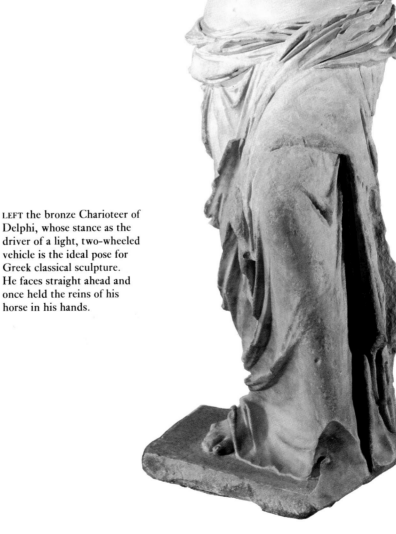

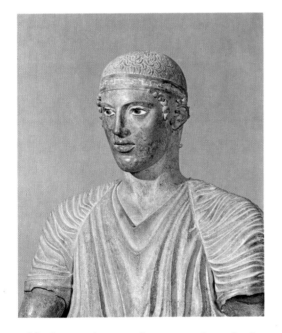

LEFT the bronze Charioteer of Delphi, whose stance as the driver of a light, two-wheeled vehicle is the ideal pose for Greek classical sculpture. He faces straight ahead and once held the reins of his horse in his hands.

with the previous need to strengthen slender legs with a supporting urn or tree.

What we now refer to as the Greek spirit flourished for about 200 years until the death of Alexander the Great, who conquered all of Greece, in 323 BC. It was an attitude of mind in which tradition was questioned, the natural world was investigated, and people sought to represent life as it truly was (though often it was idealized). In the succeeding centuries this spirit died away, and 1500 years would pass before Europe saw its like again.

the sequence of biblical scenes could both "feel" the emotional content and express it vigorously.

The elongated statues of the cathedral at Chartres were completed by about 1200, and in the course of the next century sculptors turned to natural forms other than the human figure. No longer content to decorate arches and columns with geometric patterns, they studied the shapes of leaves, flowers, and fruit. Abbeys and cathedrals throughout Europe began to sprout foliage carved with astonishing skill and intricacy.

The man recognized as the "father" of modern sculpture – as distinguished from ancient classical sculpture – is Niccolò Pisano (1220–84), who executed many works in his hometown of Pisa and neighboring centers such as Lucca, Perugia, and Siena. By studying the Roman sarcophagi and other classical fragments that had been accumulated in Pisa, he was able to bring to his own crowded marble scenes a rediscovered sensitivity for the dignity and realism of late Roman sculpture. His works mark the apex of the style known as Romanesque.

Art was beginning to wake from its long

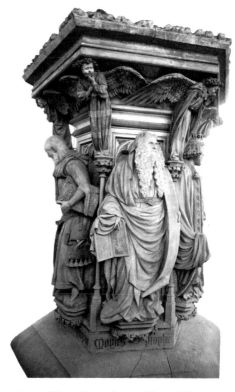

The Age of Saints

After the collapse of the Roman empire, life in Western and northern Europe was far too uncertain for most of the arts to flourish. But in monasteries and royal palaces small sculptured objects, often in ivory, have survived to show that not all the forms and styles of the past were lost. Images of Hercules were adapted to become images of Samson – one pagan strong man turned into another, from the Old Testament.

By about the year 1000 conditions had sufficiently stabilized for the building of the great stone cathedrals of the Middle Ages. One of the earliest was at Pisa in northwestern Italy, at that time one of the wealthiest cities of Europe. The façade was decorated with sculptured columns, and the spur this building gave to craftsmen in neighboring towns led to the erection of sculptured façades in nearby Lucca, Modena, Parma, and elsewhere. The bronze cathedral doors created for Abbot Bernward in the north German town of Hildesheim about the year 1010 prove that the craftsmen who worked on

ABOVE the beautifully proportioned façade of the cathedral at Pisa. Built of black and white marble, it dates from the late 12th century. The basic unit, an arch of fixed width and (except for the topmost story) fixed height, sets a rhythmic pattern of arcades.

RIGHT the *Well of Moses* by Claus Sluter, with the figure of Moses as a wise, bearded patriarch.

slumber. The Dutch-born Claus Sluter, who worked for Philip the Bold, Duke of Burgundy, at Dijon in France between 1385 and 1400, carved six life-size prophets to ornament the base of his masterpiece, a fountain called the *Well of Moses*. The sharply characterized poses and features of these bearded figures are exceptional for the age.

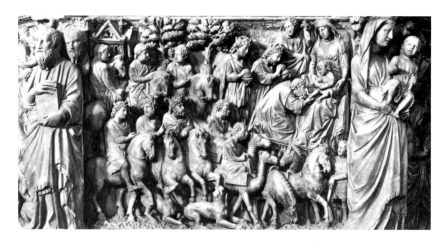

work was considered to have surpassed that of his predecessor, and he had scarcely completed the first set before he set to work on yet another pair of doors for the baptistry. This third set, with scenes from the Old Testament, occupied him for a further 27 years until three years before his death. These doors, later described by Michelangelo as worthy of the Gates of Paradise,

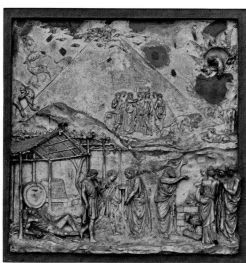

In 1401 the citizens of Florence announced a competition for a pair of bronze doors for their baptistry. It was eventually won by Lorenzo Ghiberti (1378-1455), then only 25 years old, and for the next 19 years he devoted himself to designing, casting, and gilding the doors' 28 separate panels illustrating events from the New Testament. He closely followed the scheme developed in a previous pair of bronze doors made by Andrea Pisano a century before. His

ABOVE detail from the pulpit of Siena Cathedral, *Adoration of the Magi: Virgin and Child* (1265-8) by Niccolò Pisano.

RIGHT panel showing Noah and the Ark (detail of the Baptistery doors shown below).

BELOW top eight panels of the "Gates of Paradise," the final pair of doors by Ghiberti.

were a sensational advance on any contemporary sculpture. Their ten panels were, according to Ghiberti himself, "each framed so that the eye measures them from a distance and they appear in relief." The panels themselves are conceived with an extraordinary sense of depth. The naked figure of Eve rising from the side of the sleeping Adam was the most beautiful nude created for a thousand years. As the years passed and Ghiberti's skill and knowledge increased, he tackled more and more difficult compositions, such as his scene of Joseph in Egypt in which a round temple is shown in accurate perspective.

Ghiberti provides the link between Gothic art and a newer style influenced by careful study of the art of Rome and Greece. Ancient statues were being unearthed from fields and vineyards where they had lain since the fall of Rome a thousand years before. It was after he had studied such statues that Donatello, who had worked in Ghiberti's workshop, produced his astonishing bronze figure of *David* as a youthful nude. Some of his contemporaries criticized him for giving his saints and heroes the bodies and faces of ordinary Italian peasants. So very life-like were they that he is said to have muttered while working on them, "Speak, damn you, speak." The achievement of this degree of imaginative power and technical skill led people to hope that the scope and greatness of classical art had returned, and they began to talk of a *Renaissance*, a rebirth, of cultural aspiration.

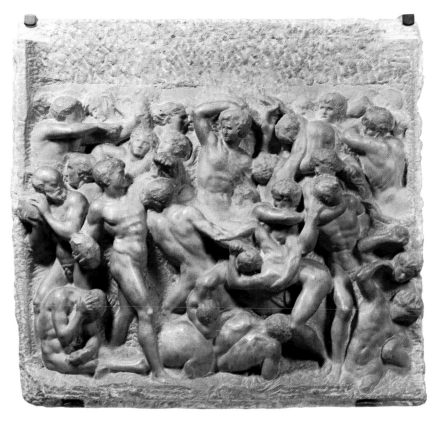

popular artistic subjects of this time was a battle between naked men: energy, exultation, pain, and despair could all be shown in the rendering of struggling bodies. Michelangelo's venture into this field was his relief called *Battle of the Centaurs*, carved when he was 17 years old. The impression of human figures emerging from their imprisoning stone is characteristic of much of his later work, and the figures of his centaurs (half horse, half man) throb with vigor. In this can be seen early versions of many of the heroic figures that appear in his later work, and in fact Michelangelo was so fond of this particular work that he kept it with him all his life.

When he was 20 he went to Rome and there carved a superb *Pietà* for St Peter's Basilica. This depiction of the Virgin Mary mourning the body of the dead Christ triumphantly solved the problem of sculpting a grown man stretched over a woman's lap by containing both figures within a pyramidal shape. Michelangelo was sufficiently proud of this work to carve his name on the ribbon of the Virgin's gown. This sculpture made his reputation, and it was as a famous young man still in his 20s that he re-

Michelangelo
1475 - 1564

Painter, architect, poet – Michelangelo Buonarroti was all of these, but first and foremost he was a sculptor. And he was a genius, outstanding even among the generation of geniuses that flourished in the last years of the 15th and first part of the 16th century. He was born near Florence at a time when the powerful Medici family was master of the city. As a child he was obsessed by drawing, and he was only 15 when he was summoned to become a member of the sumptuous Medici household of Lorenzo the Magnificent. Day after day he studied and copied the works of the old masters, particularly the sculptures, and soon he had mastered the antique style well enough to pass off his own work as theirs. A life-sized marble ·*Sleeping Cupid* was taken to Rome, buried in a vineyard, and then dug up again and sold to a cardinal as a genuine antique.

But Michelangelo desired not merely to equal but to surpass his predecessors. One of the most

ABOVE *Battle of the Centaurs and Lapiti*, a vigorous relief that remained Michelangelo's private possession all his life and is now in the Casa Buonarroti in Florence.

RIGHT statue of Moses, the only significant result of the vast project for a tomb for Pope Julius II. Housed now in a modest chapel within the Church of San Pietro in Vincoli, the 19th-century English novelist William Makepeace Thackeray saw it there and claimed that he would not wish to be left alone with it. The curious horns are generally accepted as symbols of light rays derived from primitive art.

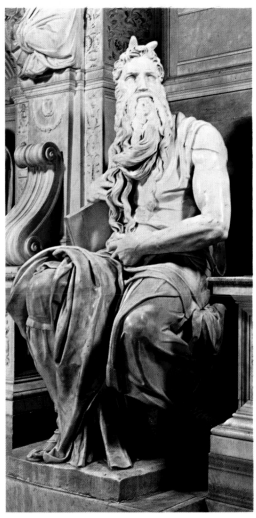

turned to Florence to take over an 18-foot-high block of marble that had been badly hacked and abandoned by another sculptor. From this awkward material Michelangelo carved in 1504 one of the most impressive and masterful of all sculptures, his *David*. In the grace, vitality, and easy power of this statue Michelangelo fulfilled and surpassed all the aims of the sculptors of ancient Greece. Some parts of the body are very detailed, while others are quite simple. The hands show veins and tendons and the nose, eyes, and mouth are boldly marked. Since the figure is much larger than life, the emphatic facial expression looks realistic from the ground.

With this statue Michelangelo became the most famous artist in Italy. The warrior Pope Julius II summoned him to Rome and persuaded the 30-year-old sculptor to design his tomb. The plans for this monumental project, initially conceived as the eighth wonder of the world, were to be constantly revised and would suffer repeated interruptions by, among other work, the four years spent on the frescoes of the Sistine Chapel. Many years later he was to say despairingly, "I find I have wasted all my youth

ABOVE detail of a painting of Michelangelo, long assumed to be a self-portrait but actually the work of a contemporary. It is the only likeness for which he ever agreed to sit.

and manhood tied down to this tomb."

As he grew older his works were increasingly given the description *terribilità*, an untranslatable word meaning something like "awesome mightiness." There was something alarming about the desperate energy of his creations, an unease increased by their sexual ambiguity. The musculature of some of the female figures and the rounded shapes of many of the male nudes generate a tension that is a significant element in their power. In his last work, the unfinished *Ronandini Pietà*, now in Milan, the body and limbs of the dead Christ merge with those of his mother. And in the four reclining statues (*Day*, *Night*, *Dawn*, and *Dusk*) that flank the two tombs in the Medici Chapel, the figures have not fully emerged from their womb of stone.

Michelangelo lived to the great age of 89; even then, he claimed in his deathbed confession that "I die just as I am beginning to learn the alphabet of my profession." But his inexhaustible invention, the vigorous yet graceful attitudes of his figures, and the emotional intensity with which he endowed them have established him as perhaps the world's greatest sculptor.

BELOW the *Ronandini Pietà*, on which Michelangelo worked almost to his dying day in a return to "sweet sculpture" from his other activities of painting, architecture, and poetry. It also marked his return to the theme of the descent from the Cross, the pathos of which had attracted him throughout his long and productive life.

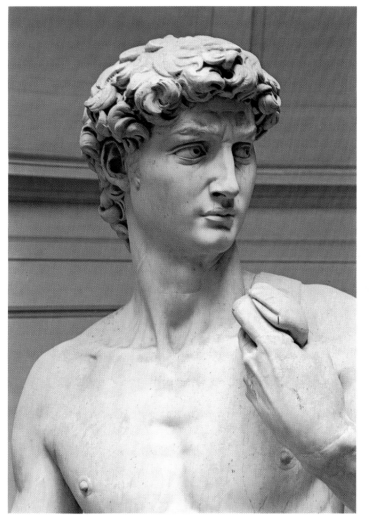

RIGHT the marble *David*, begun in 1501 and completed three years later. Florentines hailed it as "the Giant" and considered it an allegory of the moral strength of their democracy. Michelangelo's characteristic glorification of the male nude, partly a result of his long study of anatomy, was also due to his platonic belief that the body was the "veil" through which God revealed himself.

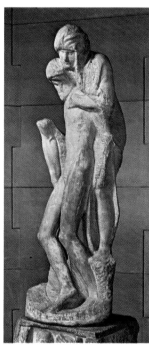

Gianlorenzo Bernini

1598 - 1680

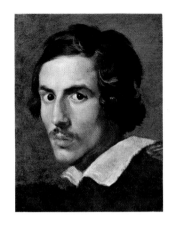

After Michelangelo's death his immediate successors hoped to show that the master's departure had not brought the art of sculpture to a full stop. They continued to sculpt in his style, which they exaggerated with frenzied distortions and gaping mouths; this excessive style came to be known as *mannerism*. Half a century passed before a worthy successor appeared on the scene, this time from Naples, in the person of a child prodigy named Gianlorenzo Bernini. At the age of 15 he was receiving commissions from Cardinal Scipione Borghese, an insatiable collector of antique and new sculpture and a member of the reigning papal family. The young Bernini is said to have held his leg in the fire on one occasion in order to observe his own expression of pain. Whether or not this is true, it is typical

ABOVE self-portrait as a young man. Bernini was the greatest sculptor of the 17th century and one of its outstanding architects, but he was also a dramatist, stage designer, painter, and courtier.

RIGHT Bernini's *David* (1623-4). It combines the sculptor's undoubted talent for representing natural facial expression with his wish to involve the spectator in the action.

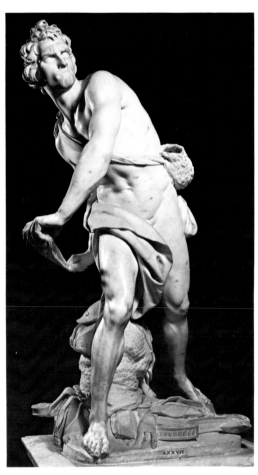

of his constant observation and experimentation to discover realistically apt expressions.

Under the cardinal's enlightened patronage in Rome, Bernini carved his first full-size standing figures in a dazzling series, of which the last three represented an artistic revolution. He chose to carve each of his subjects at the most dramatic point in their stories – Persephone is just being carried off to hell by Pluto; Daphne, chased by Apollo, is actually turning into a laurel tree before our eyes; and David (unlike Michelangelo's, watchful but still) is about to let fly with his sling. The whirling drapes and flailing arms of mannerist sculpture had tended to entice a spectator around and around a statue, but Bernini wanted people to see his work from the front. And though his figures also violently wave their arms, plunge their tridents, and even turn into branches, their crises are meant to be looked at from a single viewpoint.

As spectators look at the figure of David, who is biting his lips in wrath and concentration, they slowly come to realize that Goliath must be somewhere behind them and that the stone will be projected above their heads. Bernini was moving toward relating sculpture to the space around it, to the space in which the spectator moves. This would eventually lead him to the

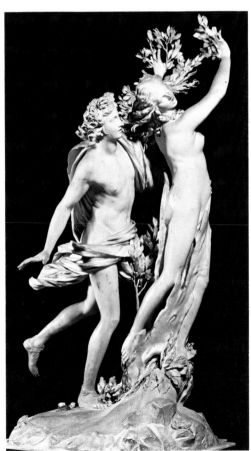

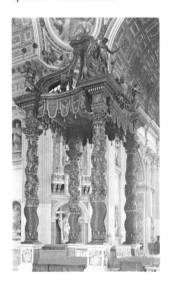

ABOVE the baldachin above the high altar that Bernini designed for St Peter's, Rome. It was an unprecedented fusion of sculpture and architecture.

LEFT *Apollo and Daphne* (1622-4), a hallucinatory vision of the physical transformation of a woman into a laurel tree, based on a Greek myth.

baroque, a style of art that brought together sculpture, architecture, and painting in order to affect the emotions of the spectator. Already he was regretting the absence of color in the marbles he used. Later he was to combine colored marbles, bronze, and gilded wood to achieve the effects he wanted.

He next turned, in 1624, to a more public work, decorating the interior of the recently finished St Peter's Basilica in Rome. His first commission, the most immediately striking feature of the tomb's superstructure, was the grand gilt-bronze baldachin above the high altar. This lofty edifice – as high as a four-story building, with vine-covered spiral columns, bronze banners, and airy canopy – took ten years to construct. The entire monument is studded with bees and suns, emblems of the Barberini papal family. When they ran short of bronze, Pope Urban VIII ordered that the bronze beams from the Pantheon, the sole surviving building from ancient Rome, be removed and melted down, thus provoking the Roman quip, "What the barbarians didn't do, the Barberini did." But the result is magnificent; it is the perfect object for its august setting, and the baldachin became the first truly baroque monument.

Bernini also adorned the streets of Rome with a number of its most delightful fountains. The most spectacular is the Fountain of the Four Rivers in the Piazza Navona, where four streams, each guarded by an appropriate mythological figure, flow from a hollowed-out rock above which rises, amazingly, a lofty Egyptian obelisk. But in later years he closed the shutters of his carriage as he passed by this work of his middle age. Always a devout Catholic, he became increasingly somber as he grew older. Fountains were a trivial matter compared to the ecstatic saints and church interiors of his last years.

He believed with the Catholic church of his day, inspired by the principles of the Counter Reformation, that religious art should be used to sweep people off their feet into faith through appeals to their emotions. Nowhere is this idea more powerfully demonstrated than in the Cornaro Chapel of the Church of Santa Maria della Vittoria in Rome, where the space above the altar is entirely filled by that masterpiece of the high baroque, *The Ecstasy of St Teresa*. In her own description of her life the Spanish mystic recounted a vision in which a beautiful angel came down from heaven and plunged a fiery golden arrow of divine love into her heart. Bernini gives us this moment: the saint's body swoons back yet leans forward, her whirling dress contrasting with the clinging drapery of

her unearthly visitor. The setting, too, is highly theatrical – heavenly rays descend from above – and it is illuminated by concealed lighting.

Baroque art never found a great deal of favor in northern Europe. Bernini's achievement influenced church art in southern Germany throughout the 18th century, but only in the present century has his work been reassessed and Bernini been restored to his rightful position as one of the greatest of sculptors – a master of movement and dramatic effect.

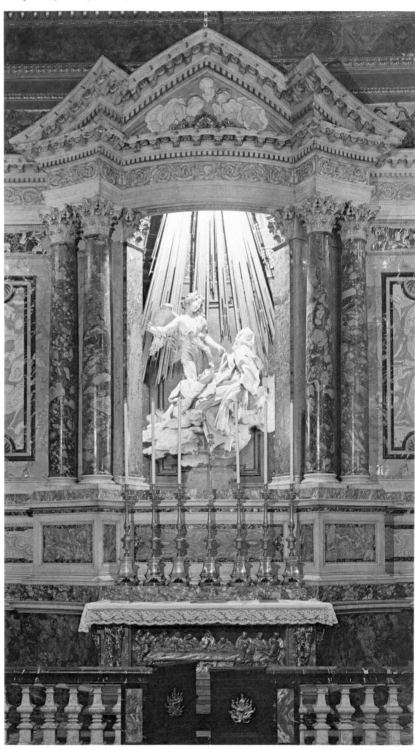

Auguste Rodin

1840-1917

Some artists seem to need to burden themselves, willingly or not, with a large commission so beset with difficulties, yet inspiring such fruitful ideas, that completion of the work occupies them for much of their lives. In the year 1880 Auguste Rodin was 40 years old. His fame had begun to spread only in the two years before. Yet in that year he was commissioned to create a pair of bronze doors for the future Musée des Arts Decoratifs in Paris. Rodin called them the *Gates of Hell*; they were to inspire some of his most famous images, but at his death nearly 40 years later the project was unfinished – and unfinishable.

As a child he had been a poor scholar. His only wish had been to draw until one day at the Petit École in Paris, where he was studying design. He chanced to enter the room where pupils were modeling in clay, constructing molds, and making plaster casts. "I saw clay for the first time," he later wrote, "and I felt as if I were ascending into heaven."

It was a revelation to him, but many years were to pass before he would be in a position to produce the work he wanted. For 20 years he labored at menial tasks for fashionable sculptors, and not until he was 35 could he afford a visit to Italy. In Florence he was overwhelmed by the statues of Michelangelo, in particular those of the nude males *Night* and *Dusk* in the Medici Chapel, figures only partly emerged from the rough-hewn marble.

On his return from Italy he completed a statue of a young soldier called *The Age of Bronze* and submitted it to the Paris Salon in 1877. It was his first accepted work, but due to its realism rumors spread that he must have cast it from a living model. Rodin was indignant, holding along with most of his contemporaries that to cast from life was a shameful practice. In fact, while 19th-century sculptors covered every possible surface of every new building with allegorical groups of one sort or another, the artistic standards of sculpture had never been lower. The judges of the Salon recognized that Rodin's soldier was more vital than the works of his contemporaries, but instead of seeing in

this the early stirrings of a genius they turned to thoughts of cheating. Rodin was eventually vindicated, and due to the scandal his name was brought to the fore. But this was also an indication of the reaction much of his future work would receive.

The *Gates of Hell* fired Rodin with enthusiasm. His first ideas were inspired by the 15th-century sculptor Lorenzo Ghiberti's *Gates of Paradise* (see page 127). Rodin decided to cover his gates with images of despair and suffering. He worked in a frenzy of creation, but the images soon overflowed their frames; a host of souls in torment crammed every corner of the great doors until the effect became chaotic. One of Rodin's achievements was to bring back into sculpture a

BELOW the *Gates of Hell*, a title Rodin took from Dante's *Divine Comedy*: "Abandon hope, all ye who enter here."

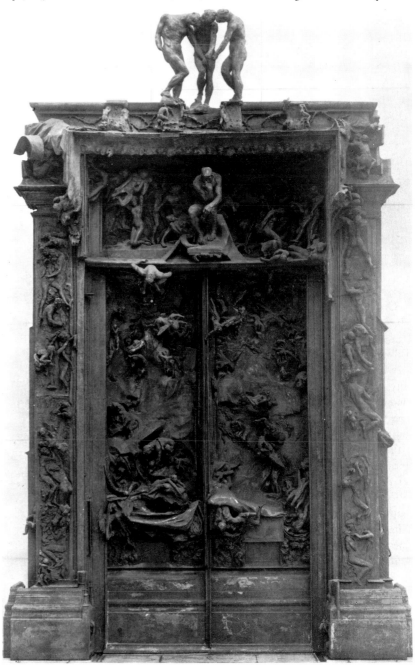

sensitivity to mass, volume, and the interplay of hollows and protuberances, but his vast conception of the *Gates of Hell* was a failure. Incapable of coordinating his teeming figures of the damned, Rodin cast many of them separately, and in this form they achieved world fame. *The Thinker* (1880) is one of these, originally intended to be placed immediately above the doors as a seated portrait of Dante, where it would seem to brood over the fate of those below. Seen separately, Rodin's bold treatment of the material can be appreciated. *The Three Shades* is another group from the *Gates*, in which Rodin had the astonishing and supremely successful idea of casting the *same* figure three times and placing the pieces so that

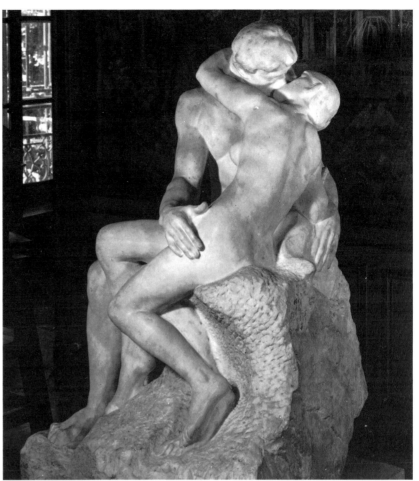

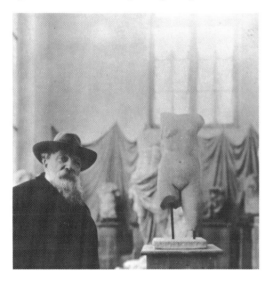

they face left, front, and right.

One of his undoubted masterpieces is the *Burghers of Calais*, a monument to commemorate those who offered themselves as hostages to Edward III of England in 1347 to persuade him to raise a year-long siege of their famine-ravaged city. Rodin imagined the emotional state of the doomed men, their uncertainty and despair, and charged the group of six figures with supreme dignity and pathos. For nine years the municipality of Calais refused to accept such a "demeaning" statue of their heroes. Rodin's statue of the mighty French novelist Balzac was also rejected for some time by critics, who failed to appreciate that the figure's huge robe, engulfing him from neck to toe, threw into greater prominence his determined, titanic head and was not some sort of trick to cheat the viewer.

Rodin was to be the last sculptor of greatness in an artistic tradition that stretched back 3000 years. Already by the time of his death during World War I sculptors were following other guidelines, and the human figure was no longer the prime subject and index of art.

LEFT Rodin in the workshop at Meudon, a residence he bought in 1896.

BELOW the *Burghers of Calais* (1886). A bronze cast of the work is outside the Houses of Parliament in London.

ABOVE *The Kiss* (1886), most sensuous of the many passionate couples that make up a great proportion of Rodin's output. Originally conceived as Paolo and Francesca for the *Gates of Hell*, it is sometimes considered his masterpiece.

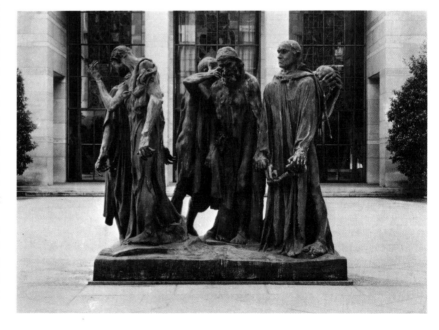

Constantin Brancusi

1876-1957

The pioneer of modern sculpture was a peasant from a remote village in Romania. Constantin Brancusi worked as a shepherd in the Carpathian Mountains from the age of seven. He learned the peasant craft of carving in wood, and even after he began work in a dyer's at nine his interest in wood carving never waned. When he was 18 a local industrialist was struck by his ability and entered him in the local school of arts and crafts. From the age of 20 he earned his keep as a wood-carver, but his ambition was to be a sculptor and he was eventually admitted to a school of fine arts in Bucharest. In 1903 he received his first commission and also became interested in the work of Rodin. He decided to see the originals for himself. He traveled to Munich and later walked the rest of the way to Paris, where he lived for some years in considerable poverty. Rodin took an interest in his work, but Brancusi declined the older man's invitation to become his assistant, explaining that "one can do nothing beneath great trees."

Even so, Rodin's influence is evident in the first version of the *Sleeping Muse* of 1908, in which the features of a woman's face suggest an unformed block of marble. By 1910, however, he

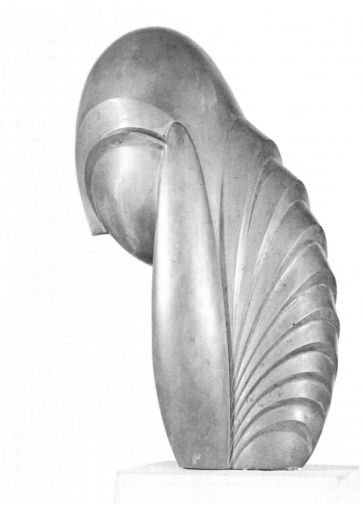

ABOVE *Mademoiselle Pogany III* (1933). The first version of this bust was exhibited in 1913, and ever more schematized variations culminated in this one.

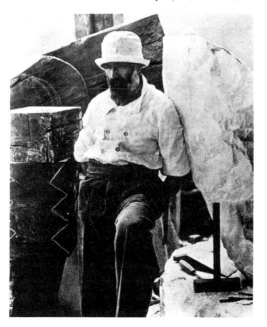

LEFT photograph of Brancusi taken in his studio about 1920-22. According to Henry Moore, "It has been Brancusi's special mission to make us once more shape-conscious. To do this he has had to concentrate on very simple direct shapes, to keep sculpture, as it were, one-cylindered."

had refined this image to an egg shape faintly marked with features. The resting head of a child in *The New-Born* (1915), a more spherical form, underwent the same gradual refinement as the line of the nose, the ridge of the ear, and the slight slit of the mouth all became progressively shallower. What Brancusi dared to do was reduce an image to the simplest possible form in which it could still retain a connection with the idea that initiated it.

Following this principle, he created the image of a fish that was no more than a fine, bladelike fin. A bust of *Mademoiselle Pogany* began as the round head of a young woman with large eyes (the lids seemingly closed) resting her hands against one cheek. Over 20 years the shapes were reduced to their essence, evoking a mysteriously hooded presence.

The passage of half a century has made us familiar with art "abstracted" from the forms of nature. But in the years before World War I, even though cubism was already shifting the guidelines of art, Brancusi was venturing where no sculptor had been before.

Brancusi polished the sculptures he cast in

metal, usually bronze, to a very high degree as though to remove all suggestion that they had been made by human hands. They have the gleaming finish of machine-made products, and this plays a considerable part in the image one actually sees. *The Beginning of the World* (1924) is in the shape of a perfect marble egg, placed in the center of a circular metal disk. The disk is an essential part of the composition, because in its mirrorlike surface the egg is reflected in different patterns and densities of shadow. Brancusi called this work "sculpture for a blind man," and it may be his most representative and accomplished piece.

Brancusi concentrated on a relatively small number of images, repeating and refining them in different materials over many years. He also regularly returned to working in wood. His first version of *Torso of a Young Man*, sculpted in 1922, was the upturned trunk of a Y-forked tree. This image in the form of a cylindrical trunk resting on two sawn-off legs was later transferred virtually unaltered to a work of polished bronze. As a male torso it may have had no genitals, but a more frankly phallic image can scarcely be imagined.

Possibly his masterpiece – or masterpieces, since he produced 29 different versions between 1912 and 1940 – is his *Bird in Space*. Beginning with the marble figure of *Maiastra*, a miraculous bird of Romanian folklore, Brancusi turned it into a leaping flame. Anatomically this slender

RIGHT *Bird in Space*, one of the later versions of the work that may be Brancusi's most characteristic. It is just 5.25 inches thick and over four feet high on its pedestal.

BELOW Brancusi's studio in 1925. Above all he loved carving itself, which required, he said, "a confrontation without mercy between the artist and his materials." He always constructed the base of a work himself and even built his own furniture, including his bed and his pipe.

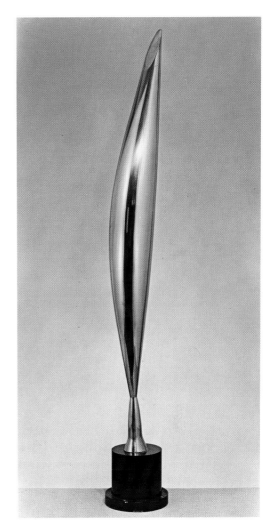

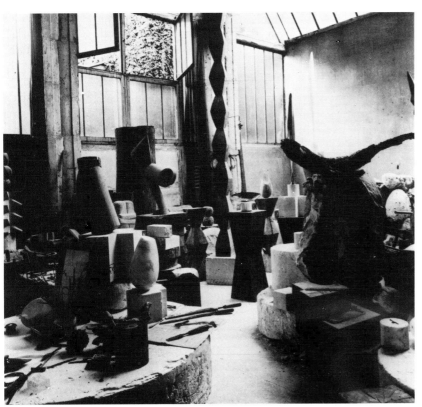

curving shape of polished bronze is nothing like a bird, yet no other sculpture has caught and conveyed so well the very essence of flight. This work became the subject of a two-year legal battle when Brancusi sent it to New York in 1926 for exhibition. Customs officials in the United States, seeing in it some resemblance to a propeller blade, refused to accept that it was a sculpture, and Brancusi was accused of trying to smuggle in an industrial part. He eventually won his court case.

In 1937–8 he returned to Romania for the unveiling of a new steel version 100 feet high of the *Endless Column*, first carved in wood in 1918. Inspired by the pillars of Romanian peasant houses, this work expressed the need for spiritual elevation with which Brancusi was always preoccupied.

Brancusi is a seminal figure in modern sculpture because he led the way for a whole generation of artists who were trying to free themselves of having to represent specific and recognizable subjects. His work embodies their search for an ever more perfect synthesis of pure abstraction and the essence of form.

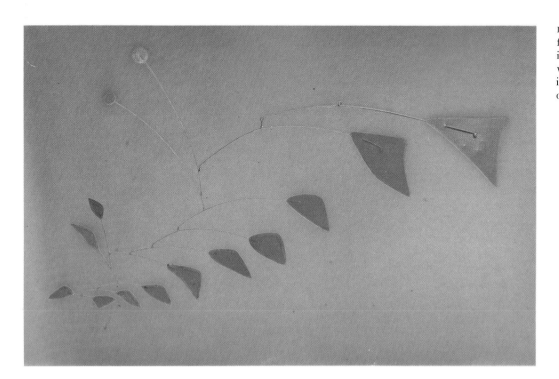

LEFT *Untitled* mobile dating from the mid-1950s. Calder invented this new art form and was the first to realize the full implications of the element of motion.

Alexander Calder

1898-1976

Alexander Calder is the man who made sculpture move. Yet until he was in his 30s he did not think of himself as a sculptor. Born in Philadelphia into a family of artists – his mother was a painter, his father and grandfather both sculptors – art did not appeal to him as a career, possibly in reaction to this background. Instead, he studied mechanical engineering. Afterward, drafting work in an engineer's office awakened his interest in drawing, which he studied at a New York night school. In 1924 he began doing illustrations for a police journal, and he found himself covering a circus. The performance filled him with enthusiasm; he sketched all the animals and went back every night for two weeks. He then published a small book called *Animal Sketching*, but the experience was to have far more important consequences. From this was to grow his miniature circus and from that his wire sculpture.

In the summer of 1926 he crossed the Atlantic by freighter and settled in Paris, where over the next year he made a number of animated toys, first merely for his own amusement. The bodies were spools or corks, twisted wire formed the limbs, and buttons served as eyes. There was nothing elaborate about their appearance, but such was Calder's mechanical ingenuity that he was able to make them perform astonishingly lifelike acrobatic tricks. He began giving short performances for friends. Word got around the Paris artists' quarter of Montparnasse; the performances became longer. Their fame spread and by 1930 all the Paris art world had heard of them.

ABOVE Alexander Calder in 1976. Throughout his career he isolated himself from the "art world," though his close friendships with artists such as Joan Miró, Piet Mondrian, and Jean Arp inspired him.

RIGHT a Calder *stabile*, a term first used by the surrealist painter Jean Arp.

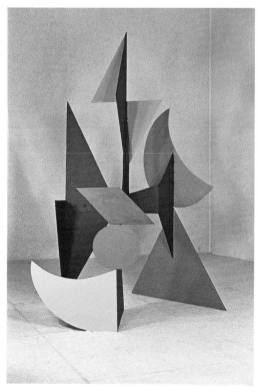

When a friend suggested he make a construction wholly out of wire, the result was the 39-inch-high figure of the singer Josephine Baker. Similar figures of acrobats and tennis players followed, and he became increasingly skillful at suggesting three-dimensional form by means of his wiry contours. A chance visit in 1930 to the studio of the Dutch painter Piet Mondrian seemed to give him what he later called "the necessary shock" that altered his way of looking at his own creations. Against Mondrian's immaculately white walls had been placed brilliant red, blue, and yellow panels. Calder mused over "how fine it would be if everything there moved." As a result of this visit he turned away from representational sculpture and made more abstract compositions of circles and rectangles that moved in fixed patterns from a base attached to a wall. Small electric motors or hand cranks powered their movement, and they were named *mobiles* by the French painter Marcel Duchamp.

Tiring of the controlled movements of these constructions, Calder recalled the Chinese wind bells he had seen in California. From an overhead support he suspended objects subtly balanced against one another and let the wind or the movement of a spectator set them in motion. The mobile in the form we know it was born.

Calder's nimble, rotating wire creations stand as an antithesis to sculpture's traditional values of solidity and permanence. But sculpture is essentially a spatial art: sculptural objects

ABOVE the wire figure, just over three feet high, of the singer Josephine Baker (1926). Calder created other wire sculptures that included a seven-foot-high woman entitled *Spring* and an 11-foot-long wolf for *Romulus and Remus*.

BELOW photograph of Calder at work in his studio/workshop. His interests included making jewelry and illustrating books such as *Aesop's Fables* (1931) in addition to sculpture, painting, and drawing.

isolate a particular space from the surrounding air. What Calder's mobiles do is reveal the shape of this "internal" space. This aim could also be realized through the use of transparent materials – which several artists have done. But the mobile also reveals the constantly changing contours within this "internal" space. It moves through space like a slow cascade or a silent flight of steps, and as it turns it creates the illusion of a volume forever altering its shape.

Calder's work initiated the reliance upon what would now be called "audience participation" for a full effect. The spectator contributes to the creation by tapping the wires, nudging the weights or otherwise starting the movement. Faced with a stationary Calder mobile, most people find it very difficult to restrain themselves from setting it going. In this respect his work appeals to the play instinct in humans. Mobiles can also be humorous due to unexpected consequences – touching a small red ball high up at one end of a mobile can set up a ripple that travels down through the intervening forms to shift a large black disk at ankle level. Calder's work over the years has shown a remarkable capacity for variation on his basic theme – that sculpture can be created from objects that move. A full retrospective exhibition, entitled "Calder's Universe," opened at the Whitney Museum of American Art in New York just a few months before his death, and this helped to enhance Calder's reputation for forcefulness, vitality, wit, and inventiveness among a wide audience.

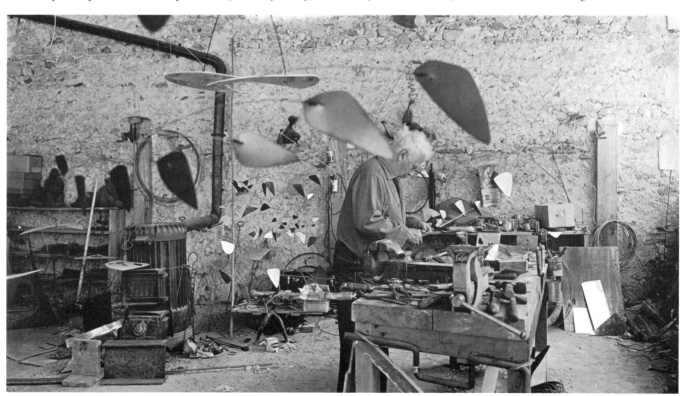

Henry Moore

born 1898

The human being as landscape: breasts and knees as mountain peaks and hips as cliffs, these are the images that come to mind when looking at the reclining figures of Henry Moore. He has developed other image forms in his long and productive life, but with these reclining figures he achieved his first major successes and for years they identified him in the eyes of the public.

Born in Yorkshire in 1898, the seventh of eight children of a coal miner, Moore first studied art in Leeds after army service in World War I. Later he went as an art student to London and was powerfully impressed by the Aztec sculpture in the British Museum. But a visit to Italy in 1925, which introduced him to the undeniable richness of early Renaissance art, brought his own work virtually to a standstill. He could no longer consider that vitality was to be found only in primitive art, yet his creative powers were unable to merge the qualities of European and non-European sculpture. He was eventually to find his solution in the reclining female figure, a motif common to both. His first *Reclining Figure* is dated 1929, and he returned to this extraordinarily fertile subject time and again over the next 50 years.

Some of the figures, in wood, bronze, lead or stone of various kinds, are only 5 or 6 inches long, but the length of the one carved in traver-

tine marble outside the UNESCO building in Paris (1957–8) is 17 feet. In all of these the female figure props itself on one elbow; the knees are raised and the head is watchful. But while these features remain essentially the same from year to year and piece to piece, the intervening forms and spaces – because for Moore the space of an arch or a hole is as suggestive as the forms around them – are enormously varied.

In the late 1950s Moore separated his figures into two parts and later (perhaps less success-

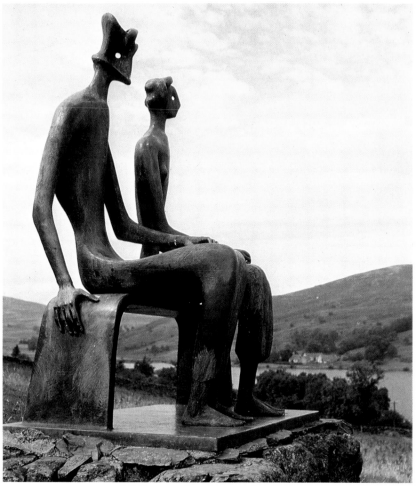

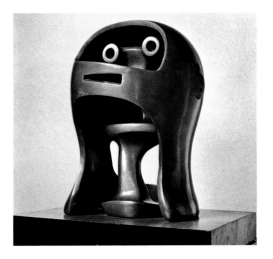

ABOVE *King and Queen*, two seated bronze figures whose curved outlines blend with those of the softly sloping hills of their setting – the moors near Dumfries.

TOP Henry Moore photographed at home in 1956. He represents the continuance of a vital tradition of humanist sculpture into the 20th century.

LEFT *Helmet Head No. 2* (1950). Moore's wartime experiences, including his evacuation from London, strongly affected him.

fully) into three. The *Two-Piece Reclining Figures* of this period are like great outcrops of rock, broken and weathered. But the emotional effect of these massive compositions is not one of despair. From some viewpoints the break between the two parts cannot be seen; as the spectator moves past them the gap appears, seems to widen, and then closes again. This parting and joining and the close "togetherness" of the pieces on their plinth engenders a powerful sense of human endurance, undaunted vigilance, and resistance – qualities that have animated Moore's work throughout the years.

Vitality, the life spirit, is what Moore cares about in sculpture. He felt this spirit had been

lacking in English sculpture since the end of the Middle Ages; his inspiration came from early Gothic and Romanesque statues, from Sumerian sculpture, and above all from the powerful yet sensitive images of gods carved by the peoples of Mexico. Representing in naturalistic detail a flesh-and-blood woman was never Moore's aim. He seems to have imagined how a woman might look if she had actually been made of stone – how the internal structure of the stone would have affected her form and exposed it to erosion. This

BELOW LEFT *Reclining Figure: Angles*, one of a great many explorations of this motif carried out since 1929. Some are gigantic in scale.

BELOW RIGHT *Locking Piece* (1963–4), set outside a bank in Brussels. Moore feels a sense of responsibility as an artist to the wider public, and this is reflected in many commissions and trusteeships.

and a *King and Queen* (1952–3) in bronze, now erected on a Scottish moorland. Though not a Christian, he is also one of the handful of modern sculptors to have produced a *Madonna and Child* (1943) that is both appropriate to the subject and a good work of modern art. In 1956 he completed a series of freestanding vertical pieces called *Upright Motives*, in which he risked producing a sort of totem pole of shapes placed one on top of another, but otherwise unrelated. Moore instead linked the shapes in such a way

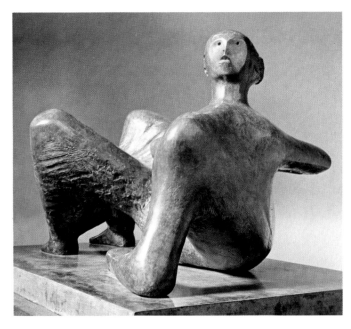

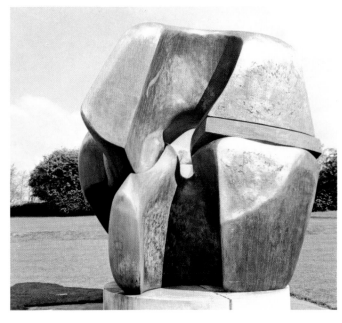

is his principle of "truth to materials" and explains the resemblance of his figures to rolling landscapes of valleys and hills.

Moore's sculpture has been described as a tribute to the feminine principle in a mechanistic age. While there is certainly something in this interpretation, it would be a mistake to see nothing in his work but maternal images, images that somehow remain reassuring no matter how much they are tunneled into or opened out. There are monsters in his world. Some of these emerged after World War II, when he began casting in metal a series of *Helmet Heads*. The smooth, domelike turrets in these forms enclose a variety of thin, skeletal figures, but whether these are protected or imprisoned by the surrounding helmet is difficult to decide. Moore's interest in trying to "get one form to stay alive inside another" had been developing since he carved his *Reclining Figure* in elmwood (now in the Cranbrook Academy of Art, Michigan), in which the lower figure can be imagined as a lover or a child, born or unborn. Some sculptures after the *Helmet Heads* show an entire visible form enclosed within another.

He created a small number of family groups

BELOW *Three-Piece Reclining Figure: Draped*, another of the massive, supremely tactile female figures that have become synonymous with Henry Moore. The landscape within which the sculpture is set can be glimpsed through the gaps in the material, and this adds to the sensations of the viewer.

as to obtain a single vertical form reminiscent of a shaft of bone, a weathered tree trunk or a stone pinnacle, isolated from a cliff by the advancing sea. To commemorate his eightieth birthday in 1978 Moore's drawings were exhibited at London's Tate Gallery while his sculptures were placed out of doors in Hyde Park. At all stages of his career he has created a sculpture essentially tough and optimistic in spirit, in which landscape and the human body stand as metaphors for one another.

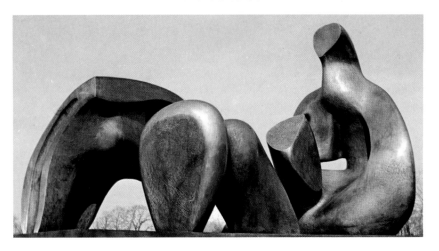

Trends in
Modern
Sculpture

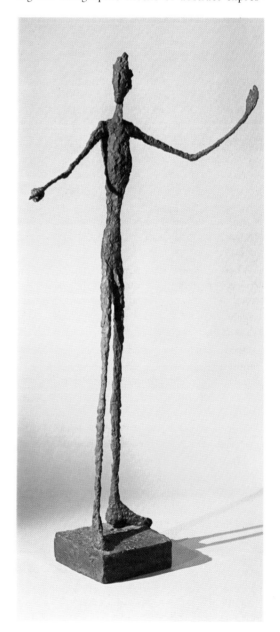

Since World War II the disquiet of the age has been reflected in the rejection by many artists of traditional styles and their attraction to materials and methods that are markedly unconventional. Everyday objects have been isolated and named as works of art; sculptures have been made from scrap metal and industrial waste; kinetic art,

ABOVE RIGHT a set of shapes by the British sculptor Barbara Hepworth (1903–75), a simple yet subtle study in spatial relationships. She was one of the first British abstract sculptors, and her works are often set in the open air.

to exist in an individual but total isolation.

The human figure has continued to exert its traditional power over the creative imagination, as represented in the compositions of several American sculptors working in sheet steel or welded iron. David Smith (1906–65), in developing the calligraphic motifs of abstract expres-

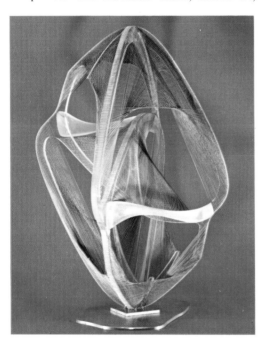

pop art, *art brut*, totemic art, and minimal art are some of the terms that have been given to the different styles of modern sculpture. However, it is still too early to be certain which of these will prove fruitful and which, while interesting, are essentially dead ends.

The work of the Russian-born sculptor Naum Gabo (born 1890) shows his concern with rhythmic form and reflected light in the use of such materials as glass, transparent plastic, and polished brass. The Swiss sculptor Alberto Giacometti (1901–66) was one of the leading surrealists during the 1930s. In the late 1940s he began a series of extremely elongated human figures, disquietingly emaciated in form, usually built up with plaster of Paris on a wire foundation. Even when shown as part of a group they seem

LEFT *Linear Construction No. 4* by Naum Gabo. Like many of his works, it depends on the play of light on its pure, transparent forms. To create such effects, Gabo exchanged traditional clay and stone for modern steel, plastics, and aluminum. Gabo is known as a founder of *constructivism*.

RIGHT *Man Pointing* (1947) by the ex-surrealist sculptor Alberto Giacometti. His skeletal bronze figures, of which this is one of the first, are among the most memorable images of postwar European art. They were modeled roughly in clay outward from a metal armature and later cast in bronze, and part of their effect comes from their surface texture, which seems to repel touch.

sionism, produced constructions of loops and twists that are like squiggles drawn in the air. Whereas Giacometti expressed his sense of the internal impoverishment of modern human beings in figures so thin as to leave no room for an inside, Smith communicated the same concept by outlining figures around an empty interior.

The junkyards of urban life have provided the material for several modern sculptors. The compositions of the French sculptor César (born César Baldacchini in 1921) originate in chunks of compressed, scrapped automobile bodies or kitchen stoves. Eduardo Paolozzi (born in Scotland of Italian parents in 1924) also found the inspiration for his early sculptures in the shapes of machine-made objects. His alarming "junk monsters" begin with such scraps as rubber toys, broken radios, parts of clocks, and fragments of wood. The figures are then assembled by an intricate process of making molds, carving wax impressions, and then casting the result in bronze. His later works are smoother and show a more rigorous symmetry. They give an impression of being the tribal gods of a machine-worshiping people.

Human figures of a different sort are created by the American George Segal (born 1924). His plaster molds are made around live models and then placed next to a Coca Cola machine, in a dry cleaner's or against a cinema wall. They are "frozen" in scenes that are part of daily life. His initial inspiration may have come from the plaster casts found at Pompeii. Much of their strange effect, of a combined vitality and inertia, comes from their ghostly whiteness.

The 1950s were in many ways an "age of anxiety," and many artists expressed this in their work. By the 1960s these anxieties had been largely absorbed and several of the early phases of modern art were being reexamined and revived. Sometimes they were brought back almost unchanged from their first appearance among the surrealists and dadaists 40 years before. Movable objects on a shelf, industrial cartons, articles of clothing glued to canvas, and pocket flashlights cast in bronze are among the works of what came to be called pop art.

The inclusion of everyday objects in works of art was an expression of another contemporary tendency in which artists rejected the traditional idea that a piece of sculpture represented something outside itself. A block of marble shaped by, for example, Michelangelo, was meant to represent David or Christ. Some modern sculptors have said that, on the contrary, the only thing a piece of iron can legitimately be is a piece of iron. This viewpoint is predominantly American and has been termed minimal art. Carl Andre

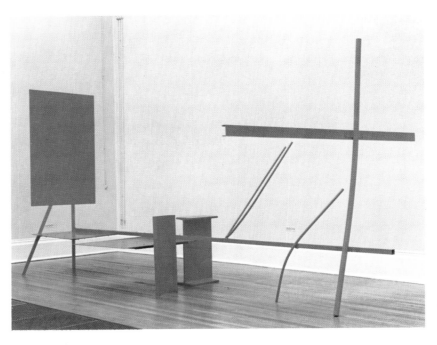

ABOVE *Early One Morning* (1962) by Anthony Caro, a three-dimensional composition over 20 feet long and 11 feet wide made of painted steel and aluminum. Caro, a British sculptor born in 1924, was once an assistant of Henry Moore.

BELOW *Running Fence* (1972–6), a temporary artwork designed by New York artist Christo Javacheff to undulate through hilly terrain north of San Francisco, California, for a period of two weeks. The fence, 18 feet high and 24.5 miles long, was made of over 165,000 yards of heavy white nylon fabric hung from steel cables strung between 2200 steel poles and braced with guy wires.

(born 1935) placed 65 Styrofoam planks in a row on the floor, and on another occasion arranged 120 firebricks in a rectangle. The planks are and remain planks, the bricks bricks. The objects of Richard Serra (born 1939) have an inbuilt instability: in his *Stacked Steel Slabs* he went on placing one slab on top of another until, after the sixteenth, he could add no more without the stack toppling over.

Such experiments, however, while they may direct people's attention to seeing "things as they are," would be pointless to continue indefinitely, and meanwhile human beings continue to relate to objects, themselves, and the world in which they live. The human figure as a subject has never disappeared for long from the mainstream of sculpture, nor is it likely to do so in the future. Sculpture not only keeps pace with but anticipates new directions in modern life.

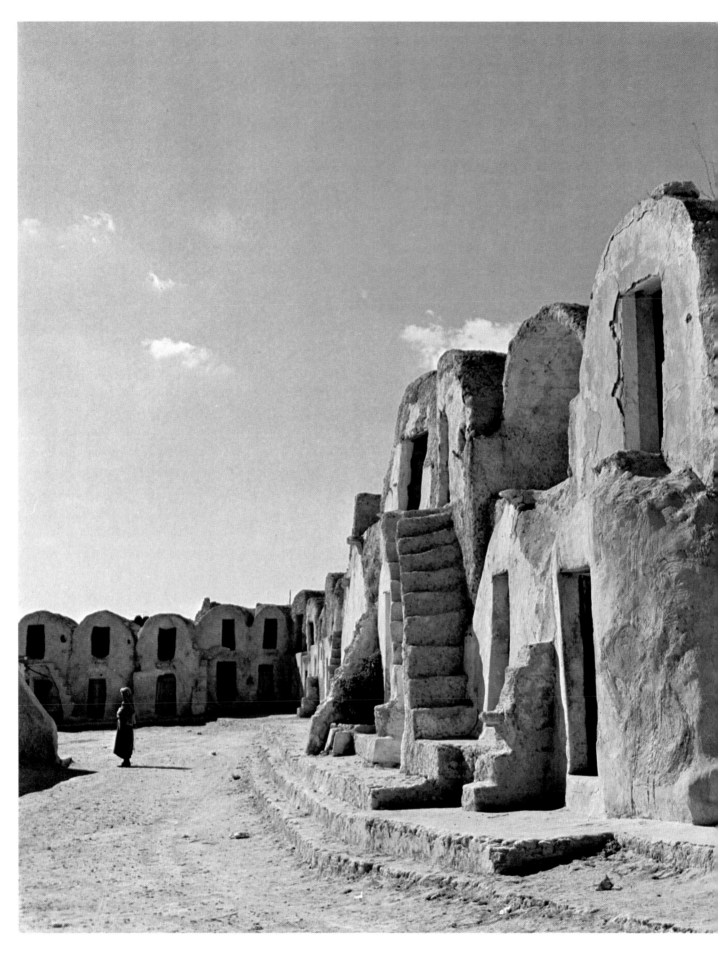

Chapter 5

ARCHITECTURE AND BUILDING

Architecture is the art of planning and designing buildings that will satisfy human needs for physical and psychological security. In ancient times building techniques were relatively straightforward and buildings were required for relatively simple purposes – for shelter, as places of worship, as storehouses or as communal areas. In many cases a suitable design was worked out by the members of the community themselves after a period of trial and error. Where the basic needs of the community have remained unchanged, so has the design of the buildings – sometimes for several thousand years. But in a time of scientific change, new conditions bring new materials, and new techniques are developed to exploit them. All over the world architects are working on ways to house expanding populations and to satisfy the demand for all the new and various buildings required for modern living. More than ever today, it is as vital for architects to have an understanding of people and their needs as it is for them to know about the possibilities and processes of construction.

OPPOSITE *rhorfas*, the cavelike homes and storehouses of the Berber town of Médenine in southeastern Tunisia. A dry climate and rocky terrain inspired the local architecture.

143

Shelter
and
Security

Recently a psychologist asked a large number of young children from many nations to draw a house. All the children drew houses that looked strikingly similar, although they lived in a wide variety of different styled houses, coming as they did from Europe, Africa, and the East. The psychologist concluded that, although these children were too young to have noticed any *details* of the house they lived in, they had grasped the essential *idea* of a house and their drawings reflected this idea. Each child's house was basically four walls, a roof, an entrance, and a window for looking out – a place, in fact, providing shelter and protection. This experiment is a vivid reminder that, despite the complex and varied life of today reflected in our many kinds of special buildings, the basic purpose of the builder is unchanged.

Early peoples first found shelter in caves and simply piled up stones to block the entrance against marauders. Many wandered from place to place, looking for food as the seasons changed (just as some primitive nomads still do today). The wandering bands could not always rely on finding a cave when it was needed, so they started to build shelters. The earliest kind were

ABOVE ruins of Mesa Verde, a Pueblo Indian village clinging to a canyon wall in Colorado. The terraced dwellings, made of adobe bricks, were built 700 years ago.

BELOW LEFT a young child's drawing of a house, reflecting a standard idea of home.

BELOW RIGHT a Zulu hut, made of twigs and branches woven together and thatched with grass. It can easily be taken down and moved to another location.

formed by pulling down branches from nearby trees and arranging them to form a windbreak. Later, a second windbreak was leaned against the first, making a hut rather like a modern tent. Other huts were made by arranging branches in a circle and binding them at the top (like the American Indians' tepees and wigwams) to form an extremely practical support for the outside covering of skins, mud or branches (which in time was refined into the thatched roofs of the late Middle Ages).

The circular form is also characteristic of primitive buildings made of more permanent materials. Perhaps this is because people who had lived in caves found a circle a natural shape to make, or because many of these early shelters

were just dugouts with a roof on top. Another reason that has been suggested is related to the discovery of fire. Fire revolutionized mankind's life on earth; it frightened off wild animals and provided warmth. It was quite natural to build a circular shape around the fire so that as many people as possible could gather round it to warm themselves.

One of the oldest settlements to be excavated is Jericho in modern Jordan, which was built

BELOW house on stilts, separate accommodation for single men and boys provided by the community on the Solomon Islands.

like the Bororo Indians in Brazil's Mato Grosso and many others scattered over Africa, Malaysia, and Australia. In each, areas that are particularly important to the social pattern of the tribe – the dancing floor or the houses reserved for the men or women of the tribe – are given carefully chosen sites. Even if the tribe moves or has to rebuild its village after a disaster, the important areas will always be arranged in the same pattern, showing how much people value the reassurance

8000 years ago. There, many of the mud and stone houses are round. But even when houses were no longer circular they were still built around a central point – the hearth – focus of life within the household and the place where the family worshiped.

Just as the dwelling of the individual family contained a central place of activity, so a village or town, the collective dwelling of many families, had its central place of activity. From the earliest times the center was where day-to-day business was transacted and religious ceremonies held (two activities that were often more closely linked than they are in Western civilization). In fact, by looking at the design of a settlement it is possible to deduce a great deal about the way its people live and what they believe is important. Many early settlements were similar to those of primitive tribes today,

BELOW the Old Town Market in Warsaw's main square – rebuilt after the devastation of World War II from the minutely detailed paintings of the 18th-century Italian artist Canaletto. The houses belonged to the wealthy citizens of Warsaw.

offered by familiar surroundings.

This concern for the psychological security provided by stable building forms was intimately related to primitive people's ideas about religion and remained an important influence throughout the development of architecture. People's ideas about how the universe is ordered have often been expressed in the form of their buildings, and they have taken great care to perform the religious ceremonies they believed were necessary to initiate and maintain a successful building project. Some of these rituals still survive. The ancient ceremony of "beating the bounds" to mark the boundaries of the community is still celebrated annually in some English villages. In many societies, speeches by local or visiting dignitaries and formal ceremonies commonly accompany the laying of a cornerstone for a new building or town project.

Origin and Growth of a City

Once people had learned to produce more food than was necessary to satisfy immediate needs, those with special talents were freed from hunting or laboring in the fields. A class of artisans grew up, specialists who made utensils, tools, and weapons and traded them with farmers for their surplus food. Settlements of artisans were founded, and in time these trading communities developed into towns.

Towns and cities have always had, at their center, special places for religion, government, and trade. In the past these were not always distinct, for religion and government were one when the king was a god's representative or even a god himself. The ancient palace of Peking, which housed the Chinese emperor, was built to form the sacred climax of a long procession of spaces and buildings leading up from the secular city of his subjects. Nonetheless, the storehouses and markets were always nearby.

In some cultures, notably that of the Greek city-states, the market place was used for more than just commerce. Trade resulted when people met for other reasons – to gossip, hold judicial meetings, educate themselves by debate, or

ABOVE striking example of a cross-and-circle town plan, found in cities and villages of many different cultures all over the world. This Mexican fishing village is built on a lagoon on the Pacific coast.

LEFT the Acropolis, hilltop citadel of Athens. The ruins of its temples can be seen all over the city, and they would have been safe from almost any type of attack.

honor their gods. Indeed, the Greek *agora* was first intended as a meeting place – a market for ideas – and it was only later that commerce pushed all other functions aside. The forum played a similar role in Roman cities. Rows of shops, shaded by lengthy colonnades, ringed an open square or rectangle. Adjacent were the theaters, baths, amphitheater, and government buildings.

After the collapse of the Roman empire, towns dwindled in size. Only religious settlements provided sanctuary for travelers and preserved old achievements. With the return of security and trade in the Middle Ages, however, new towns grew up around the abbeys and cathedrals, with markets placed in close proximity. Most townspeople held fairs on feast days and, like the Greeks, used the market square for commerce, entertainment, and pageantry.

In lands exposed to the dangers of foreign

invasion, cities had to be built on sites that could be defended. Jericho, one of the earliest known cities, was built inside high walls. It lay north of the Dead Sea and, like Troy – another famous walled city founded around 7000 BC, some 1000 years after Jericho – commanded a strategic position on a plain. Often, easily defended sites such as hilltops were chosen and then made more impregnable by walls and battlements. In Greece towns were grouped around a hilltop citadel called the *acropolis* or "high city," where the main shrines of the city were protected. The best known of these is the Acropolis of Athens, which rose high above the city that clustered around its base.

Water also provided a natural defense, and settlements were even built on stilts over rivers and lakes or on islands. Paris and Venice were built on islands. In other cases (such as Assur in Mesopotamia), a canal or moat was dug around the city and filled with water. For economy the moat sometimes surrounded only the town's citadel or castle. When under attack, the townspeople would take refuge within these defenses.

ABOVE Currier & Ives print of "New York and Brooklyn," originally supplied with its own key. It dates from 1875 and shows how Manhattan Island became the center of a thriving port.

trolled. Beyond this, "new towns" of about 60,000 inhabitants were planned to grow around existing villages and absorb the overflowing population of the capital.

As cities spread farther and farther as a result of the opportunities provided by modern trans-

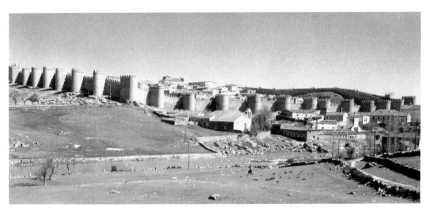

Of course a tyrant could also subjugate his people, for the citadel not only protected the king and the priesthood but also held the city's granaries.

Walls and moats remained proof against attack until the perfection of siege guns in the 16th century. A number of cities still bear the mark of their early defenses. The concentric street layout of Paris is a reminder of the enclosing walls built at successive stages of its growth. Many other European cities, such as Cracow and Vienna, contain large belts of parkland created on the sites of obsolete defenses.

With industrial growth in the 19th century a period of urban expansion began that still continues. Efforts have been made to control the growth of some cities so that they do not sprawl for mile after mile. London has established a "green belt," an area of countryside around the city within which development is strictly con-

ABOVE Avila, a provincial capital in Old Castile, Spain. Situated on a treeless plateau about 3000 feet above sea level, the city is still surrounded by its medieval granite walls.

ABOVE RIGHT Rotterdam's Lijnbaan, a modern shopping center built as an enclosed precinct.

portation systems, their form, once limited by the need for face-to-face communication, becomes ever more dissimilar to that of the past. In an attempt to preserve the human scale and the traditional advantages of urban living, today's planners have proposed such schemes as traffic-free city centers. A totally new inner city was built in Rotterdam, for instance, the second largest city in the Netherlands, following its virtually complete devastation by bombing during World War II. Its Lijnbaan shopping center, known as the "Fifth Avenue of Europe" when it was erected in 1953, became the prototype for similar pedestrian-only areas in Europe and America. In many cities large areas of old buildings have been cleared to create new centers for recreation and culture. But all too often such fine-sounding schemes disrupt what survives of the old communities and speed up the city's seemingly inexorable process of decay.

147

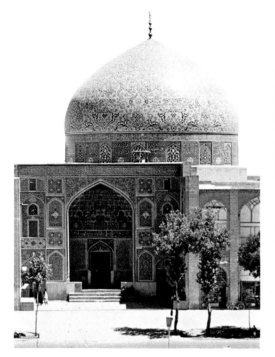

Buildings as Symbols

ABOVE LEFT a jigsaw pattern of color-glazed mosaic tiles covers the dome of this small 16th-century Persian mosque.

ABOVE the Porcelain Tower, Nanking, China, in a sketch by a 19th-century Royal Marine.

BELOW cruciform plan, easily identified in this aerial view of Salisbury Cathedral.

itself was a vast dome, hanging above the earth. A Mycenean tomb of around 1400 BC, called the Treasury of Atreus, is a domed underground room; rows of bronze rivets show star-shaped decorations that may have symbolized the sky.

Another architectural symbol is the tower. Throughout history it has been associated with power, fertility, and spiritual aspiration. Many civilizations believed that the center of the universe was a spot in their own country and this

Ever since people learned how to build, they have used their skill to provide themselves with more than mere shelter. When buildings were designed to have some cultural purpose, transcending practical necessity, the art of architecture was born. Just as painting and poetry were originally charged with magical significance, so the shapes of a building were often symbolic of a civilization's ideas about the order of the universe. The architecture acted as a physical reminder of the ideas expressed in religious mythology and created a formalized setting for the way of life it prescribed.

Certain building forms, perhaps because they have strong associations with forms in nature, have taken on similar symbolic meanings in different civilizations. The dome was a widespread symbol for the creation because it resembled a mountain. A mountain both signified nearness to heaven and could also be regarded as womblike. Primitive burial mounds all over the world were made in this rounded *tumulus* shape, indicating that the dead were returning to the earth to be reborn. In India solid brick mounds of this kind, called *stupas*, developed into extravagantly decorated and carved shrines. (One in Sri Lanka – Ceylon – was over 400 feet high.) Another common belief was that the sky

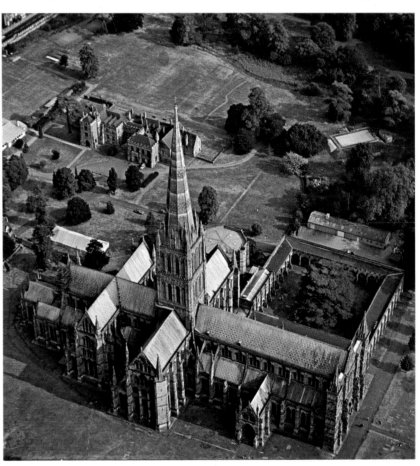

spot was marked with a special building – usually a tower. Sometimes towers were also symbolic supports for the heavens themselves. Chinese *pagodas* (related to stupas) are towers of this kind with each one of their projecting roofs representing a stage in the ascent from earth to paradise. In medieval Europe the spires of Gothic cathedrals could be seen from far away, a constant reminder of the religious aspirations that they symbolized.

The actual ground plan for a building often had symbolic meaning. Traditional Christian churches were built in the form of a cross, with the head of the cross pointing toward Jerusalem (which medieval geographers held to be the center of the earth). Sometimes whole cities were laid out to symbolize religious ideas. Peking was planned as a perfect square having

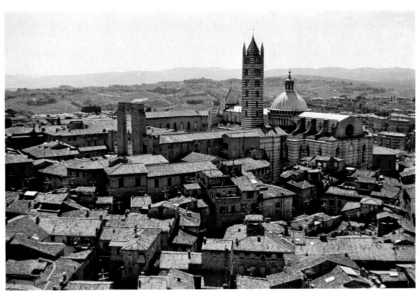

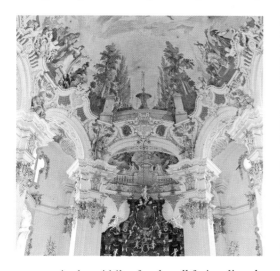

one gate in the middle of each wall facing directly north, south, east, and west. The Chinese believed that "Heaven is round, Earth square," and in Peking a perfectly circular "Temple of Heaven" has four stairways leading to the altar from the cardinal points.

Renaissance architects, influenced by neo-platonic ideas, planned their buildings according to geometric principles to achieve a harmony corresponding to the divine order of the universe. The Florentine architect Andrea Palladio (1518–80) argued that the most suitable plan for a church was a circle because the circle is the most perfect form and therefore suitable to the house of God. Others based their plans for churches on the shape of Christ's body on the Cross; the nave represented his body, the transepts his outstretched arms, and the apse beyond the altar his head. These architects maintained that the interior must be richer than the exterior, because the interior symbolized the soul of Christ and the exterior his body, and the soul was more beautiful than the body.

ABOVE beautiful towers, churches, and other monuments reflect the civic and religious pride its 14th-century inhabitants took in Siena, Italy.

LEFT ceiling of the basilica in the baroque church at Steinhausen, Bavaria.

BELOW RIGHT the modern symbol of a city – the Gateway Arch, 630 feet of stainless steel designed by Eero Saarinen to commemorate the historic role of St Louis, Missouri, as the gateway to the American West.

BELOW a 15th-century plan for a church by the Italian architect Francesco di Giorgio, in which the building is based on the proportions of the human body.

Baroque architects of the 17th and 18th centuries treated the interiors of their churches as theatrical sets representing God's power and majesty. By skillful planning and elaborate use of sculptures and paintings, they made the walls apparently melt into a vast, light-filled heaven – the domain of saints and angels.

Sometimes a building acquires a symbolic meaning that was not originally intended. The Eiffel Tower, built in 1889 as the centerpiece of an international exhibition, was designed to demonstrate the industrial achievements of the 19th century. Now, of course, it is so firmly associated in people's minds with Paris that it has become a symbol of the city.

Building for Prestige

Mankind's constant desire to leave its mark on the world – to commemorate its achievements, honor its gods or display its wealth and temporal power – has inspired many of the world's most impressive buildings.

The desire for immortality prompted the building of the pyramids, those vast artificial mountains of stone. The Egyptians believed that life would continue after death but only so long as the body of the dead person was preserved. So their rulers had every incentive to build as permanently as possible. Each pyramid is perfectly square, with the sides facing the points of the compass. Inside is a maze of rooms and

and the Euphrates rivers. These were not tombs but substitutes for the mountains on which so many primitive peoples chose to place their shrines. These "hills of heaven" were built in a series of vast steps, reached by ramps or stairways, and on top was the "holy of holies," the god's dwelling place. Mesopotamia had no stone, and the mud brick construction has not lasted. Only the largest ziggurats, such as the one built at Ur about 2300 BC, survive to the present day.

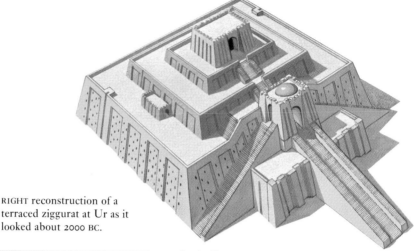

RIGHT reconstruction of a terraced ziggurat at Ur as it looked about 2000 BC.

A similar type of artificial mountain appears in an entirely different part of the world. The Maya Indians of Mexico and Central America also built stepped pyramids with a temple on top. Typical of these *teocallis*, or "god houses," are the ones in Chichen Itzá in Mexico, built of stone in the 6th and in the 11th century AD.

corridors designed to keep out intruders. Laid out in a central burial chamber was the mummified body of the dead pharaoh, with his personal possessions. The pyramids were built before 2500 BC. The passage of more than four millennia has not altered them substantially, so massive is their scale and so skillfully were they constructed. The Great Pyramid of Cheops covers an area of 13 acres. It is 482 feet high and is made from an estimated 2,300,000 separate stones, none of which weighs less than two tons and some of which weigh almost 50 tons.

Very similar to the pyramids in form but different in purpose were the *ziggurats*, built on the flat plain of Mesopotamia between the Tigris

ABOVE the pyramids at Giza. The three 4th-dynasty pyramids date from about 2550 BC and are among the Seven Wonders of the World.

RIGHT arch of Caracalla in Djemila, Algeria. Caracalla reigned as Roman emperor from 211 to 217 AD, during which time he led several military expeditions.

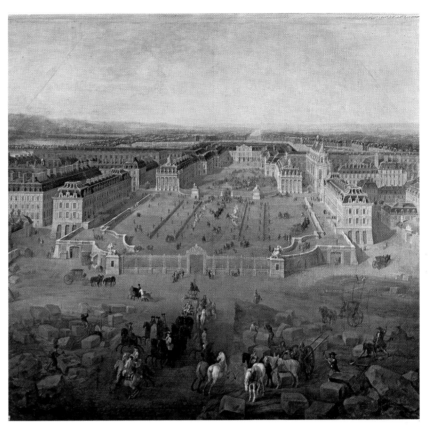

During the Roman empire, columns and triumphal arches were erected to commemorate victorious campaigns. Martial rulers at all times have sought to glorify their exploits in monuments and other grandiose building projects.

Perhaps the last occasion when virtually all the people of a society pooled their resources to celebrate a common belief occurred during the Middle Ages when the great cathedrals of Europe were built. Everyone wanted these soaring monuments of stone and glass to stand as a testament to a universal faith in the wisdom of the church as the instrument of God. The age that followed was one of questioning and disbelief, and the old order of church and feudal lord was replaced by one in which kings, bishops, and new merchant princes went their different ways. The buildings they left behind were palaces and, just as many of the splendid buildings of the ancient world had been the palaces of emperors and kings, these princes of the Renaissance now vied with one another to show their wealth and influence.

The most impressive and extensive of these was the baroque palace built by the French king Louis XIV at Versailles. The "Sun King" devised this building, which stretched for over a quarter of a mile, as an instrument with which to dominate the state. Most ministries of government and the aristocracy were gathered there and, almost within sight of the king's bedroom, which occupied the center of the plan, France's governmental decisions were made.

Today, of course, kingship and religion do not hold the predominant positions in the structure of society that they once did. Building for prestige is as strong as ever among other elements of society, however. Big business, for

ABOVE LEFT *Building the Temple* by Jean Fouquet, the major French painter of the 15th century. This amazingly detailed study of Gothic builders at work is one of the miniatures in a book of Jewish antiquities.

ABOVE painting of extensions being built at the palace of Versailles by Louis XV in 1722.

instance, thrives on it. Buildings such as New York's Lever House or the Pan Am Building advertise their owners as much as house them. The power of the state in many walks of life is also displayed in the grand government buildings of the new city of Brasilia or the skyscraper university of Moscow.

RIGHT the crown atop the new cathedral in the center of Brasilia, designed along with the city's other major buildings in the early 1960s by the Brazilian architect Oscar Niemeyer.

151

Development and Tradition

Because people associate familiar things with security and comfort, they are usually conservative in their attitudes toward their surroundings. The result is that the appearance of buildings often remains the same long after the building techniques and materials have changed. We have only to look around to see that many 19th- and 20th-century banks and offices were built to resemble Renaissance palaces or Greek temples.

There is also another factor that inhibits innovation – the problem of imagining what the form of something new should be. This is so difficult that a new invention is usually grafted onto a familiar form. The first airplanes had birdlike wings, and the "horseless carriage" had to come before the modern car.

Prehistoric people were nomads, needing only the temporary shelter offered by simple windbreaks and lean-tos. Once they discovered how to rear animals and farm crops, however, they began to settle down, establishing communities that needed more durable shelters. At first these were peaked structures like a ridge tent laid on the ground. Later, the peaked roofs were put on top of upright posts rammed into the ground. Such were the large rectangular houses of the Danubian Stone people who lived about 5000 years ago, the remains of which have been excavated in Germany at Lindenthal, near Cologne. In other countries such as China, where timber was also plentiful, walls were made of wooden stakes bound tightly together, like the stockades of pioneer America. In Asia Minor reeds were bound together into bundles to make columns. Woven reed mats, straw or thatch were placed over the columns and mud was plastered over the walls to make them more solid.

When even more durable materials such as stone were introduced, new buildings still reflected the styles of humbler structures. One of the largest religious buildings, the Egyptian temple of Ammon at Karnak, has columns derived from bundles of papyrus reeds. The engraved bands around the upper parts of the columns represent the ropes that bound the reeds together. Their tops, known as *capitals*, were

carved in the form of a lotus bud. Over 100 years after Karnak was built the same kind of column was still being used in the temple of Horus at Edfu. The Egyptians also imitated other primitive structures when they carved out the royal tombs in the rocks at Beni Hasan. Their sloping walls are reminiscent of early mud walls which, of necessity, had to be thicker at the base than at the top. And in these buildings, not just built but actually carved out of solid rock, there are projecting pieces that represent the ends of wooden roof beams.

The monumental stone architecture of ancient Greece developed in much the same way. The Parthenon, built around 440 BC, is perhaps the most renowned of all ancient buildings. It is built in the Doric style – a complete building formula that had been developed as a kind of metaphor for the timber construction of its less permanent predecessors. The ends of the old timber roof beams are represented (just as at Beni Hasan). Even the wooden pegs that were once used to hold the beams in place have their marble counterparts.

The stone of these temples was beautifully

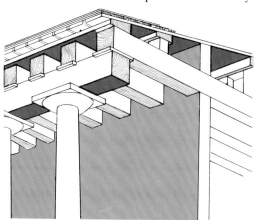

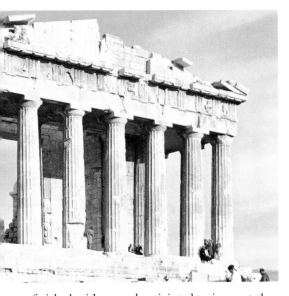

finished with scarcely a joint showing; yet they were covered with a thin layer of plaster and painted in vivid reds, yellows, and blues to conform to the traditional finish given to early wooden buildings. Today, of course, only the bare stone remains; and the Renaissance architects of the 15th century who went back to classical models for inspiration did not realize that these ancient buildings had once been brightly painted. They copied what they believed to have existed in ancient times, producing the more restrained style used so much since in all

ABOVE LEFT simple wooden structure that may have been the Doric style model. Roof beams rest on wooden posts, each cushioned by a flat block.

ABOVE 63 slender columns with flaring capitals support the six-story North Western Insurance building in Minneapolis, designed by Minoru Yamasaki.

parts of the Western world.

In the recent flowering of modern architecture in Japan it is interesting to note the same development that occurred in Greece almost 3000 years ago. Many new reinforced concrete buildings such as the town hall of the Kanagawa Prefecture by Kenzo Tange (born 1913) are reminiscent, though not imitative, of the timber architecture that is one of Japan's greatest cultural achievements.

RIGHT the town hall of the Kanagawa Prefecture, designed in 1955–8 by Kenzo Tange. It is considered a particularly fine example of the blending of modern and Japanese styles.

Techniques
and
Materials

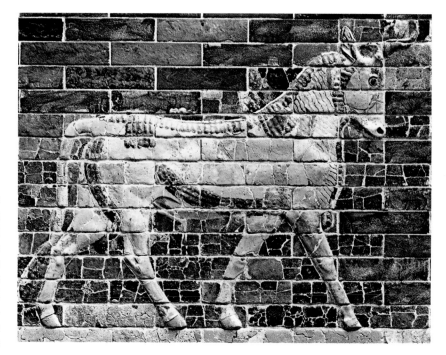

In early civilizations, methods of building were directly dependent on available materials. The architecture of those who lived in richly forested areas was naturally very different from the architecture of those inhabiting arid parts of the world. There, timber was scarce but mud for making bricks was plentiful. As mankind emerged from the most primitive level of civilization, the methods that were used to process natural materials in order to make them suitable for building began to exert an even greater influence on building forms than the materials themselves. What had at first been made of natural clay, branches, and stones at a later period was made of bricks, and sawn timber.

Inexhaustible supplies of mud from the plains between the Tigris and Euphrates rivers, for instance, provided bricks used by the ancient

ABOVE one of the bulls that adorn the Ishtar Gate of Babylon. Blue enamel was applied to a burnt-brick background. The gate dates from around 575 BC and is more than 38 feet high. The burnt bricks are decorated with symbols of the goddess Ishtar.

RIGHT interior of a Roman house, showing the central court or atrium that led off to a shrine for the household gods.

Sumerians to build their ziggurats. These can still be seen today as huge mounds of earth. Smaller, less massive Sumerian buildings – houses and even palaces – have disappeared entirely because mud bricks are not very durable.

Despite their disadvantages, sun-dried bricks of mud and straw continued to be made without any improvement for many thousands of years –

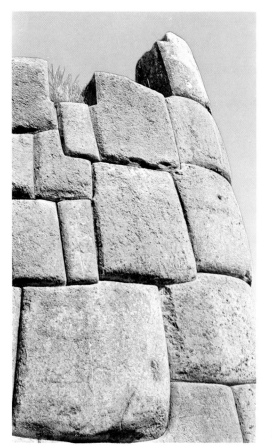

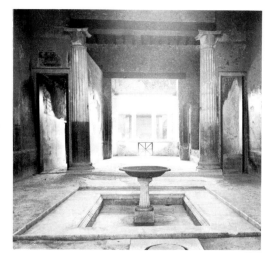

LEFT massive stones in a wall built at the city of Cuzco by the 12th-century Incas of Peru. These pre-Columbian builders used no mortar, but trimmed each stone so carefully that it fit into place. Though some of the boulders weigh several tons, they fit so snugly that a knife blade cannot pass between them.

and are used even now. Eventually, builders in Persia and Mesopotamia learned to make stronger and more durable bricks that were not affected by the rain. They baked the bricks in an oven known as a *kiln* at very high temperatures. Later they improved on this further by glazing the surfaces – just as pottery is glazed – to give a long-lasting decorative surface to their buildings. Unlike the primitive mud bricks, baked bricks had to be bedded on a bonding material, and Middle Eastern peoples discovered that a

mortar could be made of *bitumen*, a natural tar that is sometimes also used as an adhesive and waterproofing material. The Romans, who did not originally have ready supplies of bitumen, bonded bricks with a cement made from burned limestone mixed with hair and sand. This technique survived until modern times, as has the making of plaster from burned limestone, invented in prehistoric times and used by the Egyptians, Greeks, and Romans.

The most durable material has always been stone. But the hardness that makes it durable also makes it difficult to work, so the laying of fine masonry ranks as one of the great technical achievements of early civilizations. The Egyptians cemented their masonry in mortar at first, but around 1000 BC stone-cutting techniques were refined and bronze *cramps* – a kind of clamp – replaced the coarse mortar beds. The Greeks improved on this when they learned how to grind the faces of each stone so finely that the joints

RIGHT an exhibition hall for machinery built by French engineers for the Paris Exhibition of 1889. Steel webbing formed the roof of the huge glass and metal structure.

BELOW "Habitat," the apartment block built in Montreal, Canada for Expo '67. It combined prefabricated (precast) concrete with on-site pouring; entire rooms could thus be lifted into place.

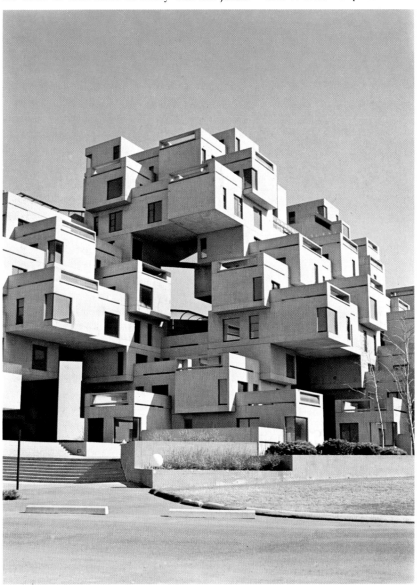

were practically invisible.

Despite its beauty, masonry has one great practical disadvantage: there is a limit to the size of stone that can be handled easily. The Romans overcame this by inventing concrete. They crushed sandy volcanic ash – plentiful in Italy – and made a cement to which they added rubble. This concrete was poured into molds to make the vast vaults and domes that could not be built before the invention of what is really a reconstituted stone. The formula for making this useful material was lost after the fall of the Roman empire, and it was not until the 18th century that builders in Holland, Britain, and France started to use it again. In the late 19th century, engineers such as the Frenchman François Hennebique (1842–1921) learned how to improve concrete still further by incorporating steel bars, producing the reinforced concrete from which so many buildings are made today.

The use of metal for building structures began slightly earlier than the introduction of reinforced concrete. In the 18th century cast iron was used as a fireproof replacement for traditional timber construction in a number of buildings. By the mid-19th century new methods of production made steel economical to use in large quantities and opened up new possibilities, which the pioneering builders of Chicago's skyscrapers of the 1870s were quick to exploit.

Today the development of new materials and techniques is spurred on by rising costs of labor. More and more effort is put into producing systems of construction that are largely prefabricated and require little time to erect. Such systems have been used for schools, first in England and then in California, where light steel-frame construction has been used to produce buildings that are easily altered and relatively inexpensive to build. Houses are also being prefabricated, and the French have pioneered the development of large-scale reinforced concrete structures.

Structure and Framework

There are essentially two ways to construct a building, and they are analogous to certain differences in the animal world. The higher animals are divided into two kinds: those (mammals, reptiles, and birds) with an internal support, such as a skeleton, for the body, and those (insects and crabs) with an external protective support, such as a shell, that contains the body. In the same way, there are buildings in which there is a structural *framework* rather like the bones of the body (made up of vertical posts, horizontal beams, and diagonal bracing members); the walls hung on this serve both as partitions and as an external skin. And there are also buildings in which the walls themselves are the structure, containing and supporting everything just like the shell of a crab.

These two approaches to building have differing characteristics. For instance, frameworks are essentially light, whereas integral construction is heavy. People have adopted one

ABOVE a longhouse of the Kenyahs of Borneo. Designed to hold an entire village under one roof, they are built of poles, floored with planks, and roofed with leaf thatch.

BELOW the "President's Lodge" at Queen's College, Cambridge. The half-timbered building was built around 1540 in the Elizabethan style.

or the other approach depending on the kind of building they wished to put up and the kinds of materials that were available. As far back as the late Stone Age, huts on the shores of the Swiss and northern Italian lakes were made of timber poles, lashed and notched together to form a framework that was covered with thatch over skins or reed matting. This method continued and by medieval times "half-timbered" houses, common in parts of northwestern Europe, had evolved with complicated frames, usually of oak, filled in with brick and plaster. Many of these houses still survive in England and Germany.

Toward the end of the 18th century, European architects started to replace timber with cast iron for the columns in framed structures. By the 1840s architects had made entire frameworks of iron. The pieces were prefabricated and jointed by means of slots and wedges. The most famous example of this kind of construction was the Crystal Palace, designed by Joseph Paxton (1801–1865) for London's Great Exhibition of 1851. Every piece of this enormous building, which consisted of nearly 300,000 single panes of hand-blown glass, was prefabricated, and Paxton is now recognized as a pioneer of industrialized building construction.

Most large-scale buildings today have a framework of steel or reinforced concrete, although this is not always evident, for very often they are dressed up in stone or brick to resemble load-bearing wall buildings. People's conservatism about building frequently leads them to copy inappropriate past styles.

In the past, load-bearing walls had to be

massive in order to support the enormous weight of the roof. Roofing created many problems. A flat roof is made easily enough by putting beams from one support to another. Unfortunately, beams that are too long start to bend or sag. They can be made deeper and bigger, but this calls for columns to support them, and there is also a limit to the size of any beam. So eventually a better way was discovered for spanning wide spaces. The single horizontal beam was replaced by two beams propped against each other (like the letter V upside down), with one end of each standing on the walls. This pitched roof produces its own difficulties, however, for the two beams do not just push down on the walls beneath them, they also tend to slide out sideways – to do a split, as it were.

The earliest method used to contain this sideways *thrust* was to make the walls very thick and massive. A second way, adding thicker parts – known as *buttresses* – to the wall where thrust is greatest, reached its highest level of refinement

RIGHT flying buttresses set around the Chapter House of Lincoln Cathedral. Their support was essential to medieval churches, for the stonework is very heavy.

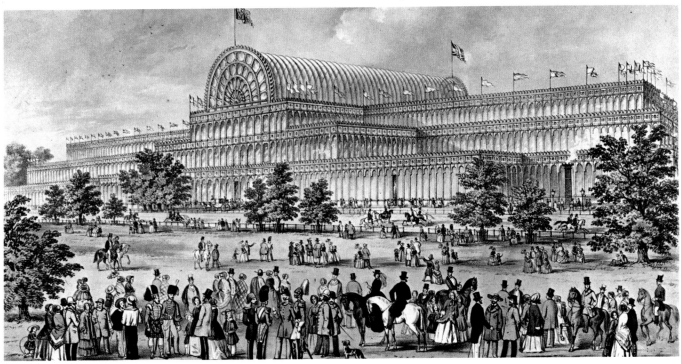

in Gothic cathedrals of the Middle Ages. Not only were there ordinary buttresses against the walls but great stone arches were built out from the sides. Vividly named *flying buttresses*, these arches ended in heavy stone piers a little distance away from the building. A third method of countering the thrust of two roof beams is also the most economical – linking the bottom ends of two beams with a third so that a complete triangle is formed. The outward thrust of the upper beam is contained by the bottom tie beam and only a downward force is put on the walls.

ABOVE Crystal Palace in Kensington Gardens, Hyde Park, London, in 1851, in a painting by Augustus Butler. Paxton developed his architectural principles by building greenhouses. The Crystal Palace, destroyed by fire in 1936, was the first iron-framed building, the first in which the outer walls were reduced to glass curtains, and the first for which structural units were prefabricated.

Such a tie can be of timber, cable or even rope.

Architects must also contend with a force that tends to "twist" parts of a building, a phenomenon known as *torsion*. Twisting occurs when a structure is too tall and thin. It cannot support itself against the downward pull of gravity and begins to "corkscrew" along its own axis. Overcoming this force is especially important in the skyscrapers of New York, for instance; they are strengthened with triangular steel supports that create a kind of tension similar to that used to counteract roof thrust.

157

Arch, Vault, and Dome

Because it is relatively easy to construct a building of any size today, we tend to look at those of previous ages without recognizing how much ingenuity went into their design, or how many thousands of years were needed to develop the techniques used to build them. In previous ages there was little more than natural materials and only animals and men to handle them, whereas today we have strong, light materials that are handled on the building site by powerful machinery. Why is it that despite all our modern advantages, buildings from the past survive that rival, both in size and strength, many that we now put up?

Before the introduction of steel and reinforced concrete for large frame structures, builders generally had to rely on masonry or brick construction for their important buildings. The result was that these structures were massive by today's standards. Walls had to be thick and columns close together, as in the temples of Egypt or Greece. Even the delicate-looking Gothic cathedrals, which at first glance appear to be light-framed structures, are really very heavy, though this is disguised by their ornate fluting and tracery.

When people first began to span over solid-walled buildings, the simplest method was to lay beams of timber or stone across the opening. In areas where there were plentiful supplies of large timber this was easy. Where timber could not be used only stone or brick was likely to be available, and it requires a very thick slab of stone to span even a small opening. (The strongest stone known to the Egyptians could span just 25 feet.) Bricks were too small to be useful until the arch was invented. The first arches to be used were not true arches, but something halfway between a beam and an arch and known as a *corbeled* arch. Small flat stones were built out, or "corbeled," from either side of an opening, each layer getting nearer, until they met. This method was used in Asia Minor and was the only one known to the Maya of Mexico. It was left to the Romans to develop the true arch, however – one that depended on a central

RIGHT an old corbeled arch leading into the pre-Columbian city of Labná in the Yucatán peninsula of Mexico. Each stone of a corbeled arch is set so as to overlap the one below. A fairly primitive method, it can only span narrow gaps.

BELOW the well-preserved bath built by the Romans at Bath in the county of Avon, near Bristol, England. The Romans founded the city as Aquae Sulis, dedicated to the goddess Minerva (Sul). The Roman bath, lined with lead from the nearby Mendip Hills, was only rediscovered by the authorities in 1755.

keystone for its stability.

The natural developments of the arch are the *vault*, an arch extended in the third dimension, and the *dome*, which can be thought of as a vault with a circular base. The Romans employed these three devices for the construction of almost every kind of building throughout their empire. The arch became a recognized symbol of their technical achievement and imperial power. One type of vault particularly favored by them was the semicircular tunnel or *barrel* vault, spanning continuously between two paral-

lel walls. The immense halls of Roman public baths, for instance, were roofed by these vaults and semicircular domes.

Small domes had previously been used by the Sumerians and, to some extent, by the Greeks, but again it was the Romans who first developed the dome into an architectural feature of any importance. One of the first and still one of the largest domes was built in 112 AD over the Pantheon in Rome. Since then, architects in almost every age have built domes. The Byzantines, with the domes of their 6th-century Church of Santa Sofia in Constantinople, set a pattern that culminated in the great mosques built a thousand years later in the same city by the Turkish architect Sinan (about 1489-1578).

The outward thrust of the domes was counteracted by heavy buttresses that partly hid the dome from outside. In cases where architects

wished a dome to be seen rising above the rest of the building, they had to devise some other way of constraining the thrust. In the Renaissance dome of the cathedral in Florence, for example, Brunelleschi achieved this by encircling the base of the dome with a great ring of chains.

The last 30 years have seen an important development of the dome by the American engineer and architect Buckminster Fuller (born 1895). His *geodesic* domes are based on studying how a sphere can be divided into a large number of identical pentagons and hexagons. The domes are constructed of mass-produced components and made from lightweight modern materials such as aluminum and fiberglass. The dome built in 1958 in Baton Rouge, Louisiana has a diameter of 384 feet.

159

New Buildings for New Needs

Changes in the way of life of a society have often meant that new kinds of buildings were needed. The Industrial Revolution necessitated a whole range of new buildings. The new machines needed shelter, and the workers who flooded into the towns and cities from the countryside to tend the machines had to be housed. The business created by new industrial concerns produced the need for offices, where clerks could handle the paperwork.

The size and weight of new machines and power plants, along with the complexity of mass-production processes, led the engineers and architects who built the factories to concentrate on structural strength and the provision of large areas of uninterrupted space. There was no precedent for buildings of this kind, and often they display a grim grandeur resulting from the single-mindedness with which their designers pursued the objective of economy. The first of these new factories were built in England – where the earliest industrial advances, involving a greater use of iron and steam power, were made – but they were soon copied in Europe and America.

The United States can claim invention of the large office building. After the Civil War in the mid-19th century there was a boom in trade and industry. New office space was needed quickly, and land suitable for commercial buildings was expensive. Most industrial cities were laid out on a gridiron plan so that building lots were usually rectangular. In order to provide office space for the maximum number of people, architects started to build upward. The introduction of the elevator, and in particular the electrically powered elevator (invented by W. von Siemens in 1880) made it possible to erect buildings far higher than would have been practical when people had to reach the top floors by stair. At first architects used masonry but by the 1890s the steel frame was developed, and its use in skyscrapers was pioneered by the Chicago architects William Le Baron Jenney (1832-1907) and Louis Sullivan (1856-1924). Sullivan's buildings, such as the Wainwright Building in St Louis and the Guaranty Building in Buffalo, New York, make use of stone decorations at the top, where the bull's-eye windows are another decorative feature, and the masonry strips at the side are wider than their function – to cover steel stanchions – strictly requires. But buildings of this kind were the final stage before the introduction of truly modern architecture, and in building them Sullivan resolved to take his cue from "the individual cell, which requires a window with its separating pier, its sill and lintel, and without more ado, make them all look alike, because they all are alike."

However, skyscrapers created as well as solved problems. Traffic congestion increased

ABOVE the Carl Christenson motor works in Denmark, designed by the Danish architect Arne Jacobsen (1902-71). Known for his severely modern style, he also designed Copenhagen's first skyscraper. His theory was that "economy plus function equals style."

FAR LEFT one of the earliest skyscrapers, Louis Sullivan's Guaranty (now the Prudential) Building, built in 1895. True skyscrapers could not be constructed by traditional methods because of the immensely thick masonry walls that would have been needed to support all of the floors. The solution was found to be a framework of steel girders, which gave the buildings their characteristic vertical façade.

commissions such as the Sydney Opera House.

Large-scale housing schemes are also a product of industrialization and the resulting concentration of many people in large cities. The apartment house, which first appeared in the 19th century, seemed to provide an obvious solution, but like its precursors in the crowded areas of ancient Rome (which were up to ten stories high) it often produced appalling slum conditions. Far too many modern ones, some of them erected only within the past ten years, have ignored the obvious needs of families with children. Often the grounds around them are not designed for recreation, and the locality is devoid of other facilities for social life. High-rise towers have failed to generate the neighborhood feeling that was so characteristic – and so important – an element of the slum streets they replaced. Architects of the 1950s and 1960s, aided and abetted by local planners and policy-makers, introduced vast slum-clearance and rebuilding schemes that produced little more than a different kind of slum – the "slum in the air." The real needs of the people that such apartment complexes were designed to house were insufficiently taken into account. Certain particularly bad high-rise towers have already been abandoned; one prize-winning complex in the United States has been demolished.

Very recently, and none too soon, a reaction has set in against the "concrete wildernesses" that have scarred the faces of far too many cities in Europe and America. In the next few years the emphasis may again be placed on the small neighborhood, the home as distinct from the "dwelling unit," the people rather than the plan.

ABOVE the resort town of La Grande Motte, begun in 1967 on the Gulf of Lyon south of Montpellier, France. It was designed especially for its purpose as a leisure center by the Hérault provincial administration under its chief architect, J. Balladur.

because many people were trying to get to the same area, and buildings were often in each other's shadows. Modern town planners have had to learn the importance of insuring that a tall building will not overload local transportation services and that there is enough space around it to allow light into neighboring buildings. Architects have experimented with unique and unfamiliar shapes, especially in public

ABOVE a modern development of apartments in Buenos Aires, Argentina. When housing is scarce in overcrowded cities, the tendency is to build upward to fit as many people in as few square feet as possible.

RIGHT Neath Hill, a complex of rental housing in the center of the "new town" of Milton Keynes, near London. Corner stores and bus routes are part of the plan.

Chapter 6

THE GREAT ARCHITECTS

The art of designing and erecting a building calls for profound understanding of several related skills. A thousand years ago these skills could all be mastered by a single person – the master mason, who in the Middle Ages was both designer and builder. In Renaissance times a distinction began to be made between these two functions, but designers – now called the architects – frequently started their careers working as masons or engineers. The complexities of modern building are such that the architect requires the help of other professionals competent to deal with particular phases of the work: surveyor, quantity surveyor, structural and mechanical engineer all have their parts to play. Yet the first and final decisions remain with the architects; it is they who must grasp the potentialities of new materials and techniques and devise fresh answers for the multifarious social needs of mankind.

OPPOSITE skyline of Florence – dominated by the Cathedral of Santa Maria del Fiore, begun in 1294 and consecrated in 1436 after Brunelleschi's dome was built; the campanile or bell tower designed by the painter Giotto; and the city's oldest surviving building, the octagonal baptistery.

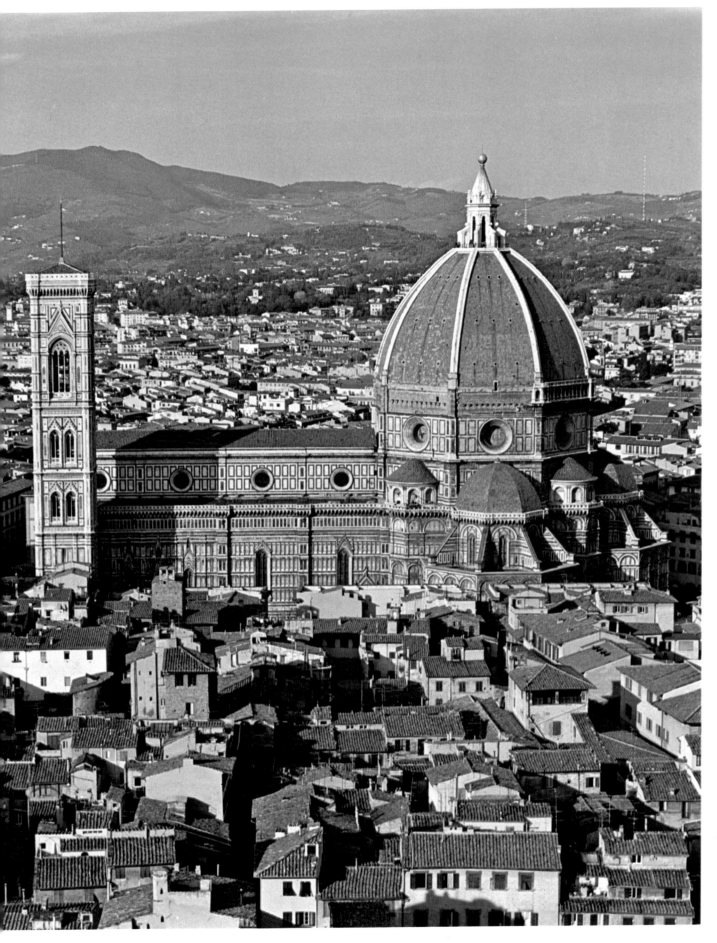

The Age of
Master Masons

The first architect became a god. Imhotep, builder of the earliest pyramid, the stepped pyramid of King Zoser at Saqqārah (about 2650 BC), was also the first person to make use of stone columns. Later Egyptians venerated him as a god. A different kind of immortality was conferred upon the great architects of ancient Greece and Rome. Their names are known, although little other information about them is, and the same is true of many of those who designed the cathedrals and abbeys of medieval Europe.

One of the reasons for this is that an element of mystery was deliberately fostered by the

RIGHT page from the album of architectural designs compiled by the 13th-century mason Villard de Honnecourt. These drawings were among studies for a château.

architects, or *masons* as they were called. Today a mason is simply someone who works in stone, but in the Age of Cathedrals – roughly the four centuries between 1000 and 1400 AD – the word meant very much more. The mason was the person who designed the building, organized the acquisition of the materials, and supervised all stages of the construction. The necessary skills

ABOVE the St-Denis Abbey, founded by King Dagobert I in the 7th century. Under Abbot Suger (1136-47) the basilica was built that marked the transition between Romanesque and Gothic, and for 12 centuries the kings of France were buried there.

were passed down in families of master masons from father to son, and they carefully guarded their methods of setting out geometric plans, obtaining right angles, and devising a system of proportion for use throughout a building. Some of the plans would be drawn on a plaster board or plaster floor and could be obliterated as soon as it had served its purpose. A plaster floor kept for this purpose at Strasbourg Cathedral was still in use in the 18th century.

Many building techniques had been forgotten during the long, dark centuries after the fall of Rome in the 5th century. Walls had to be built to a massive thickness in order to stay up with certainty. The stones were roughly cut and the core of the walls was filled with rubble. Stone for the upper levels was small, so that it could be carried aloft by hand. Mechanical aids, if present at all, were rudimentary. Towers seldom stood for long. After 1066 the Norman conquerors of England started building mighty cathedrals in the Romanesque style throughout the land. But the tower of Lincoln Cathedral lasted a mere 50 years. The central tower of the cathedral at Ely crashed to the ground in 1322.

In 1140 the foundation stone was laid for the new choir of the Abbey of St Denis, near Paris. Whoever designed this choir brought together architectural features from elsewhere in Europe and by combining them created the Gothic style. For the first time the pointed arch, the rib

vaulting, and the flying buttress appeared in the same building. At once, throughout northern Europe, the naves, choirs, and transepts of religious buildings began to soar heavenward. The master mason of St Denis started an architectural revolution – yet his name is not recorded.

This strange omission is characteristic of the age of anonymity, when only the names of nobles and clerics were thought worthy of remembrance. Within a couple of generations the growing self-confidence of the master masons led to the rejection of this tradition. Their names are recorded as are the great sums of money they could earn in salary and allowances. The links they maintained throughout Europe kept them abreast of new developments and the latest achievements, and they established an international organization of lodges under the control of the master of the Strasbourg lodge to look after their interests. They became the friends of princes. Eudes de Montreuil, who designed the choir of Beauvais Cathedral (the highest ever built at 158 feet), accompanied King Louis IX of France (St Louis) on the Sixth Crusade and worked in Cyprus and Jaffa.

The master masons, like the Gothic style,

ABOVE the flying buttresses of the west front of the Cathedral of St Pierre in Beauvais, north of Paris. Conceived as the largest in Europe, its construction spanned the 10th to the 16th century.

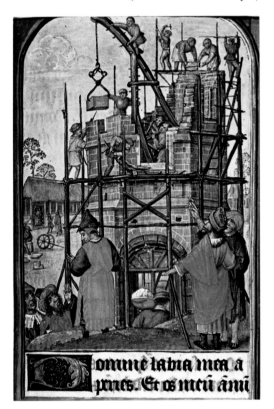

LEFT a 15th-century French manuscript illumination showing the work involved in the building of a cathedral.

knew no frontiers. Etienne de Bonneuil went from Paris to Sweden to build the cathedral at Uppsala. Members of the renowned Parler family worked on cathedrals throughout Europe. The openwork spires of Burgos Cathedral in Spain are the work of Hans of Cologne (Juan de Colonia), who based his design on drawings for the western spires of Cologne Cathedral. The Cologne spires remained unbuilt until 1880 when the long-lost drawings were rediscovered and the cathedral at last finished.

An album of such designs was discovered in the 19th century and is now in the Bibliothèque Nationale in Paris. It had been compiled by the 13th-century mason Villard de Honnecourt, who worked in Paris, Austria, and Hungary, and contains architectural sketches of the buildings he visited as well as designs of mechanical devices used by the masons and artisans of his day. The lengthy explanations alongside show that the album was designed as an instruction manual.

The achievements of the master masons is all the more remarkable in that they had little theoretical knowledge of mechanics to guide them. The various measures they devised to build higher and arch wider took into account the achievements and failures of their predecessors but were still essentially a process of trial and error. Eudes de Montreuil lived to see his vault at Beauvais collapse. Within 50 years it had been rebuilt and stands to this day – and though the master masons might have had little mathematical theory to guide them, many of their designs did work and have survived 700 to 800 years, monuments of engineering skill that are triumphant by any standard.

Filippo Brunelleschi

1377-1446

"Sent by heaven to renew the art of architecture" – this is how his Italian contemporaries regarded Filippo Brunelleschi. Gothic architecture had been the creation of northern Europe and was never a popular style in Italy, flourishing only in a few northern cities, notably Milan. It came to be seen as a barbaric – hence the term "Gothic" – interruption of the proper Italian style, which was the Roman style of rounded orders and classical columns. Brunelleschi led the way back to this "proper" style of building.

Born in Florence into the wealthy family of a notary, he early discovered an interest in the visual arts and was apprenticed to a goldsmith. In his spare time he studied mathematics and mechanics, and one of his achievements was the discovery of the principles of perspective. He drew several views of the squares of Florence showing buildings, streets, and objects diminishing gradually in size into the distance. This discovery caused a sensation among the artists of his time, who enthusiastically introduced foreshortening and vanishing points into their compositions.

In 1401 he submitted a design for the bronze doors of the baptistry. His came second to Ghiberti's and he angrily departed for Rome with his friend, the sculptor Donatello. The ancient buildings of Rome were a revelation to the two artists. Even in their ruined state Brunelleschi could recognize their greatness. He and Donatello drew the ground plans of dozens of buildings and measured hundreds of arches and cornices. When Donatello went back to Florence Brunelleschi continued on his own, working for Roman goldsmiths when he ran out of money, and nourishing his ambition to restore the best features of the architecture of ancient times. He particularly studied the Pantheon, the circular domed building that remains the unique complete survivor from the days of the Roman empire.

His study of this building proved invaluable when he returned to Florence offering to solve a dilemma that was causing the city considerable embarrassment. A large cathedral had been built

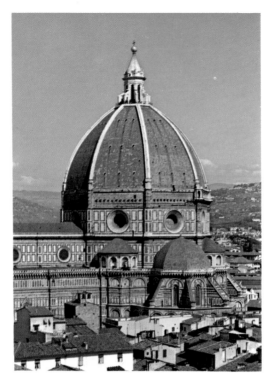

LEFT Brunelleschi's famous dome for the Duomo in Florence. He is buried in the cathedral, and his epitaph praises "both the wonderful vault of this celebrated temple and the many machines invented by his divine genius."

and an octagon constructed above the junction of the nave and transept; this was to be covered with a dome, just as the cathedrals of Siena and Pisa were domed. There was only one snag. Whereas the width of the dome in Siena was 70 feet, the opening at Florence was 138.5 feet, and no one knew how to build a dome across an opening that wide. There were no trees big enough to form a supporting framework across it – and even if trees could be found, the drum above the octagon was 180 feet above the ground, too high to support the strength of scaffolding that would be needed.

Knowing that the dome of the Pantheon measured 142 feet across, Brunelleschi realized there must be some way of covering the opening at Florence. The Pantheon had been built, he discovered, not by adapting the principle of the arch – shaped stones supported by a temporary framework until the keystone was placed in position at the top – but by casting in concrete in horizontal layers, each layer being allowed to harden so that it could support the next. Unfortunately, this method could not be used in Florence because the drum was too thin to support the enormous weight of the concrete necessary. It was Brunelleschi's genius that enabled him to combine the Roman practice of concentric circles with the Gothic principle of stone ribs to take the thrust. Eight large ribs and 16 smaller ones between each pair of large ribs were built upward in self-supporting courses of brickwork laid in herringbone pattern. It is this method of construction that gives the dome its

ABOVE anonymous bust of the architect above his tomb in the Duomo. Most of what is known about his life and career comes from a biography written in the 1480s by a young contemporary admirer.

pointed appearance, a new shape in Western architecture.

Brunelleschi was very secretive about his plans and overrode the doubts and objections of his critics by the sheer force of his self-confidence. He designed the scaffolding, invented a special hoist for conveying material into the dome area, and supplied exact models for every shape of brick required. While it was going up he worked on several other buildings, all in Florence. First was the Foundling Hospital, begun in 1419, which he designed as a deliberate contrast to the Gothic style. Instead of massive piers resembling clustered pillars, he introduced slender unfluted columns of the old Corinthian order, pediments above the windows, and ceilings that are either flat or *coffered* – having deep concave moldings. For the Church of San Lorenzo he drew on the antique motifs of frieze and *pilasters* (flat half-columns) and painted the whole interior white with bands of gray stone to emphasize the proportion and the shapes.

His masterpiece is the Pazzi Chapel (erected between 1442 and 1461) which, though small, can rank with the most famous buildings of the world. It may not closely resemble a building of ancient Rome (Brunelleschi was never a mere imitator) yet it makes a firm break with Gothic. The delicate columns of the portico give a marvelous sense of lightness and grace. Inside there are no pillars nor narrow windows but an amazingly open space with gray stone pilasters to emphasize the shapes again. The gradations

LEFT looking up into the dome of the old sacristy in the Church of San Lorenzo. Originally intended as a Medici family mausoleum, Brunelleschi designed it as a cube vaulted with a hemispherical dome and decorated with characteristic elegance and restraint.

of color throughout the interior are of great delicacy and extend to the glazed terra cotta roundels.

Brunelleschi lived to see the work begun on the elegant *lantern*, a small decorative structure that crowns the cathedral dome. Completed after his death, the whole edifice stands, as its designer knew it would, as an imperishable monument to the first Renaissance architect.

RIGHT the interior altar wall of the Pazzi Chapel, Florence. The glazed terra cotta roundels were unprecedented in church decoration, and the creamy walls are further marked off by geometric patterns in dark gray stone.

Donato Bramante

1444-1514

ABOVE anonymous engraved portrait of Bramante, who introduced the style of the High Renaissance through his work in Rome at the beginning of the 16th century.

Florence saw the creation of Renaissance architecture, but artistic leadership soon passed to Rome. The man who took it there was Donato Bramante, a 55-year-old architect who had been born into a well-to-do peasant family near Urbino in Umbria. He had worked in Milan and had become the close friend of its ruler, Ludovico Sforza. But in Rome he became the personal friend and confidant of the pope himself, Julius II, the greatest patron of the arts the church had ever seen and a man fired with the determination to rebuild Rome in a manner fitting its position as capital of the Christian world and heir to the empire of the Caesars. Bramante seized this stupendous opportunity and for the last 12 years of his life designs of amazing boldness poured from his brain.

His early years are obscure, but at the time he came to maturity the small town of Urbino was enjoying its most brilliant period under the benign and cultured rule of its duke, Federigo da Montefeltro. The painter Raphael was born

there. Another painter, Piero della Francesca, worked there and the young Bramante's first job is thought to have been as Piero's assistant. His interest in architecture developed early and he studied the designs of buildings during his travels to Rimini, Mantua, Padua, and of course Florence. Until he was over 30 years old his main occupation seems to have been that of planning and painting architectural perspectives for other painters to adapt and incorporate into their compositions.

In 1477 he settled in Milan, where for nearly 20 years he worked in the company of the greatest intellectual genius of the age, Leonardo da Vinci. Bramante learned much from his great colleague, and his memory of Leonardo's plans for octagonal churches was to help him create the imposing ground plan for St Peter's Basilica in Rome 20 years later.

His first building in Milan, completed about 1482, was the oratory of Santa Maria presso San Satiro, which he designed as a rectangle on an east-west axis and with a central dome. While it was being built the monks asked for the oratory to be extended and made into a church. Bramante boldly transformed his rectangle into a transept, building out the nave southward. Lacking the space for a choir he seized the opportunity to show his knowledge of perspective, and by architectural foreshortening and painting created the illusion of a long barrel-vaulted choir behind the altar, when in fact it was only a few feet deep. From the viewpoint of a spectator standing at the south door of the nave

BELOW LEFT the oratory of Santa Maria presso San Satiro, the first architectural work that can be definitely attributed to Bramante, in which he created an illusion of space.

BELOW RIGHT Bramante's design for Santa Maria della Grazie in Milan, showing the main altar. The many round windows provide much more light than was usual in churches.

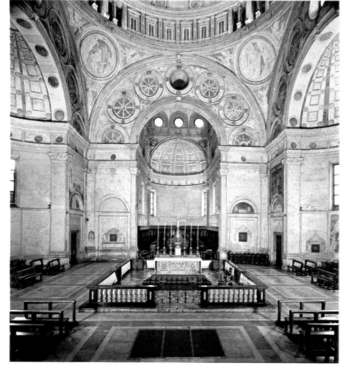

this ingenious piece of *trompe-l'oeil* (optical illusion) appears to double the length of the church.

Bramante worked with other architects on the design of Pavia Cathedral (1488) where, as later at St Peter's, the problem was one of grouping together large spatial units. Back in Milan, he built the choir of Santa Maria della Grazie in 1492 at the same time that Leonardo was painting his *Last Supper* there. Bramante's choir is a wide space flooded with light from the numerous windows in the 16-sided drum above, and historians have sensed in this design the tensions of a man longing to do greater things than his patrons require. When Milan was captured by the French in 1499 Leonardo went to France but Bramante left immediately for Rome. The scale of the buildings there stirred him to produce the astonishing plans of his more severe, but grand-scale "last manner."

To begin with, he spent a period of time studying the buildings of antiquity, assimilating their principles together with what he had already learned in Urbino and Milan. His first building, in 1502, was the small Tempietto of San Pietro, built on the traditional site of the martyrdom of St Peter. This small circular building was the first truly classical structure built in Rome since the fall of the empire. Appropriate to its memorial function, the columns are Tuscan Doric, the most severe and unadorned of all the orders.

The Tempietto was Bramante's tribute to ancient architecture. Next, about 1505, he designed the magnificent Cortile del Belvedere, a courtyard and garden flanked by two arched galleries, each 1000 feet long, stretching from the buildings around the Sistine Chapel to the distant Villa Belvedere. These extraordinarily long buildings were consciously designed to rival the imperial palaces of ancient Rome. Nero had had his Golden House on the Palatine Hill; Pope Julius would have his own equivalent on the Vatican. Although both building and garden have been changed since Bramante's day, they exerted an enormous influence on formal garden design in the 16th century.

Eventually, in 1505–6, came the commission to rebuild St Peter's Basilica. The crumbling remains of the basilica erected by Constantine 1000 years before were cleared away – earning for Bramante the name "Maestro Ruinante" ("Master Wrecker"). In its place he designed a domed basilica with the ground plan of a massive Greek cross with four identical apses and chapels in the four corners, each with their own smaller apses. The deaths of Pope Julius II in 1513 and of Bramante himself the next year brought the work to a halt. All that had been completed were the four colossal piers and arches of the crossing. The nave was later lengthened and Michelangelo redesigned the dome, but the imposing monumentality of what Bramante had built dictated the style of the basilica as it now is. The "grand manner" created by Bramante in the early years of the 16th century lasted as the "proper" style for important buildings until the Gothic revival 300 years later.

BELOW LEFT the Tempietto of San Pietro in Montorio. This small church marked the first reappearance of purely classical architecture in Rome since the fall of the empire.

BELOW RIGHT the Basilica of St Peter's in Rome, one of the most ambitious building projects ever attempted and considered Bramante's greatest work. He is buried there.

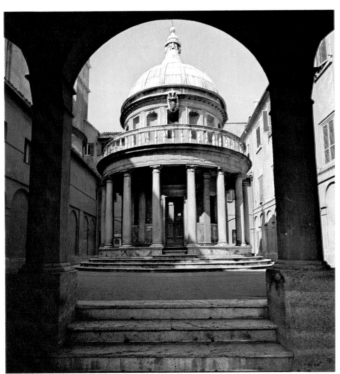

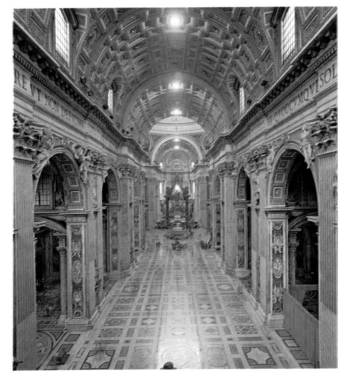

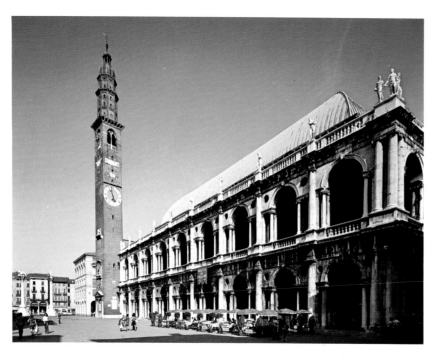

Andrea Palladio

1508-1580

ABOVE a Palladio exhibition at the Basilica in Vicenza, his first major public commission. The building was not actually completed until 1716, after the architect's death, and it involved recasing a vast 15th-century hall with a two-story arcade of white stone to serve as a buttress to the medieval structure.

count took with him to Rome, and there Andrea remained for two years, drawing the ancient buildings and the more recent ones by Bramante, Michelangelo, and other leading architects. The fruit of this labor was *The Antiquities of Rome* (published in 1554), a scholarly work that remained the standard guidebook for 200 years.

Back in Vicenza in 1548 he won the competition for a structure to surround the medieval Palazzo della Ragione (town hall). He designed a two-story screen of arches, the lower with Doric and the upper with Ionic columns, and the building has come to be known as the Basilica, so perfectly does it suggest one of the great basilicas of ancient times. Bramante is an obvious influence but, while Palladio's proportions are, as always, meticulously correct, by including such features as masks on the keystones and figures and festoons as decoration he gave the building a rich yet attractively light appearance. It established his reputation, and the remaining 30 years of his life were filled with commissions for palaces, villas, and churches. In 1570 he published the *Four Books on Architecture* in which he presented his architectural theories, copiously illustrated with drawings of his own and (a few) other people's buildings. These volumes spread the chaste, somewhat Puritan "Palladian" style throughout Protestant Europe. (Catholic Europe preferred the baroque.) In England, Ireland (then ruled from England),

Vicenza is a small and ancient town on the Venetian mainland, but its importance in the history of architecture lies in its large number of palaces and villas designed by Andrea Palladio, last of the great Renaissance architects.

His true name was Andrea di Pietro della Gondola, and he was born of humble parentage 20 miles away in Padua. When he was 14 he was apprenticed to a sculptor but left after only three years of service and went to Vicenza. For the next 14 years he worked for two sculptors until at the age of 30 he was noticed by Count Giangiorgio Trissino while at work on the construction of his villa. Trissino was a man of wide cultural interests, a poet, philosopher, and amateur architect. He had made his villa into an academy of humanist learning, and he encouraged Andrea to study mathematics, music, and Latin. An epic he was then writing was entitled *Italy Liberated from the Goths*, and he gave to Andrea the name of the winged messenger that featured in it – Palladio.

Andrea profited immediately from the count's patronage and was soon mixing on equal terms with the well-born young students at the Academy. He was one of three students the

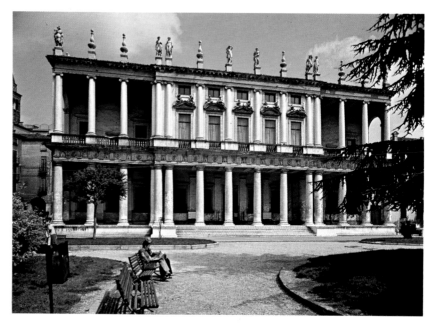

ABOVE the Palazzo Chiericati (1550), based on the idea of an extended forum enveloping a loggia or roofed open gallery. The colonnaded elevation is divided into three parts to provide a central focus.

North America, and the West Indies, the style was adapted for public and private buildings alike.

Its essential features are symmetrical planning and a precise system of proportion. The measurements of the rooms and of the building as a

whole, as well as the placing of the smaller flanking buildings, followed certain simple mathematical ratios. In the Villa Pisani at Bagnolo, for example, completed in 1542, the smaller rooms measure 16 by 16 feet, the middle ones 16 by 24 feet and the largest one 18 by 30 feet, ratios of 1:1, 2:3, and 3:5. In his many villas dotted around among the small towns and countryside of the Veneto, Palladio experimented with variations on the basic ground

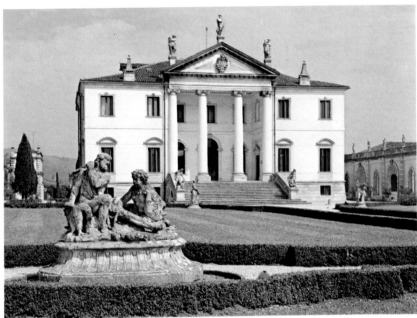

ABOVE the Villa Cordellina-Lombardi at Montecchio, near Vicenza, showing Palladio's characteristic roofed porch supported by four columns.

LEFT engraving of Palladio.

BELOW La Rotonda, a hilltop summerhouse of completely symmetrical plan with central halls surmounted by domes.

plan of large central hall, living rooms or bedrooms on either side, and between these and the hall space for staircases. The façades of his villas he adapted from classical temples because, as he explained, they "add very much to the grandeur and magnificence of the work; the front being thus made more eminent than the rest." The Villa Capra or "La Rotonda" (1550–51) has a temple portico on all four of its façades, whereas the Villa Cornaro (1552–3) has a double portico – a feature much imitated in colonial America. These are two of Palladio's grander compositions but there are others, such as the Villa Saracena (1545), that are considerably smaller. All, however, are elegant, unfussy, and practicable, whether designed as a setting for musical entertainment or, like the Villa Badoer (1556), as a working farm where the lesser buildings are within sight of the main building so that the owner could keep an eye on things.

In Vicenza itself he designed eight palaces which, after a further visit to Rome, showed an increasing massiveness in the lower story. In the beautiful Palazzo Valmarana (1565), giant pilasters the height of the building contrast with smaller ones framing the windows. In Venice

toward the end of his life he built four churches (two of which were unfinished when he died), and for these too he triumphantly adapted the façades of classical temples. Four giant columns or pilasters with a pediment above mark the front of the nave and seem to thrust through the lower pediment and smaller columns that mark the aisles on either side. So successful was this integrated design that versions of it were still being erected 300 years later.

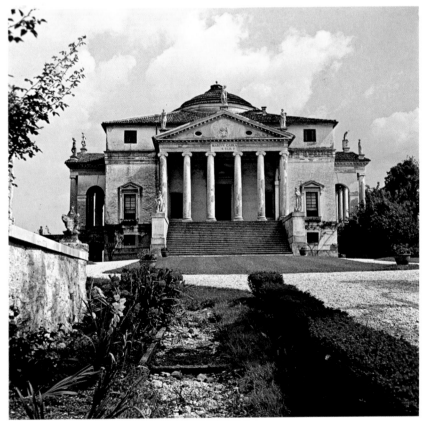

Christopher Wren

1632-1723

Christopher Wren, known as the greatest of English architects, did not in fact design a single building before he was 30 years old. He was born into a family of churchmen – his uncle became a bishop – and his early passions were for mathematics and astronomy. At the age of 25 he was appointed professor of astronomy in London and four years later he moved to Oxford. It was at Oxford that he was asked to design a support for a wide ceiling, needed for a building without columns.

Wren devised a method of supporting the ceiling *from above* using an ingenious framework of timber trusses. The building was built between 1662 and 1669, and it is now the Sheldonian Theater.

Evidently this fired his interest in architecture because he spent the following year in Paris studying churches and châteaus. Shortly after

ABOVE Wren, painted in 1711.

RIGHT the interior of Wren's Church of St Stephen, Wallbrook, in which, within the outer walls, a dome and vaulted nave are carried on a system of isolated columns.

his return to London the Great Fire of 1666 destroyed a large proportion of the city, including more than 80 churches, and left the old Romanesque St Paul's Cathedral in ruins. Wren was appointed a member of the commission to plan the rebuilding and three years later he became Surveyor-General in charge of all the public works. By 1673 he had already achieved so much that King Charles II knighted him.

His fame rests on his 51 city churches and his

ABOVE the northern range of buildings, showing one of the two domes that face each other across an open courtyard, of Wren's colonnaded Greenwich Royal Hospital, which in 1873 became the Royal Naval College.

masterpiece, the new cathedral. The churches were designed and built with remarkable speed. Nearly all were completed by 1687, though some of the steeples were added later. These elegant stone structures are one of the most attractive features of Wren's work, and though nearly all his churches were severely damaged in the air raids of World War II, and several were totally destroyed, most of the steeples survived or have been rebuilt as they were.

One effect of the war and modern develop-ment has been to expose Wren's churches to views he did not intend. He had to build on the cramped sites of existing churches, hemmed in by rebuilt houses and shops, and though he gave a few of the churches façades, the majority have simple exteriors of brick with stone dressings. The parts that were to be seen were the steeples and the interiors. These are astonishingly varied. The Church of St Bride, Fleet Street (1670–84), has a nave divided from two aisles by arcades carried on large coupled columns. This is a classic design for a straightforward rectangular site. In St Martin, Ludgate (1677–84), which is almost square, two barrel vaults intersect at right angles above the center. St Mary Abchurch (1681–6) is also square but is roofed with a shallow dome carried on cantilevered arches rising directly from the walls. Wren's most distinguished design is for St Stephen's, Walbrook (1672–9), which is also domed, but there the dome rests on a complex arrangement of arches and columns.

The interiors of his churches were filled with rich woodwork and plaster, sometimes gilded, but large areas of wall were left white and Wren introduced no stained glass. He did not dislike

the Gothic tradition but the effect he wanted was of clear light falling on contrasted plain and molded surfaces.

Wren worked on several secular buildings around London, notably the Chelsea Hospital for retired soldiers (1682-5) and the superbly placed wings of the Greenwich Hospital for retired sailors (begun 1696). His impressive additions to Hampton Court Palace (1696-1704) for King William III are attractively built in stone and a richly colored brick. But his greatest achievement was St Paul's Cathedral.

Work began in 1675. While the site was still being worked on, Wren asked for a stone to mark a particular spot. One was picked up at random and was found to be part of an old tombstone inscribed with the word *Resurgam* – "I shall rise again."

Wren, like Bramante at St Peter's in Rome,

ABOVE St Paul's Cathedral, one of the landmarks of London. No one with a dome to build could ignore his masterpiece; versions of it can be found from Leningrad to the Capitol Building in Washington, DC.

ABOVE LEFT an arch of plain glass illuminates the interior of Wren's Church of St Mary Woolnoth, combining gilded plasterwork with smooth white walls.

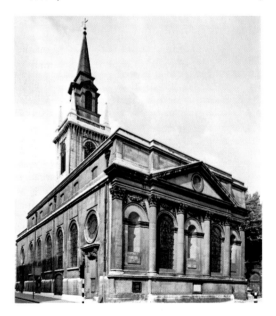

LEFT St Lawrence Jewry Church (1671-7), one of over 80 that Christopher Wren designed for the rebuilt City of London. Wren's steeples even became a worldwide symbol of the Anglican church.

to believe that Wren seriously proposed to construct it. However, the clergy approved and Wren set his masons to work. From the outset the plans were altered, and in every case for the better. The clergy had wanted the aisles to be half the height of the nave. Wren built the aisle walls to the height of the nave, thus giving the building an immensely grander appearance and suggesting that the interior is the same great height all the way across. But this is not the case. The upper wall is a false wall, with blind niches in place of windows; on the other side of it, unseen buttresses rise from the flat roof of the single-story aisles to support the high nave. Between the buttresses wide windows pour clear light down into the interior of the cathedral.

Wren's ingenuity extended to the dome, which is made up of an outer dome and an inner, much lower dome. Between them is a brick conical structure that supports the weight of the lantern, and at the base of the cone are windows, unseen from below, that allow light to pass down through the cone to the eye of the inner dome. St Paul's Cathedral, adorned with rich stonework on the exterior and topped with its spacious dome, is a marvel of construction.

Wren lived to see the building completed, in 1709, and when he died, aged 91, he was buried in the cathedral he had built. His grave is marked with a simple epitaph: *Lector, si monumentum requiris, circumspice* – "Reader, if you seek a monument, look around you."

wanted the plan to be a Greek cross with four equal arms and a dome. The clergy wanted a long nave and a steeple. Being a peaceable man, Wren proposed a compromise – a short nave and a steeple placed on top of a dome. This strange conjunction would have made the cathedral look more like a Buddhist temple, and it is hard

Francesco Borromini

1599-1667

The tragedy of Francesco Borromini was to live in Rome at the same time as the more popular Gianlorenzo Bernini. To Bernini, the urbane extrovert, constantly-in-demand sculptor turned architect, life was an almost unbroken succession of triumphs. His character could hardly have been more different from that of the neurotic, resentful Borromini, whose innovatory work was often misunderstood and frequently aroused controversy. In the last years of his life disillusionment and mental illness overwhelmed him, and at the age of 68 he ran himself through with his sword.

He was born Francesco Castelli in Bissone on Lake Lugano, in northern Italy. While still a boy he was trained as a sculptor and architect in

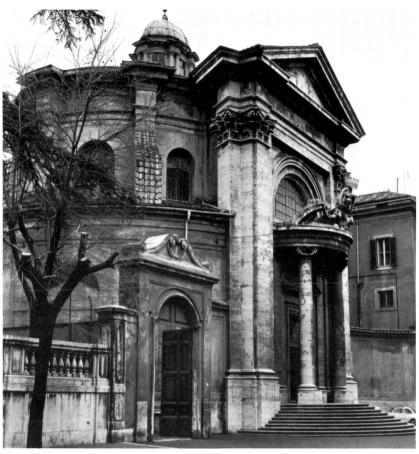

ABOVE the Roman church and monastery of San Carlo alle Quattro Fontane, for which Borromini stacked three distinct units: an undulating lower zone, a middle section suggesting the shape of the Greek cross, and an unusual oval dome.

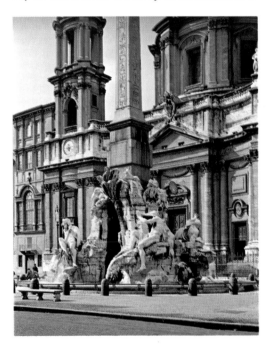

LEFT the Church of Santa Agnese in the Piazza Navona, a commission Borromini began in 1652. Bernini's Fountain of the Four Rivers stands in front of the church, and a popular legend has it that the face of the statue of the Nile is covered so that it does not have to look at Borromini's work, while the figure representing the Plate holds out its arm as though to prevent the church from falling over.

Milan. At the age of 20 he left the region and made his way south to Rome. There he worked for his distant kinsman Carlo Maderno, the latest of the many architects in charge of building St Peter's, and changed his name to Borromini.

For ten years he carved coats of arms and balustrades at St Peter's, first for Maderno and then under his successor, Bernini. Both men recognized and encouraged Borromini's architectural talents, and in 1631 he became Bernini's assistant on the construction of the Palazzo Barberini. One of his first identifiable architectural works is on the palazzo – a top-floor window capped with an undulating pediment and with the corners turned outward at an angle of 45 degrees. This restless, twisting line is characteristic of all Borromini's work and seems to give expression to his neurotic personality.

His first opportunity to work on his own came in 1638 with the commission to build the monastery of San Carlo alle Quattro Fontane. In the small cloisters he typically replaced the usual right-angle corners with convex curvatures that carry the eye smoothly on without a break. But it is the interior of the church that astounded his contemporaries and established Borromini's reputation as a master of capturing space and giving movement to solid form. The site is small and awkward, and it is said that the entire area of the church is no bigger than that occupied by one of the piers that support the dome of St Peter's. The shape is roughly that of a diamond with rounded edges. Columns line the walls, and the doors, niches, and moldings between the columns tie the undulating surfaces together so that the eye wanders around it without interruption. Above the columns a cross-

shaped transition area leads to an oval dome that is flooded with light, through windows surrounding the base but concealed by a wreath of ornamental foliage. The maze of hexagons, crosses, and octagons coffered onto the dome seems to float in space.

The bold achievement of this church attracted visitors from all over Europe – and even from India – who tried to obtain the plans. It also attracted criticism from architectural purists who complained that Borromini had broken the rules of architecture. Certainly he had broken away from particular traditions accepted without question by Italian architects since the Renaissance. Briefly, this humanist tradition held that since God created Adam in his image, so buildings should be based on the proportions of the human body or, alternatively, on the perfect shape of a circle. Borromini, however, based his buildings on geometric shapes in a manner reminiscent, though perhaps unconsciously, of the Gothic builders.

His mastery of geometric form was again demonstrated in his second church, that of San Ivo della Sapienza (1642–60), also in Rome. The ground plan there is a six-pointed star with concave and convex recesses alternating in the "points." This quite unprecedented shape gives

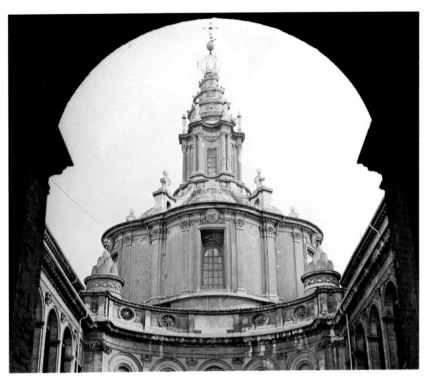

ABOVE the spire of the Church of San Ivo della Sapienza.

BELOW the basilica of San Giovanni, completely restored.

the walls an amazing swaying rhythm while a vertical movement is carried up by 18 fluted pilasters to the base of the dome, where the gilded ribs of the vaulting take it soaring up until it comes to rest in a circle surrounded by stars. The effect is breathtaking. The dome is extraordinary from the outside also, because Borromini encased it in a stepped pyramid and surmounted it with a golden spiral, a strange motif recalling Babylonian ziggurats.

Between 1644 and 1655 the papal chair was occupied by Innocent X, no friend to Bernini, and Borromini received a succession of commissions that kept him occupied until his death. He helped restore the ancient basilica of San Giovanni in Laterano. He took over the plans of the Church of Santa Agnese in the Piazza Navona, transformed the interior by a few seemingly minor alterations, and designed a façade of the sort that had been intended for St Peter's – a dome flanked by two towers. Bernini's Fountain of the Four Rivers stands in front of Santa Agnese, ironically enough.

At the end of his life Borromini returned to San Carlo and built the voluptuously swaying façade of convex bays and bulging balustrade. Throughout his career he had questioned architectural tradition. No one before him had given such energy to walls and façades, yet however unorthodox his designs were, his sense of structure masterfully tied the elements together and unified them. His achievement gave an enormous impetus to church and palace architecture north of the Alps.

Johann Balthasar Neumann

1687-1753

The Portuguese call pearls of irregular shape *barroco*, meaning imperfectly rounded. When in the 17th century the style of building derived from Renaissance architects began to bulge and twist, the word was transferred from the jeweler's art to architecture and gave rise to the term *baroque*. In baroque architecture the oval was preferred to the circle as being a shape that implies movement. Architects took a delight in large sweeping vistas, and architecture competed with sculpture and painting (and frequently incorporated them) to stir the emotions of the onlooker.

Central Europe, ravaged by the Thirty Years' War and other 17th-century disasters, took up the baroque a century after it had first emerged in Italy and Flanders. This late baroque was soon flourishing in Vienna, Bohemia, and Bavaria but reached its astounding climax in Franconia, a region of small principalities and bishoprics immediately north of Bavaria. There an architect of genius encountered patrons with ambition – a succession of prince-bishops of Würzburg and Johann Balthasar Neumann.

Born at Eger in Bohemia into a family of cloth-makers, Neumann trained as a cannon-founder and left his hometown to study military engineering in Würzburg. He enlisted in the palace guards as a lieutenant, the bishop made him an architect, and in 1720 he was appointed one of the two surveyors of the Residenz, the vast episcopal palace being built in Würzburg. Work continued on this project over a number of years under the patronage of different bishops of the Schönborn family, but its glory is Neumann's staircase. A central flight leads up to the landing, turns through 180 degrees, and returns in two flights. Gradually the unsuspected vastness of the ceiling area is disclosed and seems even wider than it is because a balcony runs all the way around the upper level. The walls supporting

ABOVE the central staircase of the Residenz Palace in Würzburg (1719–46), Neumann's great memorial to the late baroque style.

LEFT a detail from the ceiling decoration of the Würzburg Residenz (above), painted by the Venetian artist Giovanni Battista Tiepolo. The soldier figure sitting on a cannon is a portrait of the architect (Neumann had started out as a cannon-founder).

the painted ceiling are thus set back and out of sight of someone climbing the stairs. No columns support the ceiling, though it has a span of 60 by 107 feet, and Neumann had to face many objections before he could build it. So sure was he of the soundness of his bold design that he offered to let a cannon be fired inside the staircase. In fact, the staircase did survive the air raids of World War II that destroyed so much else of the palace.

Another of Neumann's staircases, designed in 1731 for the Schloss Bruchsal northwest of Karlsruhe, also developed the typically baroque sensation of climbing into a brighter world. From a somber ground floor the two arms of the

staircase curved up on either side of an oval chamber. The chamber, visible through arches, was also dimly lit, but as the stairs were climbed the vault above grew lighter and lighter until the main floor was reached, an oval platform (above the oval chamber) surrounded by high windows frothing with delicate curves and wisps of stucco decoration. Those who climbed this staircase have said that it provided a very dramatic sensation. Alas, it was destroyed in World War II.

Delicate stucco reliefs are characteristic of late

baroque and its successor, the even more delicate *rococo*, with its pastel, ivory, and gold coloring and the enormous ornate variety of its elegant moldings. It was one of several means available to architects who wished to bring about a unity in their work. Neumann's masterpiece of blended baroque and rococo, begun in 1742, is the pilgrimage church of Vierzehnheiligen – "The 14 Saints" – near Bamberg. The site of the church is dramatic, with its yellow-brown towers soaring above the river Main; the exterior is admirable but in no way leads you to anticipate what lies within. In fact, the façade cunningly *misleads* because it seems to belong to a church of the pattern of straight nave flanked by two straight aisles. This is very far from being the case. The interior is a whirling arrangement of interconnecting ovals. The choir is oval, the transepts are circles, and the nave is made up of three successive ovals, the last of which contains the oval central altar, once described as "half a coral reef and half a fairy sedan chair." Light pours in through unexpected vistas at this focal area of the church: this, not the crossing of nave and transept, is the center of the composition. And as though to emphasize this point there is no dome above the crossing. Instead, the white and glittering transept arches simply come together and form one end of the elaborately

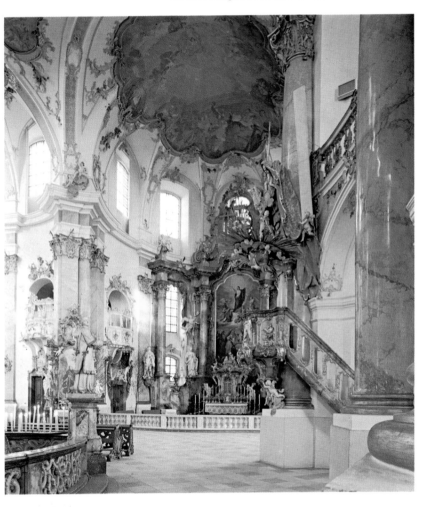

ABOVE the high altar of the pilgrimage church of Vierzehnheiligen, a whirling arrangement of interconnecting ovals of which this painted and gilded area is the focal point.

.ABOVE LEFT courtyard of shops and apartments built by Balthasar Neumann in 1724 while he was working in Würzburg.

outlined, richly painted ceiling fresco above the central altar. The interior is light, airy, dancing with delicate color, and foaming with stucco. And it is not, like so many achievements of the rococo, a palace architecture, a place for the private delight of princes, but the setting and expression of the intense religious devotion of local people.

Neumann by no means limited himself to palaces and fine staircases, nor even to the church designs of which he was a brilliant master.

From 1729 he was appointed superintendent of every kind of construction throughout Würzburg and Bamberg and later also in Trier and Speyer, where two other members of the Schönborn family were bishops. Neumann was responsible for military fortifications, streets, bridges, and garden designs. He set up a fresh water supply for Würzburg and even built a "shopping center" of eight shops and attached apartments. But by the time Neumann died, celebrated and prosperous, a reaction had set in against baroque and rococo. Elsewhere in Europe the new severity of neoclassicism was in favor, but in central Europe the ornamental exuberance took longer to fade away.

Robert Adam
1728-1792

By the middle of the 18th century a reaction had set in against the wilder excesses of the baroque style. On hand in Britain to exploit this change in taste was Robert Adam, second of the four sons of a leading Scottish architect. Born in the small town of Kirkcaldy, Fifeshire, he entered his father's Edinburgh architects' office at the age of 18. After his father's death he and his elder brother John went into partnership and were given lucrative government contracts for building coastal forts. He worked on the interior decoration of Hopetoun House near Edinburgh, the home of the Earl of Hopetoun, and in 1754, now a wealthy young man, he accompanied the earl's younger brother to Italy.

There, he was torn between his fondness for the delights of society life and his ambition to enlarge his artistic knowledge. Art won, and he spent four years studying what he called "the solid foundation of genuine antiquity." In this respect he resembled generations of young architects before him. But unlike them he was critical of the indiscriminate application of monumental forms derived from temples. He argued that an ancient Roman did not spend his entire life inside a solemn temple. "With regard to the decoration of their private and bathing apartments, they were all delicacy, grace, and beauty." The early discoveries at Pompeii were being made during his stay in Rome but the excavators were intent on keeping their findings secret. For an understanding of Roman domestic architecture Adam had to rely on such rare surviving examples as the so-called *grotesques* painted on the walls of Nero's Golden House in Rome. He also journeyed to the ruins of the Emperor Diocletian's palace on the coast of modern Yugoslavia, a building so extensive that the town of Split had grown up within its walls.

He returned to London, his head teeming with decorative motifs – ram's heads, sphinxes, urns, griffins . . . all features that were to recur again and again on the ceilings and walls and furnishings of the country houses on which he worked. He built few entire buildings, though toward the end of his life he was responsible for a number

RIGHT the elegant entrance hall of Osterley Park, an 18th-century English country house near London that was remodeled by Robert Adam. The geometric shapes are emphasized by the design of the marble floor and the patterns of the stucco work on the walls and ceiling.

ABOVE neoclassical portrait, in keeping with his characteristic style of architectural decoration, of the 18th-century Scotsman Robert Adam.

of neo-Gothic castles in Scotland. His main work lay in adding onto existing houses or reconstructing their interiors.

At Osterley Park near London his exterior work was limited to the wide flight of steps and double screen of columns that fills the fourth side of the square. This makes an imposing approach to the palatial house, but it is in the interior (1761–80) that Adam's genius is revealed. He believed that an architect's responsibility was not limited to erecting the structure of the house but embraced the whole appearance of it. So the oval pattern in the marble floor of the entrance hall echoed the oval plasterwork of the ceiling; the *ormolu* (gilded metal) griffins on the front of the commode in the sumptuous drawing room are repeated in gilded wood above the doors. The furniture was designed for this particular house: braziers, andirons, mantel-

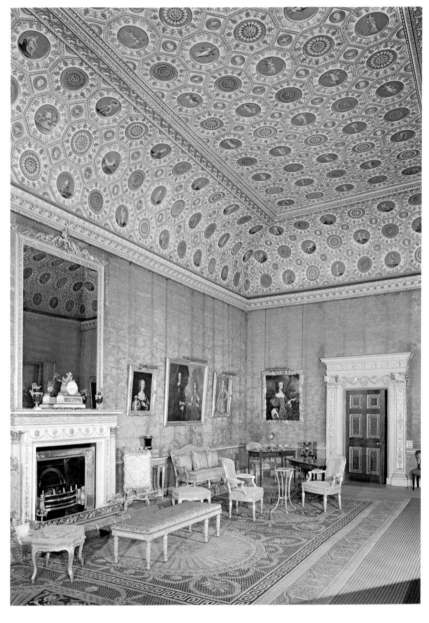

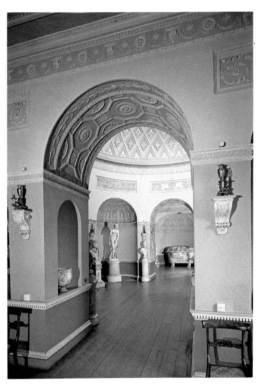

as Nostell Priory (1766-85) or Newby Hall (about 1767-85), both in Yorkshire, exquisitely delicate patterns of neoclassical motifs appear in relief against panels of pink, pale blue or green. The effect is airy and light, yet domestic – though large rooms were, of course, required to show them off properly.

Between 1768 and 1772 he and his younger brother James embarked on the ambitious project of building a terrace of grand houses in the Adelphi, a tract of land between the Strand and the Thames in London. They were spacious and elegant but failed to sell, and the Adams brothers were brought to the verge of ruin and

pieces, candlestands, even doorknobs reveal Adam's close attention. He employed teams of plasterers, carvers, sculptors, carpetmakers, and metalworkers to produce work to his satisfaction.

Some of his early designs are heavy and florid. There is an overpowering richness to the state rooms at Syon House, also near London, remodeled from 1762 to 1790. The first three rooms each display a different order of columns – Doric to give grandeur to the statues in the great hall; highly polished Ionic columns topped with gilded statues in the anteroom; and a dining room that exhibits one of Adam's favorite motifs, an apse at each end flanked by Corinthian columns.

Adam was also fond of colored plasterwork, which he introduced "to take the crudeness off the white" color that had previously been obligatory for all plaster. On the ceilings of such houses

ABOVE the Red Drawing Room at Syon House, reflecting the heavier, more florid side of Adam's style of interior decoration. The doorway is enhanced in importance by its ornate architrave.

ABOVE RIGHT the Sculpture Gallery at Newby Hall in Yorkshire, for which Adam used rose pink coloring and a pattern of repeated arches to create a feeling of serenity.

had to dispose of their assets in a lottery.

Neoclassicism as popularized by Adam was an eclectic style. He drew its elements from a wide variety of existing styles and showed a genius for tasteful recombination. Classical motifs were rendered with the feeling for movement that came from the baroque; he adapted features from the contemporary French rococo of Louis XV and from the fanciful "grotesques" of Renaissance Italy. There was always the danger that this style would degenerate into frivolity, and at the end of his life the fashion revived for more severe, supposedly "Greek" architecture. But the concern Adam had applied to the "general look" of a room was a lasting innovation. The style of rooms today may be vastly different, but the principles by which modern interior decorators work is the same and can be traced directly back to Adam.

Antoni Gaudí

1852-1926

"One of the most hideous buildings in the world"; "Horrible, still unfinished, and I trust never to be finished." These are two contemporary reactions to the fantastic creation of Antoni Gaudí y Cornet – the Church of the Sagrada Familia – whose great towers soar like gigantic, corroded hock bottles above the office buildings of Barcelona, Spain. But others took a different view. Walter Gropius, an architect who designed very different buildings from those of

ABOVE thin-shell, laminated tile vaults twist into uncanny shapes to form these spires atop the Casa Batlló, a multi-story apartment building in Barcelona that Gaudí renovated between 1904 and 1906.

BELOW Church of the Sagrada Familia (Sacred Family), in a photograph taken in 1977.

Gaudí, described the walls of the Sagrada Familia as "marvels of technical perfection."

Gaudí is unique. There was never another architectural vision like his, and it is doubtful if any building comparable to his will ever be erected in the future. His career spanned the last quarter of the 19th and the first quarter of the 20th century, a period during which many architects rebelled against the spate of revivals that had inspired the dominant characteristics of the previous hundred years. Greek revival, classical revival, Gothic revival, Renaissance revival – it was time to find something truly new. The pioneers of what came to be called the modern movement eliminated ornament, but Gaudí's vision took him on an opposite course. The surfaces of his buildings are encrusted with lumps and twists of stonework; brilliantly glazed tiles stud the walls; metalwork writhes and slithers along swollen, melting balconies.

His father was a coppersmith from Reus near Tarragona in Spain, and from an early age the young Gaudí absorbed the traditions of craftsmanship. To the end of his life he would continue to work in the masons' yard along with his men, turning his hand to all aspects of building. He settled in Barcelona in 1869 and remained there until his death nearly 60 years later. Almost all his buildings are to be found in Barcelona itself or in the surrounding countryside.

Gaudí was fortunate in that the province of Catalonia, of which Barcelona is the capital, had become the most highly industrialized region of Spain. There was no shortage of wealthy patrons prepared to commission lavish buildings. Barcelona's rising prosperity also induced a tremendous civic pride that affected all classes, including the church. Gaudí was only 31 when he was entrusted with the commission to build the Sagrada Familia. He was also noticed at about this time by the wealthy industrialist Eusebio Güell, who remained Gaudí's chief patron until his death.

Gaudí's buildings have an elaborate richness reminiscent of Moorish art. The ironwork is twisted into the swaying points and tendrils typical of art nouveau. For the gateway of the Güell Park (1900-1914) he designed a jagged dragon in elaborately wrought iron. For the gloomily sumptuous Güell Palace (1886-9) he introduced what was to become a favorite motif, the *parabolic arch*, which sprang from the ground to form a rounded doorway or window opening.

Another favored motif was the tilted column, seen at its boldest in the unnerving crypt of the unfinished Colonia Güell church at Santa Coloma de Cervelló, a small industrial park owned by Güell. Four columns of roughly

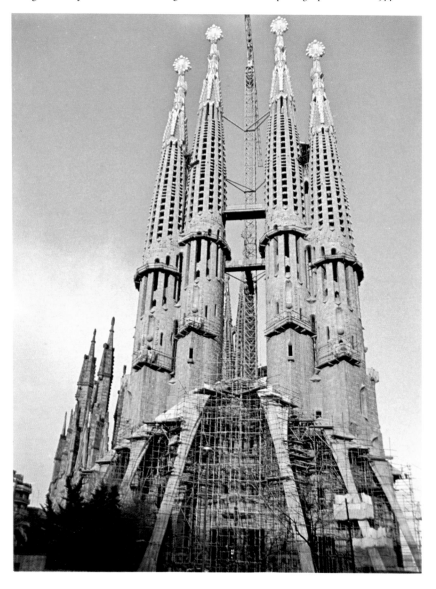

hacked basalt "cemented" with lead slant inward to support a canopy of ribbed brick. Twelve more columns, of brick partly covered with cement like trees losing their bark, ring the outer wall. The effect is indescribable, yet the place leaves an impression of moving sincerity. Gaudí was a devout Christian and designed this crypt to represent the grief of Christ's death.

His last secular building was the Casa Milá, completed in 1910. The ponderous, undulating façade of this Barcelona apartment complex has been described as "a petrified wave or a liquified

LEFT the gateway of the Güell Park, Barcelona, for which Gaudí fashioned a dragon in wrought iron.

RIGHT the Casa Milá, for which Gaudí designed a multistory effect like clusters of tile lily pads veined with steel beams.

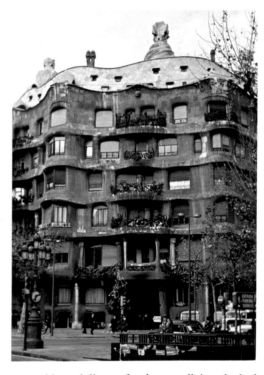

mountain." The shapes and surfaces were designed as metaphors of the geographical character of Catalonia. The balconies ripple around the corner site, erupting at intervals into tangles of decorative ironwork that must be a considerable hazard for the residents. Initial plans for the interior show the individual rooms resembling the irregular shapes of plant cells. As built, the majority of the rooms have straight walls, but curves are never far away, and the plaster ceilings swirl and hang like frozen cream.

The Sagrada Familia, begun in 1883 and still

ABOVE the amazingly dreamlike quality of the Güell Park, full of structures designed to stand on their own without any internal bracing or external buttressing – as a tree stands, as Gaudí himself observed.

far from finished, has come to represent Barcelona much as the Eiffel Tower represents Paris. Gaudí himself retired to the site in 1910 to live a hermit's existence there until his death. It was conceived as the church of a religious association formed to honor St Joseph. The ground plan is the traditional one of nave, transepts, and apse. Gaudí's intentions included a central tower of some 557 feet that would rise above the crossing, symbolizing Christ, surrounded by four smaller towers representing the four Evangelists. The east, west, and south façades would each have a further four bell towers, representing the twelve Disciples. Only the east façade, the Portal of the Nativity, was completed in Gaudí's lifetime, but after a long interval work was begun in 1960 on the west façade (the Portal of the Passion) and the towers are almost finished. These amazing structures, Moroccan in influence though more like termites' nests than anything else, are topped by still more amazing ornamental *finials* – stumpy pyramids and lines of spheres, all interlocked and coated in mosaics of colored glass.

Gaudí was not worried that the church would not be finished in his lifetime. He is reported to have said, "My client is in no rush." Like the medieval cathedrals, it was to be the work of generations – and for all its strange, non-European associations, its closest resemblance *is* to those achievements of 700 to 800 years ago. One man's faith and inspiration have bound together a community of craftsmen who have created an unrepeatable masterwork.

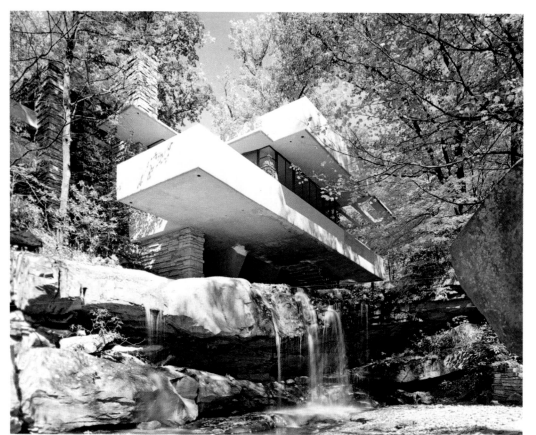

Frank Lloyd Wright

1869-1959

Like painters, architects can suffer periods of neglect in their own lifetimes, even after years of achievement. Success retreated from Frank Lloyd Wright, America's greatest architect to date, in his middle years. But he lived to be 91, and within his last two decades the pendulum of acclaim swung back in his favor.

Widely known today for such public buildings as the Guggenheim Museum in New York (1956-9), Wright began his career designing private houses. Some of their characteristic features – rectangular masses placed at right angles and cantilevered slab roofs – may relate to his childhood fondness for those geometric wooden blocks and cards that can be used to construct complicated yet unified structures. His early years seem to have been somewhat unsettled. His mother was a Welsh schoolteacher and his father an itinerant musician and

preacher. Frank was born at Richland Center, Wisconsin, but the family moved six times before he was ten.

In the 1880s the University of Wisconsin gave no instruction in architecture, so Wright studied engineering and then set off for Chicago, where architects such as Louis Sullivan were transforming the city with the world's first skyscrapers. Wright was barely 21 when his drawing skill earned him a place in Sullivan's office. Soon he was Sullivan's chief assistant, responsible for most of the residential designs. But he designed several houses on his own in violation of his contract, and in 1893 he parted from Sullivan to set up his own practice.

By the turn of the century he had defined and mastered the principles of what he called "organic" architecture and demonstrated his philosophy in several houses designed with the Midwestern landscape in mind – the "prairie houses." "I saw," he later explained, "that a little height on the prairie was enough to look like much more – every detail as to height becoming intensely significant, breadth all falling short." He noted in the typical houses of his day, even when space was plentiful, a "tendency to 'huddle' and in consequence a mean tendency to tip everything in the way of human habitation up edgewise, instead of letting it lie comfortably and naturally flatwise with the ground." Superb

examples of Wright's many "prairie houses" are the Willits House in Highland Park, Illinois (1902) and the Coonley House in Riverside, Illinois (1907–9).

In his early, often single-story houses a focal point is often a big fireplace. Houses were raised on cement or stone platforms; the ground plan spread freely. Walls ceased to be the sides of a box with holes punched in them as terraces and overhanging roofs broke up this old notion, helped to interweave interior with exterior, and allowed for long bands of windows between the structural walls. The composition's horizontal movement was generally locked into place with a massive chimney near the center. Inside the house Wright gradually developed the concept that is now known as *open plan*. Bedrooms and bathrooms remained separate rooms with doors, but everything else became one large room of an irregularly rectangular shape that allowed for alcoves and other secluded areas.

By 1914 Wright's first marriage had broken up. In that year the woman he had hoped to marry and her children were brutally murdered, and Wright set off on a period of restless wandering that was to last until the 1930s. He designed an average of three or four houses a year, but the only major building was the Imperial Hotel in Tokyo (1916–22), a ponderous structure that nonetheless survived the Tokyo earthquake of 1923 undamaged.

Wright and his third wife founded the "Taliesin Fellowship" in 1932 as a studio-workshop for apprentices, and in the same year he published *The Disappearing City*. He also began planning a weekend house for Edgar J. Kaufmann. The result was "Falling Water," for which Wright dramatically projected "ledges" of living space over a waterfall as reinforced concrete terraces cantilevered from a cliff, and it brought Wright back to prominence. In 1936 he was commissioned to build the Johnson Wax administration building in Racine, Wisconsin. Overjoyed to be at work again, he created one of his master strokes: the top-lit office interior has graceful, slender columns only 9 inches in diameter at the foot that soar up 24 feet, spreading at the top like lily pads to bear the weight of the ceiling. These columns are, of course, functional, but so are the "lily pads" – they serve to reduce the ceiling light that would otherwise be too glaring. Ten years later Wright added a magnificent research tower.

During the last two decades of his life he experimented with different spatial elements – triangles, circles, and arcs. The Price Tower at Bartlesville, Oklahoma (1952–6), Wright's only other constructed tower, develops from the

BELOW Tokyo's Imperial Hotel, commissioned as a place where visitors could be officially entertained and housed in Western style. Exceptionally suited to its cross-cultural purpose, it survived an earthquake but was later demolished.

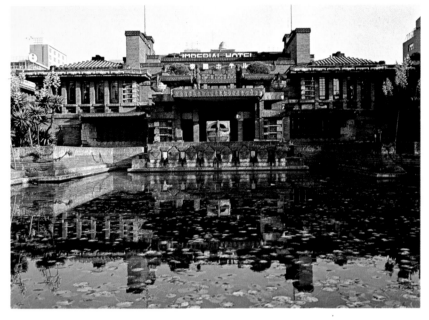

ABOVE the "great workroom" in the Johnson Wax Administration and Research Center. Chairs and desks were specially designed by the architect for the building, but the towering pillars, sometimes described as golf tees, remain the most striking feature.

RIGHT an optically distorted view (through a fisheye lens) of spectators visiting the Solomon R. Guggenheim Museum of modern art in New York City. A spiral ramp replaces the separate floors and ceilings of more conventional buildings, thus allowing for more space and light to view the art.

space produced when a square and a cross are superimposed and extended vertically. The last work he watched being completed before his death was the Guggenheim, visually astounding and open to criticism but nonetheless a significant building. Taking Wright's "open plan" principle to the limit, the building has no separate floor levels but a spiral ramp down which spectators must pass to view the pictures – *all* the pictures, for there is no way out until they reach the ground.

Wright produced memorable exteriors and chose sites for their dramatic potential. But perhaps more lastingly influential than these effects will be his creation of the idea of continuous internal space, still very much a part of modern design.

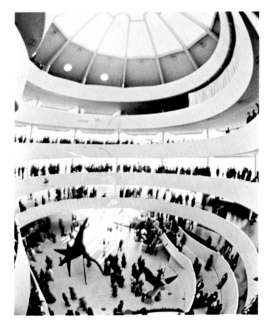

Walter Gropius

1883-1969

"Let us create a new guild of craftsmen, without class distinctions that raise an arrogant barrier between craftsman and artist. Together let us conceive and create the new building of the future, which will embrace architecture and sculpture and painting in one unity." With this statement the Bauhaus (Building House) art school in Weimar, Germany, announced its principles in 1919. The newly appointed director, Walter Gropius, had definite ideas about how to bring about the desired unity. Whether the object to be designed was a house, factory or school, or household objects or articles of public use such as lamps or lamp posts, each should be designed only after study of the particular needs and problems presented by the object. Modern factory and construction techniques were relevant, but past styles and solutions might not be.

Walter Gropius, the greatest teacher of architecture of the modern age, was born in Berlin into a family of painters and architects. He studied architecture but did not attempt to get a degree. After a year spent traveling in Italy, Spain, and Britain, he returned to work in the office of Peter Behrens (1868–1940), one of the leading figures of the new movement in Euro-

BELOW Walter Gropius in 1929, a year after he resigned as director of the Bauhaus.

BELOW the Fagus shoe factory near Hanover when it was first built in 1911. That year Gropius joined the *Deutsche Werkbund*, though he also said it was up to an artistically trained designer to "breathe a soul into the dead product of the machine."

pean architecture. The Turbine Factory, built at Moabit, Berlin by Behrens in 1908–9 with Gropius as his assistant, has been called the first modern factory. Its design boldly proclaims its steel construction. Wide glass panes replace the walls on the sides and in the middle of either end. The only concession to tradition is the cladding of the four corners of the building in heavy stone.

The following year Gropius set up in partnership on his own. He became a member of the *Deutsche Werkbund* (German Work Union), founded to make creative designers more aware of machine techniques. In 1911 he produced his first building, the Fagus Works at Alfeld-an-der-Leine near Hanover. The advance this building shows over the Turbine Factory is remarkable. For the first time an entire façade is of glass; the supporting piers are reduced to narrow strips of steel and brick. The roof is flat and the corners are unsupported, allowing a revolutionary feature – a continuous window that turns the corner with the wall – that was to be imitated a thousand times by other architects. Whereas the Behrens factory suggested that modern architecture was on its way, the Fagus Works declared its arrival. And so admirably does a building of this form satisfy "the peculiar needs and problems" of a wide range of offices and light factories (the Fagus Works made shoe lasts) that versions of it, appropriately modified, have been going up in most parts of the world ever since. For his own and succeeding generations Gropius defined the shape of the small factory.

Three years later Gropius designed another factory, for the Werkbund Exhibition at Cologne, in which a pair of glass towers flanks the main façade, each containing and revealing a spiral staircase. This feature too has been widely imitated. It can be seen as an attempt to abolish the separation between interior and exterior, since people using the staircase belong, in a sense, to both the inside and outside of the building.

The ten years during which Gropius remained with the Bauhaus, first at Weimar and later in Dessau, were profoundly influential for the development of architecture and design generally. The Bauhaus effectively created industrial design. Many of the objects that have entered our everyday lives – furniture and furnishings, books, advertisements, modern graphics – are derived from plans evolved at the Bauhaus for industrial production. Gropius' reputation attracted many artists – including the Swiss painter Paul Klee (1879–1940), the Russians Vassily Kandinsky (1866–1944) and Marc Chagall (born 1887), and the Austrian Oskar Kokoschka (born 1886) – to come and teach at the Bauhaus, one of the principles of which was to do away with the distinction between artists and craftsmen. This had been tried before, by William Morris (1834–96) in England in the 1860s, but there it was bound up with the refusal to accept the machine. Much of the Bauhaus work was designed specifically

ABOVE the Bauhaus in Dessau, which Gropius built in 1925–6. The school itself is a key monument of modern architecture and Gropius' best-known building. Its asymmetrical plan, smooth white walls set with horizontal windows, and flat roof are now associated with the "international style" of the 1920s.

BELOW LEFT interior of Walter Gropius' study at his house in Lincoln, Massachusetts (1937). The chairs and shelf-fixed desk lamps are characteristic of Gropius' furniture design, in which modern materials and functionalism are paramount.

BELOW RIGHT the rectangular modern slab of the Pan Am Building, built 20 years ago, contrasts strongly with the older Chrysler Building.

for machines, and the Bauhaus style is characterized by an emphasis on geometric forms, smooth surfaces, primary colors, and, of course, modern materials.

Gropius himself designed the Bauhaus headquarters after the move to Dessau. The problem there was to bring together a large number of workshops (carpentry, weaving, machineroom), a technical school, administrative offices, living quarters for the students and staff, and recreation rooms. His solution was a building designed like two connecting Ls. He decentralized the complex into three blocks, connecting the technical school and workshops by means of a bridge on which were the administration offices, and connecting the workshops and students' quarters by a single-story arm in which were the recreation rooms (including a theater, dining room, and kitchen). The building was of steel, concrete, and glass, but what might otherwise have been a severely functional structure gains a liveliness from the different heights of the blocks and the rectangular units that make up the wall surfaces.

Gropius never designed buildings of such quality again. He left Germany in 1934 as a refugee from Hitler's Third Reich and eventually settled in the United States, where he became professor of architecture at Harvard University in Boston. He continued to produce buildings such as the Pan Am Building in New York, the Harvard Graduate Center, and many private houses, but they are the work of an experienced modern architect and not those of a revolutionary. It is on his achievements in Germany between 1909 and 1929, and his inspired leadership of the Bauhaus, that Gropius' reputation rests. Through these he has helped to alter the world and the way we see it.

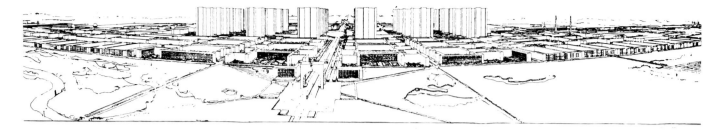

Le Corbusier

1887-1965

No 20th-century architect has so divided opinion as Charles-Edouard Jeanneret, born near Geneva in Switzerland but a resident of France for most of his life. Painter as well as controversial architect and energetic writer, in 1920 he took as a pseudonym the name of a paternal ancestor and was afterward known simply as Le Corbusier.

Some of the early antagonism toward him was in response to his apparent mechanistic view of the function of architecture. "A house is a machine for living in," he declared. "A curved street is a donkey track; a straight street, a road for men." He devised grandiose schemes for new cities; he poured out plans for rebuilding the center of Paris on a rigidly rectilinear grid. In his "City for 3 million inhabitants" (1922) the citizens traveled into the center to work in huge skyscrapers set 1300 feet apart, returning in the evening to multistory villa complexes set in open parkland. The impracticality of such schemes enraged critics; the opposition embittered Le Corbusier, and battles between

BELOW Charles-Edouard Jeanneret (Le Corbusier) in a photograph of 1938.

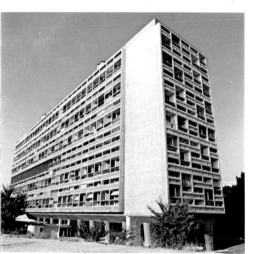

LEFT the Unité d'Habitation in Marseilles, an 18-story apartment building conceived as a community for 1800 people.

supporters and detractors still continue, years after his death. By the end of his life many of the ideals for which he fought had been adopted – and frequently distorted – by planning authorities in many parts of the world. His influence upon contemporary architecture has been profound.

His earliest designs were for small, eminently reasonable private houses. They are painted white, firmly rectilinear, and in many of them an external staircase leads up to a flat roof garden. The living rooms are two stories high and a tall window replaces the front façade. Later versions of these houses stand on *pilotis*, piers of reinforced concrete, that were to become a general feature of Le Corbusier's style.

His prize-winning design for the League of Nations building in Geneva (1927) was an elegantly planned and admirably modern scheme that took into account the building's function and totally rejected the "neoclassical temple" tradition for such structures. It was finally rejected by a conservative jury on the technical grounds that it had not been drawn in India ink. The ensuing scandal brought Le Corbusier valuable publicity, and a building based on the rejected design was later erected in Moscow.

The Salvation Army Hostel, a technological and financial failure, is characterized by an airtight, permanently closed, "breathing" curtain wall of glass, but a more successful building is the Swiss Dormitory at Paris' Cité Universitaire (1931-2). The four-story residence hall, carried on massive concrete *pilotis*, is firmly rectilinear, but the dining hall attached to it has an irregularly curved plan. Not only is this shape unexpected and highly expressive, but its windowless curved wall is constructed of rubble masonry, creating an intriguing contrast between this and the exposed concrete and smooth stone of the dormitory block. Le Corbusier was moving away from exclusively rectilinear solutions to problems of urban architecture.

The Depression of the 1930s and World War II reduced opportunities for building. Le Corbusier's work during this period took the form of projects for museums and other public buildings and theoretical essays that were to influence an entire generation of architects. But despite the accusations of antihumanity

leveled at Le Corbusier, his best designs never ignored the fact that human beings would inhabit them. However, it is still possible to criticize him for considering human beings as simple, identical units of mankind rather than as men and women with individual personalities.

After the war Le Corbusier was able to erect

RIGHT diagram illustrating Le Corbusier's "Modulor" system of proportion, conceived in the 1930s, in which he related the size and scale of buildings to the proportions of the human body. Based on mathematical progression, one series takes its base value from the height of a 6-foot man and another from the height of the same figure with arm upraised, calculated as 7 feet 5 inches. The point was a return to the Renaissance idea of harmonious relationships of scale between people and their environment.

three major works. With the Unité d'Habitation in Marseilles (1946–52) he realized, at long last, his ideal for mass dwelling. The 1800 inhabitants live on 18 floors in 337 split-level apartments of 23 different types. Two "streets" run the length of the building inside and the apartments are ingeniously interlocked around them so that each extends the full width of the block and also contains a two-story living room. They are conceived as individual "villas" stacked in the concrete frame like wine bottles in a rack. Halfway up the block one story is devoted to shops, a school, and a hotel, and the roof contains a gymnasium, nursery, kindergarten, and open-air theater. The functional structures of ventilator and elevator shafts are expressed as sculptural objects. All the poured concrete was left rough so that the grain from the wooden molds patterns the surface – a "natural" motif that subsequently became doctrinal practice among the architects of the "new brutalism" school.

At Chandīgarh in India Le Corbusier designed the public buildings for the new state capital of the Punjab (1952–6). Their scale is monumental and daunting, with colossal round piers, dipping rooflines, and gigantic ramps, all in concrete. Since 1956 the influence of these imposing structures has spread worldwide.

Many of his followers were taken aback, however, by his pilgrim church of Notre-

ABOVE the sensually appealing pilgrim church of Notre-Dame-du-Haut at Ronchamp, a small town in eastern France. The curves of walls and roof are punctuated by tiny windows.

ABOVE Le Corbusier's own abstract paintings, filled with amoebic curves in primary colors, add to the interior design of Ronchamp. On a site where many churches had been destroyed in the battlefields of World War II, Le Corbusier ironically combined feelings of aggression, joy, meditation, security, and monumentality.

RIGHT the Court of Justice at Chandīgarh (1956), a complex interplay of small, medium, and large-scale shapes. The "butterfly" roof curves out for protection from monsoons.

Dame-du-Haut at Ronchamp, near Besancon (1950–55). The rough walls, curved with huge overhanging eaves, are so thick that the womb-like interior is hardly lit by the tiny, deep-sunk windows that irregularly pierce the walls. The roof is another extraordinary feature, appearing to be suspended but actually resting on a forest of supports. It is "a place of silence, of prayer, of peace, of spiritual joy."

Le Corbusier was not personally impressed by his eventual acclaim, and up to his death at 78 he steadfastly believed himself misunderstood. But he has been called "the lodestar of his generation" and was unquestionably the creator of a new "modern" aesthetic.

LEFT the central administration area of Aalto's Tuberkuloosi-parantola (1929-33), from which the patients' wing (right) stretches forward to catch the sun and welcome the visitor.

Alvar Aalto

1898-1976

The six-month-long winters of Finland periodically remind its people of the harsh facts of nature. They affect its architecture in two ways – by encouraging research into new ways to outwit and defeat the elements, and by forcefully suggesting the essentially close relationship between a building, its setting, and its materials. The product is an "organic" architecture that has remained closer to its original impulse than any other. This Finnish response to the forces of nature is preeminent in the work of the country's most outstanding architect, Alvar Aalto, one of the most important architects of the 20th century.

Born in Kuortane in west central Finland, Hugo Alvar Henrik Aalto's architectural studies were interrupted by the Finnish civil War of Independence (1917-19) in which he took part. After graduating in 1921 he toured Europe before returning to his home country to set up practice.

Aalto was among the first modern architects to reject the rigidly geometric designs associated

BELOW Alvar Aalto at work. His rich architectural language reflects his personality – relaxed and flowing rather than violent, and patient instead of assertive.

RIGHT the library at the top of the Wolfsburg Cultural Center, naturally lit by circular recessed downlighters. Each area is accentuated by a break from the constriction of an overall rectangle shape.

with the Germans Walter Gropius, Ludwig Mies van der Rohe (1886-1969), and their followers. Although the influence of the modern movement on his work was still powerful when he designed his early buildings, he already possessed the confidence to be different. The ceiling of the machine hall in his Turun Sanomat (newspaper office) Building in Turku (1930) is supported by tapering reinforced concrete columns as vigorous as trees. The tuberculosis sanatorium (1933) built amid thick forests at Paimio is attractively designed, based on a ground plan like a staggered K. From the central administration area the six-story patients' wing stretches away at a right angle, the balconies turned toward the low northern sun. But

the recreation areas and service blocks radiate from the other side of the center at angles that are not right angles, thus taking away some of the severity of the building. For the Municipal Library at Viipuri (1935, destroyed 1943) Aalto introduced an undulating, sound-reflecting ceiling of slatted wooden strips which delighted the public and stimulated other architects, who were becoming resistant to the extreme "block-ishness' of contemporary architecture. Like the majority of attractive innovations, both the form and the material were functional in origin. Aalto's growing fame was also spread by the popularity of the bent plywood furniture he designed in 1932.

Before World War II Aalto was involved in housing schemes, and after the war he was placed in charge of the Finnish government's vast rebuilding plans. The city of Rovaniemi in Lapland, totally destroyed during the war, was the first of these. Aalto's street plan divides the area into regular hexagons, but while these may seem rigorously geometric on the map, the buildings are arranged so sensitively that they seem to be an organic part of the landscape.

Aalto's later work developed his original approach to form and materials. His buildings always retain a human scale, and his approach to architecture was flexible. Yet he fought for what he believed. He is reputed to have organized a night raiding party to shoot out the advertisements that defaced his town hall at Säynätsalo (1950–52). In the Cultural Center he built at Wolfsburg in northwestern Germany (1959–63), five lecture halls nestle against each other at one end of the center, their fan-shaped roofs climbing outward to form a silhouette interesting from all angles.

The curving roofs of his church at Vuoksenniska, Imatra, Finland (1957–9) produce a more complex range of feelings. Severe yet cautious, watchful yet peaceful – Aalto has managed to incorporate these ambiguities into a design that also functions excellently as a church. The acoustic curves of the ceiling end in bunched walls and windows that form angled folds, looking as though the building were being grasped from above by a mighty hand.

In the United States Aalto built the Baker House hall of residence at the Massachusetts Institute of Technology on the Charles river in Cambridge (1947–8), where a curved frontage gives a river view to each of the rooms. In his home country he built offices, public buildings, factories, and houses. He resisted on the one hand what he called "parallelepipeds of glass squares and synthetic metals – the inhuman dandy-purism of the cities" but also rejected

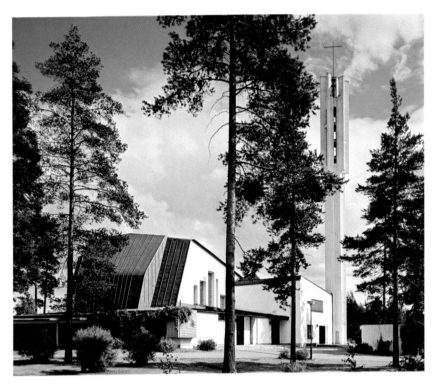

ABOVE Vuoksenniska Church at Imatra, set among trees and conducive to its purpose of communal worship. The low white walls suggest peace and serenity, yet an admirer described it once as "humping its copper roofs defensively against the sky and lifting cautious windows, like watchful alligator eyes, above the white substructure in which it seems to burrow." The interior is also white, but wide and high, and from a three-part window in the ceiling light floods down upon the three crosses on the altar, an ambiguous blend of joy and concentration.

what he saw as a common alternative: "grown-up children playing with curves and tensions they do not control." Of this latter type of architecture he said simply, "It smells of Hollywood." Aalto's work does not smell of Hollywood. It is genuine, natural, and humane.

The last of his major buildings, the Finlandia Concert Hall in Helsinki (1967–71), is a worthy and appropriately monumental climax to a long career. Classically simple in form and covered entirely with white marble, it is set in a park overlooking Lake Töölö. From being a revolutionary Aalto had become one of the greatest of modern architects and the supreme advocate of humanizing, through art, the harshness of our contemporary technological landscape.

RIGHT the Finlandia Concert Hall in Helsinki, part of a concert and congress center built by Aalto on the shore of a lake in the Finnish capital. Here the emphasis is on visual and acoustic requirements.

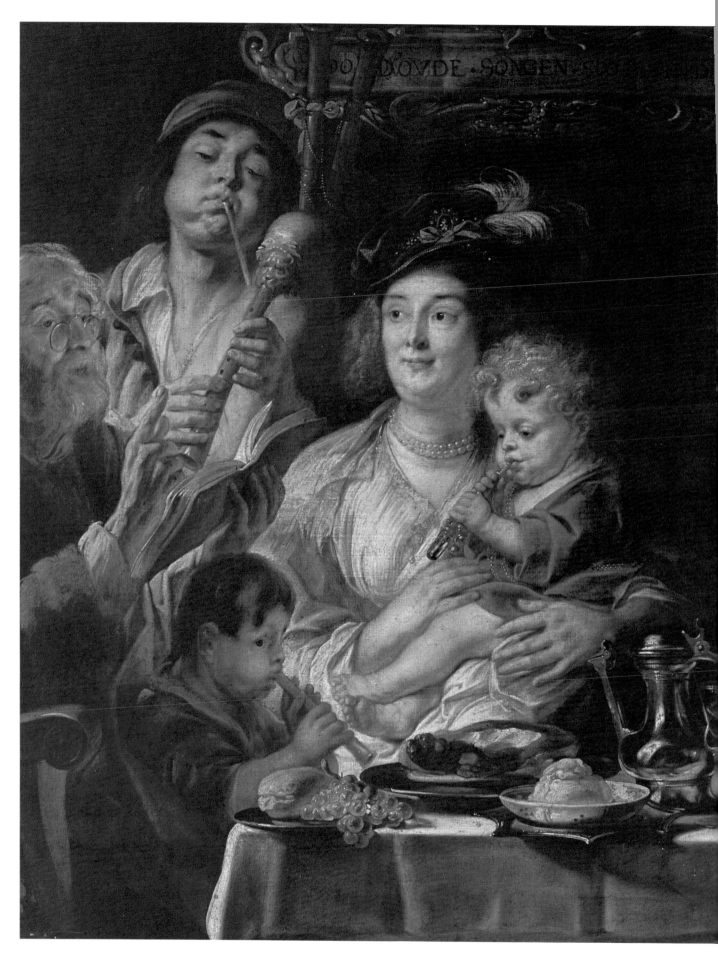

190

Chapter 7

THE ART OF MUSIC

Since the dawn of civilization the charms of music have comforted, persuaded, inspired, and entertained countless listeners throughout the world. Musicians have built up an impressive and imperishable body of work over the centuries, and this has become a rich heritage of vivid, moving, and dramatic masterpieces in sound.

Most important, perhaps, a tone language has been evolved that can express every poetic impulse known to humanity. And this language is not restricted to professional performers trained in the discipline of their art. Through the simple activities of hand-clapping and humming, anyone can make music of some sort. This very accessibility may account for the constant popularity of music as an art form in the most diverse cultures.

OPPOSITE *Family Concert* by Jacob Jordaens (1593–1678), who was born in Antwerp and worked as an assistant to Rubens. Music has always been played for the sake of private enjoyment as well as being performed professionally.

Music as a Language

From time immemorial people have expressed their feelings in music. Long before speech was developed, primitive humans raised their voices in lamentation, mating calls, and war cries. These vocal sounds, produced under the stress of emotion, had a life and character of their own and were eventually enjoyed for their own sake. The repetition of patterns of sounds makes them easier to remember, so little by little early singers must have extended their songs. As their musical memory developed so did their awareness of musical form. These impulses, of expressing feelings and delighting in sounds, lie behind all music.

Music, both sung and played on primitive instruments, has for centuries been used to placate or terrify forces otherwise considered beyond human control. Banishing wild beasts from primitive agricultural settlements is not very different from exorcising evil spirits or chanting prayers to gods. Players accompanied singers and dancers in hailing the living or mourning the dead in the Far East, ancient Egypt, and Assyria.

The earliest known *scales* probably evolved through "filling in" simple, audibly recognizable intervals of four or five notes that occurred when people sang together. Groups of such notes, sung at different pitches, overlapped to make five- or seven-note scales. As civilization developed, music became closely interrelated with

ABOVE musicians played a religious role in ancient Egypt. They played harps such as this to "see out" the dead.

LEFT plainsong manuscript from the 10th century, in which the marks above the words (neumes) reminded singers of changes in pitch and rhythm.

BELOW French engraving of the 17th century showing pipers and drummers accompanying a peasant celebration.

mathematics, astronomy, and religion. The Mesopotamians worshiped the planets, and they believed there was an overall harmony between the universe and mankind that was mirrored in music and could be described using numbers.

In the 5th century BC Pythagoras, the founder of Greek musical theory, used a *monochord* (stretched string) to calculate musical intervals. Greek scales were based on descending four-note groups called *tetrachords* after the four strings of the early lyre, a relative of the harp. Seven-note scales, or *harmoniai*, were formed by linking tetrachords.

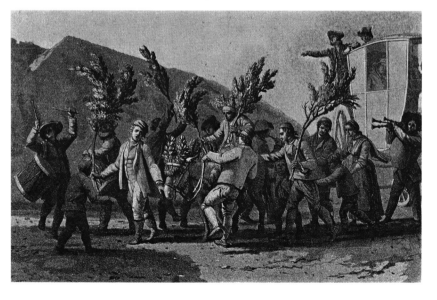

Other cultures – those of India, China, and Arabia, for instance – left musical performance to memory. But in the West a written language of musical notation – a set of compressed instructions for producing music – was evolved to tell performers how to sing or play. Notation based on letter names was first introduced in Greece in the 4th century BC and was passed on to medieval Europe by later Roman writers such as Boëthius, who lived in the 6th century AD.

From about the 7th century AD a system of *neumes*, signs for notes or groups of notes, began to be used as an approximate notation for church *plainsong* – unaccompanied, single-line vocal music sung in unison as part of Christian religious worship. The neumes reminded the singers when to sing high or low pitches but did not show exact intervals or durations of notes. In the 11th century an Italian Benedictine monk, Guido d'Arezzo (about 990–1050), invented syllable names for the notes of the scale as an aid to sight-reading music. Like most knowledge in the Middle Ages, this system was primarily available to members of religious orders who were taught the skills of composing and reading music so that they could perform their church duties.

Most people, however, could still not read or write. Traveling minstrels or singer-poets went from place to place carrying news to people who were otherwise cut off from their contemporaries and their rulers. Poems set to music – *ballads* – were easier to remember and thus a more reliable form of communication than long speeches. *Folk songs*, too, were important. Often based on patterns of words spoken to accompany everyday activities such as lulling a child to sleep, working at a spinning wheel, falling in love or marching into battle, their tunes are the result of improvisation and repetition and are remembered and handed down over several generations.

Meanwhile, to enable the growing body of composers to score their music (usually for the church) and to solve the problem of showing pitch, modern *staff notation* gradually evolved. Pitch is shown by the vertical position of a note on a five-line *staff* or stave. Letters of the alphabet ranging from A to G are given to each line as well as to the spaces between the lines, and these give the notes their names.

By thus organizing the sounds of their own voices and those made by musical instruments, people have created a vividly expressive language that over the centuries has been developed and refined into an amazingly wide variety of forms and meanings.

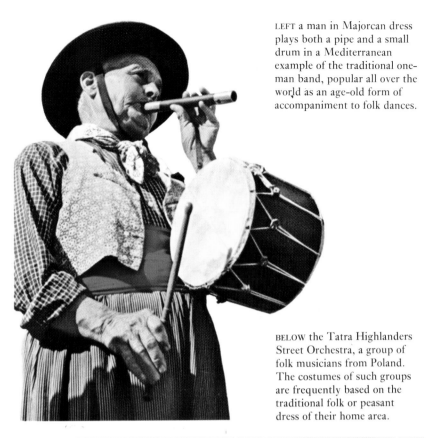

LEFT a man in Majorcan dress plays both a pipe and a small drum in a Mediterranean example of the traditional one-man band, popular all over the world as an age-old form of accompaniment to folk dances.

BELOW the Tatra Highlanders Street Orchestra, a group of folk musicians from Poland. The costumes of such groups are frequently based on the traditional folk or peasant dress of their home area.

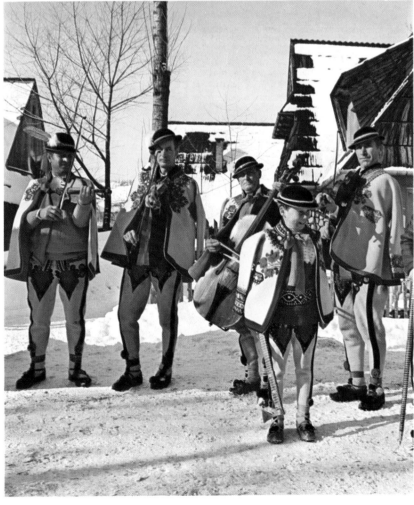

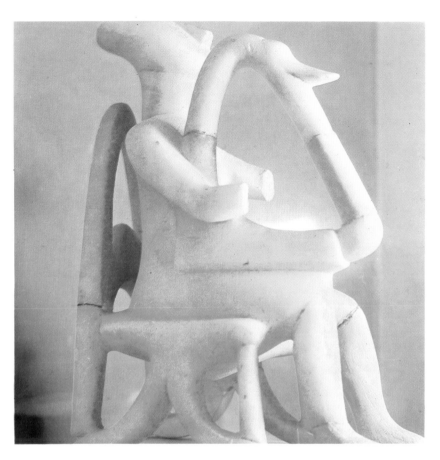

Origins of Musical Instruments

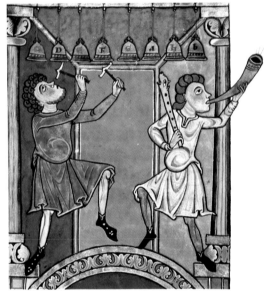

ABOVE ancient Greek figurine of a poet playing a harp, dating from about 600 BC.

RIGHT a medieval bell ringer accompanied by a horn player. Like many musical instruments, bells originated in Asia.

BELOW a Japanese transverse flute. In Japan women were often trained to be musicians.

Anything that sets up sound vibrations can become a musical instrument. A hollow tree can be hit with a stick; a hollow tube of bamboo can be blown through; the trip thong of a hunter's snare can be plucked.

Musical instruments, both ancient and modern, are divided into three main categories. Those that are hit, tapped, banged or clanged belong to the *percussion* family, and some of these are probably the oldest of all. Asiatic and Egyptian peoples first stretched animal skins tightly across hollow gourds or logs; the drum today is still the chief percussion instrument. Its various types include the kettledrum (timpani), snare (side), and bass. Other percussion instruments used by the orchestra are the triangle, tambourine, castanets, cymbals, bells, gongs, and glockenspiel (similar to a xylophone).

Stringed instruments are those in which a stretched string is scraped or plucked, and of all these instruments still played today the lute is probably the most ancient. Introduced into Europe and elsewhere by Arabian musicians toward the end of the 13th century, this pear-shaped instrument is the forerunner of all those whose strings are plucked with the fingers or a *plectrum* (a small thin piece of ivory). The lute was popular from the 15th to the 17th century.

The mandolin derived from a small lute called a mandora or mandola and is of Italian origin. The guitar, particularly popular in Spain, usually has six strings, although there are many kinds. The sitar is the most widely known stringed instrument of India. The fingerboard is about 3 feet long and has 16 to 22 movable brass or silver frets. Other plucked-string instruments include the psaltery (zither), gittern (guitar), crwth, harp, and (although its plectra are actuated mechanically by keys) the harpsichord.

The harpsichord, whose name comes from the Italian word *arpicordo*, goes back to the 15th century. During the next 300 years this keyboard instrument was as important as the piano is today. Its strings are plucked by quills or hard leathers, whereas those of the piano are struck by hammers. Other keyboard string instruments are the clavichord, with a softer tone than the harpsichord; the smaller virginal, popular in Elizabethan England; and the wing-shaped spinet, in use from the 16th to the 18th century.

The word *pianoforte*, commonly shortened to piano, comes from the Italian words for soft (*piano*) and loud (*forte*). Its invention is attributed to Bartolommeo Cristofori, an 18th-century harpsichord-maker and custodian of musical instruments for Prince Ferdinand de

Medici of Florence. Because its strings were struck by hammers, the piano produced a louder and fuller tone than instruments of the harpsichord type, especially with the addition of foot pedals. In 1781 the English firm of John Broadwood and Sons produced its first iron-framed grand piano.

Stringed instruments played with a bow include the medieval rebec, hurdy-gurdy, and tromba marina as well as the viols, ancestors of the modern string family – violin, viola, cello, and double bass. All of these can also be plucked. The viol was invented in the 15th century but ceased to be in general use after 1700. Unlike the

violin, the viol originally had a fretted fingerboard, and the style of bowing was different.

Wind instruments are those that are blown into or through and they fall into two main categories – brass and wood. The notes of *brass* instruments are produced by changing the player's lip position or *embouchure* and are further modified by the use of valves or slides. The trumpet, which evolved from the hunter's horn through the Roman cavalry lituus, is a cylindrical tube inside which an air column vibrates. It originally had no keys or valves – these were added early in the 19th century.

The trombone, whose medieval forerunner was called the sackbut, has a slide that the player pushes in or out, thus lengthening or shortening the tube of air. Other members of the brass family include horns, bugles, cornets, clarions, tubas, and saxhorns.

Woodwinds are divided into two main kinds, pipes and reeds. *Pipes* are simply blown through (as with the recorder) or across, i.e. the flute, piccolo, and fife. The flute, whose ancestors include the mam and náy of ancient Egypt, the Greek aulos, and Roman tibias, dates in its modern form from the early 18th century, and it was the first woodwind to appear regularly as a member of the orchestra.

For *reed* instruments the player's breath sets in vibration a single or double reed. The clarinet,

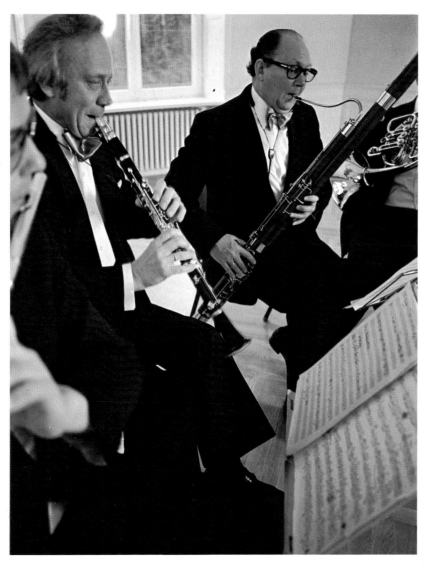

BELOW LEFT Babembe tribesmen of Zaire, in central Africa, play wooden tam-tams.

ABOVE a German wind ensemble including a flute, clarinet, bassoon, French horn, and a fifth instrument to make up a quintet. The woodwinds work on the same principle as the brass instruments in that all are blown through, but each type produces its own characteristic sound. Small groupings of instruments exploit their combined effects.

whose single reed vibrates in a slot in the mouthpiece, was invented about 1690 by Christopher Denner of Nuremberg. It first appeared in the orchestra in the 1770s. The saxophone, not normally an orchestral instrument but popular in marching band, jazz, and dance music, is named after the Belgian, Adolphe Sax, who invented it in 1840. The double-reed instruments, which developed from medieval shawms and pommers, are the oboes and bassoons.

A third class of wind instrument whose sound is initially actuated by means of a keyboard is the organ. Legend claims that the organ originated from the reed pipes of the Greek god Pan, and an instrument used in China as early as 3000 BC – the cheng – was somewhat similar. About 265 BC an Alexandrian called Ctesibius improved the water organ or hydraulus, and by the 15th century organ music had developed into a specific art form, partly due to its predominant role in church worship since the Middle Ages.

Patterns
of Sound

Voices and musical instruments have one thing in common: they both produce sounds. That means they both set the air vibrating in a certain way. The sound waves thereby created impinge on part of the inner ear which senses the waves and passes them as nerve impulses to the brain, where they are received and interpreted as sounds.

The *pitch* of a sound depends on the speed of its vibrations. The lowest C on the piano produces a basic sound of 32 vibrations per second. But the piano string vibrates slightly differently over its full length, so that the actual sound produced contains several related overtones or *harmonics*. The quality of a sound – the *timbre* or tone color – depends on the number and strength of the overtones combining with the basic tone. A flute sounds clear and cool whereas a violin sounds warm because the violin's tones are much fuller, with many harmonics combining to produce a more complex sound.

Sounds alone do not form music, though, even

ABOVE a view of the electronic equipment in the British Broadcasting Corporation's radiophonic workshop, where not only are experiments made but radio and television music are also composed and recorded using the sounds that can be produced electronically.

when they are sounds of definite pitch. Music moves through time like dancing or any other "active" art, and *rhythm* is its organization in time. Most music has a regular throb or pulse arranged in patterns of strong and weak *beats*.

Tempo is the speed at which the rhythmic pattern moves; it does not affect the duration of each note *in relation to* the others, but only governs how quickly the whole series of notes is played. Tempo can strongly influence the mood of the music, as can the *dynamics* – that is, whether it is played or sung softly (*piano* or *pianissimo*, from the Italian) or loudly (*forte* or *fortissimo*).

The sounds of different pitch that make up the tune of a song or melody are usually grouped around a central note which often ends the tune. This note is called the *tonic*, or home note. The series of notes CDEFGABC form a *major scale*

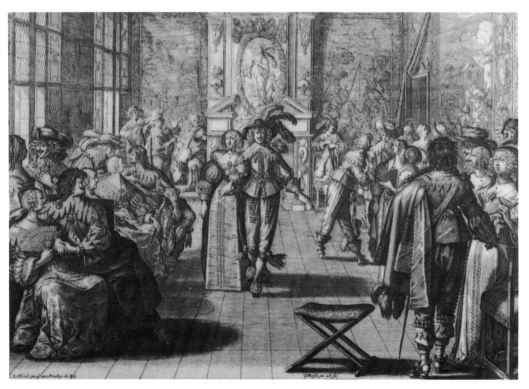

LEFT *The Ball*, an engraving made for the French court in the 17th century, when music and dancing played an important part in the social and diplomatic life of the nobility.

(C-Major). Most cheerful melodies use the notes of major scales, whereas sad, poignant tunes often incorporate the sounds of *minor scales.* A minor scale differs from a major scale only in its third and sixth notes. These are slightly lowered in pitch and introduce a melancholy, somewhat unexpected feeling to a piece of music. The black keys of the piano represent the half-steps up (*sharp*) or down (*flat*) between the basic notes.

In much Eastern music, as played in China, Japan, and Java, for instance, a five-note or *pentatonic* scale is used. This scale is formed by playing only the black keys of the piano.

Playing or singing two or more different notes or pitches at the same time creates a *chord.* Some paired notes, such as C and E or C and A, make a pleasing sound called a *concord.* Other pairs, such as C and C-sharp, C and D or C and B, do not balance each other so well and make a harsh sound, called a *discord. Harmony* is the art of combining both types of chord so that they make sense to the listener. *Counterpoint* is the combination of two or more independent melodies sounding pleasingly at the same time.

The court dances popular all over Europe during the 17th and 18th centuries prompted thousands of attractive pieces of music, all with one characteristic in common. They were all in two sections, the first ending on the *dominant* (the fifth tone of an eight-note scale) and the second on the tonic (the first tone). Thus they could be described as excursions from one *key* (a system of seven tones based on a particular tonic note) to another and back again. In time this type of instrumental work became known as a *sonata.*

Later composers developed the sonata into a work of three or four movements, still in contrasting keys. The first movement, usually in *sonata form,* is written as a series of three sections. The first, or *exposition,* presents two contrasting themes or groups of themes, frequently ending on the dominant. The second section is the *development,* often improvisatory, in which composers freely develop their material to get as far away as possible from the home key before returning to it. Once back in the home key the whole first section is repeated, but with certain differences in key and presentation that give this third section, the *recapitulation,* a feeling of the resolution of conflicts. This is sometimes followed by a *coda,* or tailpiece, which serves as a summation or commentary on the piece as a whole. The *symphony* and the *concerto,* two of the most important forms of classical music, are longer and more complex works based on the elements of the sonata.

RIGHT (1) a section of piano keyboard indicating early names for notes and the letters that later replaced them. Church scales were based on the white keys only.

2 chromatic notes (first introduced to add color) eventually led to the chromatic scale of 12 equally spaced semitones.

3 sharp (♯) and flat (♭) symbols were added to indicate the extra notes.

4 the modern major scale consists of two groups of two tones and one semitone.

5 rhythmic values and the corresponding rests (silences). At far right are time signatures and the combinations of various lengths that might be used to make up each bar.

6 the opening of a prelude from Bach's *Well-Tempered Clavier,* in which four sharps are noted at the beginning.

7 the pitch ranges of the human voice (blue), the brass instruments (red), woodwinds (brown), and strings (green), as well as the comprehensive range of the piano (gray).

8 the F-Major scale as written on the alto clef, with each note (FGAB-flatCDEF) labeled according to its position in the scale. The tonic is the first and last note and gives its name to the scale.

9 the harmonic series, which is defined by the number of vibrations per second that any particular note creates. These are measured in frequency cycles per second.

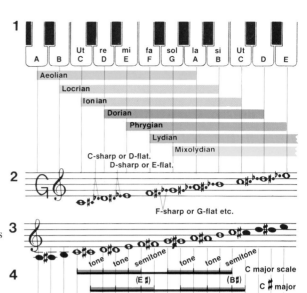

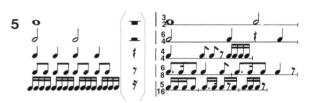

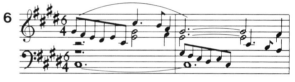

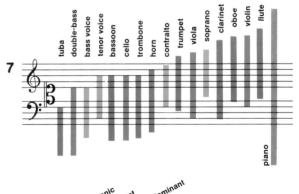

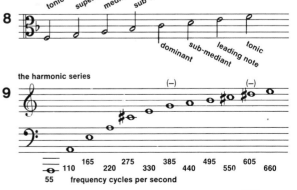

Vocal Music

First among all the different means of making music was, of course, the human voice. Music for voices has its origin in religious observance and the desire to worship, praise or adore. It has long been recognized that enhancing speech in some way adds a magical, sacred dimension to the human voice. The prophecies of Greek oracles such as Apollo's at Delphi were pronounced with the aid of rock formations that acted as megaphones to make the voice sound

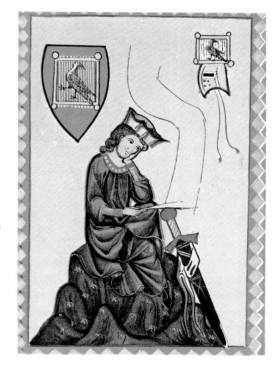

RIGHT Walther von der Vogelweide (1170?-1230), probably the most famous of the German Minnesänger. His patron was Frederick I but he also wandered from court to court singing political, religious, and love songs.

LEFT a group of monks singing their daily prayers, psalms, and readings in a painting from a 15th-century English psalter.

Beginning in the 11th and 12th centuries in France a tradition of secular solo song was built up by the *troubadours* and *trouvères*, aristocratic poet-musicians who sang of courtly love and chivalry in battle. Three of their song forms – the ballade, rondeau, and virelay – became models for the French *chansons* of the 14th and 15th centuries. The *Minnesänger* (love singers) were their German equivalents.

Once plainsong had become established in Christian worship, church musicians turned to

louder and more authoritative. The actors of Greek drama, primarily a religious activity, used masks to magnify and alter their voices. Jewish rabbis and cantors used *chant*, a form of stylized speech, to read the words of the Torah, and other early societies used chant as part of their initiation rites. Unaccompanied plainsong melodies, codified by Pope Gregory I at the end of the 6th century, became known as *Gregorian chants*. Most of this music was never written down, although some manuscripts of church plainsong were annotated with symbols reminding the singers when to raise or lower their pitch.

ABOVE detail from a panel of *Christ Glorified in the Court of Heaven*, by Fra Angelico (1400?-1455). The angelic orchestra employs violins, lutes, clarinets, harps, and song.

embellishing the basic melodies by adding extra parts. This was the beginning of choral music. The gradual decline in authority of the church in the 12th and 13th centuries soon led to the relaxation of the more rigid requirements of the

liturgy, and this new freedom to experiment allowed the introduction of melodic and rhythmic complexity into religious music. As the *vocal polyphony* – music for many voices – of the early Middle Ages reached a peak, so composition began to be considered a specialized activity.

In the late 14th century began the most important development in early Renaissance music – the rise of *choral polyphony*. Instead of one voice per part as in the Middle Ages, music was written for several voices singing each part, and the chief aim was to achieve a blend of voices. This led to a greater interest in harmony. The idea of definite voice ranges to sing the different parts was obviously essential to this kind of music. Boys' voices are called *treble*; women's voices can be either high *soprano* or lower *contralto*; men's voices are *tenor* in the higher range and *bass* in the lower.

The French chanson was combined in the 16th century with the Italian secular part-song or *frottola* to produce the *madrigal*, a secular part-song for one voice per part. Its prime characteristic was its very detailed matching of words and music.

With the development of the art of drama, especially during the Renaissance, music began to play an increasingly important role on the stage. For a time madrigals were sung behind the scenes as a background to the action of a play. But near the end of the 16th century a group of Florentine poets and composers known as the *camerata* began to rediscover the ideals of ancient Greek theater. In particular they wished to recreate the lost art of musical declamation.

ABOVE modern performance of a grand mass by the Austrian composer Anton Bruckner (1824-96) in the State Theater in Darmstadt, West Germany. A full chorus accompanies the orchestra.

BELOW Benjamin Britten at a performance of his *War Requiem* in Coventry Cathedral. Work began in 1954 on the new cathedral, which incorporates the 14th-century ruins destroyed by bombs in World War II, and it was consecrated in 1962.

To write accompanied solo song in which the words could be clearly heard was impossible within the complex polyphonal texture of the madrigal, so the *camerata* evolved a style of singing in passages corresponding to ordinary speech, called *recitative*. This made it possible to perform whole dramas without relying on the spoken word – and this became known as *opera*.

With the Protestant Reformation in the 16th century, when whole congregations were encouraged to take part in group singing of hymns and chorales, the foundations were laid for two new musical traditions. *Oratorio* is an extended setting of a religious *libretto* (text) for chorus, solo singers, and orchestra. It is sung in a church or concert hall, not acted out upon a stage as is opera. The *cantata* is a shorter vocal composition for one or more soloists and a choir or chorus. The religious cantata began with the German composer Heinrich Schütz (1585-1672), whose work was based on Lutheran chorales.

After being eclipsed for some time by these developments in choral music, the solo song came dramatically back to the fore with the *Lieder* (art songs) of 19th-century German composers Franz Schubert (1797-1828), Robert Schumann (1810-56), and Johannes Brahms (1833-97), and of the Austrian Hugo Wolf (1860-1903). French composers of songs in the late 19th and early 20th centuries were Gabriel Fauré (1845-1924), first master of the *mélodie*; Achille-Claude Debussy (1862-1918), the founder of musical impressionism; and Maurice Ravel (1865-1937). One of the greatest modern songwriters was the British composer Benjamin Britten (1912-76), who was influenced by Wolf and Debussy. Britten's *War Requiem* (1961), written for the consecration of the rebuilt Coventry Cathedral, brings together the sacred and the secular in one of the most powerful choral works of the 20th century.

The Orchestra

The orchestra that modern concertgoers have come to regard as essential to the performance of symphonic music is a comparatively recent development in the history of Western music. In the 16th century orchestras were simply chance groupings of available instruments. But in the first operas of the early 1600s, effective sound combinations were deliberately *orchestrated*; in addition to accompanying the singing, the composer wanted the orchestra to provide music for dramatic dances and to perform an introductory piece called an *overture*. Bowed strings were the most prominent musical element. Numerous viols were supported by various combinations of woodwind, brass, and keyboard instruments as well as kettledrums. They were kept together by a director or *maestro di cappella*, who beat time with his hand.

The violin grew in popularity during the 17th and early 18th centuries due to the tonal brilliance it could offer over its predecessor the viol; the emphasis on string sound persisted. The most famous orchestra of the time was that of the French king, Louis XIV, and it was called "the 24 violins of the king." It was directed by its first violinist Jean-Baptiste Lully, who thumped out the beat on the floor with a stick.

Concerted orchestral pieces (arranged for several parts) came into fashion. In the *concerto grosso*, passages for small groups of solo players alternated with *tutti* passages performed by the rest of the musicians. Later composers evolved the *virtuoso concerto* most often heard in orchestral concerts today, in which a soloist plays a duet with the full orchestra.

Instruments themselves (the violin in particular) were being improved as composers experimented with different combinations. A cello or other bass instrument and a harpsichord or organ supplied the *basso continuo*, the bass line that held the composition together.

In the mid-18th century the foundations of the modern symphony orchestra were laid by a generation of composers headed by Bohemian-born Johann Stamitz (1717–57), who is considered the originator of the modern professional

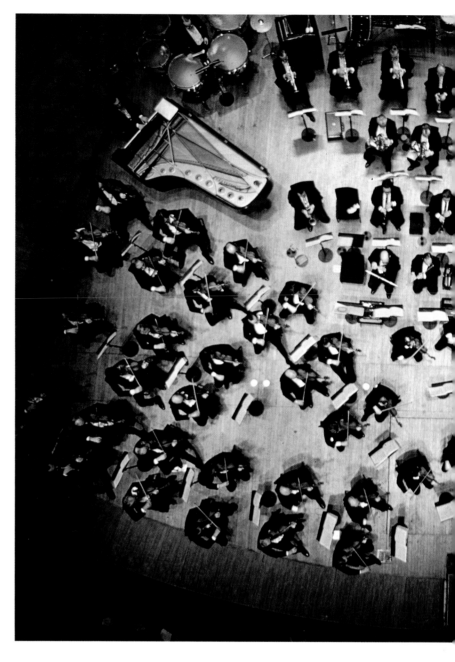

ABOVE a bird's-eye view of the New York Philharmonic orchestra. From this position it can be seen that the strings of a modern symphony orchestra outnumber all the other instruments combined: they extend across the whole front of the stage and down the right side to the rear. For this particular piece, in which almost 100 players perform, the woodwinds and brasses are typically grouped in the center with the percussion at the rear left. The piano marks the division between string and percussion.

OPPOSITE Otto Klemperer conducting the New Philharmonic

orchestra of London. This German conductor, who died in 1973, achieved international fame and received invitations for guest appearances all over the world. Like many famous conductors, he became known for his outstanding personal interpretations, in his case of the work of Beethoven and Mahler. Conductors came to the fore in orchestral music only in the 19th century but have maintained a position of the highest importance ever since. They not only keep the orchestra musicians in time with each other and set the pace, but they are also responsible for the music's tonal quality.

conducting technique. Stamitz founded the Mannheim orchestra, which numbered up to 50 performers on paired flutes, oboes, bassoons, and horns. The stimulus it and others provided helped to invigorate both orchestral playing and the symphonic style of composition.

During the 18th century the role of the keyboard as background accompaniment diminished as the orchestra grew in size, although Franz Joseph Haydn (1732-1809), an Austrian who is often called the "father of the symphony," habitually "presided at the instrument" when conducting his own works. A typical "classical" orchestra of Haydn's time had about 35 members. The strings remained paramount, and each line of music written for them was played by several musicians. There were about a dozen violins (first and seconds), two violas, two cellos, and at least two double basses. The woodwind instruments gradually acquired their own functions instead of merely echoing the violins' melody. The brass section consisted of two horns and sometimes two trumpets as well, and percussion was chiefly kettledrums (timpani).

The Haydn orchestra became a sensitive and responsive instrument in the hands of other great composers. Wolfgang Amadeus Mozart (1756-91), Haydn's compatriot and contemporary, developed orchestration to a fine art. Mozart's contribution to the composition of the orchestra itself was to add clarinets.

The first symphony by the outstanding German composer Ludwig van Beethoven (1770-1827), written in 1800, is scored for first and second violins, violas, cellos, and double basses; a pair each of flutes, oboes, clarinets, bassoons, trumpets, and horns; and two kettledrums. He later added trombones. This now constitutes the nucleus of the standard symphony orchestra, in which massed strings still make up two-thirds to three-quarters of the total.

Hector Berlioz (1803-69), a leading French romantic, and Richard Wagner (1813-83), immensely influential German operatic composer, helped to revolutionize the classical symphony orchestra in their search for intoxicating tonal color and expressive harmony. Not only did they demand many more players, but they also added further instruments, especially in the woodwind and brass sections. Berlioz's *Treatise on Orchestration* (1843) remains a standard work. Using the Wagnerian orchestra as a basis, the Bohemian-born conductor-composer Gustav Mahler (1860-1911), German operatic conductor-composer Richard Strauss (1864-1949), and Russian-born composer Igor Stravinsky (1880-1971) developed the orchestra to its modern proportions.

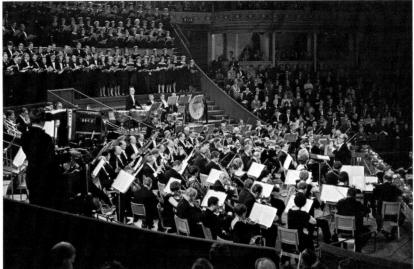

Instrumental Music

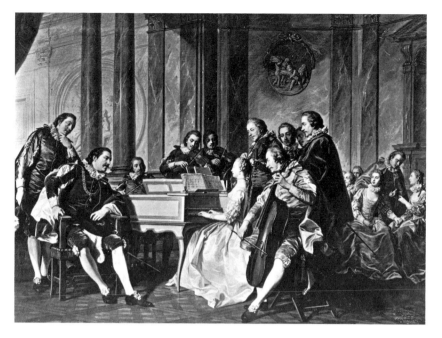

ABOVE *The Concert*, a picture of aristocratic musical entertainment in the first half of the 18th century in Europe. The artist is Carle van Loo (1705-65), a Frenchman of Flemish descent.

Music, like painting or sculpture, comes to life in specific forms. Classical (as opposed to modern) instrumental music is firmly shaped according to patterns that evolved during three main periods – the baroque, Viennese classic, and romantic eras.

During the baroque period (1600-1750) the ideal was *virtuosity* – technical proficiency. Another important principle was the *stile concertato*, in which the sounds of several solo or groups of instruments were contrasted with those of the entire orchestra. Baroque composers used this style for concertos, sacred music, and opera and were the first to distinguish between vocal and instrumental styles. Both the expressive or emotional and purely technical capabilities of each instrument were explored and developed.

The Italian composer Antonio Vivaldi (about 1685-1741) was a noted violinist and lived at the same time as the great violin-maker Antonio Stradivari. He wrote nearly 250 string concertos in addition to 40 operas. The German composer Johann Sebastian Bach (1685-1750) perfected the form of instrumental counterpoint known

RIGHT a 19th-century portrait of Beethoven as a young man by Mähler, an Austrian artist. Beethoven was one of the most influential composers of instrumental music ever.

as the *fugue*, in which each part follows upon the one before and closely imitates its melody.

Bach was the last of the great composers who could earn his living employed full-time by the church authorities. After 1750 the new patrons were the rich princes and aristocrats, who

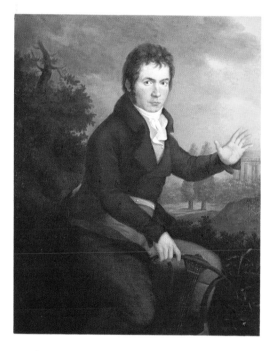

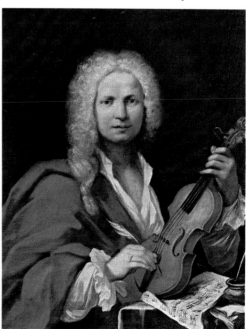

LEFT Antonio Vivaldi, noted violinist and composer of instrumental music and opera, who generally conducted his own works. The sprightly concertos he wrote for solo violin, bassoon, cello, oboe, and flute that can be traced today number no less than 450, and his musical style influenced J. S. Bach, among others.

employed musicians in their palaces as part of their permanent staff. These connoisseurs wanted courteous formality in music, so their composers evolved new styles to replace the serious religious counterpoint and dramatic operatic overtures of the baroque era. The character of this new classicism, which grew up around the cultural center of Vienna, Austria, was gallant, elegant, and unruffled, and the

music is strict in proportion and moderate in expression.

Employed for 30 years on a country estate, Franz Joseph Haydn wrote *chamber music* (literally, "room music" to be played by a small group of musicians) for whatever instrumentalists were available. He incorporated the combined sound of two violins, a viola, and a cello into the first *string quartets*.

Mozart was the other great figure in 18th-century classical music. Also based in Vienna, he wrote in a style characterized by disciplined restraint that made his depth of feeling all the more effective. The classical composers established the symphony, sonata, and string quartet as the major forms of musical expression.

After Haydn and Mozart a new generation of composers inevitably began to seek ways to extend the boundaries they had imposed. The romantics of the 19th century sought to express feeling through music in a more direct way than had previously been considered necessary or desirable. The type of music they wrote was still recognizable as having been adapted from the 18th-century classical sonata form of the Viennese school, but the mood of courteous formality was transformed into a warmth and openness

ABOVE *A Matinée by Liszt* with the Hungarian-born musician at the piano. Standing (left) is French romantic composer Hector Berlioz. Liszt was the greatest virtuoso pianist of his time.

that expressed the composer's personal emotions.

Revolutionary idealism, the democratic participation of the new middle classes in culture as well as in politics, the quest for national and personal liberty, and a whole new self-awareness characterized the romantic age in all the arts,

ABOVE *Chopin at the Piano*, a characteristic portrait of the intimate performances for friends that he preferred to more elaborate concerts. His recitals included his own romantic études and nocturnes.

including music. More than any other figure, Beethoven typifies the romantic movement in its idealistic search for liberty, equality, and fraternity, but it is generally accepted that, just as Beethoven stood chronologically with a foot in both the 18th and 19th centuries, he belongs stylistically to both worlds. His achievement lay in resynthesizing the elements of classicism, not in abandoning them.

The development and improvement of the piano after Beethoven led to a move toward short piano pieces with strong melodies supported by subtle harmonic accompaniments. Among the leading keyboard composer-performers were Frédéric Chopin (1810–49) and Franz Liszt (1811–86) in France. Liszt introduced a new form, the *symphonic* or *tone poem*, into orchestral music. It is an extended but unified descriptive composition in which themes are "transformed" without being broken up into separate movements.

The Russian romantic Peter Ilyich Tchaikovsky (1840–93) composed six symphonies using folk song material. The Austrian composers Anton Bruckner (1824–96) and Gustav Mahler used opulent orchestration in large-scale symphonies that expanded the symphonic form. A German writer, Johannes Brahms, used smaller orchestras and contained his themes within the disciplined musical structures of four symphonies and various sonatas for combinations of piano, cello, clarinet, and violin. Eventually the romantic style culminated in a fusion of poetry, painting, and music, with an increased emphasis on orchestral color, the textures of sound, and the dramatic expression of feelings and ideas.

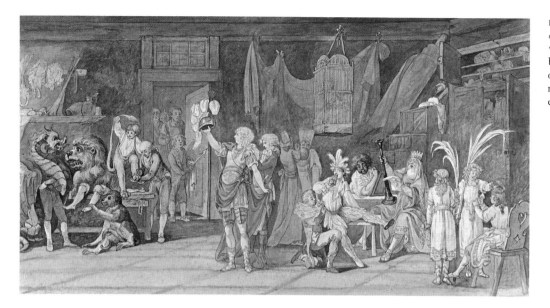

Music in the Theater

Music in the theater dates from the classical dramas of Athens in the 6th and 5th centuries BC, in which the music was sung in unison by a chorus as a commentary on the action. The tradition of medieval plays and court entertainments combined with the revival of classical Greek drama during the Renaissance to lay the foundations for opera – a complete dramatic entertainment that included both vocal and instrumental music. The works of Alessandro Scarlatti (1660-1725) marked the birth of modern Italian opera, and his works provided a model for later composers.

During the 17th century the audience for Italian opera changed from the nobility to the general public. Because songs with regular patterns were easier for untutored listeners to follow and remember than unmelodic vocal lines, *arias* became the most prominent feature. The cult of *bel canto* ("beautiful singing") was growing, and displays of the vocal virtuosity of soloists came to dominate opera performances.

Later the more light-hearted *opera buffa* style evolved, in which flesh-and-blood (as opposed to mythological) characters were placed in contemporary settings with uncomplicated, unembellished music. The *Barber of Seville* (1816) by Gioacchino Rossini (1792-1868) is an ex-

ample. But one of the greatest operatic geniuses was Mozart, whose *The Magic Flute* (1791) is a masterly blend of spectacle, comedy, fairy tale, and morality play.

The age of large-scale *grand opera*, heroic in theme and grandiose in design, setting, and costume, was launched with the production of works such as Rossini's *William Tell* (1829). Giuseppe Verdi (1813-1901) was the greatest exponent of grand opera and, with Richard Wagner, was unquestionably one of the giants of 19th-century operatic music. But Russian works such as *Boris Godunov* (1874), by Modeste Mussorgsky (1839-81), and *Eugene Onegin*

RIGHT a scene from a production of Wagner's *Tristan und Isolde* at Bayreuth in West Germany. Unlike many operatic composers, Wagner wrote the words (libretto) as well as the music for his operas.

(1879) by Tchaikovsky also enriched the repertoire. With *Carmen* (1875) by Georges Bizet (1838-75), a Frenchman, came a new realistic approach later termed *verismo*, in which violence and passion among the lower classes were the usual subjects. Other prime examples of *verismo* and the legacy of Verdi are the Italian operas *I pagliacci* (1892) by Ruggiero Leoncavallo (1858-1919) and those of Giacomo Puccini (1858-1924), among them *La Bohème* (1896), *Tosca* (1900), and *Madam Butterfly* (1904). Important modern operas include the psychological drama *Pelléas et Mélisande* (1902) by Debussy, *Wozzeck* (1925) by the Austrian modernist Alban Berg (1885-1935), and *Peter Grimes* (1945), *Billy Budd* (1951), and *Death in Venice* (1974) by the British composer Benjamin Britten.

Light opera evolved in forms other than *opera buffa*. Familiar English melodies were arranged by John Pepusch (1667-1752) with dialogue by John Gay (1685-1732) for *The Beggar's Opera* (1728), a comic story that satirized the pretentious highbrow Italian operas of the day. Jacques Offenbach (1819-80), French composer of nearly 100 witty *operettas*, suggested that Johann Strauss the younger (1825-99), of the famous Viennese musical family, write in the same mode. Among the results were *Die Fledermaus* (1874) and *Cagliostro* (1875), the true forerunners of the modern stage musical. In Victorian England the famous partnership of W. S. Gilbert (1836-1911) and Arthur Sullivan (1842-1900) produced a dozen unique works of comic

ABOVE Figaro, a central character in Mozart's *Marriage of Figaro* (1786) as well as Rossini's comic opera *Barber of Seville* 30 years later.

opera including *The Pirates of Penzance* (1879) and *The Mikado* (1885), notable for their verbal wit, felicitous tunes, and apt orchestration.

Musical comedy in the United States grew out of burlesques and revues staged in New York City by Ziegfeld Follies, based on the music hall entertainments of the Parisian Folies-Bergère. Florenz Ziegfeld produced *Show Boat* (1927) by Oscar Hammerstein (1895-1960) and Jerome Kern (1885-1945), which set a trend for many other musicals by George Gershwin (1898-1937), Irving Berlin (born 1888), and Cole Porter (1893-1964). More recent stage and film musicals such as *Oklahoma!* (1943), *South Pacific* (1949), and *The Sound of Music* (1959) by Hammerstein and Richard Rodgers (born 1902) have been seen and enjoyed in many languages by audiences worldwide.

Memorable music composed specifically for the ballet, which originated in the court spectacles of the Renaissance, ranges from Tchaikovsky's classically romantic works – *Swan Lake* (1877), *The Sleeping Beauty* (1890), and *The Nutcracker* (1892) – to the scores commissioned by the Russian impresario Serge Diaghilev (1872-1929) for his Ballets Russes. These included the colorful *Scheherazade* (1888) by the Russian composer Nikolai Rimsky-Korsakov (1844-1908); Debussy's jewellike *L'Après-midi d'un Faune* (1912); Ravel's *Daphnis et Chloë* (1912); wryly amusing works by the French pianist Erik Satie (1866-1925); and three early masterpieces by Igor Stravinsky.

LEFT the beginning of a dream ballet called "Laurey Makes Up Her Mind" from *Oklahoma!* (1943), in which the choreography of Agnes de Mille, who was an important proponent of modern ballet in America, revolutionized the musical comedy form. She expressed in movement the subconscious fears and longings of the heroine and carried the plot forward through dance.

All That Jazz!

Jazz is a fusion of African and European styles and may prove to be America's most important contribution to world music. It is largely the creation of American blacks, who are still its leading innovators. Before the Civil War in the mid-19th century slaves were active participants in Protestant denominations in the southern states, and they adapted many Baptist and

ABOVE yells of acclamation from Louis Armstrong (Satchmo, from "Satchelmouth") as his clarinetist Edmund Hall takes a bow after a solo at a performance in Britain in May 1956. The band also included trombone, contrabass, and a singer called Big Fat Mamma.

LEFT Dejan's Olympia Marching Band struts through the streets of Washington, DC. The black marching bands that were common in the South after the Civil War were a major influence on the first New Orleans jazz bands.

son of an ex-slave.

The first jazz bands appeared in New Orleans, Louisiana as smaller versions of the earlier Civil War marching military bands. They featured trombone and clarinet players who improvised a counterpoint around the lead cornet or trumpet. The cornettist Buddy Bolden, trumpeters Joe "King" Oliver (1885-1938), Freddy Keppard, and the young Louis Armstrong (1900-71), and clarinettist Sidney Bechet were legendary figures of early New Orleans jazz, nowadays more often known as "traditional" or "dixie-land." The first jazz recordings were made in 1917 by a white group, the Original Dixieland Jazz Band. In the same year the New Orleans red-light district, the home and main source of employment for black jazz musicians, was closed down. Many migrated northward to the big cities of Kansas City, Missouri and Chicago, Illinois.

In the mid-1920s Louis Armstrong helped to

Methodist hymns to their own purposes. Other European forms such as marches and quadrilles were similarly transformed, and from this combination of influences various styles emerged – Negro spirituals, rural blues and work songs, and black marching bands – which during the 1880s coalesced into jazz.

The *syncopated* style of piano-playing known as *ragtime*, in which the beat stressed is not the main accented beat of the phrase, crystallized around the turn of the 20th century. Unlike spirituals or blues, ragtime was usually composed, written down, and published, often with some commercial success, by black composers such as Scott Joplin (1868-1917), who was the

RIGHT pianist Thelonious Monk, whose distinctive, innovatory style of both playing and composing have always made him instantly recognizable among jazz musicians. Like many of his contemporaries, he always plays alone or in small groups.

initiate a change to virtuoso solo playing with his historic "Hot Five" and "Hot Seven" recordings (1925-8). His innovations were quickly matched by the tenor saxophonist Coleman Hawkins, the pianist Earl Hines, and others. "Jelly Roll" Morton (1885-1941) made tightly organized recordings called "Red-Hot Peppers" that added Creole influences to the blend of ragtime and jazz. The rise of the soloist was paralleled by the rise of big bands and the popularity of blues singers such as Bessie Smith (about 1898-1937), and the importance and scope of the arranger-composer-conductor grew accordingly. Major big-band leaders of the decade nicknamed the "Jazz Age" were Fletcher Henderson, Edward Kennedy ("Duke") Ellington (1899-1974), and Paul Whiteman (1891-1967), and they were followed in the 1930s era of "swing" music by Count Basie and Benny Goodman.

In the early 1940s young black musicians developed *bebop* (or just *bop*), a difficult, angular style of music. This was partly a reaction against the stereotyped swing music then in vogue and partly to counter the threat of white exploitation. Count Basie's tenor saxophonist Lester Young, who played in a spare, laconic style, could be considered the spiritual father of bop, but its direct and perhaps most original instigator was the alto saxophonist Charlie ("Bird") Parker (1920-55). Parker's style combined harmonic and rhythmic innovation with emotional urgency and through it he influenced a whole generation of musicians.

Perhaps equally important in this first phase of modern jazz were the trumpeters Dizzie Gillespie and Fats Navarro, pianists Thelonious Monk (born 1920) and Bud Powell, and drummers Kenny Clarke and Max Roach. Subsequent developments included the short-lived "cool" movement of the West Coast in the early 1950s that featured white musicians such as Lee Konitz, Lennie Tristano, Gerry Mulligan, and Dave Brubeck, and the quasi-classical work of the Modern Jazz Quartet. Trumpeter Miles Davies, saxophonists Sonny Rollins and John Coltrane, and the bassist Charlie Mingus extended the boundaries of bop while the pianist Cecil Taylor and saxophonist Ornette Coleman developed "free" jazz.

The jazz repertoire now ranges from simple 12-bar blues to 32-bar compositions with which improvised solos are often performed. Jazz groups usually include a rhythm section of piano and/or guitar, string, electric or brass bass, and drum kit; and a front line of one or more wind instruments, often a trumpet or saxophone. Groups range in size from trios (usually piano,

ABOVE the Count Basie Band in performance in 1978, still going strong since the era of big bands and swing music.

RIGHT Duke Ellington at the piano during a performance by his band at Coventry Cathedral. Both his music and the building mix traditional themes with the freshness of 20th-century innovation.

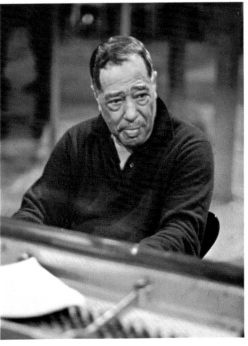

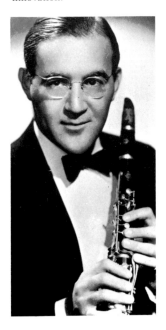

ABOVE Benny Goodman, famous both as a bandleader and for playing the clarinet. Swing music was his trademark, and he was one of the earliest white men to adopt jazz and make his living at it.

bass, and drums) to big bands (usually seven brass, five saxophones, and four rhythm instruments). In between are the traditional seven-piece ensemble of trumpet, trombone, clarinet, and four rhythm; and the modern quintet of trumpet, saxophone, and three rhythm. Jazz has become predominantly instrumental but with a leaning toward vocallike tone and expressively varied intonation. Although it is often composed, arranged, and committed to paper, jazz is essentially an improvised music based either on a regular, "swinging" beat, with frequent syncopation and cross rhythms, or on an erratic pulse as is evident both in modern "serious" music and avant-garde jazz.

Contemporary Music

Music of the 20th century includes both "serious" experimental works, written in reaction to the 19th-century classical tradition of romanticism, and popular music – those light songs and instrumental pieces that have acquired universal appeal through radio and television. Although the two "streams" of creative art have usually proceeded separately, at some points they do cross and influence one another in style or form.

Late romantic music had achieved its characteristic intensity of expression by an increasing use of the chromatic 12-note scale of semitones and less reliance upon the simpler seven-note diatonic scale. The works of Wagner, Liszt, and Richard Strauss strained the limits of the harmony possible within the conventional system of major and minor chords. In the early 20th century composers such as the Hungarian Béla Bartók (1881-1945) and Igor Stravinsky began to combine different keys, sometimes simultaneously, in their orchestral music; this is called *polytonality*. They also sought to combine rhythms (*polyrythms*) that may be heard independently or together.

A new idea that was to prove more revolutionary was the use of *atonality*, introduced by the Austrian composer Arnold Schoenberg (1874-

1951) to produce unusual, often dissonant harmony that consciously avoided a sense of key. In 1923 he formulated his influential *12-note* or *dodecaphonic* system. Two of his greatest followers, Alban Beag and Anton Webern (1883-1945) – both fellow Austrians – created expressive works using both methods.

Experiments in sound combined with developments in technology led also to electronic instruments. The first were invented in the late 1920s. A pioneer in the use of tape-recorded sounds (both natural and electronic in origin) is the German composer Karlheinz Stockhausen (born 1928), who wrote *Hymnen* (1971). The American John Cage (born 1912) obtained new sounds from conventional instruments by "preparing" them with unexpected objects as in his *The Perilous Night* (1942). Although no common direction seems to have evolved yet, the diverse strands of contemporary concert music indicate a continuing excitement about the possibilities of musical expression.

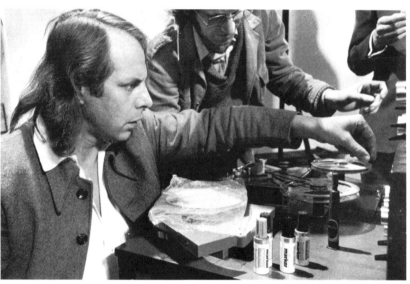

ABOVE Karlheinz Stockhausen (left) at work composing his electronic music from tape-recorded sounds of all kinds.

TOP leader of the modern revolution in atonality: Arnold Schoenberg, as drawn for the cover of a recording of his *Piano Music*.

LEFT the durable Frank Sinatra in concert recently at the Royal Albert Hall in London. His continued popularity makes him an exception among modern recording stars, who usually fade from public awareness as musical trends change.

Usually contrasted with serious or "classical" music and yet distinct from related forms such as jazz, *popular music* typically consists of melodies, harmonies, and words that are simple enough to be remembered after only one hearing. Produced purposely for a mass market, it is therefore more likely to be short-lived than most other types of music.

Popular music first flourished in the late 19th and early 20th centuries. Sold as sheet music, the songs were taken from successful operas, operettas, musical comedies, and variety theater. Solo vocalists such as Bing Crosby and Rudy Vallee sang with American dance bands of the "Jazz Age," and songwriters including George Gershwin, Cole Porter, and Hoagy Carmichael provided them with material. Glenn Miller

epitomized the "swing" style of the 1930s and 1940s. After World War II a new generation of young male singers – among them Frank Sinatra and Frankie Laine – attracted an impassioned audience for their recordings.

The product of the fusion of white "country and western" and black "rhythm and blues" music – *rock 'n' roll* – had its first popular success with Bill Haley's 1954 record "Rock Around the Clock." Rock 'n' roll's first star idol

was Elvis Presley, whose recording of "Heartbreak Hotel" (1956) sold eight million copies in six months. Social dancing – the jive, twist, and shake – was an important adjunct.

A new movement began with the British group the Beatles, who by 1964 had become the top pop stars in both Britain and America. In that year their songs occupied the first five places in the "hit parade" charts. Most of their distinctive and original melodies, harmonies, and lyrics were composed by members John Lennon (born 1940) and Paul McCartney (born 1942).

Within a few years a clear division emerged, which has remained, between light (*pop*) and serious (*rock*) popular music. Rock was developing in three main strands. Bob Dylan (born 1941), whose first long-playing (LP) album

ABOVE Bob Dylan, who first emerged as a performer and writer of folk music and protest songs in the early 1960s. He has since embraced rock with its electrically amplified instrumentation as well as the flowing vocal sounds of black gospel music.

ABOVE LEFT popular music in America has roots in black spirituals, anonymous folk songs, country and western, and rhythm and blues. One of the reasons for its popularity is its accessibility to many different types of people.

LEFT popular music since the 1960s has been profoundly affected by the Beatles, four musicians who still write and/or record, though not together.

RIGHT Steve Howe, a guitarist with the British rock band Yes. Many of the more serious groups in the business today write their own music rather than rely on outside songwriters, so that they control their characteristic "sound" as closely as possible.

appeared in 1961, created serious folk-inspired anthems for the protest movements then gathering momentum among young people. The American West Coast saw the blossoming of the "hippie" youth movement, and its musical spokespeople were "psychedelic" bands such as the Grateful Dead and Jefferson Airplane. And in 1967 came the Beatles' *Sergeant Pepper's Lonely Hearts Club Band*, an eclectic blend of influences welded together with surrealist humor and melodic craftsmanship.

Rock has continued to develop on both sides of the Atlantic while pop music reaches everhigher peaks of mass popularity. The psychedelic rock tradition, built upon by Cream, Pink Floyd, Led Zeppelin, and Yes, even has interests in common with "serious" modern composers such as John Cage. Both use sophisticated electronic *synthesizers* to explore the possibilities of sound distortion and manipulation.

Chapter 8

THE GREAT COMPOSERS

The function of a composer is to invent musical ideas and write them down so that they can be performed. Frequently composers are accomplished musicians as well, and often they play or conduct their own music. But their greatness must be judged by the depth of creativity and skill that have gone into their works – as reflected in the beauty, intellectual challenge, and attraction their listeners find in the music.

For music must be heard; it is an aural art. Musical innovators such as Beethoven, Monteverdi, Wagner, and Schoenberg, who developed ideas that shaped the course of music, must evoke responses in their audiences that are just as profound as those called forth by composers who consolidated the best aspects of their eras – Palestrina, J. S. Bach or Mozart. Though it may take years for new ideas to be accepted, eventually great music seems to find an appreciative audience, thus proving that it is a dynamic and responsive means of communication.

OPPOSITE Verdi's *Othello*, perhaps the greatest Italian tragic opera, as staged by the Royal Opera in 1977. The story is based on Shakespeare's play about the effects of jealousy, intrigue, and passion.

The Middle Ages and Renaissance

The 12th-century spirit in architecture, epitomized by the church spire reaching up from earth to heaven, was expressed in music by the expansion from a single melodic line to the interlaced melodies of polyphony. This branching out of music from unaccompanied troubadour chansons and church plainsong to the intricacies of songs accompanying each other evolved over a long period, culminating in the 16th century. The famous English round "Sumer is icumen," the so-called Reading Rota, dates from the late 13th century.

Much of the music written in the 13th and 14th centuries was written for the church by clergymen. De Vitri (1291–1351), born in the French Champagne district in a town now named after him, was the bishop of Meaux. He was not only a composer but also a poet, theorist, and diplomat. Perhaps the greatest composer of the 14th century was Guillaume de Machaut (about 1300–1377), also from Champagne. He was secretary to King John of Bohemia, Duke of Luxembourg, and later became canon of Rheims. His Mass, the *Messe Notre Dame*, is the first known complete polyphonic setting achieved by one composer. He also wrote a great deal of secular music.

The Englishman John Dunstable (about 1370–

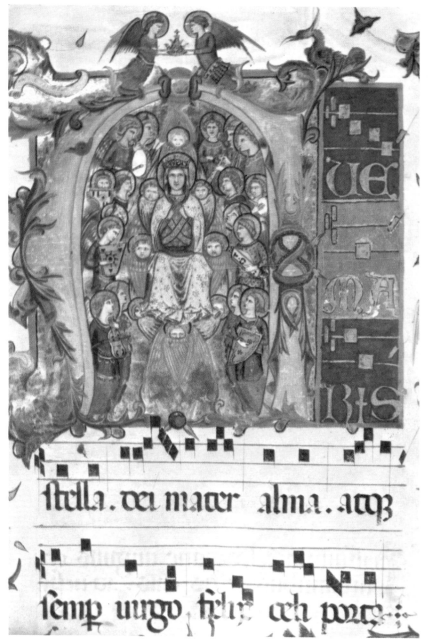

ABOVE an illuminated manuscript dated 1415 on which a plainsong hymn to the Virgin has been written out for singers. By the 15th century plainsong was giving way to polyphonic music, secular and religious.

LEFT late-14th-century canon or round written by Baude Cordier in circle form to show how one voice comes in after another. All sing the same melody.

1453) added variations to the polyphonic styles and forms then in use and strongly influenced his continental contemporaries. A French poet at the court of the Duke of Burgundy, which Dunstable visited between 1423 and 1435, wrote of the French and Flemish composers: "The English guise they wear with grace, They follow Dunstable aright, And thereby have they learned apace, To make their music gay and bright."

Two of these composers were Guillaume Dufay (about 1400–1474) and Gilles Binchois (about 1400–1460), both churchmen at Mons in Flanders, though Binchois wrote mainly secular music. Johannes Okeghem (died about 1495) was born in eastern Flanders and served Duke Charles of Bourbon and King Louis XI of

France. He delighted in complex contrapuntal detail and extended polyphonic writing from the previously usual three parts to four, five, and six parts – and even produced a *motet*, a sacred choral composition, for 36 parts. Jakob Obrecht (about 1430-1505), born in Utrecht, became the choirmaster at the cathedral there. He composed the first passion motet, a work for four voices taken from the four Gospels.

Josquin des Prez (about 1440-1521), born near Cambrai, was probably the greatest com-

LEFT Palestrina presenting his *Book of Masses* to Pope Julius III on the frontispiece to the volume published in 1554.

poser to bridge the 15th and 16th centuries. He wrote voluminous masses, motets, secular songs, and instrumental music. From 1486 to 1494 he was connected with the Sistine Chapel in Rome and there, as a wide-ranging Renaissance man like his contemporary Leonardo da Vinci, he helped prepare the way for the art of Palestrina (about 1525-94).

Giovanni Pierluigi da Palestrina was a child of the Counter Reformation – he was born only five years after Martin Luther defied the pope at Wittenberg – and the order and control of his music reflects the discipline of the newly founded Jesuit order, which gave a new impetus to Catholic learning. Palestrina also echoes the Jesuits' singleness of purpose, in that he wrote religious music almost exclusively.

Born in the small cathedral town of Palestrina at the foot of the Sabine Mountains in the Roman *campagna*, tradition has it that before he was 20 years old he sang in the chorus at the Church of Santa Maria Maggiore in Rome. He married in 1547, and in 1551 Pope Julius III selected him as choirmaster for the Capella

ABOVE courtiers in medieval France performing secular music together informally in a castle garden.

Giulia at St Peter's in the Vatican. His first *Book of Masses* (1554) is dedicated to Julius who, in 1555, appointed him Singer in the Sistine Chapel. But Palestrina was soon dismissed by Julius' successor Pope Paul IV, along with other married singers, because the church preferred all its employees to be celibate. In 1561 he returned to Santa Maria Maggiore as choirmaster, and during his ten years there he wrote his greatest work.

In 1562 the Council of Trent censured the prevalent style of Catholic liturgical music, and two years later Pope Pius IV set up a commission to investigate the complaint. Palestrina was invited to submit what he considered suitable church music; the pope's reaction to the *Missa Papae Marcelli* (1562) was to compare it to the music St John heard in his vision of the New Jerusalem. Thus Palestrina's greatest work, the fulfillment of his polyphonic style, helped to preserve artistic freedom for Catholic composers throughout the Counter Reformation.

Palestrina's later music is more homophonic than polyphonic, and harmony predominates over counterpoint. His *Stabat Mater* (1589-90) has been described as "one of the simplest compositions in the world, the purest cloudscape in the world of harmony, without even a flight of birds to show the scale of its mighty perspective." He also wrote both secular and spiritual madrigals, but all his music is based on the concept of proportion between long lines of freely flowing phrases. The austere beauty of Palestrina's compositions reflects the proportionality of high Renaissance architecture – indeed, according to the German poet Goethe centuries later, "Architecture is frozen music."

Claudio Monteverdi

1567-1643

Basing his work on the belief that music must "move the whole man," Monteverdi's consummate skill in combining contrasting emotions into unified works of art made him the most effective of the revolutionaries responsible for the birth of opera and decline of polyphony. His musical innovations brought drama and characterization to secular music with such impact that in his lifetime opera became firmly established

RIGHT contemporary portrait of Monteverdi playing a bass viol.

BELOW Janet Baker and Robert Ferguson in the English National Opera's 1971 production of *The Coronation of Poppea* (1642). The opera covers a whole range of complex plots and subplots.

as an important and popular art form.

Born in Cremona in the Po valley 45 miles from Milan, Claudio Giovanni Antonio Monteverdi was the son of a barber-surgeon and chemist. By the age of 15 he had already published a group of short religious pieces. He assured his youthful reputation with two books of charming madrigals in 1587 and 1590. At 23 he became a string player at the court of the Duke of Mantua, and in 1602 he became musical director.

In 1603 and 1605 he published two more books of madrigals, which were attacked by conservatives for disregarding the rules of composition. This publicity not only made Monteverdi the most famous composer of the day – it also provoked him to reply as the figurehead of the avant-garde movement. He defended his use of intense and prolonged dissonance and his reliance on the verse or text to set the mood of the music by claiming that his style was built "on the foundations of truth" and reflected the ideas of the Greeks. He said he was following a tradition that sought a union of the arts, especially of words and music, into a dramatic whole.

Monteverdi's first opera, *Orfeo*, performed in 1607, finally established him as an important composer of large-scale music. This work reflected a broader conception of the new genre of opera than that held by the Florentine *camerata* who had first put it forward as an ideal. He combined the opulence of late-Renaissance dramatic entertainments with a straightforwardly simple tale told in recitative, a speechlike vocal style. Monteverdi's use of recitative is more flexible and expressive than the Florentines' and he had a greater gift for dramatic unity.

A few months after the production of *Orfeo* in Mantua the composer's wife, a singer, died. Monteverdi entered a state of deep depression that lasted for several years. But he was summoned back to court almost immediately to compose a new opera celebrating the marriage of Francesco Gonzaga, the duke's heir, to a princess of Savoy. Unwillingly he returned, and after various complications *Arianna* was produced in 1608. It was a great success, and Monteverdi's reputation reached new heights.

In 1613 Monteverdi took his two sons to Venice, where he became musical director at St Mark's church. Although he had not been primarily a liturgical musician before, he took his new duties seriously and wrote a great deal of church music. He also continued to accept commissions from Mantua, such as for the ballet *Tirsi and Clori* (1616).

His efforts to evolve a practical philosophy of music also continued, leading to various stylistic

BELOW scene involving two of the minor characters in *The Return of Ulysses*, from a 1972 production staged at the annual open-air opera festival held since 1934 in the grounds of a Tudor mansion near the tiny agricultural village (population 257) of Glyndebourne in southern Sussex, England.

innovations. His secular oratorio *The Combat of Tancredi and Clorinda* was first performed in the palace of a Venetian nobleman in 1624.

In 1630 the plague broke out in Venice, and Monteverdi became a priest soon after the epidemic ended. He spent the next few years assembling a retrospective anthology of all his secular music, entitled *Madrigals of War and Love*, which was published in 1638. But just as he was settling into a calm old age, having passed 70, the first public opera house opened in Venice in 1637. In 1641 he wrote two operas, one of which was *The Return of Ulysses to His Country*, and the next year he wrote his final masterpiece, *The Coronation of Poppea*. Described as the first modern operas, they reveal the development of human beings in realistic situations and the music accurately expresses their varied emotions. Monteverdi died in Venice and was buried in the Church of Santa Maria Gloriosa dei Frari, where a memorial plaque still hangs.

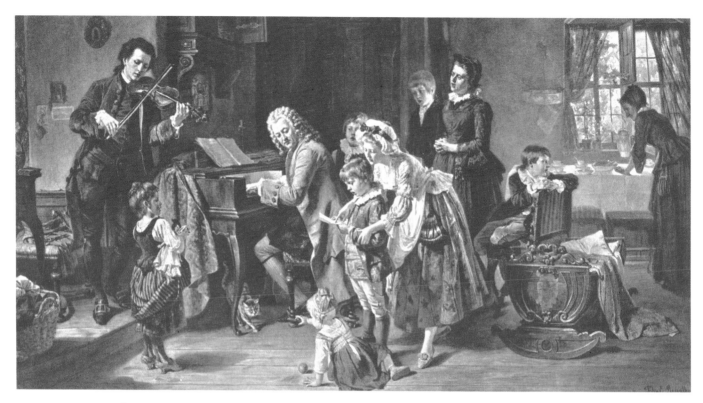

Johann Sebastian Bach

1685-1750

Although not generally considered an innovator, Bach was unique in his ability to survey the principal musical forms, styles, and national traditions that preceding generations had developed and creatively to synthesize and enrich them through his own contributions. Respected in his own day primarily as an organist rather than as a composer, Bach carried the baroque movement in music to its peak even as radical new concepts were beginning to undermine it.

Johann Sebastian Bach was born in Eisenach, Germany, the youngest of eight children. His father was a church organist whose family proudly claimed descent from a long line of musicians, and Johann Sebastian showed early promise as an organist, violinist, singer, and keyboard player. By the time he was ten years old both his parents had died and he was sent to live with his eldest brother at Ohrdruf. On the strength of his voice he was admitted to a church school known for its boys' choir in Lüneburg, and by the age of 18 he had been appointed

ABOVE morning prayers at the home of Johann Sebastian Bach, from a print published in Munich in 1874. Bach was a devout Lutheran.

organist of the Church of St Boniface in Arnstadt. In 1707 Bach left for a similar post in Mühlhausen, where he married a cousin and published his first composition.

A year later Bach became court organist and a member of Duke Wilhelm Ernst's chamber orchestra in Weimar. Many of his great organ compositions were written during the nine years he spent at the court of Weimar. He became concertmaster of the orchestra in 1714, and one of

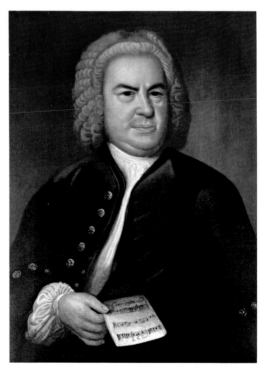

RIGHT portrait of J. S. Bach painted by Elias Gottlieb Haussmann and now in a museum in Leipzig.

216

his duties was to compose a cantata every month.

Never a self-effacing man and frequently at odds with his employers, Bach was annoyed at being passed over for the position of musical director at Weimar. He agreed to move to Köthen and the court of Prince Leopold in 1717. Duke Wilhelm at first refused to let him go and even imprisoned him for a month, but in December Bach took up his new duties.

As musical director at Köthen Bach's principal concerns were to conduct the court chamber orchestra – in which the prince himself played the viola da gamba – and to compose music for it. The six *Brandenburg Concertos*, dedicated to the Duke of Brandenburg, were finished in 1721. In 1722 he wrote the first of two books of *The Well-Tempered Clavier*, a remarkable collection of 48 preludes and fugues that systematically explore both a new keyboard tuning procedure and the possibilities of *functional tonality*, a kind of musical language that prevailed for the next two centuries. The unexpected death of Bach's first wife in 1720 and the prince's marriage to a woman unsympathetic to his musical interests

RIGHT handwritten and signed manuscript of a sonata for solo violin by J. S. Bach.

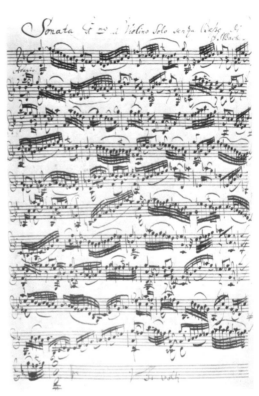

BELOW St Thomas' Church in Leipzig, where Bach conducted the choir and his sacred cantatas were first performed. The organ is at the back of the church.

made the composer restless again, and with his young second wife, the daughter of a trumpeter, he moved his family to Leipzig in 1723.

As *cantor* – director of church music – for the city of Leipzig, Bach taught and conducted the choirs of two churches in his own compositions. It was for the Sunday services at St Thomas' and St Nicholas' that he wrote his great series of sacred cantatas. The first version of the *Passion According to St John* and, at Christmas, the Sanctus of the *Mass in B Minor* were produced in 1724. In 1729 his *Passion According to St Matthew* was performed and in 1734 he produced the *Christmas Oratorio*.

Baroque composers were required as working professionals to compose new works to order at a remarkable pace, leaving little time or inclination for relying on "inspiration." But in general they considered their art only in connection with their religion – Bach himself was a staunch Lutheran – not as a means of self-expression. Bach once said, "The aim and final reason . . . of all music . . . should be none else but the glory of God and the recreation of the mind."

Bach's last years were spent in Leipzig where his ten surviving children grew up. In 1749 his eyesight began to fail, and he died of a stroke at the age of 65. Though his polyphonic music was not to the taste of the next generation, to whom it seemed old-fashioned even during his lifetime, his greatness and versatility were recognized after 1800 as musicians and composers helped to revive it through performance.

George Frideric Handel

1685-1759

German by birth and English by naturalization, Handel consolidated and adapted the techniques of late baroque music from Germany, France, and Italy and created works of such power that they became an essential part of the popularization of European music worldwide. He both served and expressed the needs of a wide public, and more than anyone else he could be said to have democratized music.

Handel was born Georg Friedrich Händel in Halle in Saxony, the son of an elderly barber-surgeon. He showed an early aptitude for music and studied with the town's organist and choirmaster and also had lessons in the oboe and violin. His father died when he was 11 years old, but the boy was able to continue his studies and in 1702 enrolled as a law student. After a year, however, he left for Hamburg where he played the violin and harpsichord in the town's opera orchestra. In 1705 he oversaw the production of

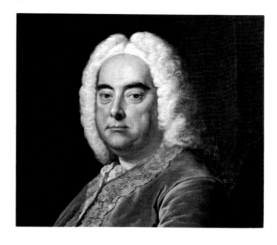

RIGHT portrait of Handel by an English artist, dated 1756.

BELOW print showing Handel (far right, standing) conducting an orchestra and choir in a performance of his own music.

his first opera, *Almira*, which was successful enough to encourage him to write others.

In 1706 Handel went to Italy, then considered the musical center of Europe. He wrote his first Italian opera, *Rodrigo*, in Florence in 1707. He enjoyed sensational success there for four years and then was invited back to Germany, where he was appointed musical director at the court of Hanover. Within a few months he left for London. He was still officially in the employ of the elector of Hanover, but since the German rulers were also heirs to the British throne, a special relationship existed between the two royal houses.

The London aristocracy craved Italian opera, and Handel's *Rinaldo*, composed in two weeks and presented early in 1711, was a tremendous success. It permanently secured the composer's reputation among his enthusiastic English audiences. In 1713 he won the favor of Queen Anne with his *Ode for the Queen's Birthday*, the first time he set English words to music, and she awarded him an annual pension. On the death of the queen the next year the elector, George Louis of Hanover, became King George I of England. In 1717 Handel's famous *Water Music* was performed at the king's request at a royal party on the river Thames.

From 1720 to 1728 Handel composed the music for most of the operas presented at London's King's Theater by the Royal Academy of Music, of which he was a director. In 1726 he became a British subject and changed his name to George Frideric. By 1741 Handel had written about 40 operas, but the form was becoming less popular with English audiences. As it declined, the oratorio replaced it, and Handel's *Messiah*, quickly composed in the late summer of 1741, made a powerful impression at its first performance. Numerous oratorios in English had preceded it – *Saul, Israel in Egypt* (both 1739) – and many followed – *Samson* (1743), *Belshazzar* (1745), *Hercules* (1745), *Susanna* (1749) – but

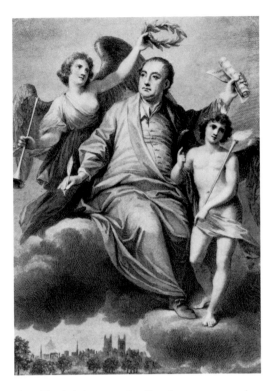

LEFT *The Apotheosis of Handel*, after a picture by T. Hudson (the composer's contemporary) in a private collection. The allegory seems to have been intended seriously.

RIGHT satirical view of Handel published in England about 1730. The accompanying verse reads, "Strange Monsters have Adorn'd the Stage, Not Afric's Coast produces more, And yet no Land nor Clime nor Age, Have equal'd this Harmonious Boar."

the *Messiah* became by far the most popular, even during Handel's lifetime.

He became a governor of London's Foundling Hospital and personally supervised charity performances of the *Messiah* there annually. Handel was well loved by the British and his music was recognized as a reflection of the national personality. He had indeed become an institution and was accorded the status of a classic during his lifetime. His eyes began to trouble him in 1751 while composing *Jeptha*, the last of his oratorios, and although he never became completely blind, his eyesight continued to fail in his last eight years. When he died he was given a state funeral and was buried in the Poets' Corner of Westminster Abbey.

RIGHT Handel Opera Society performance, at Sadler's Wells in London, of *Alcina* (1735) in a production mounted in 1975.

Joseph Haydn

1732-1809

One of the giants of classical music, whose contributions led to the flowering of the symphony and the string quartet as great art forms, Franz Joseph Haydn had a prodigious output over a long lifetime. He wrote more than 100 symphonies and about 80 string quartets as well as operas, oratorios, masses, and many smaller pieces for voice, piano, and other instruments. Unlike many creative artists, he was appreciated and celebrated in his own day, during which he rose from rags to riches.

The second child of a wheelwright, Haydn was born in the Austrian village of Rohrau. Even as a toddler he showed remarkable musical gifts and, at the age of five, went to live with a choirmaster cousin to learn the basics of music. At eight he was invited to Vienna by the musical director of the capital's most important cathedral where, over the next nine years, he gained much experience in performing but disappointingly little knowledge of theory. In both places he suffered from actual hunger and lack of care but

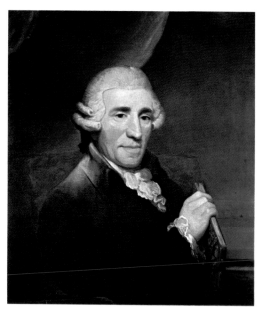

RIGHT contemporary portrait, painted in 1791, of Franz Joseph Haydn by Thomas Hardy.

was sustained by a natural strength and cheerfulness of character.

When his voice broke at the age of 17 Haydn was turned out penniless with "three poor shirts and a threadbare coat," as he described it later. Taken in by a struggling musician, he eked out a living by giving music lessons and performing where and when he could, all the while studying and composing on his own.

A great change for the better came with his appointment to the household of an Austrian nobleman, where he wrote the first of his string quartets. In 1758 this employer recommended him to a Bohemian count and Haydn wrote his

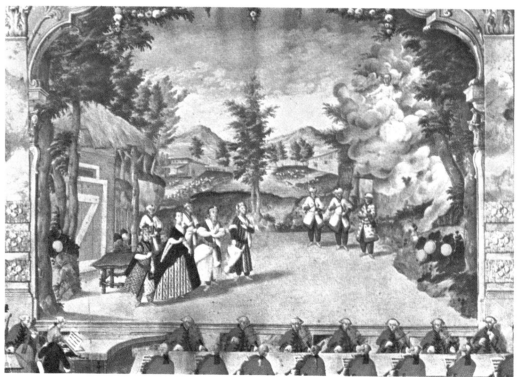

LEFT the first performance, in 1775, of a Haydn opera in the theater that was part of Prince Esterházy's magnificent estate. Haydn is seated at the harpsichord.

first symphony for the count's 16-member resident chamber orchestra. Three years later he entered the service of Prince Pál Esterházy, a wealthy and influential noble who supported the arts, especially music. Thereby began a 30-year association. Haydn's duties were formidable and arduous, as some kind of performance was put on at the splendid castle every night. Not only was he the administrator in charge of the musicians, music, and instruments, but he also conducted, directed opera, performed in chamber music – and wrote original works in every branch of music. During this period he enlarged the symphony orchestra to the size and general composition it is today.

Haydn had a warm and loving disposition that endeared him to all who knew him – the musicians he worked with affectionately called him "Papa." His marriage was unhappy, so he found his emotional satisfaction outside the home. But his unfailing good humor was often expressed in witty musical passages. In 1781 Haydn formed a firm and affectionate friendship with the much younger Wolfgang Amadeus Mozart, on whom he had a great influence in string quartet composition. In turn he learned from Mozart a greater facility for drama.

Eventually a young Esterházy who was disinterested in music became heir to the title and, though Haydn was paid as usual, he had nothing to do. So at the age of 58, in 1791, he accepted an

ABOVE performance of Haydn's *Creation* oratorio on March 27, 1808, in the ballroom of the University of Vienna. This watercolor is a copy of a scene that decorated a special snuffbox presented to Haydn on this occasion but later lost.

impresario's invitation to go to London. Full of vitality and inspiration, he met the heavy demand for new work from his English sponsors with six major symphonies in 18 months. He was feted and honored – and paid handsomely enough for him to be able to afford an expensive house in a Viennese suburb on his return home.

In 1792 Haydn met and befriended the 22-year-old Ludwig van Beethoven and invited him to become his pupil in Vienna. Not long afterward he left for a second trip to London where, from January 1794 to August 1795, he produced six more symphonies. Known as his "London" symphonies, these 12 are among the composer's best and include the two known by their nicknames of the *Surprise* (1791) and *The Clock* (1794).

Working for another Esterházy who became head of the family in 1795, Haydn produced his monumental oratorio *The Creation* (1798), based partly on John Milton's *Paradise Lost*. He also completed another oratorio, six masses, and one of his finest string compositions – known as the *Emperor Quartet* (1797). During his last years he prepared a complete catalog of his own works.

Haydn died soon after the Napoleonic armies invaded Austria in 1809 – and even the French soldiers joined in paying him homage at his funeral. Although Haydn's reputation suffered in the 19th century, he has since been restored to popularity and esteem.

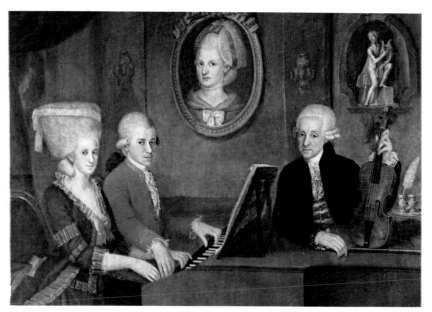

Wolfgang Amadeus Mozart

1756 - 1791

No one in the history of music has ever surpassed Wolfgang Amadeus Mozart as a combination of child prodigy, virtuoso pianist, and prolific creative composer. One of his 22 operas, *Don Giovanni*, is often considered the most perfect in the whole operatic repertoire. Six of his 40 symphonies rank among the finest ever written. His native genius was so extraordinary that he picked out chords and memorized passages of music at the age of three, taught himself to play the violin at about four, and composed music at five. (His father had to write the compositions down for him.) He left an artistic legacy of more than 600 works although he lived for only 35 years.

Mozart was born in Salzburg, Austria, the son of a violinist and composer employed by the archbishop. The infant was imbued with music from the cradle because his father was instructing his sister, who was four years older and also greatly gifted. Their father schooled them relentlessly but well with an eye to exploiting their talents commercially, which he did in a series of tours over more than a dozen years through almost every country of Europe. The children enjoyed tremendous success, but ironically as an adult Mozart could never again attain such popularity.

During the first tour, from 1762 to 1766, the

ABOVE Mozart at the piano with his sister Marianne, performing at one of the European courts with their father Leopold on violin.

BELOW watercolor-and-ink scene by a French artist showing Mozart as a child with his father and sister. Here Marianne sings.

Mozarts spent 15 months in London where the seven-year-old wrote his first two symphonic pieces. This was an important period in the young Mozart's life, for there he met Carl Friedrich Abel (1725–87), who gave him a lasting appreciation for the clarinet; Johann Christian Bach (1735–82), who influenced his operatic composition; and Manzuoli, an Italian singer who helped him understand how to write for the voice. A year later he wrote his first opera.

In 1769 a new Archbishop of Salzburg took office. Not only was he uninterested in music, but he had little regard for the Mozart family. Touring therefore remained essential, and Mozart only returned to his native Salzburg infrequently. This made regular employment difficult.

The tour of 1773 to Vienna was particularly auspicious because it resulted in a meeting and a lasting friendship with Franz Joseph Haydn. Influenced by the much older and more famous musician, Mozart thereafter paid more attention to writing string music, and he dedicated six brilliant quartets to Haydn.

During his brief employment as court organist in Salzburg during 1779–80 Mozart wrote the opera *Idomeneo*. It was the first of the great operas that followed in the next ten years. In 1781 he suffered the indignity of being physically kicked out of the archbishop's residence when

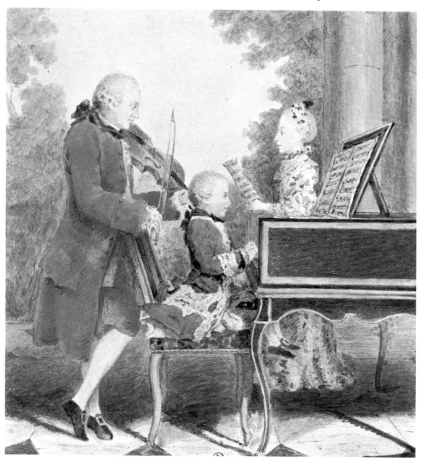

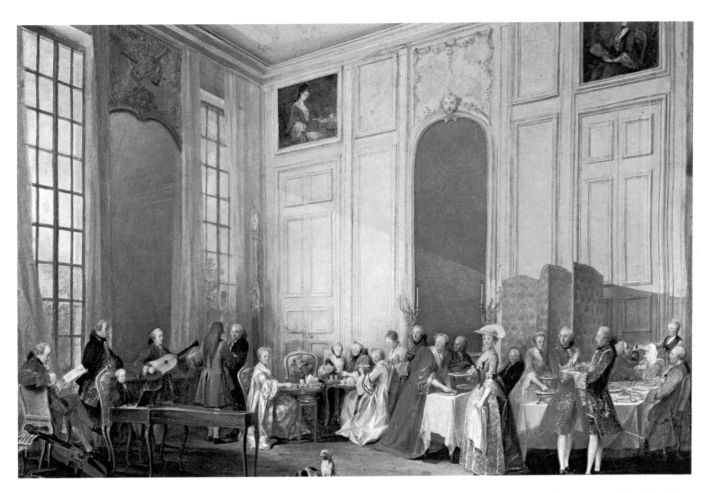

he was discharged, and he found himself without any official patronage. Thrown out on his own and uncertain of his future, he nonetheless married Constanze Weber in 1782.

Once again in Vienna, his 1782 opera *Die Entführung aus dem Serail (The Abduction from the Seraglio)* was a huge success. But Mozart could never successfully battle the court intrigue against him, and his fortunes waned. Even his own subscription concerts, for which he created most of his best piano works (Concertos K.413 to K.595), were not very favorably received. A brilliant performer, he also suggested ways to improve the piano as a concert instrument.

Mozart was full of bubbling humor and gaiety, and these are often evident in his work. Especially in his operas, he combines laughter and seriousness in the most natural way. He has never had a superior in creating well-rounded characters.

During the last ten years of his life Mozart was beset by financial worries that became a quagmire of debt after 1785. In spite of this and his artistic frustration, he then produced his greatest work. This includes the *Haffner* (1782), *Linz* (1783), *Prague* (1786), and *Jupiter* (1788) symphonies and the operas *The Magic Flute* (1791), *The Marriage of Figaro* (1786), *Don Giovanni* (1787), and *Così fan tutte* (1790),

ABOVE an English tea at the home of the Prince de Conti, at which Mozart, the child prodigy, plays the piano (left). Society gatherings like this were the ideal setting for small touring groups like the Mozart family.

RIGHT Mozart (center) listening from the stalls to a performance of *The Abduction from the Seraglio* on May 19, 1789 at the Royalty Theater, Berlin.

roughly translated as "women are like that."

In late 1791 Mozart fell severely ill, and on December 5 he died. He was buried without a single attendant in a pauper's grave, leaving his broken-hearted wife penniless and in a state of collapse. Because most of his work remained unpublished during his lifetime, he did not become widely known until years after his death. Today he is recognized as among the finest composers of Western musical literature, for his work is infinitely varied and inventive, sparkling and bright, and full of spontaneity and melody.

Ludwig van Beethoven

1770 - 1827

RIGHT portrait of Beethoven as a passionate young exponent of romanticism.

Often called the greatest composer of all time, Ludwig van Beethoven not only gave the world some of the most inspiring and enduring music it has ever known, but also changed the whole face of classical music. He developed new techniques of piano composition; altered the form of the sonata, symphony, concerto, and string quartet; and increased the importance of the orchestra in relationship to soloists. More than that, he used the power of music to convey deep emotion and to express the human spirit without sacrificing form for feeling or feeling for form.

Born into a musical family in Bonn, Germany, Beethoven showed early signs of a great talent. His father, a singer, undertook the child's initial musical training and proved a harsh taskmaster of limited knowledge. Even Ludwig's first instructors outside the home were mediocre, leaving great gaps in his education that he had to struggle later to overcome. By the time he was 11, his father had sunk so deeply into chronic drunkenness that the boy had to leave school to help the family. Thereafter he was self-taught both in music and other fields, reading on his own and later learning from educated friends.

In 1783 the court organist of Bonn helped Beethoven get his first piece of music published, and it was well received. In fact, one review said he was already second only to Wolfgang Amadeus Mozart, who was 14 years his senior. Beethoven's good fortune in being sent by the court to study with Mozart in 1787 was short-lived because of the death of his mother.

The next five years in Bonn were eventful for him. Beethoven met the von Breuning family, who became his lifelong friends; it was they who

LEFT a 19th-century idealization of the 16-year-old Beethoven playing his own work to Mozart (center) in Vienna in 1787.

Third (*Eroica*, 1804) and *Fourth* (1806) symphonies; the *Piano Concerto No. 4* (1806); the *Violin Concerto, Opus 61* (1806); and *Fidelio*, his only opera. This opera received a lukewarm reception on its first performance in 1805, but the revised version nine years later was a smash success and it has remained constantly popular in German opera houses since. Beethoven's music presents tremendous difficulties for singers because of the voice ranges expected of them, which many say is a result of the composer's inability to hear what he wrote.

By 1814 his work was widely known and he was much sought after by the royalty of Europe, but because of his disability he became more and more of a recluse. His output was considerably smaller in his last ten years, but its quality was unequaled – the *Ninth Symphony* (*Choral*, 1824), the vocal mass *Missa Solemnis* (1823), and the *Hammerklavier* piano sonata date from this period. After his death in Vienna on March 26, 1827, more than 20,000 people attended his funeral, and Austria's greatest contemporary dramatist wrote the oration.

LEFT print of a colored lithograph from the 1834 *Almanack* published by the Zurich Musical Society, showing Beethoven composing his *Sixth Symphony in F Major, Opus 68* (1808), also called the Pastoral.

BELOW Beethoven's Broadwood piano, drawn in 1817.

gave him his real introduction to literature and culture and brought him into contact with the aristocracy from whom most patronage sprang. He also met Franz Joseph Haydn, the renowned Austrian musician, on his way to London. The older man was impressed enough to invite the 22-year-old Beethoven to become his pupil in Vienna upon his return from England. During these Bonn years Beethoven earned a reputation as a virtuoso pianist and was almost idolized for his remarkable ability at improvisation.

In 1792 he went to Vienna to study with Haydn, and was immediately taken up by the aristocracy as a performer. He was less lucky in his association with Haydn, who proved an indifferent teacher. Still full of respect for the venerable older man, Beethoven took lessons secretly, learning techniques from one musician and vocal composition from another. When Haydn left again for London only two years later, the young Beethoven was able to earn his living easily by performing and teaching.

Beethoven was charming and generous but also morose, irritable, fiery, and changeable in temperament. Though involved in several romances, he was always indecisive in matters of the heart and none resulted in marriage.

Around 1798 Beethoven began to be seriously troubled with increasing deafness, and by 1802 he knew he could not be cured. Deeply depressed, he gave up performing and took a long rest in the country. It was only by a great assertion of will that he recovered his spirit: he wrote to a friend, "I will seize fate by the throat . . ." During the years until 1819, when he became totally deaf, he produced such unsurpassed works as the

Frédéric Chopin

1810 - 1849

"Between his person, his playing, and his music there was so perfect a unity that one could no more separate them than the features of a face. The very distinctive tone he drew from the piano resembled the look in his eyes; the sickly delicacy of his features was one with the poetic melancholy of his nocturnes." That is one contemporary's description of Chopin playing at one of his numerous drawing-room recitals in Paris at the height of his fame. The supreme 19th-century romantic figure, Chopin is one of the few great musicians better known during his lifetime for his playing than for his compositions. But since his death those compositions, almost all of them written for the solo piano, have brought him lasting fame for their emotional insight and the new virtuosity of expression they evoke from the piano, a relatively new instrument in his time.

Frédéric Chopin was born near Warsaw,

RIGHT portrait of Chopin in 1838 painted by Eugène Delacroix, a close friend. Chopin sat for the picture while at the piano, but originally the painting was a double portrait and the profile of George Sand appeared behind him.

BELOW Chopin playing the piano at a Salon given by Prince Anton Radziwill in Berlin in 1829. His private drawing-room recitals were extremely successful and particularly suited his intimate style.

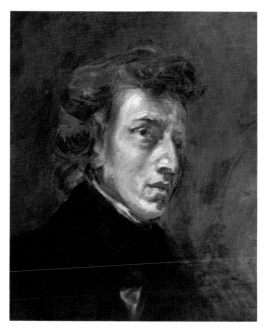

Poland, though his father was French. He began playing the piano in public and composing when he was six years old. At 15 he played before the Russian czar Alexander I and published his first composition. At the Warsaw Conservatory his teacher, while insisting on traditional training, wisely decided that Chopin's highly individual imagination should not be checked by purely academic restrictions. In 1829, after three years' study, he traveled abroad, first to Germany and

Vienna, then in 1830 to Paris. It was there, in Europe's cultural capital, that he spent most of his few remaining years.

At first Chopin found concerts difficult and unsuited to his delicate technique. He felt increasingly that his intimate style was more appropriate to the drawing room. A chance meeting with a fellow countryman, Prince Radziwill, resulted in an introduction to the wealthy Rothschild banking family, and by late 1832 Chopin was a favorite in the great houses of rich Parisians, both as a recitalist and a teacher. He was at the peak of his performing career, and he made the best he could of his opportunity. As he wryly remarked, "You at once have more talent if you have been heard at the English or Austrian embassies; you at once play better if Princess Vaudemont has patronized you." A friend described him during this period when he was the rage of Paris: "Chopin is well and vigorous. He is turning the heads of all the women; the men are jealous of him. He is all the fashion. His only trouble is his consuming regret for his native Poland." Poverty made Paris attractive to the young Pole, but the Russian occupation of his country made his stay there a self-imposed exile.

Chopin's personal life was less successful. After a number of disappointing love affairs, in 1838 he was taken up by the notorious free-living novelist George Sand (Aurore Dudevant). Overcoming his moral scruples, Chopin first joined her and her two children in Majorca and then lived with her in Paris and at her summer home, Nohant, 180 miles south of Paris. Their affair lasted until they quarreled irrevocably in 1847. This was also Chopin's most prolific period of composition. A friend described his working method as "days of nervous strain and almost frightening desperation. He alters and retouches the same phrase incessantly and walks up and down like a madman."

For most of his life Chopin wrote nothing but piano solos, most of them short, though toward the end he wrote one cello sonata. His music has an astonishing originality that is still apparent today. He established and extended the whole range of the piano. His compositions fall into three main well-defined kinds. First there are those based on Polish folk dance rhythms – the stately *polonaise* (of which he wrote ten), to which he gave a fresh grandeur and dignity, and the *mazurka* (he wrote 55), to which he gave unexpected melodic and harmonic twists. Secondly he wrote waltzes (14) and nocturnes (19) for his drawing-room recitals. Finally there are two sets (a total of 27) of *studies*, for Chopin was the first composer to give artistic value to

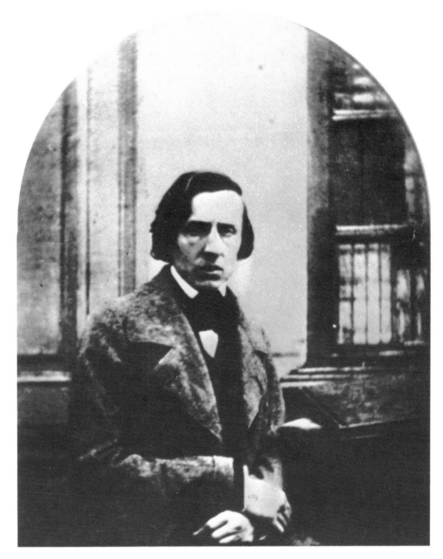

ABOVE the only known photographic portrait of the great pianist and composer, a daguerrotype probably taken two or three years before his death in Paris at 39.

piano exercises. His orchestral writing in comparison seems amateurish and is evidence of his preference for the piano, an instrument whose special range he demonstrated so brilliantly.

Chopin had always been consumptive and was never physically strong. His recitals and even composition increasingly tired him. In 1848 he visited England, where he played before Queen Victoria, and Scotland, where he gave a number of recitals. He planned the visit partly to escape the revolutions that broke out all over Europe in that year. In 1849 he returned exhausted to Paris, where his last public appearance was a concert for Polish exiles. He died in Paris of tuberculosis, aged 39, and was buried there. A small box of Polish soil that he had brought with him 19 years before was scattered on the grave.

Chopin's contemporaries were astonished at his combination of amazing originality with exquisite technique. Today he is recognized for his supreme understanding of what the piano can do, and also as a composer whose harmonic language was greatly in advance of his time. But above all it is the gaiety and tenderness of his music that make him so lastingly popular and his compositions so frequently played and enjoyed.

Richard Wagner

1813-1883

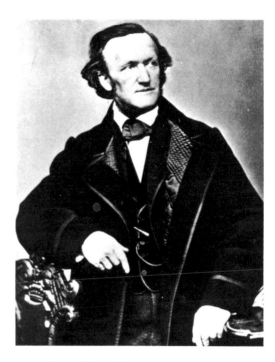

"Now you have seen what we can do. Now want it! And if you do we will achieve an art." With characteristic arrogance Wagner introduced the first complete performance of his massive opera cycle, the *Ring*, in 1876. Egotistical, controversial, and brilliant, Wagner became the most influential composer of the late 19th century.

His unique contribution lies in the fact that he was not simply a composer but, as he described himself, a "musical dramatist." He created his dramas single-handed – plot, characters, words, and the music that conveys their dramatic expression. Wagner also unified the opera form in a revolutionary way. Although his early works contain set pieces, Wagner worked increasingly in terms of whole scenes, acts, and finally operas. In his later works he achieved closely knit scores of uninterrupted music – gigantic symphonies accompanied by stage action rather than plays with music. His music, too, has such a range of emotional expression that, according to one expert, the "history of music

RIGHT photograph of the composer – an amazingly self-willed, self-righteous, but brilliant man – who influenced the course of 19th-century music.

BELOW *The Mastersingers of Nürnberg* as performed in 1967 at Sadler's Wells, London.

stems from him, either by extension of his discoveries, or reaction against them."

Wilhelm Richard Wagner was born in Leipzig into an artistic and theatrical background. His father was probably an actor whom his mother married upon the death of her first husband, soon after her son's birth. He spent six months at Leipzig University acquiring a groundwork in music before struggling for six years conducting small provincial orchestras in Germany. In Magdeburg he met Minna Planer, an actress, and in 1836 he married her.

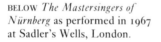

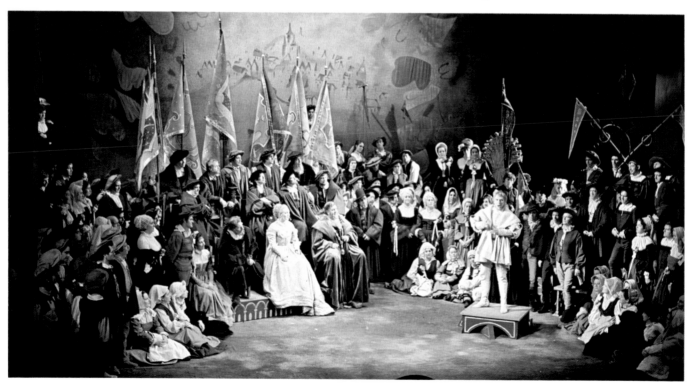

In 1839 Wagner went to Paris and there he wrote *The Flying Dutchman* (1841), an opera based on a legend of a ship's captain doomed to sail the seas forever. In 1845, as conductor of the Dresden court opera, Wagner produced *Tannhäuser*, based like all his later works on Germanic and Nordic legend. Critics were hostile, but audiences were increasingly enthusiastic. In 1848–9 nationalist revolutions erupted in many German states: when the revolution failed in Dresden Wagner fled into exile – in Zurich, Venice, Vienna, Russia, and Berlin. For 15 years he continued to write but, aside from the Hungarian composer Franz Liszt's production of *Lohengrin* in his own Weimar theater in 1850, no new Wagnerian opera was performed.

In 1864, miraculously, Wagner's luck changed. Ludwig, the new 18-year-old king of Bavaria, admired Wagner's music and ideas and he invited him to Munich. This marked the beginning of Wagner's great period. *Tristan und Isolde* was performed in 1865, his historical comedy *Die Meistersinger von Nürnberg* (*The Mastersingers of Nürnberg*) in 1868, and two parts of the *Ring* cycle were completed, *Das Rheingold* in 1869 and *Die Walküre* (*The Valkyrie*) in 1870. Extravagant debts and personal unpopularity – he was blindly self-centered and had a persecution mania – forced Wagner to leave Munich with his mistress Cosima, the wife of his great conductor Hans von Bülow and daughter of Franz Liszt. He married her in 1870 after her divorce and his wife's death.

Wagner spent the next few years in a villa provided by the king on Lake Lucerne, where he resumed work on the *Ring*. He selected Bayreuth, Bavaria, as the site for a new theater suitable for the performance of his totally new "music dramas," and he then toured Germany conducting fund-raising concerts. In 1874 he moved to a house in Bayreuth and in 1876 the opera house opened with a triumphant first complete performance of *Der Ring des Nibelungen*. Described as a "theater festival play for three days and a preliminary evening," the *Ring* combined symbolism representing at least four main themes ranging from German nationalism and international socialism to Buddhism and Christianity, while at another level further powerful themes are drawn from the newly emerging science of psychoanalysis. This mighty work dramatically uses music whose harmonic intensity and emotional force resemble that of Beethoven – whose work, in particular *Fidelio* and the *Ninth Symphony*, greatly influenced Wagner.

In 1882 Wagner produced his last work at Bayreuth. *Parsifal* is a mystical, religious drama full of Christian, pagan, and psychological symbolism. Based on the legend of the Holy Grail (the cup used by Christ at the Last Supper), it combines themes of innocence and purity, sexual indulgence, suffering and remorse. Wagner died of heart failure in Venice the next year, at the height of his fame, aged 69.

Wagner's operas, characterized by their potent fusion of words and music, broke forever the old Italian form of alternating aria and recitative. They replaced this with a continuous flexible vocal line and elaborate use of the *leitmotiv* or leading motif, in which short memorable themes represent specific characters, objects or emotions.

Wagner's character and some of his ideas, which he published in several prose works, did much to make him unpopular during and even after his lifetime. Bad debts, broken friendships, unbelievable ingratitude to those who had helped him – combined with Wagner's extreme German nationalism and his anti-Semitism (his work is still not performed in Israel) – alienated many of his admirers. But his single-minded, single-handed creation of a revolutionary type of musical drama remains impressive nonetheless for its immense scale and fantastic beauty.

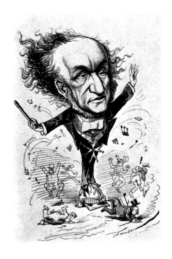

ABOVE caricature of the flamboyant conductor and composer published in the French newspaper *Le Figaro* in 1876, the year Wagner's Bayreuth opera house finally opened.

BELOW Peter Hoffmann in a 1979 production of the mystical opera *Parsifal* (1882), put on at London's Royal Opera House.

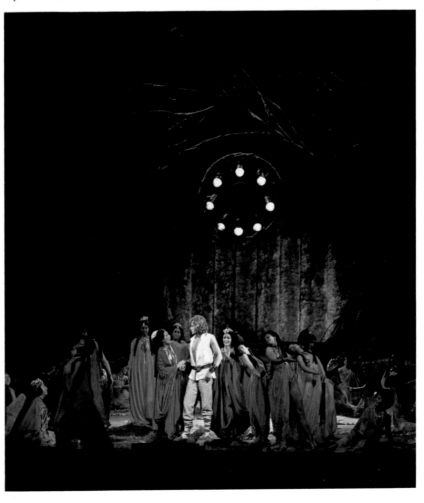

Giuseppe Verdi

1813-1901

"No one taught me orchestration or how to treat dramatic music." Yet Verdi, who wrote those words, is remarkable for a command of drama in music that has made his operas the best-loved and the most frequently performed in the world. His amazing output – nearly 30 operas, a *Requiem Mass*, and a string quartet – is matched with a fiery patriotism that made him a hero at a time when his Italian countrymen were struggling for national independence.

Giuseppe Verdi was born in Roncole, a small village near Busseto in northern Italy. Luckily his early musical talent interested a merchant, Antonio Barezzi, who paid for his basic training. Verdi was rejected as too old when he applied for the Milan conservatory at 18, so he studied privately in Milan, and in 1836 married Barezzi's daughter Margherita. In 1839 his first opera, *Oberto, conte di San Bonifacio*, was produced in Milan with, as he put it, a success "not great but good enough." But this was to be a tragic period for the composer. His two children died in 1838 and 1839, his wife in 1840. Grief-stricken, he vowed never to write music again. After an

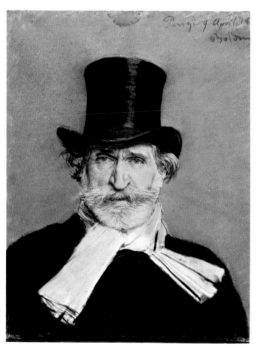

ABOVE Verdi (center, coming forward) presenting the result of a plebiscite vote by the province of Emilia to King Victor Emanuel II in 1859.

LEFT pastel portrait of Verdi made in April 1886 (when he was 72 years old) by Giovanni Boldini, a fashionable Italian portrait painter.

interval, however, he was tempted by the director of La Scala opera house to begin work on the opera now called *Nabucco*. First performed in 1842, it was at once acclaimed, partly because Italians, resentful of Austrian occupying troops, were stirred by its story of freedom and tyranny. One chorus, "*Va pensiero, sull ali dorate*" ("Fly, thought, on golden wings"), became a kind of national anthem during the long fight for an independent, united Italy.

Verdi had written 15 operas by the time he was 38 during what he called the "galley years" because he worked so fast. Whereas his fame in Europe was assured, in Italy it was stupendous. He then wrote his three best-known operas in quick succession: *Rigoletto* (1851), *Il Trovatore*, and *La Traviata* (both 1853). The first two were triumphs, but the third, with its "fallen woman" heroine, was at first considered shocking. Verdi's output remained extraordinary: *Simon Boccanegra* (1857), *A Masked Ball* (1859),

The Force of Destiny (1862), and *Don Carlos* (1867).

In 1871 *Aïda* was performed for the first time to inaugurate the new Italian opera house in Cairo. Because its music flows continuously without separation into arias, duets, and choruses, it was at once described as Wagnerian. But whatever the influence of Wagner on the form, the content was pure Italian grand opera, full of glowing melody with orchestral support. His *Requiem Mass*, completed in 1874 to commemorate the death of the Italian patriot and poet Allesandro Manzoni, is a masterpiece of 19th-century sacred music, dramatic and even operatic in character.

In 1859 Verdi married the soprano Giuseppina Strepponi after they had lived together for over ten years. Having completed 25 operas, he retired a rich and famous man to his country home near Genoa. "I am and always will be a Roncole peasant," he had said. His creative life seemed over. Then, at 74, he amazed the world with *Otello*, possibly the finest tragic opera he ever wrote. Six years later he again astonished audiences with the humor and vitality of his

BELOW Grace Bumbry (far right) appearing as the heroine of a 1968 production of *Aïda* at the Royal Opera House, London.

comic opera *Falstaff*. In both he had the help of outstanding librettos by fellow composer Arrigo Boito (1842–1918). These operas provided a magnificent climax to a long and productive life. Verdi wrote very little afterward.

Verdi's operas contributed enormously to the cause of Italian independence. Some, like *La Battaglia di Legnagno* (1849), about a 12th-century Italian victory over the Germans, were intentionally provocative to the Austrian authorities. Censors altered words or actions, but the inspiring music remained. His songs became battle hymns. Even his name was used – "Viva VERDI" scrawled on walls throughout Italy stood for "Viva Vittorio Emanuele, Re d'Italia." In 1874 Victor Emanuel, then king of a united Italy, made Verdi a senator by decree. He died in Milan aged 87.

Vigor and passion were always present in Verdi's operas, but in later works he created more vivid, subtle characters and his musical language became more elaborate and varied. His genius, in fact, was for creating dramatic forms and characters in music without losing any of its beauty or excitement.

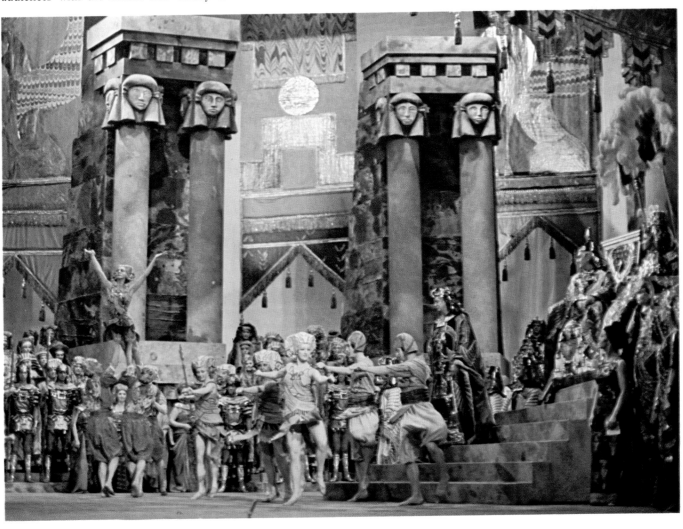

Gustav Mahler

1860-1911

"I am thrice homeless, as a native of Bohemia in Austria, as an Austrian among Germans, as a Jew throughout the world. Everywhere an intruder, never welcomed." Mahler's obsession with isolation and death, an unhappy family background, and the failure of his music to gain

recognition during his lifetime – all gave added power and individuality to his ten symphonies. The last great composer in the Austro-German symphonic tradition, Mahler is also an artist of transition, a bridge between two centuries, whose influence was acknowledged by Schoenberg and Dimitri Shostakovitch (1906–75). Today, 70 years after his death, he enjoys a popularity among concertgoers as great as that of Beethoven or Tchaikovsky.

Gustav Mahler grew up in the Bohemian town of Iglau in what is now Czechoslovakia. His father was a self-educated innkeeper and his mother, a cultured, delicate woman, was conscious of having married "beneath herself." Gustav's childhood and adolescence were scarred by his parents' often violent quarrels. His 11 brothers and sisters were sickly and few outlived him, and the young Mahler grew up nervous, tense, skeptical, and emotionally unsettled. Music provided an escape. At four he could play

ABOVE LEFT Gustav Mahler at 34. His music was widely rejected for 50 years after his death as an extravagant culmination of all that was most extreme in romanticism.

ABOVE *Fruit Trees* (1901–2) by Gustav Klimt, a friend and contemporary of Mahler's who painted many scenes of Attersee in Austria, where Mahler had what he called a "composing house" amid the beauties of nature – always a strong source of inspiration.

military marches (heard at a nearby barracks) and local Czech folk songs on the piano and accordion. He also began composing. At 15 he was accepted at the Vienna Conservatory, and after completing his studies he began to compose again, supporting himself by teaching. But, frustrated by the failure of his first major work, the cantata *Das klagende Lied* (*The Song of Complaint*, 1880), to win a prize, he turned to the more secure career of conducting.

For the next 17 years his progress was meteoric. From Cassel (1884) and Prague (1885) he eventually achieved the artistic directorship of the Vienna Court Opera in 1897, meanwhile composing between seasons. His *Symphony No. 1 in D Major* was performed at Weimar in 1889. Like his *Symphony No. 2* ("*Resurrection*"), first performed at Budapest in 1894, it met with a lack of comprehension. Audiences were not prepared for Mahler's sensational orchestral idiom.

Mahler was a brilliant conductor, but his fanatical idealism and dictatorial methods alienated many players and his extravagant productions made him unpopular with authority. He continued to compose. In 1902 he married Alma Schindler, and in the same year his *Symphony No. 3 in D Major* (1896) was triumphantly received at its first performance. His fellow composer Schoenberg wrote to Mahler: "I felt your symphony . . . I saw a man in torment struggling toward inward harmony." Five more symphonies

and the sadly prophetic song cycle *Kindertoten-lieder* (*Songs on the Deaths of Children*) were all composed between 1902 and 1907. By then a world-famous conductor, Mahler at 47 was still a poor man. His music had not yet received the wide appreciation he needed. The situation at the Vienna Opera became increasingly strained, and in 1907 Mahler accepted an invitation to conduct at the New York Metropolitan Opera House. The same year he was shattered by the death of his three-year-old daughter Maria and the diagnosis that he himself had heart disease.

Mahler's career in New York was brief but spectacular. His Metropolitan productions daz-

zled audiences with their vigor and originality, though his own compositions were less well received: one American critic called them a "painfully cacophonous din." In 1908 he also became conductor of the New York Philharmonic, an orchestra far below Mahler's high standard. Then in 1911, worn out with overwork, his weak heart failed and he collapsed. He sailed

LEFT flooded field near Lofer in the mountains southwest of Salzburg, Austria, close to the German border. This was the countryside Mahler loved.

RIGHT detail from Klimt's *Beethoven Frieze* (1902) – *The Knight*, supposedly a portrait of Gustav Mahler. Klimt was a founder of the school of painting known as the Vienna Sezession, characterized by a highly decorative style similar to art nouveau.

BELOW scene from *The Song of the Earth*, Kenneth Macmillan's ballet version of *Das Lied von der Erde*, danced by London's Royal Ballet.

for Europe and died in Vienna, aged 50.

Mahler's music is the expression of his own deeply held, often profoundly pessimistic beliefs: "Why am I made to feel that I am free when I am constrained within my personality as in a prison? What is the object of toil and sorrow? Will the meaning of life be revealed by death?" His symphonies are not technically revolutionary, though they display qualities that foreshadow modern radical methods. His *Symphony No. 5* (*Giant*, 1902) uses solo flutes, clarinet, oboe, bassoon, contrabassoon, and horn to create a contrapuntal texture based on interwoven melodies. Mahler often employed solo trumpet and

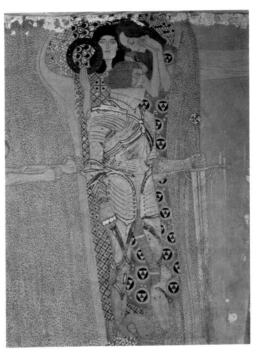

percussion in his symphonies, harking back perhaps to his early memories of the Iglau barracks. From Beethoven's *Ninth Symphony* and from Wagner he learned the impact of the human voice in songs and choruses. Four of his ten symphonies use it to convey their poetic "message." *Das Lied von der Erde* (*The Song of the Earth*, 1908) is his supreme example of this form of expression. Other innovations include *progressive tonality*, in which a piece of music ends in a different key from that with which it opens, and the ironic use of popular music styles and sounds from everyday life such as bird songs and bugle calls.

Mahler's vast experience as a conductor gave him a wider range of psychological nuance and instrumentation than earlier symphonic composers. His supreme devotion was to the symphonic form as a vehicle of personal expression. As he himself observed: "The symphony is the world. It must embrace everything."

233

Arnold Schoenberg

1874 - 1951

Describing himself as "a conservative who was forced to become a radical," Schoenberg crystallized and developed a principle of composition that revolutionized the music of the 20th century. A group of his early songs, performed when he was only 26, caused a public outburst at a recital. "Since then," he commented many years later, "the scandal has never ceased."

Schoenberg was born in Vienna, Austria, where his father owned a small store in the Jewish district. As a boy he learned about music bit by bit from an encyclopedia his family was buying on the installment plan, but later he took private lessons in composition. His first publicly performed work, the *String Quartet in D Major* (1897), reflects the influence of Brahms and was well received by Viennese audiences.

In 1899 Schoenberg composed the string sextet *Verklärte Nacht* (*Transfigured Night*), which is strongly influenced by Wagner. Performed in 1903, it was violently rejected by the public but has since become one of Schoenberg's most popular works. He married Mathilde von Zemlinsky, the sister of his music teacher, and they moved to Berlin in 1901. There, with the encouragement of the German composer Richard Strauss, Schoenberg wrote his only symphonic poem for large orchestra, *Pelleas und Melisande* (1902-3).

Back in Vienna in 1903, Schoenberg met Mahler, who became one of his strongest supporters. His teaching activities also became in-

ABOVE modern ballet based on Schoenberg's chamber work for voice and five instruments, *Pierrot Lunaire*, written for London's Ballet Rambert in 1966 by Glen Tetley.

LEFT Arnold Schoenberg, who presided over a revolution in music unmatched since the advent of the romantic era.

creasingly important – the young Austrian composers Alban Berg and Anton Webern began studying with him in 1904, and Webern later wrote that "he tracks down the pupil's personality, seeking to deepen it, to help it break through."

"Every tone relationship that has been used too often must finally be regarded as exhausted. It ceases to have power to convey a thought worthy of it. Therefore every composer is obliged to invent anew, to present new tone relations." The finale of his *Second String Quartet* (1907) opens with the words, "I feel air from another planet," and these have often been symbolically interpreted as the composer's breakthrough to a "new world" of sound. With *Three Piano Pieces*, Opus 11 (1909), Schoenberg completely dispensed with a tonal center. Such music, in which any harmonic or melodic combination of tones may be used without restriction, is usually called *atonal*. It is characterized by unusual, often dissonant harmonies. In 1912 *Pierrot Lunaire*, a chamber work of 21 recitations or "melodramas" for voice and five instruments,

was published. The pitch of each note is indicated rather than sung as the voice slides up or down in a song speech (*Sprechgesang*) that is rhythmically free and assymetrical.

But atonality grew to mean not freedom but anarchy to its inventor, who felt a compelling need for a set of principles to replace those he had discarded. In 1923 Schoenberg laid down the foundations of his system, and in 1924 came his *Suite for Piano*, Opus 25, the first piece to be constructed entirely from a 12-note row. In the

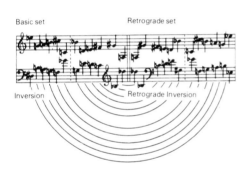

Basic set Retrograde set

Inversion Retrograde Inversion

12-note or *dodecaphonic* method, each composition is written using a row or series made up of the 12 notes of the chromatic scale (both the white and black keys of a piano). The composer places these notes in whatever sequence he or she wishes, and the resulting theme, or *note row*, can only be played in its original order, inverted (upside down), backward, or inverted *and* backward. The notes can be transposed to any pitch level and may be sounded successively (as a melody) or simultaneously (as a harmony), but every note must appear once in each stating of the series before any note is repeated. Each 12-note row allows for 48 possible variations. The repetition of the chosen note row, like the repetition of a thematic motif in tonal music, gives coherence and unity to the composition. According to Schoenberg, "What can be constructed with these tones depends [only] on one's inventive faculty."

In 1923 Schoenberg's wife died and he remarried a year later. He was invited to teach music in Berlin in 1925, and he finished the first two acts of his opera *Moses und Aron* there in

BELOW LEFT a note row by Schoenberg. The twelve notes, "related only to one another," can be arranged as a basic set; backward (retrograde); upside down (inversion, whereby the five-line staff is read from top to bottom instead of from bottom to top); and both upside down *and* backward (retrograde inversion). The clef change from G to F shows lower pitch.

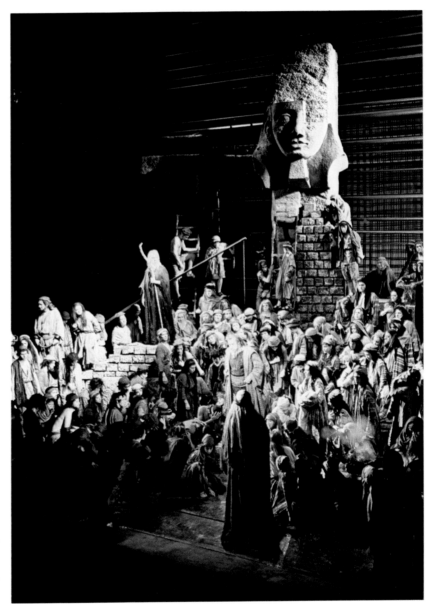

ABOVE scene from the Royal Opera's production of *Moses und Aron*, staged at Covent Garden in 1965. Schoenberg began composing the music for what many consider his greatest work in 1930, but he never completed the third act.

1932. But with the rise of Hitler's Nazi party he was dismissed from his post. In 1933 Schoenberg emigrated to the United States and formally reaffirmed his Jewish faith. He settled in California, where he taught music at the University of California at Los Angeles, and in 1941 he became an American citizen. He died ten years later at the age of 77.

Schoenberg's major American works showed an increasing mastery of his 12-note method. His intense reaction to Hitler's persecution of the Jews was poignantly expressed in *Ode to Napoleon* (1943) and *A Survivor from Warsaw* (1947). In some of his last works he combined the 12-note technique with traditional tonal music and even yielded occasionally to an urge to return to older styles: as he often told his pupils, "There is still much good music to be written in C Major."

Igor Stravinsky

1882-1971

Stravinsky's musical achievement, like his life, divides itself into three distinct parts. Twice he changed his nationality, his language, and most important of all his musical idiom. Until the end of World War I his music was largely in the tradition of his native Russia. Its exotic quality won him fame through the appearances in Paris of Diaghilev's Ballets Russes, for which he wrote most of the music. His "middle period" was spent in France where, as he put it, "The pulse of the world was throbbing most strongly." Then in 1939 Stravinsky went to the United States, and he spent the rest of his life in California. There he produced a number of short works with comparatively dense musical content in a totally new idiom. It is the remarkable versatility and originality of Stravinsky's music over this long creative life that is its continuous feature.

Igor Stravinsky was born in St Petersburg (now Leningrad), one of four sons of a prosperous, cultured family. At university he met the son of composer Rimsky-Korsakov, who recommended that Stravinsky not go to the St Petersburg Conservatory. Instead he supervised the young musician himself for three years, though from about 1905 he became increasingly sus-

RIGHT Igor Stravinsky at the first British performance of his choral work *Canticum Sacrum* in December 1956.

BELOW Royal Ballet production of Stravinsky's *Firebird* starring David Drew and Derek Rencher, mounted in 1978. It is one of the most popular works in the ballet repertoire.

picious of what he considered his pupil's Paris-oriented "modernism." Rimsky-Korsakov's death in 1908 greatly affected Stravinsky, and the following year was a turning point for him. Serge Diaghilev asked him to score two pieces by Chopin for *Les Sylphides*, which his Ballets Russes performed in Paris. The season – and Stravinsky's music – was a great success. Diaghilev next asked Stravinsky to write the music for a Russian fairy tale ballet. The result, *The Firebird* (1910), was a brilliant piece of romantic flamboyance, full of exciting orchestral effects. Its success in Paris was immediate. In 1911 the Ballets Russes performed Stravinsky's *Petrushka*, a fairground burlesque with Nijinsky, the brilliant Russian dancer, in the title role. Stravinsky's reputation in France as the leading composer of the avant-garde was established. His last major work in collaboration with Diaghilev, *The Rite of Spring*, was first performed in 1913. At first it was a fiasco, but early in 1914 it received ecstatic applause. Stravinsky was carried shoulder-high through the streets. He had reached the triumphant culmination of one set of musical ideals.

During and after World War I, which he spent in Switzerland, Stravinsky worked less and less with Diaghilev. He began to dig deeper into his own "Russianism" for inspiration. The results of this were *The Soldier's Tale* (1918) and *The Wedding*, completed in 1923, which Stravinsky called a "divertissement of the masquerade type" based on the gossip and folk sayings at a peasant wedding. These works mark what he called his "final break with the Russian orchestral school" in which he had first established his

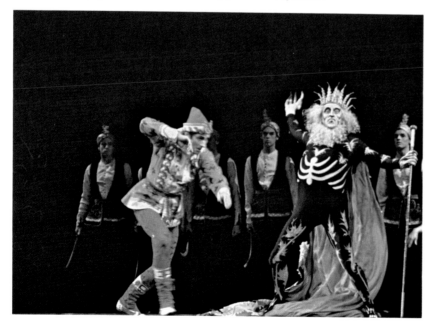

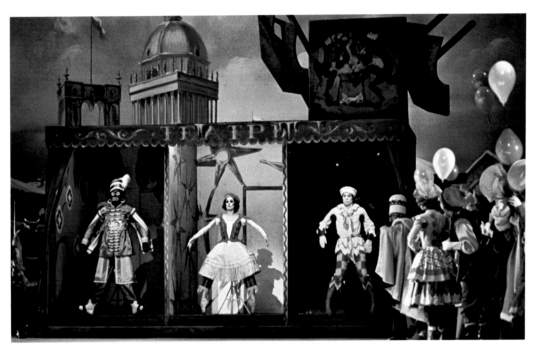

original reputation around the world.

Stravinsky then spent what he called a "decade of sampling, experiments, amalgamations." He emerged in what has been called his "neo-classical" period of composition, in which his music shows the influence of the contrapuntal masters of the baroque such as Bach and Mozart. He even came to respect and admire Beethoven, previously his special dislike. The works of these years include *Sonata* (1924), *Serenade* (1925), and *Capriccio* (1929), the second of which he described as "in imitation of the *Nachtsmusik* of the 18th century."

The loss of his family's property during the Russian Revolution meant that Stravinsky was no longer a wealthy man. To earn money he

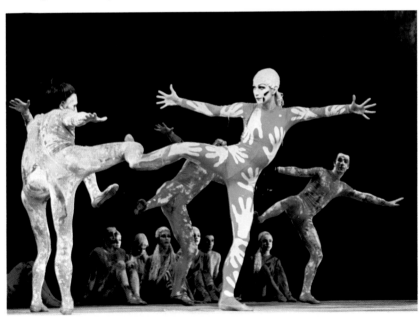

undertook a series of concert tours, both as a conductor and solo pianist. The tours were successful and profitable but audiences, particularly in Europe, were unenthusiastic about his latest compositions: "They cannot follow me in the progress of my musical thought. What moves and delights me leaves them indifferent." This lack of appreciation, the approaching war, and the deaths of his elder daughter in 1938 and both his wife and mother in 1939 brought to a close the second period of Stravinsky's life.

World War II brought a new beginning. In 1939 he was invited to lecture at Harvard University, and in 1940 he remarried. He and his second wife settled in California, where they were to spend the next 25 years. In 1948 Stravinsky met and befriended a young American musician, Robert Craft, who introduced him to the music of Schoenberg. At first Stravinsky had no time for Schoenberg's atonalism, which he described as chaos: "Schoenberg is as far from my aesthetic as can be," he once said. But through Craft's interest he became intrigued by the possibilities of 12-note serial technique. His *Threni* (1958), *Variations* (1964), and *Requiem Canticles* (1966) are all fully serial compositions. This is choral and orchestral music stripped of all but the most essential elements its components are simply line, note, and silence. Nothing could have been further from the color and excitement of the earlier works for the Ballets Russes that had first brought him international fame. Stravinsky died in New York at the age of 88 and was buried in Venice, not far from the grave of his old collaborator, friend, and compatriot Diaghilev.

237

Chapter 9

THE ART OF THEATER

Drama is essentially the art of the actor. Throughout history actors have filled the double role of priest and entertainer. Hidden behind the mask of classical Greek drama or behind the greasepaint of the modern theater, they may raise their audience to the height of tragic emotion or make spectators ache with laughter.

Acting is a mysterious art because, while remaining themselves, actors take on the guise of someone else, bringing that other character to a special sort of life within the compass of the play. Others who contribute much to drama are the director, the designer, and of course the dramatist, who initiates the process by imagining the theme and plot of a play and creating its characters and dialogue.

The art of theater results from the combination of talents, and sometimes from the singularity of genius. It is an art in which human beings speak directly to human beings, and at its greatest no art rivals its power to move us to laughter or tears.

OPPOSITE masks hung out before a performance at the Noh Theater of the Kongo School, Kyoto, Japan. *Noh* is the classic drama of Japan, developed chiefly in the 14th century and employing highly formalized patterns derived from religious and folk myths.

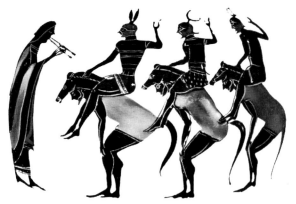

LEFT a chorus of masked worshipers of Dionysus mimicking horses and riders, from a vase painting of about 550 BC.

BELOW revelry in honor of the wine god.

BOTTOM classical Greek masks.

Origins of Drama

Today drama is a recreation and entertainment, but its origins in the remote past were very different. In prehistoric societies, many scholars believe, imitation or acting had a purely useful purpose. It was linked to magic and was intended to bring about events that primitive people could not accomplish with the limited knowledge at their command. When the rains failed or the herds wandered away, a dance that imitated raindrops or a successful hunt was believed to be able to end the drought or assure a fresh supply of meat. The more closely the dancer could imitate raindrops or a hunted beast, the more likely was the magic to succeed. In fact, by stepping into its skin and playing an animal, dancers to all intents "became" the animal – they were invested with its spirit.

It was from such superstitions and acts that drama as we know it began. This first happened in Greece in about the 6th century BC. The Greeks, who worshiped many gods, held special festivals honoring Dionysus, god of wine, fertility, and inspiration. These festivals included two major events – serious hymns sung by a chorus, and a procession of dancing revelers bearing his statue.

In both events the old traditions of imitative magic lingered on in that the processional dancers dressed up in animal skins and the chorus leader wore a mask. Their reasons for dressing up differed from those of prehistoric people, but the implications remained: by wearing animal skins the dancers "became" the legendary companions of Dionysus – *maenads* (wild women) and *satyrs* (half men, half goats).

In assuming the mask of Dionysus the chorus leader was divinely inspired to speak with the god's own voice.

It was the elaboration of the last practice that probably transformed religious ritual into drama. The person responsible was reputedly a priest of Dionysus called Thespis. He introduced a new performer who answered the chorus leader and so made dialogue possible. This newcomer was the first Greek actor.

In the acting out of serious themes connected with Dionysus, historians detect the seeds of tragedies; from the horseplay that went with the dancing procession, or *comus*, they trace the birth of comedy. At that period, Greek drama lacked playwrights, stage designers, and even a permanent theater. But it already possessed the actor – the one indispensable component in drama.

What was happening in Greece in the 6th century BC was also occurring farther east. Historians think Chinese drama had developed four centuries earlier. By the 1st century AD drama had also appeared in India; by the 14th century, in Japan. Unlike the early plays of Greece, however, those of the East were performed for a small and rich ruling class.

In other ways the plays were often remarkably

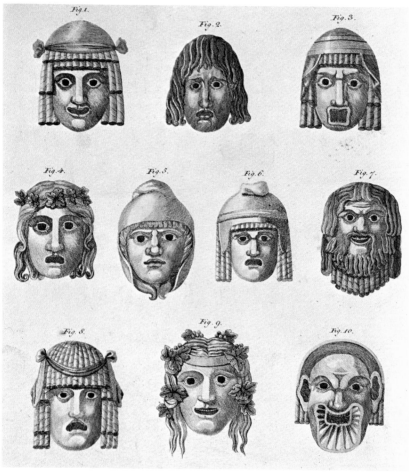

alike. For instance, actors in all these countries wore elaborately formalized masks. In India's Kathakali dance-drama and the Peking Opera, actors today still paint elaborate masks on their faces. Each tint and line of the mask has a meaning, so a Chinese audience at once recognizes a

BELOW modern performance of a Noh drama by students of a special theater school in Japan. Individual scenes may come from different plays, but each incident is complete in itself to those who know the tradition.

brigand chief by his dark blue face, scarlet eyebrows and beard, and the artificial eyes painted under his own. Even more like the Greek masks are those still used in the Noh plays of Japan.

The similarities in these dramas owe much to their common origin in religious ritual. Later, it was the religious ritual of the medieval church in Europe that eventually gave rise to our style of drama in the West.

The aim of the modern playwright is seldom that of the Greek tragedians – "to purge the soul with pity and terror." But in one respect it remains the same – to present mankind with an image of itself.

In those ages that recognized the existence of mysterious forces greater than individual human beings, a theater developed in which dramatists tried to place people in a coherent relationship with the gods. Drama of this sort was created in ancient Greece, in Japan, in medieval Europe, during the Elizabethan period in England, and by Jean Racine (1639-99) and Pierre Corneille (1606-84) in the France of Louis XIV. Dramatists were primarily concerned with showing how that power worked through human beings.

On the other hand, in ages that concentrate more on the material world and social interrelations, a different theater of comedy, melodrama, and social drama becomes popular. Such preferences occurred in Roman times and throughout the 18th and 19th centuries in Europe. The distinctions are not hard and fast, but the tendency is there. Both kinds of drama are concerned with mankind's proper place, but in the first case it is people's place in eternity and in the second it is their place in the here and now.

The Actor through History

Since theater began, many actors have had no particular ambition to declaim mighty speeches penned by great dramatists. Their main aim has been to entertain, to evoke amazement or amusement in their audience. The devices these entertainers used – the ways in which they moved, the clothes they wore, their extravagant make-up – reflected their aim and could be just as important as any plot.

When the Roman empire had made the Mediterranean world safe for travel, troupes of *mimes* (actors who perform without speech) began to tour the country. They also broke away from the religious base of previous drama. Vase paintings and the written comments of Roman writers survive to tell us what "pantomimes" were like.

At first the entertainers danced and acted silently in time to a song or a poetic recitation. Eventually, however, the actors introduced speeches and playlets, often about the gods in absurd situations of domestic intrigue. All this took place to the accompaniment of bawdy jokes spoken in everyday speech. The portable stage was usually makeshift – no more than bare boards propped on barrels. The scenery consisted of a curtain, behind which the actors changed into their costumes and grotesque masks.

Just what happened to these wandering groups of actor-entertainers when the western Roman empire withered remains speculation. But his-

ABOVE Giangurgolo, one of a set of *Commedia dell'arte* characters painted in 1862 by Maurice Sand. The essence of the form, which flourished until the 18th century, was the actors' art of improvisation.

torians catch sight of their artistic kin in the traveling *jongleurs* (singer-storyteller-acrobats) as they appeared from time to time during the centuries of feudalism.

The next clear glimpse of the actor as entertainer is in the 16th century. Once more in Italy, small groups of players were entertaining the ordinary people with uproarious improvised farces. The stock characters, the stock situation, and the emphasis on pantomime indicate that these farces may have derived from the long-forgotten mimes of ancient Rome. Called the *Commedia dell'arte* (meaning that it was performed by professionals and not by amateurs of the royal courts), it was for 200 years the most popular dramatic entertainment in Europe.

Meanwhile, in the East, actors had established an enduring role as entertainers, notably in China, where acting even now embraces acrobatics and mime. Trained in a tradition where symbolic actions serve instead of realistic scenery, Chinese actor-entertainers can draw on a complete "shorthand" dictionary of mime.

In Europe things had taken a different turn. True, the *Commedia*'s stock character of *zanni* (zany) gave birth to the modern clown. However, clowning with juggling, dancing, singing, and miming – all once stock features of stage entertainment – have now been divorced from drama. Instead, they appear as separate bills in circuses and variety shows. Only there, and in special performances by mimes such as France's Marcel Marceau, do we see the traces of the earlier tradition.

Until relatively recently the social standing of the actor was a perilous one. Onstage he or she might appear as a convincing royal personage but offstage the actor's life more often resembled a beggar's. Cold and hunger were never far off. In 1603 the Spanish writer Augustin de Rojas Villandrando wrote of the *naque*, a traveling two-man theater, that the members "sleep in their clothes, go barefoot, are always hungry, rid them-

LEFT supreme among 20th-century mimes is the French actor Marcel Marceau, shown here in his own interpretation of "The Seven Ages of Man." Marceau runs a school to teach mime, an increasingly popular art form.

ABOVE Welsh-born tragic actress Sarah Siddons, painted in 1783.

LEFT 17th-century illustration of *Don Quixote*, in which the heroes meet a band of strolling players.

BELOW street theater in 1978.

selves of their fleas among the grain in summer and do not feel them on account of the cold in winter."

In Elizabethan England, actors without a special license were classed as vagabonds, liable to imprisonment. Even "approved" players met hostility from civic leaders on the grounds that theaters portrayed vice, attracted lazy and depraved spectators, and served as focal points for the spread of disease.

However bad the male actor's social standing, that of the female was usually worse. From the time of ancient Greece, women were forbidden to perform in religious ritual or drama. In fact, no actresses performed in medieval or Elizabethan drama. (Boys took the female roles in Shakespeare's plays.) The first professional actresses appeared in Italy, the best known being Isabella Andreini (1562–1604). Actresses appeared in France about the same time but not in Britain until the late 17th century and not in Germany until the 18th century.

The climb to respectability was a slow process, and not until the second half of the 19th century was this process complete. Actors and actresses became accepted, and sometimes honored, members of the community. Curiously, the most recent trend in European theater is the appearance of small troupes of traveling players who have rebelled against this very respectability of modern theater. Working and often living together, they move between countries presenting improvised plays in a manner that is in many ways similar to – though more socially committed than – the actor-entertainers of 2000 years ago.

243

The Playhouse

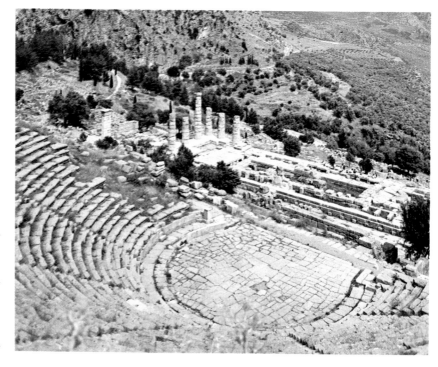

Still to be seen on the hillsides outside many Greek cities are the ruins of the mighty stone theaters built over 2000 years ago, but even they were built too late to witness the first works of Aeschylus (525–456 BC), Europe's first tragedian. His early plays were staged on a round, temporary floor (known as the *orchestra*) stamped out of the earth in Athens' marketplace. As spectators grew more numerous, performances shifted to the nearby foot of the steep hill called the Acropolis. There, on the slopes above the Temple of Dionysus, thousands of Athenian citizens had a perfect view of the actors below. The natural curve of the hillside *theater* (seeing place) let each word carry clearly. Actors projected themselves and their voices with the aid of raised boots and tall masks with grotesque "loudspeaker" mouths.

Both the theater and orchestra became more elaborate during the lifetime of Aeschylus' successors, Sophocles and Euripides (both died 406 BC). The rocky slopes of the theater were equipped with tiers of wooden seats, and the orchestra acquired stage settings. The forerunner of sets was a simple wooden dressing

ABOVE the Greek theater at Delphi, built in the 4th century BC and restored by the Romans. Its stone benches, designed to seat 5000 people, were ranged in 35 tiers.

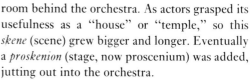

BELOW 19th-century engraving of an Elizabethan performance of Shakespeare's *A Midsummer Night's Dream*. Arena playhouses had apron stages for outdoor scenes, and the audience stood only a few feet away from the action.

room behind the orchestra. As actors grasped its usefulness as a "house" or "temple," so this *skene* (scene) grew bigger and longer. Eventually a *proskenion* (stage, now proscenium) was added, jutting out into the orchestra.

As theater building developed, the skene was built of stone and became a stage house of much splendor. The tiers of the theater were also reconstructed in stone and provided a model for the Roman city theater. Instead of carving thousands of tiered benches out of a natural hillside, the Romans erected the tiers on massive rows of arches, curved in huge semicircles fronting the orchestra. The orchestra was bounded at the rear by a stone stage, in turn bounded by a mighty stone wall decorated with marble columns and pierced with arches. There were also curtains that could be raised and lowered between the stage and the auditorium. In some theaters huge awnings protected the many thousand spectators from sun or rain.

In the 5th century the church closed the theaters and no permanent playhouses were built for 1000 years. The mystery and miracle plays that flourished toward the end of the Middle Ages were always performed on temporary stages. Only in the 16th century did Europe boast cities with enough people having the spare time and money to enjoy and pay for the entertainment provided in a permanent playhouse. The first major theaters were built in the three separate countries of Spain, Italy, and England – and each nation produced its own distinctive type of building.

By the 1560s Madrid had so-called *corral* play-

houses, named for the *corrales* or courtyards formed by the rear walls of a square of houses. The actors performed on a platform stage at one end, watched by spectators drawn from all levels of society. Seating arrangements were based on social classes, and from them descended present-day boxes, orchestra, dress circle, and balconies. The first permanent corral buildings took over the rectangular shape of the courtyards. In theaters of this sort audiences watched plays by the dramatists of Spain's Golden Age – Miguel de Cervantes (1547–1616), Lope de Vega (1562–1635), and Pedro Calderón (1600–1681).

By 1600 inn-yard stages in England had given birth to permanent theater buildings. Their shape, typically circular, was based on that of the arenas for bear-baiting and bull-baiting popular at that time. London's Globe Theater, where William Shakespeare's plays were performed, was an arena playhouse of this sort. The special feature of such theaters was an apron stage that jutted out into the audience. There actors performed outdoor scenes, reserving a curtained inner stage for indoor scenes. A balcony was also used by the performers.

While theaters in Madrid and London had grown naturally out of courtyard plays performed by wandering companies, the first permanent Italian theaters had a different origin. The Teatro Olympico of Vicenza, for example, was a deliberate reconstruction by the architect Andrea Palladio of ancient Roman theaters though, unlike the earlier buildings, Palladio's was roofed. Within it, stage backcloths were realistically painted with perspective scenery.

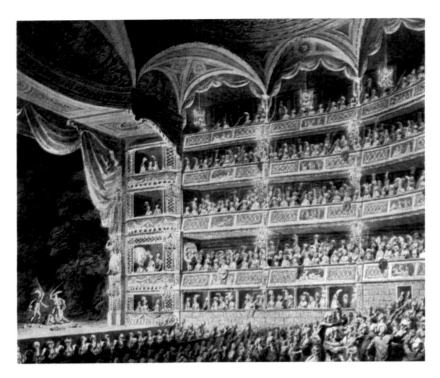

ABOVE the Theater Royal, Drury Lane, London, after it was rebuilt in 1794. This watercolor by Edward Dayes was painted the year after work was completed on the new "fireproof" building, which nonetheless burned down in 1809. Reopened in 1812, it is the oldest English theater still in use.

Opened in 1585, the Olympico is now Europe's oldest surviving theater.

Permanent theaters brought a new problem. A traveling band of players could perform the same play repeatedly for different audiences, but in a permanent playhouse they had to attract the same audience with different plays. When new plays were in short supply, theater managers turned to spectaculars, to lavish settings, and to all manner of other visual devices in their never-ending attempt to draw audiences. Mounting a new production is still an expensive gamble.

LEFT architect's model for a new theater for the Royal Shakespeare Company. Its auditorium was designed to give 1200 spectators a full view of the stage.

Development of the Modern Theater

Revenge dramas, the misfortunes of lovers, and boisterous street comedies established themselves as the plays most in demand in the 17th and 18th centuries. At different times different tastes predominated. In the late 17th century the

RIGHT set for Ivan Turgenev's play *A Month in the Country* (1855), designed by Dobujinsky for a Moscow Arts Theater production. This scene takes place in "The Blue Room," and reflects the Theater's emphasis on realistic interpretation.

neoclassical tragedy spread from France to become fashionable elsewhere in Europe. The Spanish court favored plays with a mythological or pastoral plot. In Amsterdam the Jewish community (refugees from Spain) began a flourishing Jewish drama, at first influenced by Spanish drama and the biblical plays of Joost van den Vondel (1587-1679). His *Gijsbrecht van Amstel* opened the Schouwburg, Amsterdam's first theater, in 1638 and is still revived there at the beginning of each year. Because painted sets were expensive, about a dozen sets were felt to be sufficient; any unusual setting was made up by combining portions of the others. Fortunately for historians of drama, the Schouwburg began the tradition – continued by its successor in the 18th century – of keeping unusually accurate illustrations of its productions.

Most theaters followed a similar practice but mistakes sometimes occurred. In one London revival of Shakespeare's *Coriolanus* it was noted that "some very neat Bond Street shops appeared two or three times as parts of Rome." At their best, the flat wings at the sides of the stage and the backcloth behind them gave a remarkable sense of reality. Sometimes the "flats" were placed obliquely behind one another across the center of the stage to give an even greater suggestion of depth and credibility to the scene. For episodes set in a tent or a cave the stage would be shortened and enclosed by pieces of scenery – the precursor of the 19th-century "box set."

Accuracy of setting came before the wish to have accurate costumes. Throughout the 17th and 18th centuries stage clothes bore more resemblance to the latest fashion than the clothing of the characters they represented. By the 1760s, however, the French actress Madame Farvat daringly portrayed a peasant girl in plain linen dress, bare arms, and simple hairstyle instead of the usual wide hoopskirt, elbow-length gloves, and towering gem-encrusted hairpiece. In 1776 Charlotte Brandes achieved success by appearing at a court theater at Gotha in Greek costume. At the time, *Macbeth* was still played in London in contemporary 18th-century army officer's uniform complete with tail wig, but by 1823 another London company could proudly advertise a performance of *King John* with costumes more historically accurate than any ever devised.

The historical plays produced by Johann Wolfgang von Goethe (1749-1832) in partnership with Friedrich von Schiller (1759-1805) at

Historical accuracy increased in the 19th century, in part as an excuse for lavish spectacle. Large casts in costume accurate to the last buckle mouthed romantic drama against scenery detailed to the individual brick. A reaction against this was inevitable. The English dramatist Thomas Robertson (1829–71) wrote a series of plays with one-word titles such as *Society*, *Ours*, and *Caste* that were the first of what came to be known as "the cup-and-saucer drama" – the drama of the realistic, contemporary world. His dialogue was credible and the situations recognizable. Melodrama and farce were still the staple fare of playhouses but the new element of realism steadily penetrated the theater.

The first great playwright to explore the deeper possibilities of realistic drama was the Norwegian Henrik Ibsen (1828–1906). He abandoned his youthful attempts to write historical drama in verse for plays written in everyday speech, probing the lives of middle-class citizens and laying bare hypocrisies and corruption in individuals popularly held to be pillars of society.

By 1900 other great dramatists were conveying their criticism of society in realistic plays. The Russian Maksim Gorky (1868–1936) depicted the squalid reality of slum life in *The Lower Depths*. Produced by the Moscow Arts Theater in 1902, this searing play swept the world's capitals; 75,000 copies of the play were sold within a year. The play's director was Konstantin Stanislavsky (1863–1938), a man who took endless pains to produce a convincing illusion of reality.

The emphasis on an illusion of reality in plays concerned with social abuses is only one of several dramatic styles available to the modern theater. The 20th century has seen the fruitful development of many of these alternative styles.

Weimar, Germany between 1798 and 1805 helped to establish the authority of the director in producing a drama. Goethe believed in accuracy, and for Schiller's *Wallenstein* gathered together all available woodcuts showing scenes of life in army camps of the Thirty Years' War.

ABOVE 1845 illustration from Schiller's *Wallenstein* (1800). The playwright's friendship with the great German poet Goethe became the most famous association in the history of German literature.

LEFT scene from Stanislavsky's production of *The Lower Depths* by Gorky. Stanislavsky, the father of modern Russian theater, prepared for this play by sending his actors to live in the slums of Moscow in order to portray the characters convincingly.

20th-Century Trends

By 1900 realism in the theater had reached its peak and audiences gladly paid large sums for the privilege of seeing entire restaurants recreated on stage. The American director David Belasco (1854–1931) rejected sets "built out of canvas stretched on frames. Everything must be real." To some critics the peak of realism represented an artistic trough. They felt that realistic scenery, realistic features such as doors that opened and closed, and realistic explanations for every actor's exit or entrance burdened drama with a weight of detail it could do without. At the same time, many critics believed that the realists failed in not using a great many worthwhile dramatic devices such as verse, music, dancing, and imaginative sets.

One of the first fields in which dissatisfaction broke into open revolt was stage design. Two great stage designers, the Swiss Adolphe Appia (1862–1928) and Britain's Gordon Craig (1872–1966), spearheaded the revolution. Independently, the two men found themselves loathing the stage sets in which actors were lost in forests of trees or rooms full of furniture. The two designers felt that such slavish attention to scenic detail pushed acting into insignificance.

In their own stage settings Appia and Craig abolished all unnecessary trappings, replacing them with simple, semi-abstract shapes that provided players with different acting levels and threw their performances into relief. Both designers were quick to take advantage of the dramatic effects made possible by the then newly developed electric lighting. These devices, together with a new tendency to dress actors colorfully, helped to shift the spectators' attention back to the performers.

But some stage designers and architects felt that the problem was more than fussy decor and

ABOVE magazine illustration of a horse race on stage in France in 1891, showing the interior of the rolling mechanism that moved the turf.

LEFT modern-dress production of *Oedipus Rex*, staged with a nontraditional set in Athens in 1971. Reworking of the classics goes on in every age, and it is a sign of their enduring dramatic power that directors, actors, and audiences accept the challenge.

ABOVE masked actors from the Zero Dimension Company alight from a bus on their way to a theatrical "happening" in Tokyo, Japan.

BELOW scene from the landmark production by Peter Brook of *A Midsummer Night's Dream* for the Royal Shakespeare Company, staged in 1971.

realistic costume. These people quarreled with the stage itself, seeing the proscenium arch as a picture frame that artificially divorced actor and audience. As a result of their experiments, most countries today have examples of theaters-in-the-round in which the play takes place on a stage in the center of the auditorium. For certain types of plays, much is gained by placing actors in the middle of the audience.

With the new distrust of realistic decor came mounting dislike of realistic acting. The Irish poet-playwright W. B. Yeats (1865–1939) persuaded actors to wear masks that marked them as generalized types instead of individual characters. Sweden's greatest dramatist, August Strindberg (1849–1912), wrote parts for "The Officer," "The Billposter" and so on to generalize as to type instead of characterizing as individuals with proper names.

Reflecting current preoccupations with psychology, such plays focused attention on the unconscious impulses that direct human actions, and they did so in short abrupt scenes of an unreal, dreamlike quality. One of Strindberg's plays is called simply *A Dream Play*. The structural innovations of his plays influenced the expressionist dramatists of the years between the two world wars – the Germans Georg Kaiser (1878–1945) and Ernst Toller (1893–1939) and, in his early plays, the American Eugene O'Neill (1888–1953).

Twentieth-century experiments by no means killed off realism on the stage; audiences can still find many plays in which the setting and the actors imitate real life. Even experimental dramatists employ the realistic approach. Since World War II many dramatists have managed to fuse realism with expressionism in commercially successful plays. On one level, many such plays tell a straightforward story; on other levels the action is symbolic, though these deeper meanings are often obscure. The plays of some of these dramatists have been grouped together as the "Theater of the Absurd," emphasizing an attitude common to many of them that, "Cut off from his religious, metaphysical, and transcendental roots, man is lost; all his actions become senseless, absurd, useless." These are the words of Eugene Ionesco, who was born in Romania in 1912 but has spent most of his life in France. Despite the bleakness of his philosophy, Ionesco's plays contain passages of intense humor. The same mixture of comedy and alarm is characteristic of the plays of the Irish-born Samuel Beckett (born 1906), the Englishman Harold Pinter (born 1930), and the American Edward Albee (born 1928).

In the past the theater has often been hampered by strict rules as to what it should and should not do, imposed by church or state or Academy. Today there are no rules. The forms future drama will take cannot be predicted but the nature of that drama, at its best, will be what it has been since the Greeks stamped out the first orchestra area in Athens' marketplace: to present us with an image of ourselves in all the circumstances of our life – joyful and frightening, tragic and comic.

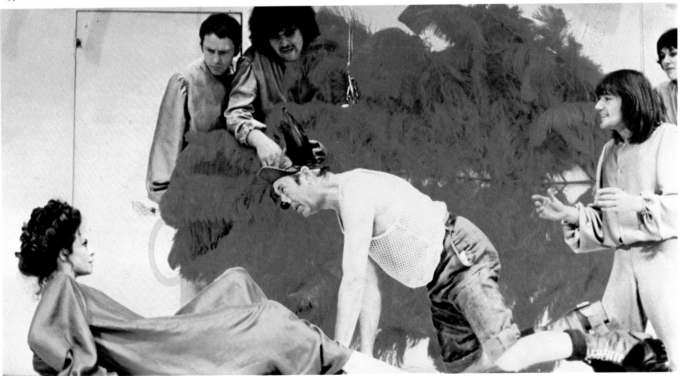

Chapter 10

THE GREAT DRAMATISTS

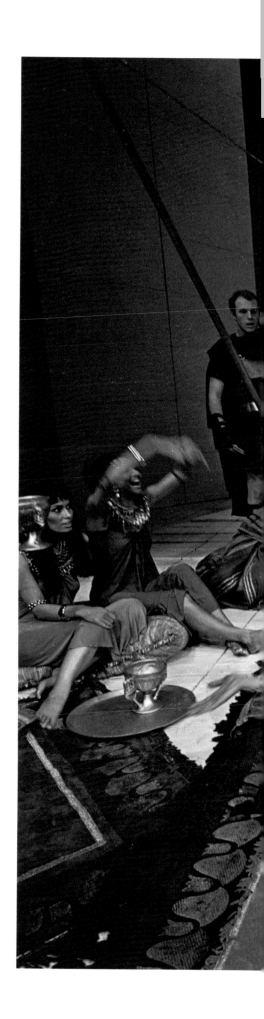

The arts of painting and sculpture, of architecture and music are alike in one thing. They are universal and recognize no national frontiers. Drama, like all literature, is a largely national art, and its worldwide appreciation and enjoyment is restricted by the frontiers of language. Only the greatest playwrights in the history of drama have, through their innovations or the broad appeal of their plays, achieved world fame. Sophocles in Greek, Shakespeare in English, Molière in French, Chekhov in Russian – these men's plays are still translated, read, and above all performed throughout the world. This is not simply because they broke new ground or introduced new styles or techniques. It is because their plays can still excite, amuse, or move us, across centuries and in spite of the inevitable imperfections of translation. These are the giants of world theater, writers who, as one contemporary said of Shakespeare, "are not of an age but for all time."

OPPOSITE a Royal Shakespeare Company production of *Antony and Cleopatra*, presented in 1972 with Janet Suzman as the queen of Egypt (in blue) and Richard Johnson as the ambitious Roman. Shakespeare's work has proved endlessly fascinating to actors and audiences alike worldwide.

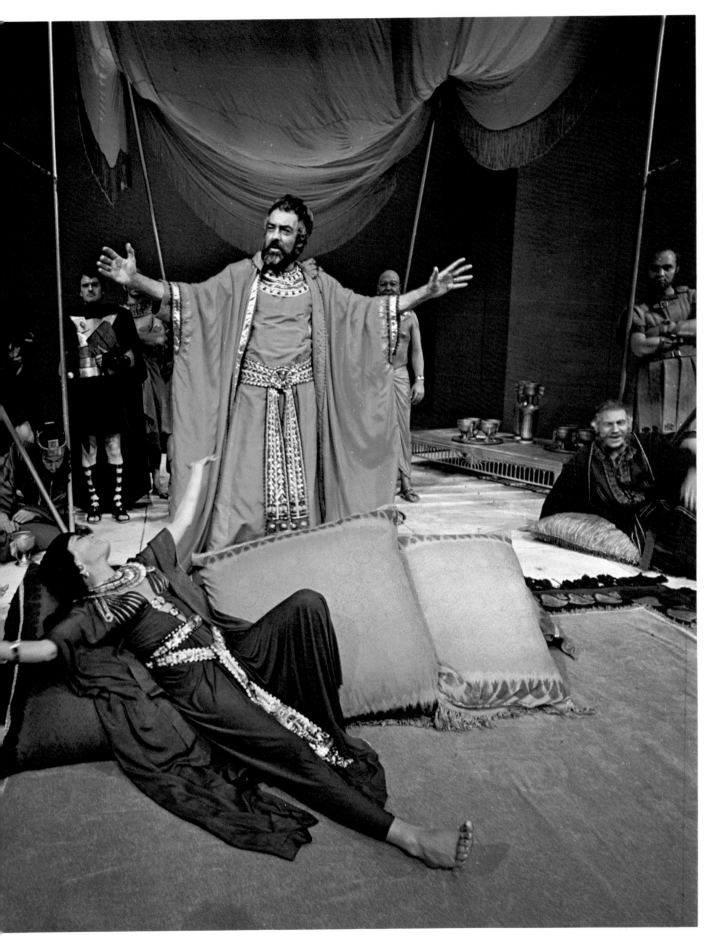

The Greeks

It was in the city of Athens in the 5th century BC during a period of amazing creativity that drama developed from static ceremony into two distinct and versatile forms – tragedy and a kind of rough-and-tumble comedy known as "satyr plays." Unlike modern plays, the early tragedies used plots already well known to the audience. They were based on famous incidents from stories about gods or legendary heroes. The fascination in watching such a play, therefore, was not in wondering what would happen next, but *how* and *why*; each playwright had an individual interpretation. In particular it is the stark, terse way the Greeks showed people struggling against cosmic forces that gives classical Greek tragedy its lasting impact.

The development of tragedy was the work of three outstanding Athenians, of whom Aeschylus was the first. He was born near Athens, and his life spans the great period of Athenian history. He fought in the victory over the Persians at Marathon in 490 BC and at the sea victory of Salamis ten years later. During his lifetime Athens ousted its dictators and became a democracy. Through a long active life Aeschylus

ABOVE modern actors recreate a classical drama in the magnificent ruins of the ancient Roman theater in Athens, Greece. Originally built by Herodes Atticus during the 2nd century AD in honor of his wife, it seated at least 5000 people.

LEFT Orestes in the temple of Apollo at Delphi. This Greek vase painting depicts a scene also enacted in Aeschylus' trilogy the *Oresteia*, first presented in 458 BC. Aeschylus himself was also an actor and stage director.

found time to write more than 80 plays, seven of which have survived. This handful are, however, remarkable enough to justify his title, the "father of tragedy."

Aeschylus introduced two important technical innovations. He added a second actor to the actor-chorus form of the original ritual. This gave greater possibilities for dramatic tension. He also, as a fellow Athenian put it, "reduced the chorus' role and made the plot the leading actor." His finest achievement is the *Oresteia*, a linked trilogy of plays whose hero, Orestes, is called upon by the gods to avenge the murder of his father Agamemnon by killing his mother Clytemnestra and her lover Aegisthus. *Prometheus Bound*, the only play that remains of another trilogy, has been compared to the *Book of Job* because it shows the suffering of a man at the hands of a cruel deity. For Aeschylus all evil, loss, and suffering are inescapable. His plays set out to "justify the ways of God to men," to reconcile divine will with the facts of human suffering and destiny with free will.

Sophocles (about 496–406 BC) was born at Colonus near Athens. His parents were wealthy, and the young man was chosen to lead the chorus in a hymn to celebrate the victory of Salamis. Later he took an active part in Athenian politics. His reputation as a dramatist rests on seven tragedies, all that survive of over 120 he wrote. He too was a technical innovator. He increased

the chorus from 12 to 15, but reduced its part in the action and introduced a third actor.

Oedipus Rex is probably Sophocles' masterpiece. In it he makes the legendary King Oedipus, "the most unfortunate and most wretched of men," into a unique and human hero – aggressive, generous, domineering, passionate, and fatally preoccupied with finding out the truth. The creation of heroes larger than life but still recognizably human is the great achievement of Sophocles. In his last known play, *Oedipus at Colonus*, the long-suffering hero, blind and worn out with age and suffering, is "reborn" to a new awareness and serenity. It is a remarkable conclusion, full of an apparent belief in the indestructible human spirit.

Euripides (about 480–406 BC) brought few technical changes to the Greek stage, though his plays begin with a prologue, a kind of program in verse, and many feature the appearance of a god or goddess who comes on at the end to wind up the plot. But his innovations are unimportant. It is his attitude to tragic events that makes him original. Euripides was apparently obsessed with the idea of an unpredictable universe in which the gods are capricious or even vindictive, sharing the worst human passions. He is relentless in his realism. "You demand fact," he seems to be saying, "and here I give it to you; these things really happened; the gods who did them were no better than you yourselves at your

worst." His *Medea*, for example, demonstrates Euripides' characteristic attitude. The chorus, at first sympathetic to the tragic heroine, changes sides at the close and rebukes her for her actions. When in the final scene Medea appears on the roof, out of reach, with her murdered children in her arms, the chorus appeals to the gods to avenge her crime. But the only response is a divine chariot sent by the gods to transport her to safety. His contemporaries attacked the ending as "illogical." Euripides' whole point is that tragedy is always illogical.

Greek comedy was originally based upon the horseplay that went on during the procession in honor of Dionysus. Aristophanes (about 450–about 388 BC) is the one writer whose reputation rests on his comedies alone. His plays, of which he probably wrote about 50, are boisterous affairs, short on comic characters but long on satire and parody. His ability to ridicule the follies of his contemporaries is astonishing. In many plays he attacked the wars that eventually brought Athens into decline. In *The Birds* (414 BC), for example, he satirizes the Athenians' dreams of empire that led them to fight such wars; *Lysistrata* (411 BC) describes how the women of Athens declare a sex strike until their men agree to make peace. In *The Wasps* (422 BC) he ridicules his fellow Athenians' tendency to go to court at the slightest provocation, while *The Knights* (424 BC) is a political comedy attacking Cleon, an elected dictator. The wide range of subjects and the delicacy of the songs interspersed in the plays are Aristophanes' contribution to comedy. They have assured him a reputation equal to that of the three great creators of Greek tragedy.

William Shakespeare

1564-1616

Shakespeare is one of the very few writers whom the whole world has taken to its heart. Actor, poet, dramatist, he dominated the English theater of his time. Today he is still the most widely performed, read, studied, and quoted of all playwrights. His achievement was extraordinary. He mastered and extended the English language at its most flexible and versatile stage of development, created characters that are uni-

ABOVE the best-authenticated portrait of Shakespeare.

BELOW a Royal Shakespeare Company production of *A Midsummer Night's Dream*.

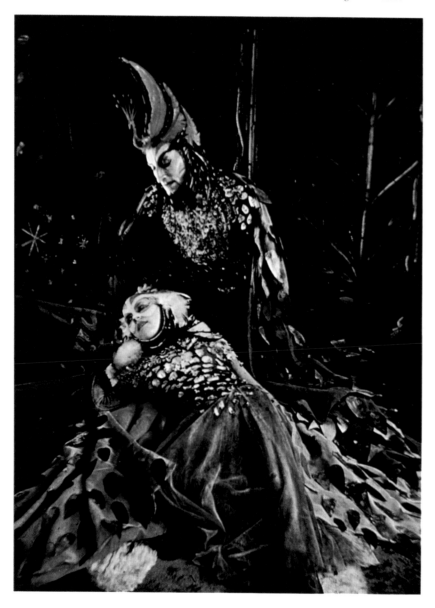

versal and recognizable without being stereotyped, and wrote more than 35 plays. Their lasting international appeal justifies the claim for him by a fellow countryman that he is "not our poet but the world's."

The details of William Shakespeare's life are sketchy. Born at Stratford-on-Avon, the son of a prosperous glovemaker, he left for London some time in the 1580s. In the next 20 years or so he became a successful man of the theater. In about 1608 he returned, prosperous and famous, to his birthplace, where he continued to write for the stage until shortly before his death.

Shakespeare's output of plays is immense. Not only does it demonstrate his own gradual mastery of the dramatic medium, but it also has a remarkable variety. He tackled every kind of play performed at that time – historical drama, romantic comedy, tragedy, Roman histories, tragicomedies – and each he perfected. His career is often divided into three periods. The first (1589-1600) is dominated by history plays, though it includes two other plays that won instant and lasting success: *Romeo and Juliet*, a romantic tragedy, and *A Midsummer Night's Dream*, a romantic comedy. The histories comprise two groups. Four linked plays ending with *Richard III* deal with the civil wars that preceded the 16th-century Tudor dynasty. Five others, of which the best-known is *Henry V*, deal with earlier reigns. For Elizabethan audiences good kingship meant stable government. Shakespeare was apparently fascinated by the question of what personal qualities make a good king, just as in *Julius Caesar*, one of the so-called Roman plays, he examines the effect of a political murder on the murderers and the republic they aim to save. The history plays are remarkable in themselves. They are also remarkable in what they foreshadow. *Richard III* is the first of the tragedies; Falstaff in *Henry IV* is the first of Shakespeare's rounded human comic characters. The comic subplots of these plays that balance the main action – these are signs of great things to come.

In the middle period (1600-1606) Shakespeare produced two perfect comedies, *As You Like It* and *Twelfth Night*. But the period is overshadowed by the dark-clad figure of Hamlet, the world's most famous, enigmatic tragic hero. Revenge tragedies were popular at the time. Shakespeare shows what happens when the task of revenge is imposed upon a weak, good man pitted against a strong villain. It is a play that has won the admiration of the world. In the same period Shakespeare wrote *Othello*, a tragedy of deception and jealousy, and *Troilus and Cressida*, a cynical play about love and war in which both

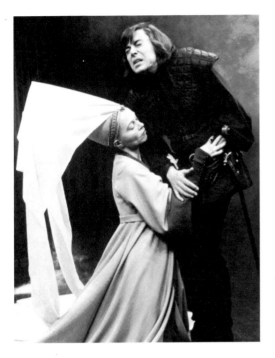

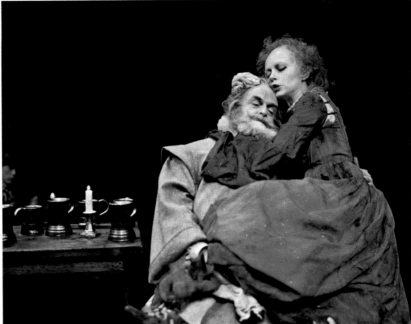

appear soiled and sordid. Critics have found in these and the so-called "dark comedies" evidence of Shakespeare's increasing seriousness and disillusion. But it is equally possible that his plays simply reflect the changed mood of London audiences after the death of the great Queen Elizabeth, in the more thoughtful, pessimistic early 17th century.

Tragedy and tragicomedy are the themes of Shakespeare's final period. *Macbeth* shows the evil that can result from an uncontrollable lust for power. *King Lear* is generally regarded as his central masterpiece to which earlier plays lead and from which the "last plays" derive. One critic described *Lear* as a "raid upon the inarticulate" because in it Shakespeare succeeds in expressing, in his most mature dramatic poetry, the previously inexpressible. Comic relief comes through the Fool who accompanies Lear throughout his misfortunes, acting as commentator and reminder in a kind of Greek chorus. *King Lear* ends with a father-daughter reconciliation, and Shakespeare's last three plays (he probably collaborated on later plays) elaborate on that theme. In all three a father loses a child through his own passion or stupidity, and suffers as a result of this estrangement. Each ends with a lost daughter – Marina in *Pericles*, Perdita in *The Winter's Tale*, and Miranda in *The Tempest* – restored to her sadder but wiser father in a scene of symbolic reconciliation. It is a theme that provides Shakespeare's plays with an overall unity that makes a suitable conclusion to his life's work.

Shakespeare's fellow Englishmen took time to recognize his achievement. John Dryden (1631–

1700), poet, dramatist, and critic, was the first, saying: Shakespeare is "the man who of all modern and perhaps ancient poets had the largest and most comprehensive soul." The 19th century praised him in a way that now seems indiscriminate and idolatrous. The 20th century has staged *Julius Caesar* with a jackbooted Fascist dictator, *Romeo and Juliet* as a Broadway musical, and *Othello* as a "rock" musical. Numerous plays have been televised and filmed. But ironically his immense achievement stifled English theater until the late 19th century. As the director of London's National Theater remarked in the 1960s: "In the second half of the 20th century we are faced with the infuriating fact that Shakespeare is still our model."

Molière

1622 - 1673

Molière was the stage name used by Jean-Baptiste Poquelin, the greatest comic dramatist of France. His plays marked a turning point in

LEFT Molière the actor. He had the build, the elasticity, and the "india-rubber face" of the born comedian. He once wrote a part for himself in which he cursed "that fellow Molière."

BELOW scene from the 1951 Edinburgh Festival performance of *Le Bourgeois Gentilhomme* with Miles Malleson as Jourdain.

the development of French drama, for in them the crude 17th-century imitations of Greek classical comedy made way for a sophisticated social comedy based upon the real world and the foibles of its inhabitants. His plays show men and women in their social surroundings, and in this way hold up to gentle ridicule the whole community to which they belong. Molière succeeded in bringing the art of comedy up to the high standards of tragedy.

Molière was born in Paris six years after the death of Shakespeare. He studied law at Orleans, but found the stage irresistible. He began by forming his own small group of players, and for 12 years toured France with mixed success. Molière was first only manager and actor, but soon became adapter and then writer of plays. His early comedies were fashionable farces with stock characters, which were always popular with audiences. It was not until the 1650s, with a reputation built up in the provinces and the patronage of the brother of Louis XIV, that Molière launched his group in Paris, calling it the "Troupe de Monsieur." Then he could write and produce the kind of comedies he wanted,

and for 13 years original comedy followed original comedy.

Molière, like Shakespeare, was a poetic dramatist, but he replaced Shakespeare's blank verse with rhymed couplets. In each of his plays he ridicules some fashionable nonsense or human weakness. For example, in *Les Precieuses Ridicules* (*The Affected Young Ladies*), first performed in Paris in 1659, he pokes fun at the affected speech and manners of the time, such as referring to teeth as "the furnishings of the mouth." In *Les Femmes Savantes* (*The Bluestockings*) of 1672 he ridicules the fashionable passion for learning which makes one character declare that she would embrace anyone "for love of Greek." In his greatest plays his ridicule is more widely applied. In *Tartuffe*, for example, first performed in 1664 and sometimes known in English as *The Imposter*, the central character is simply a weak fool and a hypocrite. In *Le Bourgeois Gentilhomme* (*The Prodigious Snob*) of 1670 his hero is a successful shopkeeper aspiring to be a fine gentleman in a comedy that is perhaps the funniest of all his plays. Jourdain, the shopkeeper, is not depicted as an unpleasant snob but simply a foolish man who, like so many of us in all ages, is as genuine as he is naive, as likable as he is fatuous. Jourdain is typical of Molière's creations because, while we laugh at his absurd pretensions, we never despise him, chiefly because we know him so well. One other play is particularly worth noting out of the nine or so

that have remained world-famous and are still frequently performed outside France. In *Le Malade Imaginaire* (*The Imaginary Invalid*) of 1673, the central character is a hypochondriac, who fears both doctors and death. Molière's last play ridicules fake professionalism and the use of jargon, the foolishness of a would-be doctor with learning and no sense, and the superstition, greed, and falsity of the other characters. At the play's fourth performance Molière himself collapsed on stage and was carried to his home where he died. Because of his profession as an actor, and because he had not received the sacrament, he was buried without ceremony after sunset on February 21, 1673.

Molière's great disappointment was that his own acting style in tragedy was out of tune with the taste of 17th-century French audiences, which liked their tragic heroes to rant and rave, to shout and pose. But it was as a comic actor that Molière found the acclaim that every actor needs, and it was as a writer of comedies that he achieved lasting international fame. It was, above all, his ability to ridicule without moralizing and to make fun without malice that justifies that fame. As he wrote: "You haven't achieved anything in comedy unless your portraits can be seen as living types . . . making decent people laugh is a strange business. . . . I wonder if the golden rule is not to give pleasure." Audiences still enjoy his plays today because they accept that as a golden rule.

ABOVE Donald Wolfit as the hypochondriac in *Le Malade Imaginaire* at the Westminster Theater, London, in 1943. The characters of Molière's greatest plays were modeled on the members of his acting troupe, and it was fitting that he died playing the part of the sick man he really was.

RIGHT Molière (near left) acting in an Italian farce with his company, a production he probably directed and stage-managed as well. He also produced mixed pieces that included songs and ballet.

Henrik Ibsen

1828-1906

The Norwegian dramatist Henrik Johan Ibsen created realistic prose drama, and his reputation is firmly established as one of the finest playwrights of modern times. His impact has been compared with that of a northwest wind suddenly blowing through the stuffy hothouse atmosphere of late-19th-century theater, with its stylized comedies of manners and equally artificial melodramas. In fact, Ibsen was nearly 50 when he began writing the famous prose plays, the "social documents" which made his name. He was over 60 when their success became known and widely imitated outside Norway.

Ibsen was born the son of a prosperous businessman in Skien, a small port about 100 miles from Oslo (then Christiania), the capital of Norway. When Ibsen was in his teens his father's business went bankrupt, and the family moved to the smaller town of Venstop. A sense of shame and family upheaval, as well as a first-

ABOVE Henrik Ibsen, the span of whose creative career – from the publication of his first play *Catilina* in 1850 to his last work and "epilogue" *When We Dead Awaken* in December 1899 – fits almost exactly into the second half of the 19th century.

BELOW RIGHT scene from a production with Agnes Thomas of *The Wild Duck*. The Ekdal's attic was based on the house that Ibsen's family moved to in Venstøp after his father went bankrupt in the 1830s.

BELOW Janet Suzman, Rosemary McHale, and Jonathan Kent in a 1977 production of *Hedda Gabler*.

hand understanding of small-town life were the results of this period for Ibsen. In 1844 he was sent as apprentice to a druggist, but the chief events of the next few years for the young Ibsen were two unsuccessful plays and a move to Oslo. Then in 1851 he joined the newly established Norwegian Theater in Bergen as its "dramatic author." His duties involved working as a producer, which he disliked, and writing one new play a year. He later described his life in the theater as a "daily abortion." After a series of other unsuccessful theater jobs Ibsen left Norway altogether in 1864 and for the next 27 years lived mostly in Italy and Germany.

Ibsen's first stage success was *Brand*, published in 1865 but not performed until 20 years later. He originally wrote it as a narrative poem, but then rewrote it as a verse drama. A second play, *Peer Gynt* (1876), is another ambitious verse drama, telling the story of one man's life from extravagant youth to failing age. These plays established Ibsen as a Norwegian dramatist – the first won him a state pension – but it was later plays that made him Norway's "grand old man" and a major force in European theater.

In 1877 his prose play *Pillars of Society* was first performed in Munich. Strongly realistic in style, constructed with superb stage craftsmanship, and based upon his own experience, the play shows how both individuals and whole communities can be damaged and destroyed by deceit and corruption. Its success was a breakthrough. Two years later, in *A Doll's House*,

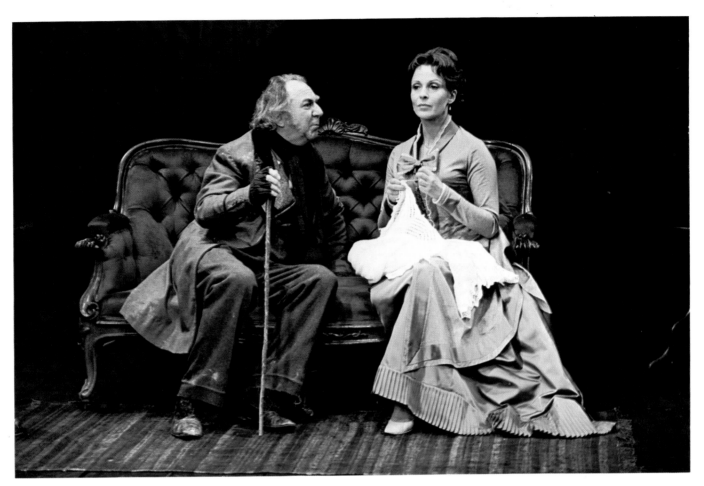

Ibsen described the attempt of a husband to dominate his spoiled wife both financially and intellectually. In this play, he shows the individual's fatal loss of freedom when he or she submits to the conventions of a particular society. The play's ending, in which the wife leaves her husband and home, provoked a long and bitter debate when it was first shown in London in the 1890s.

Ghosts, first performed in Berlin in 1889, was as its author made clear a more "extreme" play than his earlier two prose dramas. It used hereditary venereal disease as a symbol of the moral diseases of the past that overtake and destroy the living. Not unexpectedly, the play was heavily attacked in Norway and received a similar reception when it first appeared in London in 1891. Ibsen was fascinated with the long-term results of people's actions, especially by their attempts to deceive both themselves and others. His next three plays – *An Enemy of the People* (1882), *The Wild Duck* (1884), and *Rosmersholm* (1886) – deal almost obsessively with what happens to those who cannot or will not face telling the truth.

Ibsen's later plays such as *Hedda Gabler* (1890) and *The Master Builder* (1892) show a shift in emphasis. His concern is less and less for social

ABOVE Claire Bloom and Frank Middlemass star in 1977 in *Rosmersholm*. The hostile reception given the play *Ghosts* may have inspired Ibsen to write this one, which is concerned with the psychological nature of ideals.

and moral themes and increasingly for the psychological, the visionary, and the symbolic. One critic remarked that watching an Ibsen play of this period is like looking at a two-story house: straightforward drama is being acted out on the ground floor while all the time a more complex drama is going on upstairs. His final play, *When We Dead Awaken*, was finished in 1899. Ibsen called it a "dramatic epilogue" and uses the central character, Rubek, to indulge in a last merciless attempt at self-analysis. In 1900 the first of a series of paralyzing strokes cut off his creative life, though he lived until May 1906.

Ibsen's reputation as the father of modern realism on the stage remains untouched to this day. His achievement was astonishing. Not only did he substitute the "plain truthful language of reality" for the high-flown romantic diction of the 19th-century stage, but he was also the first dramatist to explore the deeper psychological recesses of the human mind, the role of the individual in society, and the problems of evil and hypocrisy. European theater could never be the same after Ibsen had shown the way. Working within the technical conventions of the theater of his time, he completely revolutionized the scope of drama and released dramatists throughout the world to extend that scope.

Anton Chekhov

1860-1904

"Chekhov is inexhaustible because, despite the everyday life which he appears to depict in his plays, he is really talking all the time not of the accidental and specific, but of the Human with the capital 'h'. His plays are full of action, not in their external but in their inner development. In the very inactivity of his characters a complex inner activity is concealed." This tribute by a contemporary, Konstantin Stanislavsky, the famous Russian actor and producer, sums up the peculiarly elusive power of Chekhov's plays.

Anton Pavlovich Chekhov's father was a grocer, his grandfather a freed serf. He was born at Taganrog, a small town in southern Russia. When his father went bankrupt the young Anton followed his family to Moscow where he studied medicine, at the same time supporting his parents, four brothers, and a sister by writing. Anecdotes and sketches (he wrote about 1000), short stories, long stories, a full-length detective novel – all this paid the family bills and taught the young Chekhov mastery of the comic and serious vein. Unaffected by the political stirrings of prerevolutionary Russia, he nevertheless in 1890 made a solitary expedition to study for himself the czarist penal settlement on Sakhalin, an island off eastern Siberia. During the peasant famine of 1891–2 he used his medical skill to alleviate suffering. Then he bought a farm 50 miles south of Moscow as a home for himself and his aging parents. There he treated the local peasants and continued to write numerous stories and sketches.

Chekhov's first play to be performed was *The Seagull* in St Petersburg (now Leningrad) in 1896. The play's humor was completely mis-understood, the production failed, and Chekhov determined never to write again for the stage. "It was a failure such as I had never dreamed of." But in 1898 the Moscow Art Theater was formed. One of its directors was Stanislavsky, who understood the need for understatement in Chekhov's play. *The Seagull* was tried again and was a success. His next play, *Uncle Vanya*, staged in Moscow in 1899, is the superbly subtle study of the aimlessness of life in a Russian

country house. Its success and that of the re-vived *Seagull* assured Chekhov's reputation.

In about 1900 Chekhov was forced by increasing ill health to move to Yalta on the Black Sea coast. There he continued to write, producing for the Moscow Art Theater two plays which are probably his masterpieces. Both display the light touch, the absence of dramatic action on stage, and the subtle mingling of humor and pathos that are the Chekhovian hallmarks. In *Three Sisters*, written in 1900–1901 and first performed in 1901, he portrays with truth and sympathy the longings of three young women living together in the Russian countryside. In *The Cherry Orchard*, first performed in Moscow on Chekhov's birthday in 1904, he depicts the Russian landowning class in decline with a selection of characters who remain comic even when they most excite our sympathy. Chekhov's

LEFT Elsa Lanchester (left) in an Old Vic production of *The Cherry Orchard* in 1933. The author insisted that his play was "a comedy, in places even a farce."

success was immediate and complete. "At the first performance I was feted so lavishly, so warmly, and above all so unexpectedly, that I have not yet recovered from it." Four months later he died of the tuberculosis that had weakened him for years.

Unlike Shakespeare, Molière, and Ibsen, Chekhov was never a man of the theater. He was primarily a writer and hardly ever, until the overwhelming reception of *The Cherry Orchard*, was his experience as a playwright completely

BELOW Ralph Richardson, Robert Stephens, and Dorothy Tutin in a 1978 National Theater production of *The Cherry Orchard*, a perennial favorite with audiences the world over.

satisfactory. His plays are remarkable for their subtlety, their delicate balance between the tragic and the comic. Too shy himself to direct their production, he owed a great deal to Stanislavsky, who brought a natural style of acting to the previously declamatory Russian stage. But even Stanislavsky's direction often disappointed Chekhov, who never in his lifetime found a director who gave his plays the lightness of touch and general understatement he felt they needed.

A great dramatist, Chekhov was also a great lover of humanity. He longed to show his fellow countrymen that they were wasting their lives with futility and falsehood. He seems to have believed that if only they could be made to see what they were like they would change their ways at once. The trouble was that he was too successful at portraying a society in decline as it affected groups of individuals. Russian audiences simply delighted in seeing themselves so truly and amusingly portrayed.

It was not until after World War I and the Russian Revolution that Chekhov's works became well known in translation abroad. He was quickly imitated; Ernest Hemingway and George Bernard Shaw are the best known of those who owed a debt to his elusive combination of humor and pathos. But no one has really succeeded in imitating this great playwright, the least dogmatic of writers and one of the most human of men.

Eugene O'Neill

1888-1953

The center of vigorous, original drama has tended to shift in the 20th century from Scandinavia and Russia to the United States. No playwright had a greater part in this shift than Eugene O'Neill, the first American to use the stage as a literary medium and the first to write tragedies that, while they are wholly American, have the universal appeal of all great drama. The originality of his plays made him world-famous. But his technical innovation was that he reintroduced theatrical devices that had not been used since ancient Greek or Elizabethan times: the painted mask, the chorus, the soliloquy, the aside to the audience, the ghost. His ambitious aim was to bring back poetry into the theater without losing realism. His powerful plots enabled him to triumph over the occasional clumsiness of his method.

O'Neill was born into the theater. His father was a popular traveling actor specializing in the melodramatic roles then fashionable with American audiences. His mother followed him to and fro across the country, a wretched life that eventually pushed her into drug addiction. The unhappy relationship between his parents and the tragic early death of a younger brother from alcoholism provided O'Neill with a rich source of material that he made full use of in later years.

After spending an adventurous youth among prospectors, sailors, and beachcombers, O'Neill turned to writing plays following a breakdown brought on by drink and an attempted suicide. This "rebirth," as he called it, took place in 1913 but it was not until 1916 that his first play, a one-act drama called *Bound East for Cardiff*, was performed in New York. Four years later his first full-length play, *Beyond the Horizon*, was produced on Broadway. By 1943 he had written 20 full-length plays – some of them longer than

ABOVE National Theater (London) production of O'Neill's *Long Day's Journey Into Night*, starring Sir Laurence Olivier as the alcoholic father.

LEFT O'Neill linked the stark New England personality, with its strong puritanical streak, to the inevitability of Greek tragedy in *Mourning Becomes Electra*, set in post-Civil War America.

the acceptable two hours or so – and a number of short plays. His reputation as a dramatist was established, and for the next 20 years it grew both in the United States and abroad.

O'Neill drew constantly upon his personal experience, and in particular upon the life of his own family. In *Desire Under the Elms*, first performed in 1924, he used themes drawn directly from the Greek tragedies – incest, infanticide, the retribution of fate – placed in the context of his own family's conflicts. Completely avoiding the style of fashionable melodrama, blending personal experience with a stark realism, the result is one of the finest American plays of the 20th century.

Themes from Greek tragedy fascinated O'Neill and he returned to them again and again. In

Mourning Becomes Electra (1931), which is not one play but a trilogy comprising *Homecoming*, *The Hunted*, and *The Haunted*, he simply rewrote the plot of Aeschylus' trilogy *Oresteia* in modern psychological terms and set it in the New England of the post-Civil War period.

Even in his later plays O'Neill remembered the experiences of his own unhappy youth. *Long Day's Journey Into Night* was written in 1940 but first performed three years after his death. It is an agonizingly autobiographical play des-

BELOW scene from a 1961 production of *Mourning Becomes Electra*, in which a heroic soldier returns from the Civil War to his New England home only to be murdered by his unfaithful wife. His daughter sets out to avenge him and incites her brother to kill their mother.

use the theater to tackle serious subjects: in his own words, to find the deeper meanings that underlie "the discordant, broken, faithless rhythm of our time." After O'Neill, Broadway – with its dreary round of European imports, contrived melodramas, musicals, and farces – was never the same. He was quickly recognized as a world figure, and as early as 1936 the Swedish Academy awarded him the Nobel prize for literature, the first time it had been given to a writer from outside Europe.

cribing relations between a father, mother, and two sons. The Greek dramatists had always restricted their tragedies to the events of one day. O'Neill borrowed this idea to give dramatic intensity to his play. The result is among the most powerful plays in modern theater, with layer after layer of deceit and pretense being stripped from the four characters to expose the tragedy of their broken lives.

Frustration, failure, defeat – these are the human situations O'Neill succeeds in depicting in his plays. He wrote one comedy, *Ah, Wilderness*, first performed in 1933. In one of his later tragedies, *The Iceman Cometh* (1946), he used religious symbolism to illuminate his hero's pathetic hope for a better life.

O'Neill was the first American dramatist to

RIGHT Eugene O'Neill, the only American playwright to receive the Nobel prize for literature. His first full-length play, *Beyond the Horizon*, won O'Neill the first of his four Pulitzer prizes in drama.

Bertolt Brecht

1898-1956

ABOVE Ewan MacColl as the Street Singer in a 1956 Royal Court production of *The Threepenny Opera* in London. Here he posts notice of the execution of Mack the Knife.

"The 24-year-old poet Bert Brecht has changed the literary physiognomy of Germany overnight. A new tone, a new melody has entered our time . . . Brecht is impregnated with the horrors of this age in his nerves, in his blood . . . Hence the unparalleled force of his images." Not all critics were as effusive in their praise of the first performance of Brecht's first play in Munich in 1922, but the words were prophetic. *Drums in the Night* is about a soldier coming home from World War I who settles for comfortable marriage with his unfaithful fiancée rather than taking part in the 1918 German revolution. The play won Brecht the Kleist Prize as the most promising playwright of the year. It was an auspicious beginning to the career of the most controversial and revolutionary of 20th-century dramatists.

Brecht's impact upon world drama was not only in his plays, but in his whole concept of the theater. With another German, Erwin Piscator (1893–1966), he introduced what he called "epic theater" – dramas that are radically different from the conventional "well-made" play which sets out to give the audience the illusion of reality. These spectacles are staged with the minimum of scenery, with explanatory captions, photographs, or other documents projected on the backcloth, with propaganda messages emphasized by choruses, spoken or sung, on stage or even in the auditorium, in such a way that the audience cannot avoid being drawn into the action. But far from the "realism" of Chekhov or Ibsen, this narrative, nondramatic theater is designed to keep the audience aware throughout that they are watching a play, that the theater is only a theater and not the world itself. The concept has had, since its inception in Berlin in the 1920s, a profound effect upon world drama.

Eugen Berthold Friedrich Brecht (he later called himself Bertolt) was born in Augsburg, Bavaria. His father was manager of a paper mill. In 1916 World War I interrupted his medical studies and he served in a military hospital. The experience was shattering. "I saw how they patched people up in order to ship them back to

BELOW scene from *The Caucasian Chalk Circle* when it was first performed in Berlin in 1954 under the direction of Brecht himself.

the front as soon as possible." He became a fervent pacifist, and after the war returned to his studies. Then in 1924, two years after the success of *Drums in the Night*, Brecht went to Berlin where he spent nine years. During that time he collaborated with composer Kurt Weill on two operas. Brecht was by then a bitter leftwing critic of postwar German society, and in *The Threepenny Opera* (1928) and *Rise and Fall of the*

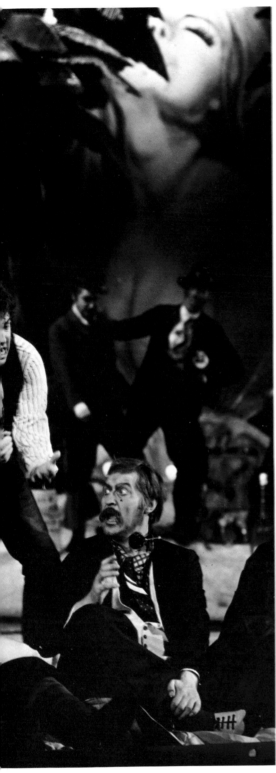

Mother Courage, first performed in Zurich, Switzerland in 1941, describes the suffering of an aging camp follower in the Thirty Years' War who loses two sons and a daughter in the war, but is finally seen determinedly dragging her cart after the marching soldiers. Brecht insisted that his heroine was a fool and a profiteer, but audiences have continued to be emotionally involved in her suffering – the very reverse of what Brecht intended. *The Caucasian Chalk Circle*, based on an old Chinese play, is about the problem of goodness and the difficulties of finding justice in an unjust world. With its use of storytellers, masks for the wicked characters, and its highly stylized action, this is perhaps Brecht's finest play. But in 1947, the year it was first performed in the United States, Brecht was called to give evidence to the now notorious Committee on Un-American Activities. He was disgusted at the experience and the next day left America for Europe.

In 1949 the East German government invited Brecht to form his own company, the Berliner Ensemble, in East Berlin. The revolutionary of the 1920s became the grand old man of the Communist regime, but found state patronage a mixed advantage. In 1951, during the Korean War, an early play of his, *The Trial of Lucullus*, was performed by the Ensemble. The authorities objected to its antiwar theme, and Brecht was forced to rework it, remarking with characteristic ambiguity, "Where else in the world can you find a government that shows such interest in artists?" In 1955 Brecht was given the Stalin Peace Prize. The next year he died of a heart attack shortly before his Ensemble made its triumphant debut in London.

City of Mahagonny (1930) – Mahagonny being his name for Berlin – he depicts lechery, greed, and violence as the outcome of that society. Another play, *St Joan of the Stockyards*, was broadcast in 1932, but the rise of Nazism made such an overtly leftwing attack on the capitalist system dangerous. In 1933 Brecht fled to Denmark, Sweden, and then to the United States.

Brecht's exile was his most productive period.

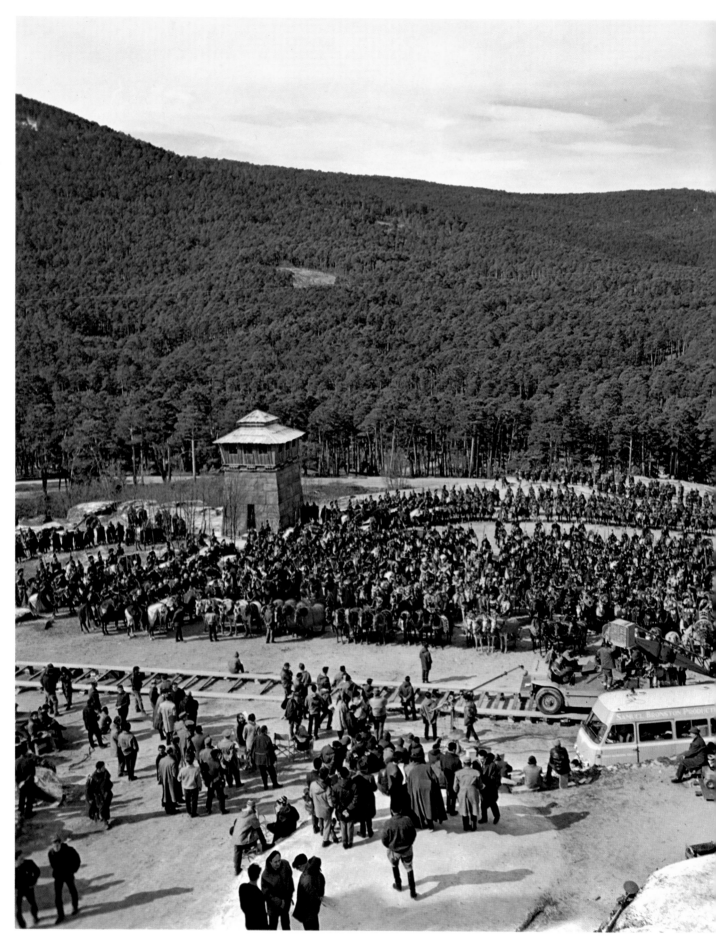

Chapter 11

THE ART OF FILM

Though films are only images on a screen, they have a compelling power and have given many 20th-century artists unique opportunities to reveal new aspects of nature and life. Modern films are the most widespread form of mass entertainment the world has ever known, and the techniques of film makers – especially the way they can manipulate space and time – has greatly influenced other art forms. Yet motion pictures, known as the cinema in Europe, have grown from a scientific novelty to a great industry and a powerful art form in a short time during the present century. Today, the making of a feature film is a lengthy, costly, and highly technical process involving the skills of hundreds of specialists, technicians, and artists. It seems improbable that any enterprise so complex and commercialized can produce a work of art but it can, and it has, and it does.

OPPOSITE the filming of *The Fall of the Roman Empire* (1964), directed by Anthony Mann. A production of this scale requires extremely detailed planning in order to coordinate a huge cast of actors and trained animals with the lighting, sound, and camera technicians.

Origins
of Film

Motion pictures move because of the optical phenomenon known as "persistence of vision." Early in the 19th century it was discovered that our eyes retain an image for a fraction of a second after it passes out of sight. In a film many pictures pass before our eyes every second, and because we retain the image of the first until the second appears, we have the illusion of movement.

A popular 19th-century toy that made use of the persistence of vision was the *zootrope* or wheel of life. A strip of drawings was mounted inside a drum showing, for example, the successive stages of someone climbing a flight of stairs. As the drum revolved, a person looking through slits on the top got the impression that the figure actually moved.

The first photographic processes were invented in 1839 by Louis Daguerre in France and William Fox Talbot in England, working independently of each other. In 1869 celluloid, the world's first plastic material, appeared on the American market, and George Eastman used it as the basis for a flexible film that he perfected in 1884. Eastman's discovery was an important

ABOVE "peepshow" of about 1907, based on Edison's kinetoscope, into which only one person could look at a time.

ABOVE RIGHT diagram of Edison's kinetoscope showing the interior mechanism. This model, dating from 1894, required no hand crank.

step toward motion picture filming, replacing the rigid glass that had been used to make prints and negatives.

The next major advance had to be the invention of a camera that could take many, rather than just one, pictures on a strip of film. The first to come up with a workable solution were the American Thomas Edison and his young Scottish assistant William Dickson. Using Eastman's film, they perforated each frame four times. Then they developed a revolving cylinder

LEFT two versions of the zootrope of 1882, in which the figures of a circus mule and a girl jumping rope would seem to move when the drawings were spun around quickly. On one a mirror reflects the pictures.

LEFT scene from the hand-colored film *Fairyland*, made in 1903 by Georges Méliès, who specialized in illusions and optical tricks, perhaps due to his first professional experiences as a magician. Some of his innovations were the now basic camera methods of stop motion, slow motion, dissolve, fade-out, superimposition, and double exposure. In his films humans were cut in two, disappeared or turned into animals.

with projecting teeth that fitted into the holes and pulled the film smoothly and evenly through the camera.

The pictures were shown on a *kinetoscope*, a viewer which, like the zootrope, only one person at a time could look through. Nevertheless, Edison's one-minute film shows became extremely popular in amusement arcades. In a move that he surely must have regretted later, Edison decided not to pay the final $150 which would have given him an international patent on his invention. He regarded motion pictures as little more than a passing novelty that would soon give way to some other large-scale entertainment form.

Others were not of the same opinion as Edison and began searching for a way to project pictures on a large screen. It is difficult to say who first achieved success, because demonstrations of projecting equipment on both sides of the Atlantic went on all during 1895. But in France, Auguste and Louis Lumière, manufacturers of photographic equipment in Lyons, invented the *cinematograph*, which could both photograph and project films.

Usually the first films lasted no more than three or four minutes and were based on real-life incidents: street scenes (like the Lumière brothers' film showing workers leaving their factory for lunch), horse races, or the local fire brigade tearing off to put out a blaze. Music hall and fairground exhibitors were responsible for promoting the new invention and proving

BELOW close-up of one of the characters in Edwin S. Porter's revolutionary film *The Great Train Robbery*. Porter pioneered the use of the technique.

that people would be willing to pay to see moving pictures. To keep people's interest, exhibitors demanded more variety. Camera crews toured the countryside looking for material. The results were often highly inaccurate stories of news events redone for the camera long after the event had taken place.

Georges Méliès (1861-1938), a French magician, was the first to exploit the narrative possibilities of film making. He had seen the early Lumière films and soon developed his own camera and bought a projector. Méliès was truly a creative jack-of-all-trades. In his studio, the first of its kind, he wrote his own stories, painted the scenery, acted, printed, and sold the films. His imaginative, witty pictures introduced many of the tricks of modern filming. *A Trip to the Moon*, made in 1902, established the "dissolve," which later became a conventional device.

Despite his pioneering inventiveness, however, Méliès remained constricted by theater techniques. These barriers were dramatically scaled by Edwin S. Porter, an Edison cameraman, in 1903. His film, *The Great Train Robbery*, was an immediate success; it lasted an unprecedented 11 minutes. For the first time Porter used the "cut" to show two threads of action occurring simultaneously. He also began to move the camera around. His techniques made the film exciting to watch and in addition to reviving popular interest in motion pictures, *The Great Train Robbery* stands as the first American film in a long line of "Westerns."

Silent Films

From their earliest days films were an international medium because, since there was no sound, there was no language barrier. Titles, and subtitles if there were any, could be translated into any language for audiences everywhere.

By World World I film studios flourished in virtually every European country. From Italy came historical spectacles like *Quo Vadis?* (1912) with its thousands of extras and *Cabiria* (1914). Denmark, Sweden, France, Britain, and Germany all produced distinguished films, often adapted from plays and novels. With the outbreak of war, however, the film industry continued to thrive only in Sweden and Denmark. In the rest of Europe studios were virtually inactive as celluloid went into the production of war materials.

At this point the American film industry began to grow by leaps and bounds. By the end of the war the United States dominated the film market almost completely and Hollywood had become synonymous with the film industry. High salaries, tax inducements, and a sunny climate encouraged directors and actors to flock to southern California – and they produced what audiences wanted to see. Comedy, romance, and glamour allowed people to forget, at least briefly, the war news coming from Europe.

In 1915 D. W. Griffith (1875–1948) completed *The Birth of a Nation*, billed as "the greatest picture ever made." Three hours long, its serious subject appealed to people who had never before gone to see a movie. The film's potential as an art form was revealed for the first time.

Mack Sennett (1880–1960) established American supremacy in comedy with the antics of his Keystone Kops. His greatest discovery was the British-born Charlie Chaplin (1889–1977) whose brilliant pantomime combined pathos with a unique sense of comedy. Within a year of his first film in 1914 he was world-famous, and became film's first legend.

Immensely popular at this same time were the weekly serials. At the end of each episode of *The Perils of Pauline*, for example, the heroine played by Pearl White would be left tied to the railroad track or facing a similar crisis. The most gifted maker of such serials was the Frenchman Louis Feuillade (1873–1925) who created in *Fantomas* (1913) and *Les Vampires* (1915) a mysterious, surrealistic Paris underworld ruled by the strangely named Irma Vep, an implacable villainess in a black jumpsuit.

German directors developed this element of fantasy and in the 1920s made a succession of films dwelling on the macabre and supernatural. These helped to establish German films as the most visually distinguished in the world. Like many of Europe's best directors and actors, nearly all the film makers responsible for the

BELOW the immortal Charlie Chaplin, the most famous actor of the silent film era. From 1918 he also wrote and directed the films in which he starred.

RIGHT Buster Keaton in his film *The General* (1926). Keaton created the classic deadpan character who is constantly in conflict with mechanical monsters. His lifelong trademark was a never-smiling face, and he was a master of subtle timing and the comic fall.

RIGHT publicity poster for *The Sheik* (1921), a Paramount picture starring Agnes Ayres and Rudolph Valentino, whose full name was Rodolfo Alfonzo Raffaelo Pierre Filibert Guglielmi di Valentina D'Antonguolla. His death in 1926 prompted worldwide hysteria, several suicides, and riots when his body was laid out in state.

German achievement went to the United States. Ernst Lubitsch (1892–1947), F. W. Murnau (1889–1931), Conrad Veidt, and Erich von Stroheim (1885–1957) joined Poland's Pola Negri and Sweden's Mauritz Stiller (1883–1928) and Greta Garbo to become as much a part of Hollywood as the native-born Dorothy Gish and Mary Pickford. The unfortunate result was a decline in European films as Hollywood productions monopolized film houses everywhere.

Hollywood's motion picture industry in the 1920s was already highly organized and fiercely competitive, turning out films in ever greater numbers as the demand soared. The variety was remarkable. Costume pictures nourished the world's romantic dreams. The swashbuckling Douglas Fairbanks dueled his way into the hearts of a million women, and Rudolph Valentino started a fashion for exotic romance with

The Sheik. Unlike the great silent comedies, these films have an oddly dated look today. Chaplin's "little tramp" makes less appeal to us than to his contemporaries but in *The Gold Rush* (1924) he produced a masterpiece. The films of Buster Keaton (1895–1966) – "the Great Stone Face" – and bespectacled Harold Lloyd (1893–1971), though set in an unmistakable 1920s America, seem timeless. The early Hollywood epic now looks unbelievable and the society comedy merely arch, but the films of Keaton and Lloyd, their sense of timing and feeling for the structure of a film, are as enjoyable today as when they were made over 50 years ago.

From the time of *The Great Train Robbery*, the Western held a secure place in the Hollywood mythology. The West was a land of simple conflicts where cowboys lived and worked in the open air, and Westerns exerted a potent appeal to the industrialized wage earners who made up the bulk of film audiences. Two of the best silent Westerns were *The Covered Wagon* (1923) by James Cruze (1884–1942) and *The Iron Horse* (1924) by John Ford (1895–1973), a romanticized story of the Union Pacific Railroad.

Though many European film makers had gone to Hollywood, the talent drain was never total. Fritz Lang (1890–1976) remained in Germany until Hitler. In Britain, largely swamped by American imports, Alfred Hitchcock (born 1899) made his first thriller, *The Lodger*, in 1926. Commercial production struggled on in France and discovered in René Clair (born 1898) a poetic genius of the film. France also founded the first film society as well as making films the object of serious critical attention.

LEFT filming *The Covered Wagon*, one of the most memorable of the silent Westerns. It was a mammoth production employing large numbers of extras and realistic backgrounds.

The Coming of Sound and Color

Although 1927 is given as the traditional date for the beginning of the "talkies," sound did not simply explode onto an unsuspecting public. In fact, before 1900 Thomas Edison and William Dickson produced a talkie when they linked the phonograph to the kinetoscope to make one of the very first moving films. The sounds were recorded on disks and matched to the filmed action. About the same time the Frenchman Léon Gaumont separately developed a similar technique, but both his and Edison's processes produced sound that was too faint to be heard beyond the first few rows of a theater. In the early 1920s, Lee De Forest developed a process for printing sound directly on film which he presented in theaters around the country, but it did not catch on with the film industry.

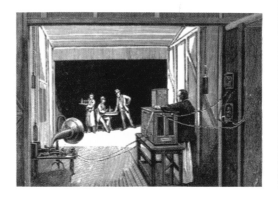

Throughout the silent era film houses had orchestras, small instrumental groups, or a piano or organ to provide musical accompaniment for films. Managers realized early that the audience could not sit in absolute silence, and music served the multiple purpose of intensifying the mood and atmosphere of the action and drowning out extraneous sounds of whirring projectors. The comedian Oliver Hardy, long before his partnership with Stan Laurel, gained his first experience of films as part of a male quartet singing behind the screen in Atlanta, Georgia.

The advent of sound was finally precipitated by a crisis in the film industry. The audience was staying away in droves, entranced by the new sound medium of radio. But film companies were

ABOVE first showing of the film *The Jazz Singer* (1927) with Al Jolson. Basically a silent film, the sound was Jolson's singing and a few spoken lines.

ABOVE LEFT Thomas Edison and William Dickson connected a kinetoscope to another of Edison's inventions, the phonograph, and by 1894 they had produced a talking film.

RIGHT full-frame caption for Charlie Chaplin's silent film *Shanghaied*, one of 12 films he made in 1915.

not at all convinced that sound was the answer to their dilemma and many resisted strongly for a time. Only Warner Brothers, in financial difficulties and with nothing to lose, ventured forth. In 1925 they acquired the Vitaphone from the

Western Electric Company, a process which again used recorded disks. Their first film with the Vitaphone was *Don Juan* (1927) starring John Barrymore. Barrymore did not talk but an orchestra score was synchronized with the film and Will Hays, head of the Motion Picture Producers and Distributors of America, spoke an introduction.

In 1927 William Fox introduced the Movietone Newsreel, which printed sound on film. Its success was immediate but it remained a sideshow attraction. Finally, in October that year, the film that was to revolutionize the industry appeared. Made by Warner Brothers, *The Jazz Singer* starred Al Jolson. It was essentially a silent film with sound for Jolson's singing and a few spoken lines including his catch phrase, "You ain't heard nothin' yet." One story is that

BELOW Judy Garland won a special Oscar for her performance (at only 17) in the classic film musical *The Wizard of Oz* (1939), based on a fairy tale by Frank Baum. "Over the Rainbow" became her trademark song.

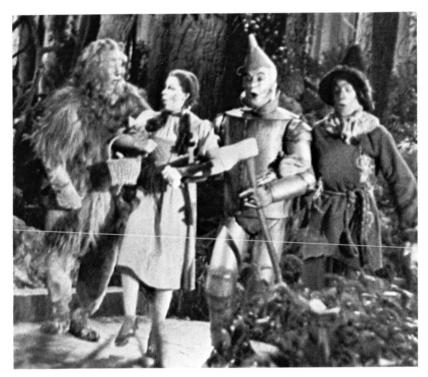

Jolson's ad libs to an actress were picked up by the microphone and that Sam Warner suggested keeping them in. In any event, Jolson electrified the audiences and sound pictures were in. The next year brought the first feature-length all-talking film, *The Lights of New York*.

Then came a period when sound dominated picture. Film companies raided the stage for actors trained in voice projection because actors with regional accents or poor voices would no longer do. Playwrights were also recruited because they knew how to write dialogue. Once again, films became stage plays. The flexibility that had come to the camera vanished. The camera had to be in a soundproof area so that microphones would not pick up noises from

RIGHT scene from *Becky Sharp*, first color feature film with sound. According to the publicity, it was "filmed in all the glorious beauty of the new perfected TECHNICOLOR."

whirring wheels, and actors were scarcely able to act – they had to stay close to microphones hidden in lamps, under tables, and behind chairs.

Gradually, of course, creative directors revolted against the renewed immobility and rigidity of the camera imposed by sound. Ernst Lubitsch in the United States, René Clair in France, and Fritz Lang in Germany realized that sound could be selected and edited, just as pictures could, and be made to work for them.

At the same time that sound was coming into use, color processes were also being developed. Some film makers experimented with color from the beginning. Georges Méliès produced several films with each frame colored by hand. An English film of King George V in India was shot in color as early as 1911. However, it was through the efforts of Herbert T. Kalmus and the Technicolor Motion Picture Corporation founded by him that color film became a commercial reality. Kalmus began experimenting in 1918 and by 1923 had developed a two-color process, but the colors were only fairly accurate and the new development did not capture the public's imagination. Kalmus continued to refine his procedures until by the end of the 1920s the colors were truer and film makers began to include color sequences. It was in 1935 that *Becky Sharp*, the

first feature film with color as well as sound, appeared, three years after Walt Disney's animated color short *Flowers and Trees*. But the introduction of color was less revolutionary than that of sound, and though silent films soon disappeared, directors have continued to exploit the artistic possibilities of black and white.

From Script
to Screen

Both the amounts of money and numbers of people needed to make a film today are enormous. It is the *producer* who coordinates and supervises the financial and administrative aspects of film production. Producers are responsible for budgeting and controlling the costs of scenery, costumes, filming equipment, and salaries. After choosing the story and *director* (sometimes the producer is also the director of a film), they oversee casting and preparation of a screenplay. Along with the director, the producer must coordinate and approve the work of costume and set designers, cameramen, and editors.

Producers are usually answerable either to the head of the studio that employs them or, if they work independently, to their financial backers. Certainly an important part of the job is convincing backers that the picture will not only be good but will also make money at the box office. The producer thereby frees the director from the financial considerations of film making but collaborates in the shaping of the film.

Arriving at a final shooting script from the initial idea is an involved process. The *treatment*, or outline, is written down in rough form, usually just dialogue and basic film directions. It is then worked out in detail so that the final plan includes not only dialogue but also descriptions of the actors' movements and the exact positioning of cameras for every scene, with the sequence and duration of each shot marked precisely.

Once the final shooting script has been approved, the *set designer* creates the sets. These must provide a suitable visual background for the story and its characters without being so elaborate that the audience pays more attention to them than to the actions and actors. At the same time they must be carefully planned to fit the movement and composition of each camera shot. Carpenters then translate the set designer's sketches into actual settings, preparing them with careful attention to detail so that they appear without fault in the eye of the camera. If needed, outdoor *locations* must be chosen and permission obtained to film there. In the meantime the *casting director* assembles actors suitable for the

RIGHT plan for the treatment of a shot, worked out by the director Sergei Eisenstein for *Que Viva Mexico!*

BELOW final take. The movie was never actually completed, although Eisenstein broke his contract with a Hollywood studio in 1932 to make the film in Mexico.

BELOW story boards for *Gone with the Wind* (1939), showing the order of the camera shots for the sequence in which the city of Atlanta burns down.

characters being portrayed, and clothes designers work on costumes.

Directors' techniques vary greatly in working with actors. Some, for example, control every nuance and inflection of an actor's performance and appearance, rehearsing every scene exhaustively. Others attempt to achieve the right tone and perspective by rehearsing only minimally and leaving the actor free to explore and interpret the role.

Before each shot, while the actors rehearse with the director, the *photography director* places the cameras in position and, with the aid of electricians, arranges lighting. A *sound recorder* places microphones so that they can pick up the

work on the sets may result in only two or three minutes of finished film, or that a full-length feature may take months or years to complete.

When producer, director, and editor are all satisfied that everything is right and the film has been assembled most effectively, the "dubbing" or re-recording phase begins. Sounds that could not be conveniently recorded during filming, like rattling train wheels and locomotive whistles, are added at the dubbing session. If there is a musical score, the composer has written it to fit the exact number of minutes and seconds of the film as well as the varying moods. It is then played in a specially equipped recording studio and combined with the other sound tracks by the sound recorder.

Finally, all sound tracks and picture sequences are combined into a "master copy" in the studio laboratories. From this, duplicate positive prints are made (sometimes as many as 1000) and then sent out to be shown all over the world.

slightest whisper from an actor and yet remain out of sight. Generally each scene is shot from several different angles to allow more flexibility in the final editing, and all scenes using a particular location or set are shot consecutively, although they may appear at many different points in the finished film. When all the scenes have been photographed they are sent to an *editor* in the cutting room. This editor arranges them in proper sequence with the aid of the shooting script and, even more important, cuts each scene to the length that will create the most powerful overall effect in the final film.

Since shooting a script is a tremendously complicated process and the camera is sure to pick up any flaws, *retakes* are often necessary. An actor may muff his lines, a camera may break down, or a plane may fly over what is supposed to be a Pony Express Rider galloping into Sacramento in 1860. So it is not surprising that a full day's

ABOVE setting up a low-angle shot of a desert railway in Jordan for the filming of *Lawrence of Arabia* (1962), directed by David Lean.

RIGHT director William Wyler (born 1902) rides on a camera truck to supervise the filming of the spectacular chariot race in *Ben Hur* (1959). Lavish historical films are always popular and are made on ever more grandiose themes with larger and larger budgets.

Documentaries and Historical Films

The word "documentary" was first used by John Grierson in a 1926 review of a Robert Flaherty film, *Moana of the South Seas*, although from their earliest days films have been consciously used for purposes other than entertainment. The first short films shown at music halls and fairgrounds were nonfictional. In the 1890s, a French scientist filmed germs and bacteria to illustrate their behavior patterns as seen through a powerful microscope. However, these cannot accurately be described as documentaries because they lacked the additional dimensions of interpretation and dramatic construction which were so integral to Flaherty's films, and which are still considered requirements of the documentary.

Robert Flaherty (1884-1951) was a creative and poetic interpreter. As a boy he spent several years in the American north woods with his father among the Chippewas and was fascinated

RIGHT scene from John Grierson's *The Drifters*. Grierson wrote of his intentions, "I look at the cinema as a pulpit and use it as a propagandist."

BELOW scene from Leni Riefenstahl's *Olympiad* (1938), an incantation to energy in the form of a report on the 1936 Olympic Games held in Berlin under the eye of Adolf Hitler.

and intrigued by the essential similarities between peoples of different cultures. In 1920 he began to explore these with a camera. His first and best-known film, *Nanook of the North* (1922), recorded the daily struggle for survival of an Eskimo family in the icy subarctic regions of northern Canada. Flaherty employed no trick

photography but instead used his camera to capture and give meaning to the small details that the human eye often fails to notice. Flaherty's other films, including *Moana, Man of Aran* (1934), and *The Louisiana Story* (1948) all share his personal vision and awareness of the close relationship between human beings and nature.

In 1929 Flaherty joined John Grierson in England. Grierson (1898–1972), founder of Empire Marketing Board Film Unit, attracted a "Documentary movement" around him of film makers who believed that films had an educational contribution to make to society in revealing the role and obligations of people in a democracy. Their approach was what Grierson described as "the creative treatment of actuality": to present life in their society with artistry. Grierson achieved this combination in his film about life in the herring fleets, *The Drifters* (1929).

During the 1930s England's documentaries became world-renowned. Throughout World War II England's documentary film makers effectively used their talents to bolster home morale and gain sympathy abroad.

After Robert Flaherty left for England there were few documentaries produced in the United States for several years. In 1935 the Museum of Modern Art Film Library was founded and through it the English documentaries came to the attention of the American film makers. The impact was immediate. Americans added their own flavor to the medium. Two of the most moving documentaries produced during this period were *The Plow that Broke the Plains* (1936) and *The River* (1938) by Pare Lorentz (born 1905). In the first, free verse narration recounted the misuse of the Plains, causing the calamitous Dust Bowl of the 1930s. *The River*, also narrated in free verse, was a visual history of the mighty Mississippi.

Directors such as Frank Capra (born 1897) and Anatole Litvak (born 1902) made documentary films for the United States government during World War II. In the years since then, documentaries have played an increasingly important role in education, science, propaganda, and even industrial training.

Old films can help us to understand the past. They constitute a unique form of historical record, showing us the long-dead heroes, villains, and innocents of the world scene, acting and behaving exactly as they did act and behave. By capturing detail, gesture, and expression, film can evoke the mood and atmosphere of a particular period and occasion that would otherwise be completely lost.

All this is the stuff of what might be called "newsreel history." Newsreels were among the earliest types of films to be made. Some were concerned with eminently newsworthy events and people, others with simple everyday activities. But all remain of intense interest to the historian or to anyone wishing to know what life was like in the early years of the century.

Many films of those days have been destroyed or were casually left somewhere for the ravages of time to take their toll. Those that survive are now preserved in the film archives of various countries under the carefully controlled conditions that film requires. (Unless films are properly stored, the photographic images fade and eventually peel away from the celluloid on which they are printed.) Copy prints are made for public showing and enable us to be spectators at events that happened yesterday – or long before we were born.

BELOW publicity poster for a 1940s German propaganda film, named after the huge British ocean liner that sank after striking an iceberg off Canada in 1912 and caused the loss of 1513 lives.

REGIE: HERBERT SELPIN

SYBILLE SCHMITZ · HANS NIELSEN
KIRSTEN HEIBERG · E.F. FÜRBRINGER
KARL SCHÖNBÖCK · OTTO WERNICKE
CHARLOTTE THIELE · THEODOR LOOS
SEPP RIST · FRANZ SCHAFHEITLIN
U.A.M.

Animated Films

The delightful creatures of the cartoons which have enchanted millions of people throughout the world began to come to life almost as soon as motion pictures were invented. J. Stuart Blackton (1868–1941) drew the first American animated cartoon intended especially for films in 1906. He called it *Humorous Phases of Funny Faces*. In 1909 Winsor McCay (1871–1934), also an American, produced *Little Nemo* and started what became a widespread practice of adapting comic strips for film cartoons.

Techniques steadily increased in subtlety and the cartoon hero of the 1920s, *Felix the Cat* – created by Australian cartoonist Pat Sullivan (1887–1933) – brought vitality to animation. In Germany Lotte Reiniger (born 1899) cut out paper figures to use as silhouettes in the world's first full-length animated feature, *The Adventures of Prince Achmed* (1926).

Walt Disney (1901–66) began making cartoons in 1923 with a series based on *Alice in Wonderland*, in which he combined cartoons with a live Alice. In 1928 he created the first

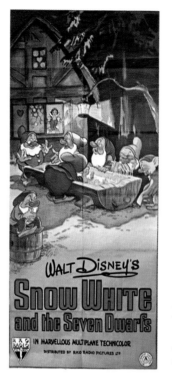

ABOVE publicity poster for Walt Disney's *Snow White and the Seven Dwarfs* (1937). In animating human figures he departed from the scope and techniques of his earlier shorts, which all dealt with animals endowed with human characteristics.

sound cartoon, *Steamboat Willie*, which introduced Mickey Mouse, one of the most famous of all cartoon characters. In 1932 Disney produced the first colored cartoon and four years later the first colored cartoon of feature length, *Snow White and the Seven Dwarfs*.

Putting a cartoon together is a complicated and laborious project. First, an artist makes rough drawings of the entire plot sequence on a huge board. Then the layout artist, musician, artists, and animator gather. They complete all the music, dialogue, sound effects, and background scenery before the animator begins sketching any of the action of the characters. If this were not done, we might see an animal crashing through the wall of a house when it is supposed to be loping along a road. The animator also needs to know how many sketches to draw for the dialogue. An analyst might calculate that the time needed for Disney's character Louie to call "Unca Donaaaald!" is equal to the time it takes for 60 frames to run through the camera. The animator then makes 60 different drawings in sequence showing all the different lip and body movements Louie uses.

Many people help with the drawing of a cartoon. The artists work on drawing boards lighted from below so that when they have finished one picture they can place a new sheet over the first and begin a second drawing. One drawing can be only the slightest bit different from the one before it if the movement is to be fluid, because when the cartoon is projected the frames run through the camera at the rate of 24 per second.

RIGHT Mary Costa, an opera singer and the voice of Princess Aurora, studying the story boards of Walt Disney's 1959 animated feature film *Sleeping Beauty*. Disney replied to his critics, "I've never called this art. It's show business, and I'm a showman."

The drawings are transferred to celluloid, on which artists sketch the drawings in pen and ink on one side and add the colors on the other side. Each celluloid strip is then matched up with the proper background scenery and photographed. It takes about two weeks to photograph the average 700-foot cartoon. No wonder it took four years to make *Snow White* when this entire procedure had to be followed for almost 500,000 drawings.

Disney dominated the world of animation in the 1930s but the enormous output of cartoons from his studios (one feature-length film and 48 shorts a year) gradually affected the quality; characters and animation tended to become stereotyped. In the 1940s a number of former Disney artists led a revolt against his style and created a legion of other characters. The animation techniques were similar to those of Disney but the adventures of Bugs Bunny, Sylvester, and of course Tom and Jerry are more frenzied, more violent, and at the same time wittier.

Other film makers have developed new and distinctive styles. In Canada Norman McLaren (born 1914) tried painting designs directly onto strips of film, bypassing the use of the camera completely. The Disney tradition of setting characters against a relatively realistic background had been largely rejected by the 1950s. Elegance of drawing, inventiveness, and wit were preferred. Richard Williams (born 1933) of Britain made his 1958 film *The Little Island* a vehicle for powerful social comment, and the thriving cartoon industries of Czechoslovakia

ABOVE rough sketches for Walt Disney's *Fantasia* (1940). (© Walt Disney Productions)

RIGHT preparing a "cell" for the rostrum camera.

(until 1968) and Yugoslavia have frequently done the same.

Contemporary cartoons range from the crowded frames of *Yellow Submarine* (1967) and inspired coarseness of *Fritz the Cat* (1971) to lyrical illustrations of folklore and puppet films. Whether their message is serious, satirical or humorous, the visual possibilities of animated cartoons remain immensely attractive to film makers and audiences alike.

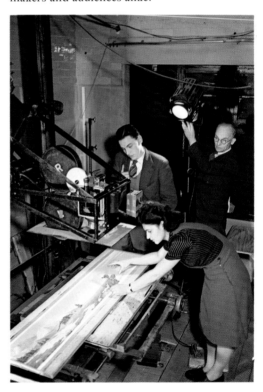

Chapter 12

THE
GREAT
FILM MAKERS

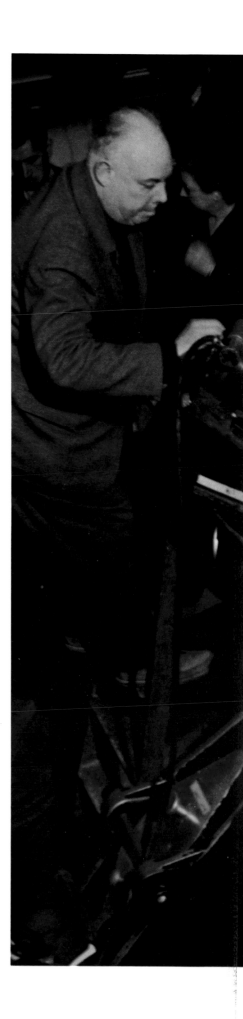

Although the making of a film is a complex undertaking that requires the participation of many different artists and technicians, the first and final responsibility for the film's artistic achievement is the director's. There was a time during the heyday of the Hollywood studio moguls when only exceptional directors could insist on approving the final version of the films they had made. But most great films bear the stamp of a director who has been the prime creator, and consciously or unconsciously directors impart to their work elements of their vision of the world. The films of some directors are unmistakably personal; in others the director's personality is revealed less obviously but no less clearly in a fondness for a particular situation, or a landscape, or even a camera angle. Recognizing the styles of individual directors adds greatly to the enjoyment of a film because the story they have made into a film is inseparable from the way they have filmed it.

OPPOSITE the French director Jean Renoir at work behind the camera. As director he was involved with every aspect of the film-making process. Son of the Impressionist painter, he was born at virtually the same time that motion pictures were invented.

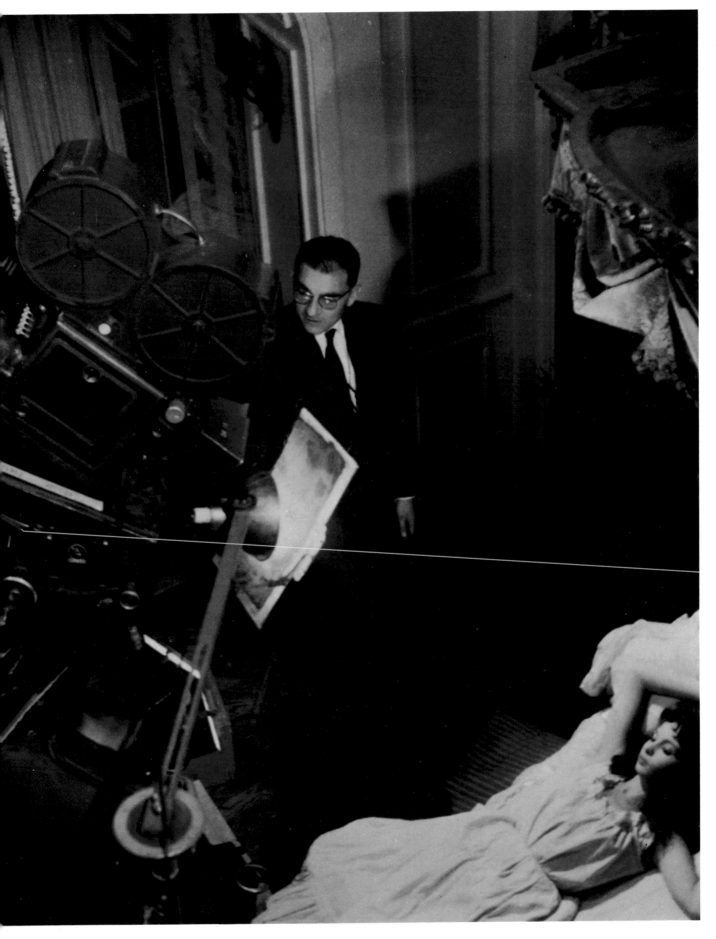

D.W. Griffith
1875-1948

Before Griffith began directing for the ailing Biograph Company in 1908, films were shot by the simple and straightforward method of placing the camera on its fixed pedestal in front of a scene and shooting it. When the actors moved outside the range of the lens, the camera was carried to a different position and the shooting continued as before. Some films were more exciting to see than others because the stories themselves were more exciting, but they all resembled one another because they were all made in fundamentally the same manner.

Griffith's intuitive feel for the camera brought a genuine revolution into film making. He introduced close-ups on faces, eyes, and hands for dramatic purposes – ignoring the warnings from the less imaginative in the industry who said audiences would wonder what had happened to the rest of the actor's body. He used extreme long shots in landscape as well as crosscutting and quick cutting to increase tempo and excitement. He experimented with lighting effects and dared to test the intelligence of his audiences with flashbacks and jump cuts. The earlier film makers had supplied film making with its alphabet: Griffith provided the grammar.

ABOVE David Wark Griffith, who joined with Douglas Fairbanks, Charlie Chaplin, and Mary Pickford to found United Artists.

BELOW close-up of Lillian Gish, who worked extensively with Griffith, from *Broken Blossoms*, an intimate and somber film. Griffith once said that the close-up technique had disclosed an unexplored terrain in the human face.

BELOW Union battlelines in the midst of the American Civil War, from *The Birth of a Nation*. The film was a dramatic masterpiece.

David Wark Griffith was born in Crestwood, Kentucky, in 1875, the eldest son of a Southern family ruined by gambling and the aftermath of the Civil War. He was ten when his father died and, in order to help his mother support the other children, he left school and worked first as an errand boy, later in a bookshop. At the age of 22 his good looks and strong voice brought him a part in a touring company of actors. He stayed with them until 1907 when he found himself in New York, out of work and with no prospects.

He managed to sell the American Biograph Company some film scenarios that were better than the usual material, and in 1908 he reluctantly took over the job of directing the films as a stop-gap before returning to writing and acting. During the first three years of this new career he made 330 films, none of them longer than ten minutes, which caused him to refer to himself as "the sausage machine." After 1910 he spent the winters in the reliably sunny climate of California and began supervising the films of his assistants, men like Mack Sennett and Erich von Stroheim. He gathered around him a stock company that included Mary Pickford – later to become known as "the world's sweetheart" – Mae Marsh, and Lillian and Dorothy Gish.

Because of the care Griffith took in casting and his innovations in camera work, the fortunes of the Biograph Company soared. His range of subjects included melodrama, Westerns, comedies, thrillers, sentimental romances, and historical drama. He even made films critical of social abuses. By 1913 he was the undisputed master of film making. However, by then the films coming from Europe took an hour to show and explored their subjects more profoundly than the shorter American ones could do. When Biograph refused to let Griffith make longer films he left, taking with him his technical crew and acting company.

He found the subject he needed for a full-length film in a melodrama called *The Clansman*, which presented the American Civil War from the point of view of the defeated South. He raised what was then the enormous sum of $110,000 and made the play into *The Birth of a Nation* in nine weeks in the summer of 1914. When film distributors wanted to show the nine-reel film in weekly installments, Griffith hired theaters and charged full prices to show it complete. By early 1915 the film had brought in $1 million and later made a great deal more. This epoch-making film can be justly criticized for its racism, but Griffith had succeeded in producing a well-constructed, technically sound, and emotionally moving epic that made people for the first time consider motion pictures as an art form of their own.

Griffith was stung by criticism of the film's theme and the next year poured all his profits into the making of *Intolerance* by which to answer his critics. In this more complex film, four stories were juxtaposed – intolerance in ancient Babylon, the persecution of Christ, the massacre of the Huguenots, and the exploitation of modern workers. The vast sets built for the Babylon scenes – a hall 200 feet high and a quarter of a mile long – and 16,000 extras unbalanced the film and confused the theme. It cost $2 million, equivalent to nearly $50 million today; Griffith spent the next eight years paying off his debts.

Of the films Griffith made afterward *Broken Blossoms* (1919) and *Way Down East* (1920) have endured. The others already had a style that seemed out of date and, after making his single talking film *Abraham Lincoln* in 1930, his next film *The Struggle* (1931) was never shown. He passed the remaining 17 years of his life as an unhappy survivor of Hollywood's infancy and though these later years were sad, his first years had been triumphant. Film makers and film-goers owe him an incalculable debt.

ABOVE Cyrus' army invades Babylon in a mammoth battle scene from *Intolerance* (1916). The film ran for three hours while Griffith attempted to present a vaguely humanitarian view of history, incorporating as much of the world as possible into the film.

RIGHT poster advertising one of Griffith's last films, *Drums of Love* (1928). Lionel Barrymore, one of the stars of the picture, was one of Griffith's discoveries from his early days with Biograph.

D.W. GRIFFITH
PRESENTS
'DRUMS OF LOVE'
Based on the Historical Incident of Francesca da Rimini . Adaptation by Gerrit J. Lloyd
with MARY PHILBIN,
Lionel Barrymore, Don Alvarado,
Tully Marshall, William Austin.
- UNITED ARTISTS PICTURE -

German Films
of the 1920s

For 15 years between the end of World War I and the rise of Hitler, German films were unequaled in the world for artistry. The partly state-owned Ufa (Universum Film A.G.) was established in 1917 and initially promoted costume films. Ernst Lubitsch proved himself a master of these, turning from the jolly farces he had previously specialized in to direct the exuberant Pola Negri (born Apollonia Chaluperz) in *Madame Dubarry* (1919) and *Anna Boleyn* (1920). The success of these films led to the departure of both director and star to Hollywood – where Lubitsch reached the pinnacle of his success directing Greta Garbo in *Ninotchka* (1939).

The most remarkable and famous film made in Germany in the first years of the decade was *The Cabinet of Dr Caligari* (1919). In it a sinister traveling showman (Werner Krauss) comes into a small town with his strange box from which at night the somnambulist Cesare (Conrad Veidt) emerges to murder at his master's bidding. The producers insisted on adding a prologue and epilogue in an asylum to make the story the mere

ABOVE Max Schreck as Dracula in F. W. Murnau's film adaptation (the first of many) of Bram Stoker's novel. Murnau makes the vampire count a grotesque and theatrical figure with an overwhelming sense of menace.

BELOW scene from *The Cabinet of Dr Caligari*, produced by Erich Pommer, who introduced the stridently painted expressionist scenery. It is set up as a detective story for the audience to solve.

fantasy of one of the inmates, whereas the film makers had intended the somnambulist to represent the soldiers sent out during World War I to kill in the name of their countries. However, it was not so much the story as the unforgettable style of its expressionist settings that earned this work its place in film history. Paths twist giddily, walls are oblique, chimneys slant, and the stylized acting matches the designs.

Caligari spawned other film tyrants: master criminals (Fritz Lang's *Mabuse* of 1922), mad kings, and most frightening of all, F. W. Murnau's *Nosferatu* (1922), a version of the Dracula legend in which the hideously bald vampire (Max Schreck) broods above the gables of a little Balkan town like the spirit of evil. In 1921 the Viennese-born Fritz Lang had directed his first major film, *Der müde Tod* (*The Weary Death*, released in the United States as *Destiny*), a film remarkable for his apparent use of outside lighting which was in fact created in the studio, and for marvels of trick photography – the spirits of the dead men moving through a solid wall, the parchment letter that unrolls and bows to the magician, and the first of filmland's flying carpets. Lang's marvelous feel for the atmospheric effects of light and mist were seen again in *Siegfried* (1924), the first of his two Wagnerian *Nibelungen* films. His most frequently reshown film is *Metropolis* (1926), a vision of life in the future which is a mixture of the visually magnificent and the melodramatic.

With *M* (1931), a film about the pursuit of a child murderer, Lang showed how sound could be an integral part of the work instead of mere

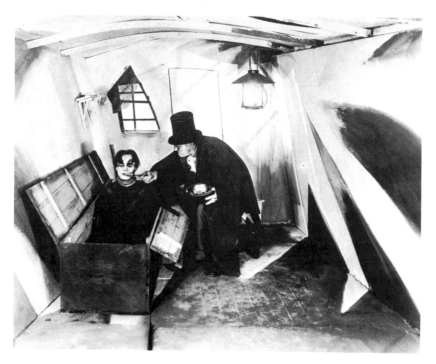

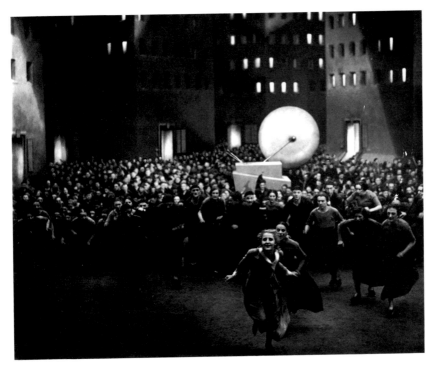

ERNST LUBITSCH

decoration. Words overlap to speed the action; distant shots and whistles heighten the tension; desperate breathing tells the audience behind which attic door the murderer is hiding. *M* is one of the great cinematic works of art.

The expressionist films of the early 1920s gave way to films set in the contemporary world. Several *Street* films were made in which tragedies and disillusion occurred in a heedless urban environment. These culminated in the 1927 film *Berlin, Symphony of a Great City* by Walter Ruttmann (1887–1941), an 80-minute montage documentary covering from morning to mid-

ABOVE crowd scene from Fritz Lang's *Metropolis*, a utopian fantasy in which a mastermind controls a city's inhabitants. The film was promoted by the Ufa company.

ABOVE RIGHT Marlene Dietrich appeared in this 1937 comedy by Lubitsch after both had gone to Hollywood.

BELOW multiple-exposure special effect showing a sleeper's dreams in G. W. Pabst's *Secrets of a Soul* (1926).

night. It was the first of many "city symphonies" and the first documentary to focus attention on the objects of everyday life.

G. W. Pabst (1855–1967) developed a different kind of realism. In 1930 and 1931 he directed three remarkable sound films. The dialogue in the pacifist *Westfront 1918* and in *Kameradschaft* (*Comradeship*) is poor but the sound effects, particularly in the second film, are hauntingly memorable. *Kameradschaft* was based on an actual incident in which German miners went to the assistance of their French counterparts just across the frontier after a disaster at Courrières. The mining scenes were all shot in the studio on one of the most authentic sets ever built. The authenticity extends to the performances, and Pabst's imagination is powerful enough to make the scenes of search and rescue dramatic without losing their realism. Between these two films Pabst made a lively film version of Brecht's *Threepenny Opera*.

The success of *M* took its star, Peter Lorre, to Hollywood, and the same happened with Marlene Dietrich after *The Blue Angel* (1930). Josef von Sternberg (1894–1969) directed this film, the moving story of a middle-aged teacher (Emil Jannings) destroyed by his infatuation for a nightclub singer called Lola. Sternberg never again produced an image of such stifling sexuality or such tenderness as the slow movement of the camera around the empty classroom that the teacher is about to leave forever. For Dietrich it was the start of a long career in films, but no subsequent part gave her so rich and subtle a character to play – sensual and yet forlorn.

Sergei Eisenstein

1898-1948

"The most influential six minutes in cinema history" is one description of the "Odessa steps" sequence of *The Battleship Potemkin*, filmed in 1925 by Sergei Eisenstein. It was only his second film, but it disclosed his mastery of a principle of film making brought to perfection by himself and a fellow Russian, Vsevolod Pudovkin (1893-1953), in the 1920s. This principle is known by its French name of *montage*, and means to assemble a film artistically by selecting shots and allotting their duration in order to convey a desired impression to an audience.

The Battleship Potemkin recounts the unsuccessful Russian Revolution of 1905 and its repression by the czar's White Guards. Eisenstein wished to arouse horror at the slaughter, sympathy with the victims, and hatred of the imperial soldiers. He first showed citizens of Odessa gathered at the foot of the steps expressing sympathy with the mutinous sailors. Then, with the title "Suddenly," the line of soldiers drawn up at the top of the flight opened fire and the sequence began. A variety of shots, some long and others lasting only a fraction of a second, show the first deaths and the crowd fleeing for safety. The different angles of the steps in the different shots add powerfully to the drama. Three consecutive shots, of less than a second each, show a man's body tipping forward, his body falling, and his knees giving way. A fourth shot of 2.5 seconds shows his dead body on the steps.

The camera then picks out from the running crowd a woman and her child. The child falls, screaming. The mother stares horrified as the crowd tramples her child, then she picks up its body and faces the advancing line of soldiers. A rapid succession of shots from all angles show her death and the boots of the soldiers stepping over her body. A similar sequence shows the death of a nurse whose falling body sets a baby carriage careering down the steps until finally it tips over, throwing the baby out. The camera continually cuts from close shots of faces, wounds, and guns to medium shots of figures and long shots of the whole flight of steps with the neat line of soldiers

lower down the flight each time. The cutting becomes swifter as the climax approaches. An elderly woman faces a soldier defiantly and he slashes at her, the angle of his sword matching the tipping of the pram. Her horrified face is seen in close-up, streaming with blood behind her smashed eyeglasses.

The Battleship Potemkin was the first Russian film to be shown widely outside Russia, and it created a tremendous impact wherever it was seen. Film makers realized the increased emotional power that could be generated when a scene, dramatic in its own right, was edited with such imagination and invention.

Sergei Mikhailovich Eisenstein was born in Riga, Latvia, the son of a Christianized Jew. He studied architecture before joining the Red Army in 1917 where he used his gift for drawing in clever pictorial propaganda. For four years he worked with an avant-garde theatrical group in Moscow, first as a scene shifter and later as designer and director. He filmed his actors in a play called *Gas Masks*, which he set in a real gas factory, and then decided to make his next production directly into a film. The result was *Strike* (1924). The idealized treatment of workers and the unrelenting view of the rich industrialists who endlessly guzzle food makes the film a difficult one to enjoy today. It was produced as part of a campaign to educate the masses of Soviet people and the propaganda is therefore heavily emphasized.

OPPOSITE scenes from the "Odessa steps" sequence in *The Battleship Potemkin*, which ends with the unforgettable image of the woman's bloody face and broken eyeglasses.

BELOW Eisenstein's evocation of the events surrounding the downfall of the czar in *October*, also called *Ten Days that Shook the World*. It relied heavily on montage allusions.

After the great success of *Potemkin*, his film of the 1917 Revolution, *October* (1928), seemed too obscure in parts and tediously overemphatic in others. Eisenstein then began to fall foul of the censor. He was allowed to leave the Soviet Union and shot a great quantity of film in Mexico, but he was never able to edit it and returned home more or less in disgrace. He took no part in the early experiments with sound and not until 1938 did he complete his next film, *Alexander Nevsky*.

The first part of Eisenstein's thrilling masterpiece *Ivan the Terrible* (1944) was received with favor but not the second part (made in 1958), known now as *The Boyars' Plot*. He was taken to task for concentrating on the barbaric splendors of Ivan's court in scenes that are superb to look at though largely static in themselves. He refused to alter the film, but the strain of resistance proved too much and on the day the editing was finished he collapsed with a heart attack. He lingered on for two years, recovering sufficiently to make a "confession" of his errors, but fortunately for his art he was never physically well enough to alter the film. It was suppressed for ten years after his death until, in a different political climate, *The Boyars' Plot* was at last released.

Eisenstein remained an innovator all his life – his experiments with color in his last film were years ahead of their time – and was never afraid of making mistakes. By most assessments, his mistakes were few and his achievements many.

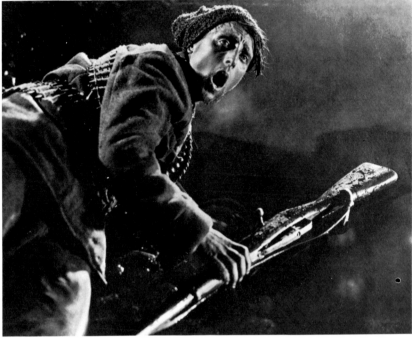

BELOW strikingly visual shot from the medieval epic *Alexander Nevsky*, for which the composer Prokofiev wrote a suitably majestic musical score.

BELOW scene from the ambitious work *Ivan the Terrible*, about the 16th-century czar Ivan IV, whom Stalin admired. It was originally intended as a trilogy.

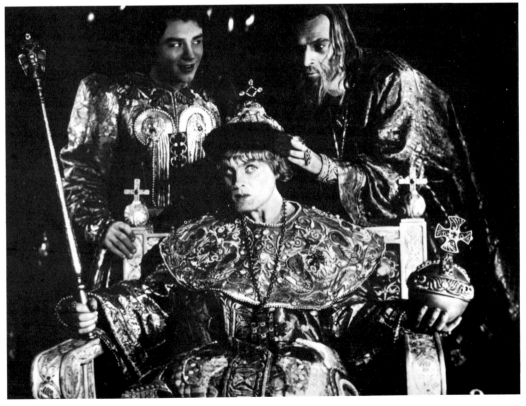

French Films of the 1930s

Paris in the 1920s was the center of surrealism. French film makers, like other artists, were affected by this avant-garde movement, and the early films of René Clair show his debt to it. Paris, immobilized by an invisible ray, formed the subject of his first film in 1924. Three years later, in *The Italian Straw Hat* (1927), an entire wedding party is involved in a frantic search for a straw hat eaten by the groom's horse. In one celebrated sequence, in which everybody is greeting everybody else by kissing them on both cheeks, Clair shot the scene directly from above so that the bald heads and huge feathered hats all dip together in the movements of an abstract ballet.

Clair at first opposed the use of spoken dialogue in sound films, though he did not object to music or noises. For his own first sound film, however, he modified his opposition and used speech as well as music and noises in *Sous les Toits de Paris* (*Under the Roofs of Paris*, 1930). He displayed such artistry that this film stands as a milestone in the art of the sound film. "If the imitation of real noises," he wrote, "is disappointing in effect or seems limited, it is possible that *interpretation* of sounds has a better future." With this in mind, he was selective in his use of dialogue. In a scene in which the young lovers quarrel with the lights turned off, he allows their voices to tell us what is happening. However, he shows a violent discussion through a glass door – when no voices can be heard. Throughout the film the catchy title song of a street singer comes and goes as a delicate comment upon the action. This interpretative use of sound was evident again in his next film, *Le Million* (1931).

After three more films Clair left France for England and eventually Hollywood, and 12 years passed before he completed another film in his native country. In the same year Clair departed, a most promising director died at the early age of 29. The total length of the four films of Jean Vigo (1905–34) runs to just over 190 minutes, but his output is unmistakably that of a most gifted and determined artist and his influence on French film making was marked. Much of Jean Vigo's childhood was spent in boarding schools – his Basque father died when Jean was still a boy – and he depicted these experiences in his most famous film, *Zéro de Conduite* (*Zero for Conduct*, 1933). The expression of young boys' emotion is years ahead of its time, a representation Vigo achieved by sensitively blending the real with the surreal. Unforgettable is the scene of a dormitory riot that culminates in a procession that carries a crucified teacher through a slow motion storm of pillow feathers.

BELOW LEFT shot from René Clair's first film, *Paris qui Dort* (*Paris Sleeps*), a Sleeping Beauty comedy about a scientist who invents a ray that can paralyze people in mid-action.

BELOW the lovers in Clair's first sound film, *Sous les Toits de Paris*. Before becoming a director, Clair had been an actor and songwriter.

Impressionist painter Auguste Renoir, he made his first sound film in 1931 and steadily developed his personal viewpoint as a film maker – that of a truthful, unshrinking observer of nature and people. He liked to work wholly on location, and when that was impossible he introduced views taken out of windows to give a studio-built room a lifelike feeling. In his concern to link characters with their background he tried to avoid the custom of shooting a conversation between two actors from over their shoulders, back and forth. He devised situations in which the speakers did not need to face one another, and by this means he showed their facial expressions without a cut and presented all the details of the background.

La Grande Illusion (1937) was the first of his two prewar masterpieces, a study of the relationships of a group of French officers imprisoned in a German fortress during World War I. The film has a richness of character and profundity of theme, and it captures the sense of a society on the edge of change. An opulent French château is the setting of *La Règle du Jeu* (1939), in which Renoir once again shows the confusions inherent in the breakup of an old social order, in this case the idle French aristocracy that was principally interested in shooting vast quantities of birds. Opening a few days before the outbreak of World War II, the film's critical tone provoked riots. Both films were ruthlessly cut and eventually suppressed and were not seen again for 20 years, after which time patient restoration had brought them nearly back to their original state. Both films were then highly acclaimed as works of art.

His last film, *L'Atalante*, was set on a barge, and in it he again blended the surreal – the dream longings of parted lovers – with a realistic treatment exceptional for 1934. The actors spoke and behaved like ordinary people, and this restraint had a bearing on the realist school of film that developed during World War II.

The last of the three influential French directors who came to prominence between the wars was Jean Renoir (1894-1978). A son of the

ABOVE the famous pillow fight from *Zéro de Conduite*. Jean Vigo compared the schoolmasters' control of the young boys with the tyranny of totalitarian states over their helpless citizens, a theme relevant to the rise of fascism in the 1930s.

RIGHT scene from *La Règle du Jeu* (*The Rules of the Game*), in which Jean Renoir himself plays one of the main characters. He describes a formalized society that has fallen into chaos because most of the people in it refuse to play the roles assigned to them. Renoir compares France on the eve of the 1789 Revolution with modern France before it fell to the Germans.

Hollywood–The Golden Years

Throughout the 1930s American films dominated the world of motion pictures. The only major countries that Hollywood failed to penetrate were the Soviet Union and Japan. The changes forced on Hollywood by the coming of sound and the Depression led to crises and mergers of the film making companies; when the dust had settled the field was occupied by four major studios and four others. The founder and managers of the studios exercised almost total control, and one result of this was that each studio tended to develop a characteristic style of its own. Warner Brothers, for instance, specialized in crime films, and their male stars were mostly

ABOVE publicity still from the flamboyant MGM blockbuster *Gone with the Wind*, a Southern fable based on Margaret Mitchell's novel and starring Clark Gable and Vivien Leigh.

Lang, *Fury* (1934), was for MGM and showed the moral havoc wreaked by lynch law. The studio's most famous film was *Gone with the Wind* (1941). Enormously expensive to make, it was produced by David O. Selznick, who used

tough and aggressive types (Edward G. Robinson, Humphrey Bogart, James Cagney), whereas those at Metro-Goldwyn-Mayer (MGM) – such as Clark Gable and Spencer Tracy – seemed more romantic or easygoing.

MGM concentrated on escapist films – musicals, romances, and costume dramas – presented with a professional gloss and later in sumptuous color. George Cukor (born 1899) directed Greta Garbo in *Camille* (1936); King Vidor (born 1895) made *Anna Karenina* (1935) and *Marie Walewska* (1938) with her. Films on contemporary subjects were rare, although the first film made in Hollywood by the exiled Fritz

ABOVE publicity poster for the Warner Brothers gangster film *Angels with Dirty Faces* (1938), starring James Cagney and Pat O'Brien and directed by Hungarian immigrant Michael Curtiz.

ABOVE RIGHT Greta Garbo and Freddie Bartholomew in *Anna Karenina*, based on Leo Tolstoy's famous novel about love, morality, and guilt in prerevolutionary Russia.

three different directors and 14 writers.

Paramount distributed the biblical epics of Cecil B. deMille (1881–1959) and a series of vehicles for Marlene Dietrich. Paramount pictures have been described as having an unmistakable "glow" upon them. "The best of them seemed gilded, luminous, as rich and brocaded as Renaissance tapestry." Ernst Lubitsch, who built a reputation for light-hearted, sophisticated comedy, had much to do with this. A more uproarious kind of comedy was provided by the zany Marx Brothers and those two irrepressible and inimitable performers, Mae West and W. C. Fields.

Until their successful gamble with *The Jazz Singer*, the first talking picture, Warner Brothers had had a relatively undistinguished record in films. Sound changed their fortunes overnight, and during the 1930s some of the screen's greatest stars were under contract to them. Their films were characteristically tough and fast-moving; they helped popularize gangster films with *Little Caesar* (1930) and *Public Enemy* (1931), but did not glamorize the gunman. For their musicals they called upon the genius of Busby Berkeley (1895–1976), who staged astonishing dance routines using every kind of camera trick.

Westerns were made by all the studios but the greatest Western film director of them all was John Ford. He produced and directed his own films and released them through Twentieth Century-Fox. Because of this freedom from studio interference, all Ford's films are stamped with his individuality. In 1939 he directed *Stagecoach*, one of his acknowledged master-

ABOVE Edward G. Robinson and Humphrey Bogart starring in the 1936 film *Bullets or Ballots*.

pieces, following this with *The Grapes of Wrath* (1940), a powerful study of poverty and exploitation in California.

The 1930s was a time when the traditional attitudes of the sexes toward each other were changing. The studios detected these alterations and disseminated them widely, notably in the screwball comedies of Frank Capra, the Sicilian-born director whose films virtually kept Columbia Pictures afloat in the early 1930s. The influence a Hollywood film exerted over the behavior of audiences is illustrated by Capra's *It Happened One Night* (1934). When in it Clark Gable revealed that he did not wear an undershirt, the manufacturers reported a disastrous fall in the sales of these garments.

The 1930s ended with a film that revolutionized film-making techniques: *Citizen Kane* (1941) by Orson Welles (born 1915). This daring

ABOVE Henry Fonda (left) in *The Grapes of Wrath*.
BELOW Joseph Cotten and Orson Welles in *Citizen Kane*.

story of a newspaper tycoon did poor business when first released by RKO, but since then not a week passes but some theater somewhere in the world shows it. Welles and his cameraman Gregg Toland wanted to break away from conventional screen photography and used a wide-angle lens that made the camera's view virtually the same as the range of human vision. As a result, it was necessary to give the sets ceilings and to light them and equip them for sound differently. Toland also used deep-focus photography that made it possible for foreground, middle ground, and background all to be in sharp focus together. Brilliant use was made of sound in linking and overlapping scenes, and, altogether, astounding technical advances were achieved. When asked how he managed them, Welles replied, "Simply by not knowing they were impossible." For one shot the camera pans down a colossal statue to a figure sitting by the base. In fact the statue is a small model, but the shift from small-scale model to human-scale base cannot be detected. *Citizen Kane*, made when Welles was only 25 years old, remains one of the screen's greatest achievements.

British Film

Alfred Hitchcock directed his first film in 1925 and had just completed his tenth, *Blackmail* (1930), when the arrival of sound films from the United States threatened to make this film obsolete before its premiere. Hitchcock thereupon reshot the film with sound, making it one of the first British talking pictures. Throughout the 1930s his thrillers showed an increasing mastery of cinematic suspense. *The Man Who Knew Too Much* (1934) was followed by *The Thirty-Nine Steps* (1935) and *Secret Agent* (1936). In 1938 came the consistently popular *The Lady Vanishes*, but after one more film Hitchcock left for Hollywood. A slightly younger generation of directors then came to prominence.

At the beginning of World War II all the theaters were closed for fear of air raids, but the

ABOVE Alfred Hitchcock in 1972. One of his hallmarks is the cameo appearance he makes in almost all of his films.

ABOVE RIGHT Orson Welles as Harry Lime in Carol Reed's *The Third Man*, a character who seems a Christ parody in a melancholy thriller involving child murder.

BELOW the height of stylish filming – the Ealing comedy *Kind Hearts and Coronets*, starring Alec Guinness (center, as young Ascoyne D'Ascoyne).

value of films as propaganda was soon officially recognized. British films had already developed a strong documentary tradition, and this was applied to the making of patriotic and other morale-boosting feature pictures. Patriotic films seldom look so impressive after the crisis that gave rise to them has passed, but the British films of World War II seem to have lasted well. This is because the documentary experience enabled directors to place stories in a convincingly realistic environment and to draw consistently believable performances from the actors.

In *One of Our Aircraft is Missing* (1942), Michael Powell (1905–78) followed the hazardous adventures of the crew of a Royal Air Force plane shot down over occupied Holland. *The Way Ahead* (1944), made by Carol Reed (1906–76), showed a group of independent-minded civilians being molded into accepting orders. One film, Powell's *Life and Death of Colonel Blimp* (1943), even ventured to criticize outmoded attitudes in the British War Office – and, despite Winston Churchill's wrath, got away with it.

After the war Powell's fondness for the fantastic and metaphysical elements in film inspired his *A Matter of Life and Death* (1946), in which an airman (David Niven) is suspended at the point of death. One of the notable special effects in this film was the vast moving stairway, seemingly as long as infinity, that linked earth and heaven.

In postwar Britain, escapist costume films answered the changed mood of film audiences and the documentary manner suffered a sudden eclipse. But distinguished films about the postwar world were still made: Carol Reed's *The*

Third Man (1949), with a screenplay by the novelist Graham Greene, made brilliant use of the buildings of war-shattered Vienna to frame a story of moral degradation.

Comedies from Ealing Studios presented a whimsical view of the eccentric English at home. Robert Hamer (1911–63) used the popular actor Alec Guinness for his stylish *Kind Hearts and Coronets* (1949), in which Guinness played eight roles as different members of a monstrous ducal family murdered one by one by a remote heir to the dukedom.

Despite occasional fine achievements, British films generally declined after the peak years of the 1940s. Characterization turned to stereotyping, and freshness became complacency. Toward the end of the 1950s a resurgence seemed to begin with the arrival of a group of film makers whose origins were, like many new playwrights and novelists of the time, provincial and prole-

BELOW RIGHT filming of *The Battle of Britain* in June 1968, with Kenneth More and Susannah York. Uncritical depictions of patriotic themes have become common fare.

BELOW David Hemmings in *The Charge of the Light Brigade* (1968), a lushly photographed dramatization of a famous incident that occurred during the Crimean War (1853–6), between Russia and Britain, France, and Ottoman Turkey.

tarian, or who were moved by strong sympathies with the working class. A group of young directors started filming teenagers in amusement parks and youth clubs and began making short documentaries of a far more personal style than formerly. The films of Karel Reisz (born 1926) and Lindsay Anderson (born 1923) turned away from the dispassionate approach of prewar documentary, and this commitment was carried over into the feature films they made in the early 1960s. The harsh mechanical laughter of Anderson's *O Dreamland* (1956) seemed to call for a genuine emotional response, and his feature *This Sporting Life* (1963), set in a northern English town mad about rugby football, showed the tragic consequences of the failure to feel.

In the 1960s American money poured into British studios and spy films, glossy thrillers, and zany comedies came spinning out. Canadian-born Richard Lester (born 1932) made the faintly

surrealistic Beatles film *Help!* and *The Knack* (both 1965), as well as the bitter comedy *How I Won the War* (1967) – at first sight a parody of comedy war films, that then caught its audience by surprise by showing death as painful. The dead soldiers, tinted an unearthly yellow, blue or red, continue to accompany the steadily depleted troops through later campaigns as though still participating in the war. But the bitter tone of this film did not win audiences. The brief fashion for reality had passed yet again. Back came costume films, adaptations of classic novels, and the glamour and glories of yesterday's wars and moral certainties.

Italy-Realism and Fantasy

Italian film makers led the field in epic films before World War I, but the Mussolini era produced few films of distinction. The most interesting of them was the string of 1930s romantic comedies that featured Vittorio de Sica (born 1923), a dashing young actor who later turned director. Four men altered this unexciting situation: the directors Luchino

BELOW father and son in de Sica's *Bicycle Thieves.* The man is caught trying to steal someone else's bicycle when he cannot find his own, and he must then suffer being chastised in front of the boy. Zavattini and de Sica presented the characters as innocents.

quarrels and separation. Although made in 1943 before the ideas of neorealism had fully evolved, the child's misery is frankly shown and becomes overwhelmingly painful at the end. The partnership of Zavattini and de Sica produced four more films including their masterpiece, *Bicycle Thieves* (1948). In it a poor workman whose bicycle has been stolen spends a despairing Sunday with his small son searching for it. None of the actors was professional but de Sica drew from them performances that make them symbols of humanity.

The first neorealist film to enjoy international success was Rossellini's *Roma, citta aperta* (*Rome, Open City*), begun in 1944 before the Germans had left the city. The authenticity of the street scenes made the shooting of the housewife and the execution of the priest seem a record of actual events. In 1946 Rossellini made *Paisà*, a second neorealist film showing various aspects of life in postwar Italy, before abandoning the

Visconti (born 1906), Roberto Rossellini (born 1906), and de Sica, and a scriptwriter, Cesare Zavattini. Zavattini argued against the tyranny of the story – which he said was "simply a technique of superimposing dead formulas over living social facts" – and coined the descriptive term *neorealism*. Films were made without professional actors, without plots, and without a happy ending. Insofar as the neorealist films possessed a common impulse, it was to reveal the innate dignity of human beings.

De Sica's first major film, *I bambini ci guardana* (*The Children Are Watching Us*), chronicled the effect on a four-year-old boy of his parents'

ABOVE RIGHT Jeanne Moreau and Marcello Mastroianni in Michelangelo Antonioni's *La Notte*, made ten years after he directed his first feature. The central character is a writer who feels alienated from his rich wife and much of the life around him.

style. De Sica also found it impossible to obtain financial backing after two more films, and turned to a different style. The mood had passed. Neorealism gave way to glamour and stars, and not until Ermanno Olmi (born 1931) made a tender social comedy out of the experiences of a youth in his first job – *Il Posto* (1961) – did the movement find a worthy heir.

Visconti, having worked as an assistant to the French director Jean Renoir in the 1930s, regarded himself simply as a realist. He developed Renoir's fondness for composing a scene in depth, making long tracking and panning shots in preference to repeated cutting and montage.

LEFT Dirk Bogarde (back to the camera) and Björn Andresen in Visconti's adaptation of Thomas Mann's short novel *Death in Venice*, an atmospheric tale of a German composer who travels to Venice, becomes obsessed with a beautiful young boy, and dies there in a typhoid epidemic.

La terra trema (*The Earth Trembles*, 1948) was his first major work in this style. Set in Sicily, it showed the struggle of a fishing community to earn a livelihood from the sea. Later films – *Rocco and his Brothers* (1960), *The Leopard* (1963), and *Death in Venice* (1971) – became richer, more lavishly decorated and sometimes self-indulgent; but Visconti never lost the capacity to create convincing sequences.

Federico Fellini (born 1920) has also been called self-indulgent by critics who dislike the autobiographical tone of films such as *8½* (1963),

which presents the problems, memories, and sexual fantasies of a film director. Enormously touching, his film of traveling circus people, *La Strada* (1954), brought him his first international success. His 1959 film *La Dolce Vita* was the first of many large-scale films commenting on the abuses of contemporary society. Even in *Satyricon* (1969), when the scene is laid in ancient Rome, Fellini is thinking of the modern world.

Michelangelo Antonioni (born 1912) met jeers from the society audiences when his *L'Avventura* was shown at the Cannes Film Festival in 1960. The film did not follow the familiar rules for shooting a scene. On the volcanic island where the search for a missing girl takes place, the camera lingered far longer than was usual on the figures moving through the desolate landscape. The motives of the characters were ambiguous and puzzling – a visit to a newly built but deserted village seemed to "cause" the bewildered central characters to make love. The judgment of the Cannes audience was soon reversed and the film became recognized as a masterpiece of the screen in which the camera was being used as never before to show people's alienation from their society. The composition in depth of *L'Avventura* – as in *La Notte* (1960) and his subsequent films – serves more to separate his characters than to relate them to each other. Antonioni's films are subtle and allusive, and the states of mind of his characters are as troubled and complex as those of people in real life.

RIGHT the exotic opulence of Fellini's *Satyricon*. He creates a world of unbelievable decadence in this exploration of human psychology before the advent of Christian morality. Fellini uses flamboyant, often bizarre images to follow the wanderings of a group of aimless young men in his own conception of ancient Rome.

Luis
Buñuel

born 1900

As the film begins we see a man in his shirtsleeves sharpening a razor on a strap. Presumably he is going to shave. He steps out onto his balcony and gazes thoughtfully at the moon. There are streaks of cloud in the sky, one of which is approaching the moon, but before it actually passes across the face of the moon the scene has changed. We are looking at a young woman's face. She appears relaxed, but a hand holds her left eye open. A man in his shirtsleeves (perhaps the same man, although he now wears a bow tie) brings the blade of the razor up to it. The scene abruptly changes again: the narrow cloud passes across the moon. Immediately afterward the razor slices open the eye.

This is the unexpected opening scene of Luis Buñuel's first film, obscurely titled *Un Chien Andalou* (*An Andalusian Dog*), conceived in 1928 by him and his fellow Spaniard, the surrealist artist Salvador Dali (born 1904). The image of the sliced eye is repulsive, shocking. It is one of the screen's most disagreeable moments, and it is comforting to learn that Buñuel himself was physically sick after cutting the eye (of a dead animal). It is an assault on the audience, jerking us out of any expectations we might have of the film. It breaks all rules of conduct. After seeing

ABOVE the famous opening scene of *Un Chien Andalou*, one of the most memorable shots on film.

ABOVE RIGHT a typically bizarre scene from *The Discreet Charm of the Bourgeoisie*, a wildly funny examination of the upper middle class under the detached eye of Buñuel.

it we are, in a sense, ready for anything.

Buñuel was born in 1900 in Aragon. After studying to be a scientist, he arrived in Paris in the mid-1920s. There, in surrealism, he found the perfect means of expression for his passionate antagonism toward Christianity, patriotism, bourgeois conventions, and sexual restraints. The story that periodically surfaces in his first film between the images of crawling ants, dead donkeys on grand pianos, and the like, is of guilty inhibitions that prevent the gratification of sexual desire. His second film, *L'Age d'Or* (1930), identifies a character physically resembling Christ with one of the lechers from a Marquis de Sade novel. (This film provoked riots and bomb throwing in Paris, and all but one of the negatives was burned by the police.) In *Las Hurdes* (1932), a film of almost documentary detachment, a telling incident symbolizes the plight of the peasants in this barren corner of northern Spain: they are often bitten by vipers whose bite, though not fatal, becomes so when they rub what they assume to be a healing herb on the wound.

After *Las Hurdes* Buñuel went to Hollywood where, instead of making films, he dubbed other people's films into Spanish. Fifteen years passed before he directed another film of his own, in Mexico, and another three before he made *Los Olvidados* (1950). This uncompromising film of the brutish life of delinquent boys restored him to international attention. Throughout the 1950s he worked at a fast pace, making 15 films before *Viridiana* (1961) took him back to Europe.

Since then he has made a new film every couple of years.

All Buñuel's films reveal his abiding personal concerns and his opposition to hypocrisy in all its forms. The extreme surrealism of his early films has gone, but he still makes use of its methods of exposing and penetrating reality. The daily life of the unprincipled businessman and his entourage in *The Discreet Charm of the Bourgeoisie* (1975) is observed with an eye for the comedy of the characters' various predicaments – but at intervals an entirely different sequence is introduced, showing them walking along an otherwise empty road in anxious haste. We are left to make our own connection between this perhaps pointless urgency and the events in the surrounding story.

In *That Obscure Object of Desire* (1977) the young servant who sexually teases the older man is played by *two* actresses, one of whom may begin a scene and the other end it. The point of this obscuring of the desired object is that once the man becomes obsessed with the girl he does not really see her at all.

Buñuel's view of mankind is essentially pessimistic. Where ideals exist they are intensely difficult to sustain – though perhaps not entirely impossible. The hero of *Nazarin* (1958) is observed with considerable sympathy as he struggles to live a Christlike life in an intolerant world. The novice nun Viridiana of the film of that name faces the same predicament. Men are lechers and beggars are as selfish as the rich. What makes the situation even more distressing

is that Viridiana's goodness and Nazarin's charity compound the corruption.

Buñuel's technical mastery enables him to present this view of the world in all its harshness, its comedy, and its ambiguity. This technique does not draw attention to itself. "I detest unusual angles," he once said. "I sometimes work out a marvelously clever shot with my cameraman. Everything is all beautifully prepared, and we just burst out laughing and scrap the whole thing to shoot quite straightforwardly with no camera effects." The intensity of his vision is such that it requires no help from technical devices to disturb and perhaps alter our familiar way of regarding the world. As Buñuel has said, "The cinema might have been invented to express the life of the subconscious."

The
French
"New Wave"

At the 1959 Cannes Film Festival, French films won the three main prizes. All were by directors who had been involved in various aspects of film making for some years but whose names were virtually unknown. Within a few months the first films of a number of other French directors had premieres, and journalist critics dubbed this revival of the French cinema *la nouvelle vague* – the "new wave."

Until this revitalization, the only new talents to create and sustain a reputation after World War II had been Jacques Tati (born 1908) and Robert Bresson (born 1907). Tati, a superb comedian and mime, created the character of a frenziedly active postman for his first film, *Jour de Fête* (1949). Six years later came the character for which he is best known, the gently eccentric uncle figure of Monsieur Hulot, at sea in a world of mechanical gadgetry that he always breaks.

Bresson is an uncompromising artist who has never made concessions to popular taste. His films are austere, his unsmiling characters caught up in private obsessions. Both the lonely young priest of his earlier film, *La Journal d'un*

RIGHT shot from the nearly speechless but nonetheless visually lyrical French film *The Red Balloon* (1956), directed by Albert Lamorisse. His simple parable is told through the skillful use of color and imaginative technique.

BELOW deliberate use of light and dark adds to the suspense of Claude Chabrol's *Les Biches* (1967), an ingenious psychological thriller like most of his latest films. He is interested in unconventional morality and explores the paradoxes inherent in the behavior of his (mostly bourgeois) protagonists.

curé de campagne (*Diary of a Country Priest*, 1950), and the student of his recent *Le Diable, probablement* (*The Devil, Probably*, 1977) are martyrs to their particular faiths. In these intense studies of character, Bresson rejects all shots that are merely decorative. He coaches his actors in every intonation and every gesture, and then explores their features with the unsparing eye of his camera.

The directors who came to the fore during the remarkable outburst of talent in 1959-60 were young men, many still in their 20s. Claude Chabrol (born 1930) and François Truffaut (born 1932) had previously been film critics for the influential magazine *Cahiers du Cinema*. Chabrol's *Le Beau Serge* (1958) was a seemingly simple film about the consequences of a young man returning to his native village and trying to help a childhood friend. Made with a cast of unknowns, it brought Chabrol the financial backing to make *Les Cousins* (1959).

From the time he won the best director's prize at Cannes for *Les Quatre Cents coups* (*The 400 Blows*, 1959), Truffaut has been the most popular internationally among his generation of French directors. The 12-year-old hero of that first film, an innocent trapped by the double standards of adult society, was observed with a tenderness that was never sentimental. *Jules et Jim* (1961) was a more complex film, shot with a mastery of different camera movements and a superb skill in the art of telling a story. As in *Les Quatre Cents coups*, the film ends with an assertion of the life force. This humanistic quality, rare in the contemporary cinema, is evident throughout Truffaut's career. In his recent film, *La Chambre verte* (*The Green Room*, 1978), a young boy who has difficulty speaking and can scarcely be understood nonetheless counters the bitter selfishness of the adult world.

Very different are the films of Jean-Luc Godard (born 1930), both in tone and style. *A Bout de souffle* (1959) presented an amoral and

treacherous world of petty crime. In succeeding films the same elements of prostitution, armed robbery, and the death of the hero or heroine in a final shoot-out recurred. These are the standard elements of an American "B" picture, but Godard used them in a revolutionary way in respect of the art of film making: he improvised dialogue, shot crowded street scenes with an unseen camera, and waited through an unexciting scene with a static camera for a significant gesture. He also broke the story line, interpolated documentary scenes and political discussion, and used technical tricks such as cutting off the sound track for one minute in the café scene in *Bande à part* (1964). Godard's films have become progressively more difficult to follow. Once asked whether he accepted the need to have a beginning, middle, and end, he replied: "Certainly. But not necessarily in that order."

Not all the reputations made in the early 1960s have survived, but Jacques Rivette (born 1928),

ABOVE François Truffaut (right) and Jean-Pierre Leaud in *Day for Night* (1973), a comic examination of film making itself.

LEFT the inevitable shoot-out (but without a gun), from the Godard film *Bande à part* (*The Outsiders*).

BELOW a piece of the "collage of fantasy" created by Alain Resnais in *Last Year at Marienbad*, a plotless film about the relationships of an undefined set of people in a German castle.

Louis Malle (born 1932), and Alain Resnais (born 1922) have continued to make interesting films. After the brilliant debut of *Hiroshima mon amour* (1959), Resnais intensified his poetic reflections on memory and imagination in the fascinating and stylish *L'Année dernière à Marienbad* (*Last Year at Marienbad*, 1961). His film of 1977, *Providence*, was a study of the confusions of identity that occur in the deeper levels of consciousness. Though the heady days of 1960, when "anybody could make a film," are gone, most of the film makers of the French New Wave are still producing imaginative work.

Ingmar Bergman

born 1918

The films of Ingmar Bergman are at once intensely Swedish and intensely personal. Exceptionally self-aware characters articulate typically Swedish anxieties. Bergman may feel with special acuteness the uncertainty of people's relation to themselves, to other people, and to God, but he has explored these personal dilemmas against the background of his native country, so that many see the world of his films as Sweden itself.

Bergman was the son of a pastor and his childhood was strict. Born in Uppsala, he left home at least once in his youth. Later he studied at Stockholm University, at the same time becoming involved in theater production. In 1944 he wrote the screenplay for *Frenzy*, made by the veteran Swedish director Alf Sjöberg (born 1903). *Frenzy* was a grim tragedy, and already some elements of many a later Bergman film were present – the difficulties lying in the path of young love and the presence in the world of powerful evil.

On the strength of this highly promising beginning, Bergman was able to direct a film himself. Since then he has completed nearly 40 others as well as screenplays for other directors, and he has also directed productions of plays and operas. His first film from a screenplay of his own was *Prison* (1949), the story of a film director wondering whether to make a film in which the devil rules the world. The conclusion of the film

ABOVE the anguish of Bergman's characters, here in a scene from *The Silence*, is usually related to their confusion over their own sanity or madness and how to achieve true human contact.

was that the only alternatives open to the human race are suicide or religion.

In 1952 Bergman was appointed director of Malmö Theater and began to gather around him a repertory company of actors. The leading members were Bibi Andersson, Liv Ullman, Ingrid Thulin, Max von Sydow, and Gunnar Bjornstrand, and their presence in one film after another has emphasized and helped to create the consistent tone of Bergman's work.

His films of the early 1950s were concerned with various problems to do with marriage, but in 1956 he changed pace, setting a story in the plague-stricken countryside of 14th-century Sweden. The result was his first masterpiece: *The Seventh Seal*. In this powerful and magnifi-

cently acted film a knight and a squire return from the Crusades to find the black-cowled figure of Death awaiting them. To delay his own demise, the knight challenges Death to a game of chess and, while the game is in progress, he and his squire travel across the countryside. They meet a procession of hysterical flagellants, villagers burning a suspected witch, and a group of wandering actors. The knight cannot defeat Death, however, and the last scene shows a group of silhouetted figures dancing solemnly hand-in-hand against the skyline.

The Seventh Seal created a sensation in the

film world and, when *Wild Strawberries* followed in a few months, a kind of Bergman cult resulted. His previous films were shown internationally and the details of the "Bergman world" were closely examined for significant clues. *Wild Strawberries* told the story of an elderly professor whose capacity for love has atrophied and who, on revisiting the places of his youth, dreams strange dreams. Superbly photographed, the film was charged with strange images – some puzzling but all with the power to reverberate in the mind. It ends on a note of optimism, of a dawning self-awareness that may be followed by a change for the better.

Not all the films that followed were successful. Some can be criticized for morbidity; of others

RIGHT Ingmar Bergman, who has built an international reputation on his steady exploration of certain extremely powerful themes and symbols.

ABOVE close-ups emphasize the psychological nature of Bergman's interest in his characters. Liv Ullmann and Erland Josephson star as one of the couples in *Scenes from a Marriage*.

it has been said that the argument is unworthy of the consistently high level of direction and camera work. In the 1960s he created *Winter Light* (1961), *Through a Glass Darkly* (1962), and *The Silence* (1963), a trilogy of bleak films that were concerned with the great difficulty of meaningful human contact. Set on a barren island that was becoming Bergman's landscape more and more often, the tormented characters of the films were unable to answer one another's needs – either physical or spiritual.

The need for love is the theme of Bergman's subsequent films. Often this love is rejected, but occasionally the ending is hopeful. The couple in *Scenes from a Marriage* (1973) achieve a final reconciliation; at the end of *Face to Face* (1975) the doctor sees her grandmother tenderly looking after her grandfather and understands the power of love. Aside from his themes, Bergman holds his place as a great film maker by his mastery of visual and aural images: the swirling movement of milk in a dish, the single cry of a gull, the figures on a distant promontory waving in greeting or farewell. Every viewer carries away his or her own store of images that cannot easily be forgotten.

Japanese Film

The Japanese were among the earliest people to make films – they began in 1897, little more than a year after the Lumière brothers first demonstrated their new discovery. They were experimenting with sound and color film at the time of World War I, and the first of Japan's great film makers, Kenzi Mizoguchi (1898-1956), began his career in 1923. However, Japanese films remained almost, if not totally, unknown abroad until 1951 when *Rashomon* won the Grand Prix at the Venice Film Festival. Since then many of the films by directors of Mizoguchi's generation, and those of his younger successors, have been seen in the West, but the process of assimilating the Japanese contribution to film will take some time. Mizoguchi alone directed nearly 100 feature films, and such an output is not exceptional.

The 1930s were the first golden age of the Japanese film; after *Rashomon* began a second golden age in the 1950s. Today, television and the popularity of Western (chiefly American) films have drastically cut the opportunities open to the contemporary Japanese film maker, but works of quality – though fewer than before – are still produced.

OPPOSITE scene from *Rashomon*. The inner story of the rape in the forest is enclosed within another concerning three 18th-century travelers sheltering from a thunderstorm under the ruined Rasho gate in Kyoto.

LEFT scene from one of the last films made by the great Japanese director Kenzi Mizoguchi, *Shin Heike Monogatari* (1955). It follows the desperate struggle of one samurai warrior against corrupt rulers.

Mizoguchi's dictum was "one scene – one shot," and his films are characterized by long takes and an exceptionally mobile camera. These long tracking shots give a lyrical flow to the scenes and build up a powerful emotional tension, like a long slow breath. Near the end of his prize-winning film *Ugetsu Monogatari* (1953), for example, a potter returns to his village after a love affair with a ghostly princess and walks through his old house calling for the wife we know to be dead. The camera passes the cold hearth as he goes out through the back door; it returns along the interior wall as we hear him calling from the other side. When the hearth comes into view again it is burning brightly and his wife, now a ghost, is cooking supper there. The shock of seeing these two different scenes of the hearth within one continuous shot is very much greater than it would have been if achieved by means of cut and montage.

The camera work of Yasujiro Ozu (1903-63) is entirely different. In his films, deeply emotional but resigned, of the sorrows of family life, his camera seldom moves. Throughout *An Autumn Afternoon* (1962), in which a widower sorrowfully decides that his daughter must marry, the camera never moves at all, and in scene after scene we see the characters at a fixed angle from about three feet above the floor.

Akira Kurosawa (born 1910) is sometimes said to be the most Western of Japanese directors. The fast pace of his films and his ready use

BELOW one of the best known of all Japanese films to Western audiences – Kurosawa's *Seven Samurai* (1954), which was remade in the West as *The Magnificent Seven* in 1961.

Ikiru (*Living*, 1952). This film is an intensely moving account of the last five months of the life of a bureaucrat who learns he is dying of cancer and is determined to do something to justify his existence.

A similar humanistic spirit is present in many of the films of the prolific Kon Ichikawa (born 1915), who has made 60 films in 30 years. Often his films have an ironic touch even when the story is set in the aftermath of war, as is *The Burmese Harp* (1956). His revolutionary *Tokyo Olympiad* (1965) concentrated more on the human than the athletic aspect of the games.

The Japanese have a rich store of legends and their full share of the tensions of modern society. In drawing upon both to explore the nature of human relationships, Japanese directors are in the company of all the world's great film makers.

of montage, camera movements, and swift cutting create the sort of film with which Western audiences are already familiar. Even the Western tradition of the gunfight has its parallel in his expertly filmed period sword fights.

Kurosawa's *Rashomon* tells the tale of an aristocrat and his wife who are waylaid by a bandit in a forest. The man is killed and the bandit and the wife make love. These few facts are the only certain ones, because Kurosawa shows four different versions of what occurred – told by the bandit, the wife, the ghost of the dead man, and a woodcutter who happens to be passing. Motives and facts differ in each account. This novel method of storytelling, together with memorable, almost violent camera work in some of the forest scenes, gave the film its remarkable quality. *Rashomon* ended on a humanistic note, which is also the case with *Seven Samurai* and

ABOVE Eiko Matsuda and Tatsuya Fuji in *Ai No Corrida* (*In the Realm of the Senses*, 1976), directed by Nagisa Oshima. The film painstakingly chronicles the mounting obsession of a couple's love affair, which culminates in the woman's ritual killing and dismemberment of her lover. Oshima's approach has been described as "too direct to be prurient." He is one of Japan's "new generation" of film makers.

LEFT gold medalist Masamitsu Ichiguchi of Japan wrestles silver medalist Uladlen Trostiansky from the Soviet Union in a scene from *Tokyo Olympiad*, the official film of the 1964 Olympic Games.

Satyajit Ray

born 1921

Indian films have traditionally been escapist, slapdash, and exceedingly long. They were made, in great numbers, for the home market and were rightly considered to be of no interest to audiences abroad. This situation was changed by one director – Satyajit Ray. For five years he struggled to make an honest and clear film based on a much-loved Bengali novel, *Pather Panchali*. Like Kurosawa's *Rashomon* it won a film festival prize (at Cannes in 1956) and revealed the arrival of a major new film maker.

Born in Calcutta to an artistic but impoverished Brahmin family, Ray became a commercial artist in the 1940s and tried without success to interest film producers in a more true-to-life kind of cinema. His employers sent him to Europe where he saw as many films as he could – 99 during his four months in London – and on the boat returning to India he began work on the script of *Pather Panchali*. Shortage of money was an acute problem throughout the making of the film – at one stage he was reduced to pawning his wife's bracelets – but the quality of the rushes eventually led to a government grant. The money came from the West Bengal Department for Road Improvement – because *Pather Panchali* means "Song of the Little Road."

In his film Ray retained the rambling quality

ABOVE *Pather Panchali*, the first film in the Apu trilogy, which surprised the jury at the 1956 Cannes Film Festival – some of them missed its screening, since no one had anticipated a masterpiece from Bengal.

LEFT Satyajit Ray at home in Calcutta. Not only does he write and direct his films, but he often provides the musical score as well.

of the original novel. As he explained, "Life in a poor Bengali village does ramble." The central character of the film and of its two sequels is the boy Apu, born at the start of the first film, who moves with his family to Benares in the second (*Aparajito*, or *The Unvanquished*, 1956) and marries and produces a son of his own in *Apur Sansar* (*The World of Apu*, 1959). The family, a central image throughout Ray's work, is viewed with affection but without sentimentality. The individual members may have faults – Apu's father is a dreamer who fails to provide for his wife and children, his ancient aunt Indir steals fruit, and Apu himself grows up to be a neglectful father – but the ties of family give the essential structure to their lives. This structure is built up before our eyes by means of a multitude of precisely observed details. These are authentic details of the setting – the houses and landscape through which the characters move – but also the utterly convincing gestures, glances, and words exchanged by the characters. One of the earliest Indian reviews of the film recognized this and pointed out, "The secret of his power lies in the facility with which he penetrates beneath the skin of his characters and fixes what is in their mind and in their heart – in the look of an eye, the trembling of the fingers, the shadows that descend on the face."

A moving instance of Ray's use of poetic detail occurs after Apu's sister has died and his mother remains for days frozen in grief. The absent

father returns, not realizing his daughter has died, and when he speaks to his wife she gives a sudden cry of agony. But we do not hear her voice: instead we hear the loud, high notes of a stringed instrument. While this substitution inevitably appears less impressive when described, its emotional power in the context of the film is overwhelming.

Before completing the last film of the Apu trilogy, Ray showed that his sympathies were not limited to poor villagers but extended to the minor nobility. In *Jalsaghar* (*The Music Room*, 1958), the forward movement of discovery and growth of the Apu films is replaced by a mood of sad decline. A nobleman, the last of his line after his wife and son are drowned, spends all of his fortune surrounding himself with the finest musicians and dancers of his time. This is in part a protest against the modern world of commerce and greed that is slowly overtaking him; the tension between old and new is another dominant motif in Ray's films. Some of the symbolic incidents in *Jalsaghar* may seem contrived – a fly drowning in a wine glass, a spider crawling over the nobleman's portrait – but the atmosphere of melancholy though slightly absurd decay is beautifully presented.

Ray's range of subjects widened to include a young girl persuaded that she is possessed by a goddess in *Devi* (1960), with tragic results; and *Kanchenjunga* (1962), in which a daughter summons from within herself the resolution to defy

her father's plans for her marriage. Ray has also gone back in time to the mid-19th century to show the ambiguities of British India in *The Chess Players* (1977). Not all of his 20 or more films have met with the approval of his countrymen, anxious to present the "progressive" face of India to the world, but his achievements have inspired other film makers. The Indian film as an art is scarcely a quarter of a century old, and it may well be that it is only just beginning.

Modern
American
Films

ABOVE publicity poster for *Jaws* (1975), one of the industry's biggest moneymakers of all time. Its director, Steven Spielberg, gained financial independence.

Hollywood studios show an outstanding capacity for survival. The threat of television was answered by the development of Cinemascope and the wide screen. Soaring costs led to the concentration of effort on guaranteed money-spinners, so that now each season a film appears – love story, musical, thriller or science fiction – that breaks all previous box-office records. But the studios of today have forfeited their previous life-or-death control over directors and actors, far more of whom now run their own production companies to finance their own films. Successful directors now have greater control over their material, and sometimes the films are written by the directors themselves.

First, however, the director must achieve that success – and the early years of Robert Altman illustrate how laborious a process this can be. He was born in Kansas City in 1924, served in World War II, and returned to his hometown to

BELOW Elliott Gould and George Segal in Robert Altman's *California Split*, a gambling film in which the dialogue is recorded realistically – which means that several people speak at the same time.

make industrial films. In the 1950s he wrote, produced, and directed a film called *The Delinquents* (1955) and codirected another, *The James Dean Story* (1957). Ten years of television followed before he made a science fiction film for Warner Brothers, who recut it. Two years later he directed a film in Canada and in the same year, 1969, he was the fourteenth director – some reports say the eighteenth – to be sent the script of *MASH*.

Altman's direction of this Korean War black comedy gave little indication of his future style except for the famous overlapping dialogue, but the success of the film gave him the financial independence to develop his own preoccupations in a series of fascinating and memorable works. Remarkable features are the eccentric characters who, from *McCabe and Mrs Miller* (1971) onward, populate his films; the emphasis on the element of chance in personal relationships that runs through his gambling film *California Split* (1974); the social implications of *Nashville* (1975), pointing out the hollowness of the American dream; and the uproarious and simultaneously unnerving comedy, represented at its most bizarre in *A Wedding* (1978). Altman has gathered a "school" of actors and actresses who reappear in many of his films, are encouraged to alter their dialogue, and sometimes even write it themselves. Technically adroit as he is, bobbing his mobile camera among a crowd to pick up fragments of conversation – and often counterpointing what we see with scraps of background sound or an isolated word from a song – his films require the audience to work for their laughter. The relationships and even the identities of his characters must be sorted out and recognized while the action swirls on.

Another significant figure on the American scene is Terrence Malick, born in Texas in 1945 and once a student of philosophy, whose two films – *Badlands* (1973) and *Days of Heaven* (1979) – disclose an individual narrative style and a remarkable gift for distancing his audience from the peculiar – and, finally, unknowable – personalities of his young characters. In the earlier film, set in the 1950s, a dreamy teenager kills his sweetheart's father and takes her off on a motiveless killing spree through the flat landscape of the Dakotas. The girl's artless commentary on their life together gives a fairy tale quality to events neither she nor we can fully comprehend, and shows that our partial understanding sometimes differs from hers.

Similar ideas occur in his second film, in which the flat lands are in Texas and the time is 1916. Another child narrator comments on a flying circus, a plague of locusts, and a burning

was the title of the first major film of Martin Scorsese (born 1942). In that film, as in *Taxi Driver* (1976), he showed himself to be a master director of city tensions and those extreme obsessions that inevitably end in violence and self-destruction. His third success, *New York, New York* (1977), treated the musical in a manner often used by contemporary makers of film thrillers. The film – in this case the story of a cabaret singer and a saxophonist who struggle to reach the big time – is a new creation yet at the same time it pays homage to older films in the same vein.

Tributes of this kind are sometimes an indication that the director cannot create a work of his or her own. But the films of Altman, Malick, and Scorsese – and of such actor-directors as John Cassavetes (born 1929) and Woody Allen (born 1935) – show that American film makers still possess original imaginative power.

wheatfield and, as before, tells us something but not everything about the states of mind of the young lovers she observes. It is as though Malick wishes us to realize that the driving force of his characters can neither be located nor explained.

A theme almost as strong in the American tradition as the journey through wide open spaces is that of the struggle for survival in teeming city streets. *Mean Streets* (1973) – taken from a quotation from a Raymond Chandler thriller –

ABOVE Linda Manz, narrator of *Days of Heaven*, written and directed by Terrence Malick.

RIGHT life in Little Italy in New York City, from *Mean Streets* by Martin Scorsese.

BELOW Jane Fonda as the writer Lillian Hellman in *Julia* (1977), a semiautobiographical tale of political commitment, love, and friendship between two women.

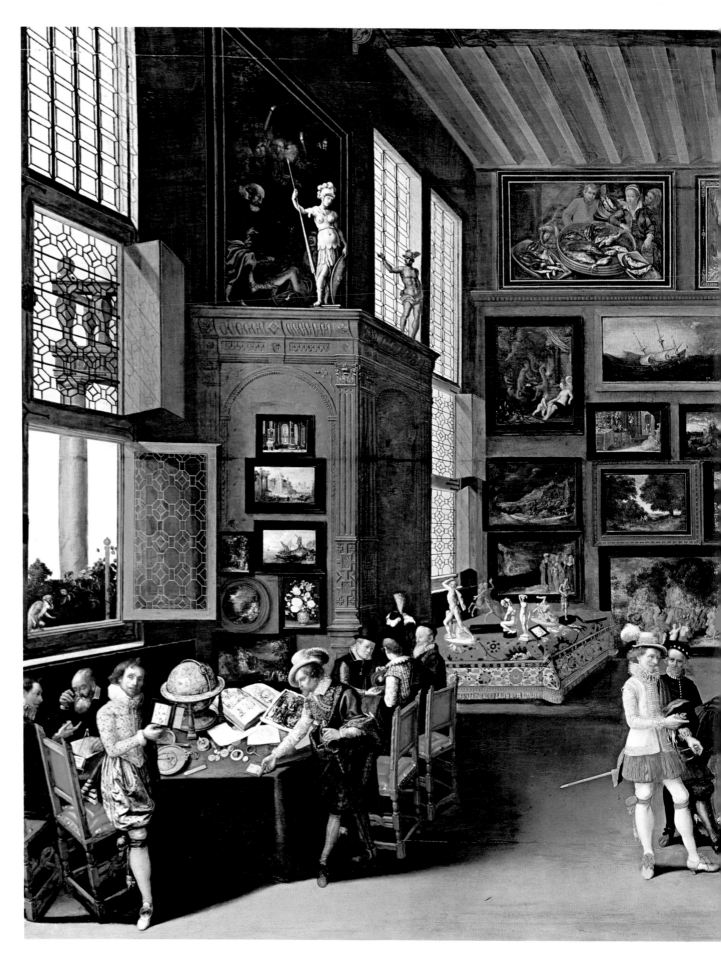

ENJOYING THE ARTS

A work of art should ideally be both immediately attractive, so as to capture our interest and involvement, and possess a deeper significance discoverable through this involvement. The full qualities of a good painting, play, film, sculpture or building do not reveal themselves at a passing glance or single viewing. We need time to consider what artists set out to achieve, how they succeed, and what makes their work different from that of others. The richly illustrated books of today have helped make art more accessible now than ever before. Specialized movie houses, film societies, and theatrical revivals provide the opportunity to see old films and plays. Paintings and much sculpture must still be kept in museums or art galleries, but a recent wide-ranging public reexamination of the function of museums has led to a revolution in display, bringing in its wake an increasing public understanding and hence enjoyment of all the arts.

OPPOSITE visiting a private collection, a detail from a painting by an anonymous artist of the Flemish school of the early 17th century. Increased affluence in Europe during this period led to a greater demand for paintings, which began to be regarded as status symbols.

Collecting the Past

Our word "museum" comes from the Greek *mouseion*, which originally meant a sanctuary for the Muses, nine goddesses who were associated with the arts and sciences. The first establishment to be called a museum was not one at all in the modern sense. It was built in 280 BC by Ptolemy Soter, a Greek-influenced ruler of Egypt, and was more along the lines of a university. Located in the heart of Alexandria, Ptolemy's museum contained, apart from a famous library, a whole complex of facilities for the use of students and scholars. Among them were a zoo, a garden of rare plants, and rooms for research into such sciences as anatomy and astronomy.

In the 2nd century BC a Greek writer described a building on the Acropolis in Athens containing a hall called the Pinakotheke, which had paintings on public display. Its name survives today in the famous art gallery in Munich, Germany – the Alte Pinakothek. The treasures of Greece were plundered by the conquering Romans, who were passionate collectors of foreign art. Many rich families added galleries to their villas and adorned them with statues. Marcus Agrippa, son-in-law and adviser of the emperor Augustus, lamented that too many Romans were housing their treasures in private and urged that pictures, statues, and valuable artifacts should be made accessible to all. This is the first recorded assertion of the value of an art collection as a cultural heritage and of the general public's right to enjoy it.

When Ptolemy's great academy at Alexandria was burned down in 640 by the Arabs, the term "museum" and the whole concept of public sharing of art died. The insecurity of feudal life meant that educational and intellectual activities were neglected to a great extent. The medieval church, however, became a sort of museum, providing a storehouse for works of art with religious associations.

The 15th century brought a revival of learning. In Italy, especially, the Renaissance flowered. Once again the wealthy began to collect objects of artistic or historical importance, but there was usually no order or plan for their display, nor were they accessible to the public. There were,

BELOW engraving of the original Alte Pinakothek in Munich, designed by Leo von Klenze in the 19th century. It was destroyed during World War II, and a reconstruction was opened in 1957. The museum specializes in European paintings from the Middle Ages through the late 18th century. Its collection is based on the accumulations of several early princes of Bavaria.

however, some exceptions. Cardinal Albert of Brandenburg, Martin Luther's antagonist, put on open display in the cathedral at Halle, Germany, a remarkable collection of religious relics in sumptuous cases, accompanied by a carefully printed and illustrated catalog.

In the 16th century rich aristocratic Italians revived the custom of building spacious private exhibition rooms. Long galleries became an essential part of their palaces. The best known of these is the top floor of the Uffizi Gallery in Florence, built between 1559 and 1564 to house the vast collections acquired by seven generations of the Medici family. After the last of the Medici died in 1737, Florence passed into the control of the Hapsburg-Lorraine family. The Grand Duke Leopold opened the galleries to the public, and the history of the Uffizi as a true museum and art gallery began.

Elsewhere in Europe there were still no museums as such. Those collections that existed, small and large, were private and served scholars in their studies or the rich as status symbols. The 17th-century British antiquary Elias Ashmole willed his large collection to Oxford University, where the Ashmolean Museum was built to house it. Another collector, Sir Hans Sloane, left 69,000 items to the British nation so that these objects, "tending many ways to the manifestation of the glory of God, the improvement of the arts and sciences, and benefit of mankind, may remain together." This became the nucleus of the British Museum, opened to the public in 1759. Those who wished to visit it had to apply in writing some days beforehand and were issued with tickets specifying a particular two-hour appointment. Not more than 15 persons were allowed to view the collection at one time.

The original Louvre in Paris was built as a fortress by Philip Augustus about 1190 when Paris became the royal residence. Greatly enlarged for Louis XIV, the building was turned into a public museum after the French Revolution. The Prado in Madrid and the Hermitage in Leningrad originally housed royal collections, as did many of the modern German museums. The Rijksmuseum, established in 1808 during Napoleon's occupation of Holland, was based on the collections of the royal house of Orange and paintings owned by the city of Amsterdam and the surviving guilds. In the 19th century museums rapidly multiplied and, besides being repositories for objects, became seats of learning that were made more accessible to the public.

· In the British Museum·

NORTH WEST EDIFICE NIMROUD.

Preserving the Past

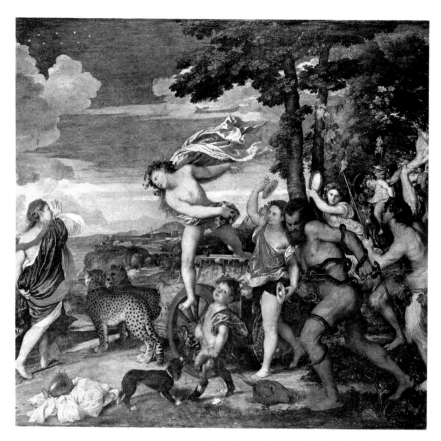

ABOVE Titian's *Bacchus and Ariadne* before it was cleaned by the restoration staff of the National Gallery, London.

The treasures that fill our museums and galleries are not always as safe as we imagine. Despite every effort to keep them well guarded, collections often come under attack from unsuspected sources. Besides light, moisture (or lack of it), and polluted air, these enemies include bacteria, insects, and people – and the human attacks may be the most destructive. Vandals cannot resist leaving behind a mark of their visit. At the Louvre in Paris, Ingres' nude *La Source* (1856) had to be covered with glass to stop visitors from scribbling all over it. Sometimes even greater damage is willfully inflicted. In 1914 Mary Richardson, a demonstrator for women's rights, visited London's National Gallery and slashed Velázquez' *Rokeby Venus* with a hatchet. In 1962 a maniac damaged 25 paintings worth about $2 million in the Uffizi Gallery, Florence. In 1978 Poussin's *Adoration of the Golden Calf* (about 1636) was attacked with a knife. In 1972 in St Peter's, Rome, a lunatic claiming he was Jesus Christ attacked Michelangelo's *Pietà* with a hammer, striking several blows and damaging it severely before he was stopped. It took nearly a year to repair the damage, using a marble paste.

The men and women who repair damage, fight decay, and protect against further troubles are the restorers. Sometimes they can do little more than despair over a terribly mutilated work of art – a rotten and discolored canvas or a worm-eaten wooden statue. More often than not, however, the restorer can use a growing armory of scientific aids to work near-miracles of restoration.

The most impressive achievements are those that involve the cleaning of old paintings. It is easy to see why. After restorers at the National Gallery in London had worked for two years cleaning Titian's *Bacchus and Ariadne*, the effect was electrifying. It was as though Titian had only just walked away from his completed canvas. The pigments had come back to life. The reds were suddenly red again, and the blues were clear and bright.

To talk of "cleaning" a painting, however, is somewhat misleading. What it really means is

RIGHT National Gallery restorers in London working on an early Rubens painting. Most oil paintings are a complex sandwich of different materials, beginning with a base or support such as wood or canvas. This is usually treated with a gluelike substance called *size* to make it nonabsorbent. A coat of white lead or similar substance known as *primer* is the basic ground on which the paint is applied.

removing from the top of the paint the layers of old varnish that have darkened and cracked over the years. It is rather like stripping off a single layer of skin without harming the one beneath. The job demands tremendous patience, skill, and experience.

Restorers need to have not only a knowledge of chemicals but also an understanding of the history of art in order to adapt their methods to the techniques and materials used by painters of different periods. The essential step is to choose a solvent that will completely remove the varnish without affecting the paint. Only a small area of the painting can be tackled at a time. A constant watch must be kept for the first signs of crumbling or dissolving paint. Then, when the cleaning is at last finished, a fresh coat of varnish is applied. The newest kinds, made with syn-

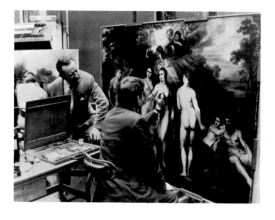

thetic resins, are far less likely to darken, yellow, "bloom" (mist over) or crack as the centuries pass than were the old natural resin varnishes. Furthermore, they can normally be removed with much milder solvents than are needed for the older varnishes.

In the very different realm of film archives, a special and urgent problem exists in that all films before 1951 were made on nitrate film – a volatile, highly inflammable substance that begins to decay chemically from the day it is manufactured. In advanced stages there is a total loss of image followed by degeneration into a powder rather like rust. The average life span of nitrate stock is 50 years. As one film writer recently asked, "Will you still be able to see *1984* in 2001?" One of the present tasks of film archivists is to duplicate the hundreds of millions of surviving feet of old film before it disappears.

The men and women who take care of our heritage of art works can never rest on their labors. In recent years the skills of preservation and restoration have made great strides. Yet there is still room for creative research to prepare for the problems that are almost certain to arise in the future.

ABOVE the cleaned painting. It was one of the 30 or so works that founded the National Gallery's collection.

RIGHT the head of Michelangelo's *Pietà* after it had been attacked with a hammer (right) and as it looks now, since being repaired (left). In addition to the problems of repair and restoration, marble sculptures may also require cleaning. This is quite difficult, as ordinary methods can drive stains farther into the material. Latest techniques favor the use of a poultice of sepiolite mixed with a cleaning agent, which "evaporates" stains.

Presenting the Past

Until very recently it may have seemed as if the prime objective of museums was simply to collect as many items as possible without regard for exhibition. Heavy, cumbersome cases often dwarfed the objects on display. Visitors could easily become confused and wander in aimless frustration among unimaginative arrays of clutter, unable to find anything or see the relationships between items.

On the whole, people who go to museums are looking for information, entertainment or a mixture of both. Whether an exhibit is a Greek terra cotta vase, a medieval carving or a Renaissance altarpiece, its value to visitors is partly determined by the way it is displayed. In present-day museum practice, the design of a new display is approached in much the same way that a script is visualized for television or film. The director maintains interest by punctuating a story with visual changes. Cuts, dissolves, and shots from different angles and distances give visual excitement to a film or program. A somewhat parallel treatment has been adopted

ABOVE visitors to the newly built (in 1975) Lehman wing of the Metropolitan Museum in New York. The Met's director, Thomas Hoving, called it an "oasis" in the otherwise austerely traditional museum, first opened on its present site in 1902.

in many museums. Good lettering and exciting graphic displays that both inform and whet the appetite for more can enhance imaginatively arranged exhibits providing a wide variety of viewing angles.

The British Museum in London, for example, has made dramatic use of light to display the unusual properties of a remarkably fine piece of

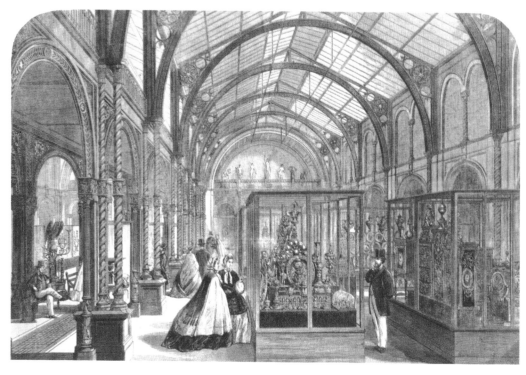

LEFT visiting the Victoria and Albert Museum (then known as the South Kensington Museum) in 1862, from the *Illustrated London News.*

everyday life of the public it serves.

In most types of museums, heavy showcases crowded with formally classified exhibits are giving way to more lively and exciting methods of display. Sculpture, for example, long housed in the often constricting atmosphere of galleries, is breaking out of its old environment into the more natural background of parks or gardens. At the Shaw Sculpture Park in St Louis, Missouri; at the Kröller-Müller Museum in Otterlo, in the Netherlands; and at Louisiana, located on the Danish coast between Copenhagen and Elsinore, sculptures can be seen in the open air against backgrounds of gardens, flowering shrubs, woodlands, sand dunes, and the sea.

Works of art cannot be fully appreciated without some knowledge of the social and artistic context in which the artist worked. To increase public understanding of the paintings in its collection, London's National Gallery inaugurated in 1974 a series of exhibitions devoted to single works. Holbein's double portrait *The Ambassadors* (1533) was the first of these "Paintings in Focus." Several Holbein paintings and photographs of others were borrowed from various British and continental museums to indicate how he tackled the painting's theme – the brevity of life – in other works. Examples of the astronomical and musical instruments shown in this painting were also displayed, and clear texts drew attention to significant details (a broken lute string, a skull-shaped hatpin, and so forth). The exhibition was warmly received, and "Paintings in Focus" is now a regular feature.

late Roman glass, dating from the 4th or 5th century AD and known as the "Lycurgus Cup." When it is lit from the front, the opaque green color of the glass makes the figures and exquisite decoration stand out in bold relief. If an alternative light source is transmitted from inside the cup, a hitherto unsuspected quality in the glass is brought out. The opaque green color changes to a rich, translucent ruby and amethyst. Displays of this kind can be informative and attractive.

One museum that found a revolutionary way of relating to its public is the Louvre, in Paris. Having decided that the best way to overcome apathy was to confront people with art where they could not avoid seeing it, the Louvre authorities staged an exhibition in the Louvre Metro stop, which was then being refurbished. Works of art, 24 in all, were carefully reproduced and, along with photographs of Egyptian and Greek statues, were placed in display cases as part of the gleaming decor of the new subway station. When the station reopened in September 1968 the success of the experiment proved startling. It was estimated that there was a 40 percent increase in passengers during the first week. Where before there had been crowds of bored, hurrying people there were now groups of interested sightseers. Whether or not they were tempted to visit the Louvre itself is not known, but the subway exhibition is a good example of a museum involving itself in the

ABOVE the third-floor gallery of the Whitney Museum of American Art in New York City, where movable gallery walls are fitted into grooves in the grid ceiling. The new building opened in 1966.

BELOW sculpture outdoors.

The Role of Television

In the 1920s the movie industry met the growing threat from newly popular radio by bringing out sound films. In the 1950s it faced an even deadlier threat – television. This time Cinemascope was the result, followed by Cinerama and various multiple screen and projector systems that could

BELOW shot from a BBC-TV program, "Nijinsky: God of the Dance," starring Kate Harrison and Nicholas Johnson.

BELOW RIGHT gold mask from the tomb of Tutankhamen.

provide the sort of tumultuous spectacle impossible to create on the small screen. Some directors and film critics, reacting against the unprecedented width of the Cinemascope screen, repeated the objections that had greeted the advent of sound: the new invention had no advantages and innumerable disadvantages. However, in the very first Cinemascope film, *The Robe* (1954), the possibilities of the wide screen for showing action in unprecedented depth and detail were apparent.

Cinemascope did not drive television away, and the film world has had to learn to live with the new arrival, which is now as firmly established in most people's lives as were films from 1920 to 1950. Part news service, part entertainment, trivial or challenging, part drama, part documentary – television covers a ragbag of offerings. In

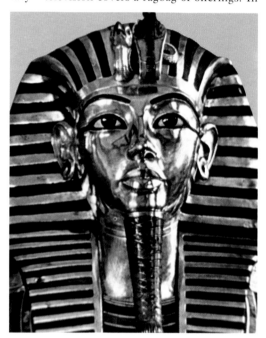

the field of documentaries lie perhaps its most valuable achievements. Movie houses would not have been eager to show such television films as a 50-minute study of the carvings of Amerindian tribes, an exploration of the life and works of the baroque architect and sculptor Bernini, or a feature on the "lost" 1938 Charles Laughton film *I, Claudius*.

The ideal medium for these is television. Such documentaries have greatly added to public knowledge of the world in general and the arts in particular. When the contents of the tomb of Tutankhamen were exhibited in London in 1972 a series of short television programs was shown, devoted to various objects in the collection, pointing out their qualities and significant details, and placing them in the context of the art of their time. These programs undoubtedly

increased interest in the exhibition. Similarly, television programs were specially prepared to coincide with the "Treasures from Ancient China" exhibition that opened in Paris in 1973 and in the course of the next year toured major centers in Europe and the United States.

A more ambitious venture was the series of 13 hour-long programs first shown by BBC Television in 1969. Given the title *Civilization* and presented by Sir Kenneth Clark, a former director of the National Gallery, the program did not set out to present a history of the arts but traced the life-giving ideas that people had made visible and audible through the medium of art. Beginning with the revival of medieval Europe under Charlemagne and the treasures of his 9th-century chapel at Aachen, the program ranged over the artistic achievements of much of Europe

BELOW Sir Kenneth Clark beside Clifton Suspension Bridge, Bristol, designed by Isambard Kingdom Brunel to span the Avon Gorge and completed in 1864.

BOTTOM jade funeral suit of the princess Tou Wan, found in her tomb at Man-ch'eng, Hopei, in 1968. Lady Tou's suit, dating from the late 2nd century BC, consists of 2160 tablets of jade, a mineral believed to prevent the decay of the corpse. The suit was exhibited as part of the Chinese archaeological collection that toured the West.

and, later, America, up until modern times. Sir Kenneth later explained some of the problems involved in preparing a program of this kind for television. "People who settle down to an evening's viewing expect to be entertained. If they are bored they switch off. They are entertained as much by what they see as by what they hear. Their attention must be held by a carefully contrived series of images. The choice of illustration is itself determined by certain material accidents. Some places are inaccessible, some buildings defy the camera, some locations are too noisy for sound recording. All of these considerations have to be in the writer's mind from the beginning, and modify or direct his or her line of thought." But even if some simplifications and generalizations were an inevitable result, the compensations provided by the medium of television are very great. For instance, the series benefited from the judicious use of appropriate music – the program on the romantic movement at the beginning of the 19th century gained force and vividness from the sound of the French national anthem, the *Marseillaise*, and the prisoners' chorus from Beethoven's opera *Fidelio*.

Over the past 25 years the film studios have changed their attitude to television. They have even sold or leased their old – and sometimes not so old – films for television showing. By this means television audiences have been presented with a number of films that might have been better forgotten. But they have also had the opportunity to view some of the great films of the past, previously only available to fairly affluent people living in large cities who are able to go out in the evenings. For many families and people who live in relatively isolated communities, television is uniquely placed to bring them the life-enhancing pleasures of art.

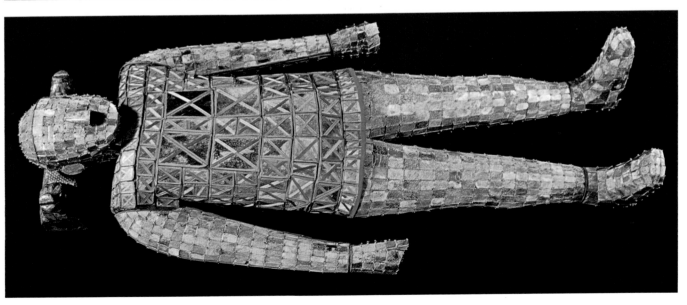

Artist and Audience

All art consists of communication between artist and audience. Each of us may now and then feel an urge to achieve something original, and to that extent might consider ourselves potential artists. But what sets the real artist apart is not necessarily that desire but the talent, which is much rarer, of finding a successful means of communicating a new idea to other people. Artists do not work merely for their own satisfaction but need outside recognition – in fact, the creative process is not complete without the reaction of an audience.

One of the functions of great art is that it should move its audience. People respond on many levels – they may be intellectually stimulated, emotionally touched, spiritually uplifted, or even a combination of all three. They may also react to the tension that an artist can set up by juxtaposing their expectations with something out of the ordinary in beauty, form or subject. The audience may be startled into rethinking its assumptions, in that way completing the process of communication between one human

being and his or her fellow humans.

Art in some form is now so much a part of the fabric of our lives that, though we encounter it all the time, we hardly acknowledge it as art. Magazine covers, advertising posters, war memorials, and the buildings in which we live, work, and enjoy ourselves — all these represent a sort of accumulation of popular artistic taste. But reducing art to a level at which it can easily

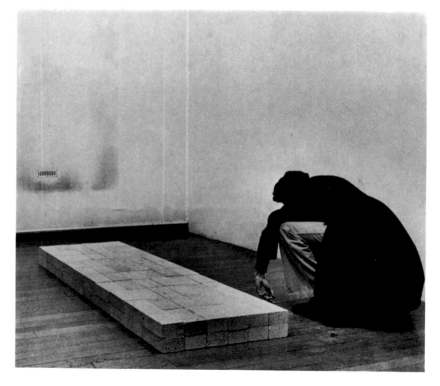

be reproduced and comprehended, and using it to sell consumer products, means that the likelihood of artists getting across an arresting new point of view is diminished. Because mass art is predominant in the experience of most people, it tends to mold their ideas and preferences on art in general and they may be unwilling or even unable to appreciate something truly original.

The 20th-century artist's audience is no longer a roomful of interested concertgoers, the devout congregation of a church, or a few rich connoisseurs. Museums and galleries cater for increasing numbers of visitors each year, and due to the pace of modern technology and increasing sophistication of Western society, artists now reach a vast public that, paradoxically, may never actually confront their works face to face. Television, filming equipment, books, magazines, recordings, and reproductions – to say nothing of related publicity and critical comment – have meant that artists are now simultaneously closer to and yet further removed from the people for whom they create. Greater popular awareness and knowledge of art have made the modern audience receptive and interested, especially in the arts of the past. But living artists must try to gain a hearing in the midst of all this activity. For them, the success of what might be called an "art industry" may seem stifling. Partly because of the frustrations inherent in this situation, a few modern artists have experimented with shocking or even repulsive works through which to jolt the supposed complacency of the public. Sometimes this may have the desired

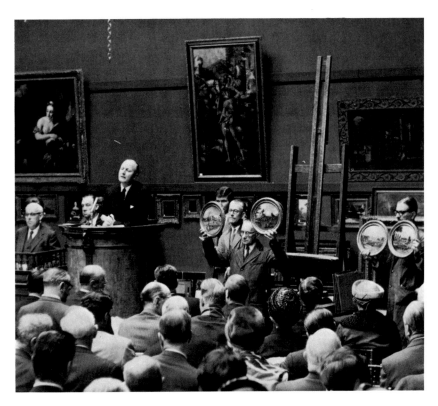

ABOVE set of four Dutch masterpieces dated 1526, sold for over $50,000 by auction.

BELOW traditional audience celebrations accompany the orchestra at the Royal Albert Hall, London, on the last night of the annual Promenade concert series.

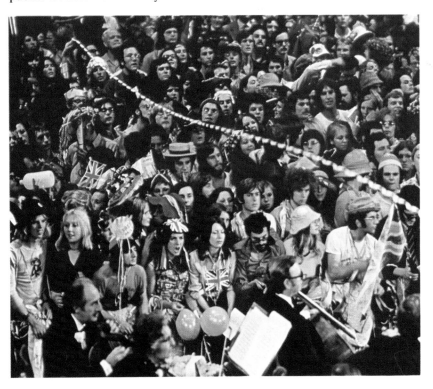

effect of expanding people's awareness of the world around them or of the purpose of art. But in many cases the artist has been accused of perpetrating a fraud.

Perhaps another reason for this distancing of the individual artist from the wider public is that artistic success has become confused with financial value. Artists whose works change hands for vast sums of money are considered masters and therefore worthy of attention, but as their art becomes the exclusive province of overcrowded museums, rich private collectors, and corporate investment funds it loses the opportunity to communicate directly, person to person, with an audience of ordinary people. Painters, sculptors, musicians, dramatists, and film directors have become modern folk heroes whose activities are newsworthy simply because their names are household words. Some critics have suggested that such a cultural elite may become increasingly irrelevant to the society from which it springs.

Today, living in surroundings that often reflect the dreariness and alienation of much of modern life, people may need art more than ever before. As changes overtake each other more and more quickly there may be a growing need for order and purpose, a mounting desire to glimpse a pattern in our existence. This is where the vision of the artist can contribute. The practitioners of modern arts, by opening our eyes to possible patterns, can help us to sense more clearly the essential nature of our own lives.

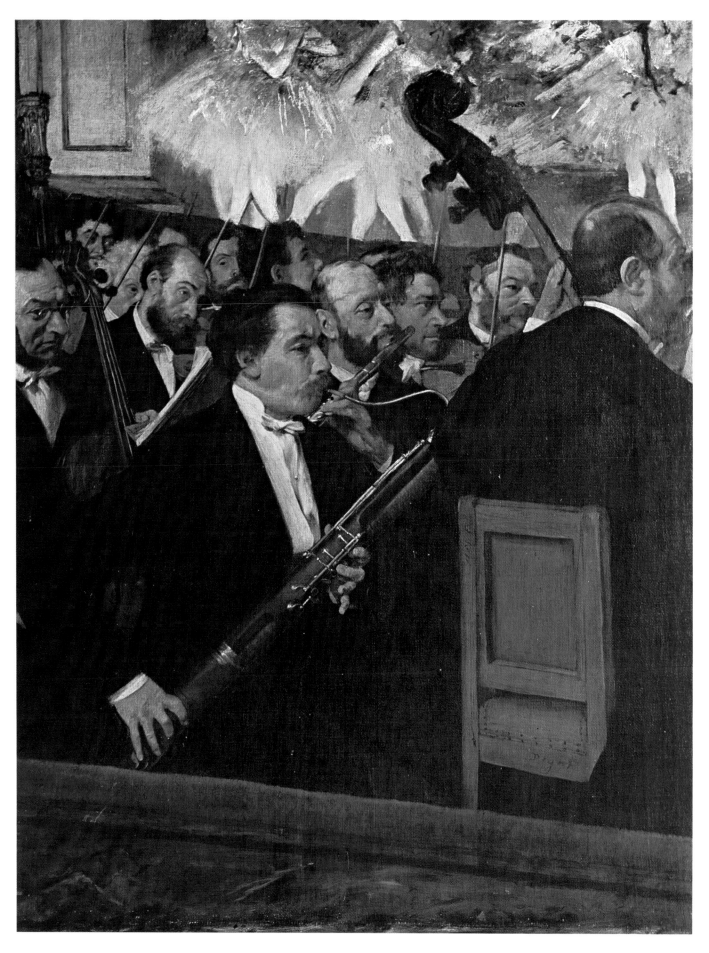

INDEX

Numbers in italic refer to page numbers of illustrations.

A

N

O

P

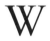

PICTURE CREDITS

Galleries, London
103(B) National Gallery, London
104 Nasjonalgalleriet, Oslo/Photo © Oslo Kommunes Kunstsamlinger Munch-Museet, Oslo
105(T) The Festival Hall, University of Oslo/Photo © Oslo Kommunes Kunstsamlinger Munch-Museet/O. Vaering
105(B) Oslo Kommunes Kunstsamlinger Munch-Museet
106(L) Camera Press
106(R) The Tate Gallery, London
107(T) Museum of Modern Art, New York: On extended loan from the Artist's Estate
107(B) The Tate Gallery, London
108, 109(T) Collection Haags Gemeente-museum, The Hague
109(BL) Emanuel Hoffman-Foundation, Kunstmuseum Basel
109(BR), 110(L) Museum of Modern Art, New York
110–111(C) Hans Namuth
111(R) The Sidney & Harriet Janis Collection. Gift to Museum of Modern Art, New York
113–115(TL) Scala, Florence
115(TR) The Henry Moore Foundation
115(B) The Mansell Collection, London
116(T) Sonia Halliday
116(B) Reproduced by permission of the Trustees of the British Museum
117(T) P.A. Interpress Photo Service, Warsaw
117(BL) The Oriental Institute of The University of Chicago
117(BR) Victoria & Albert Museum, London/Photo © F. L. Kenett, 1968
118(L) Reproduced by permission of the Trustees of the British Museum
118(R) Photo Ken Coton © Aldus Books
119(L) Photo Dimitrios Harissiadis, Athens
119(R) The Henry Moore Foundation
120(T) Picturepoint, London
120(B) A. F. Kersting
121(T) F. L. Attenborough/University of Leicester
121(L) Roger Wood, London
121(BR) Zefa
122, 123(L) Picturepoint, London
123(R) Giraudon
124(T) Michael Holford Library photo
124(B) Reproduced by permission of the Trustees of the British Museum
125(L) Photo Dimitrios Harissiadis, Athens
125(R) Musée du Louvre, Paris/Service de Documentation Photographique de la Réunion des Musées Nationaux
126(T) Picturepoint, London
126(B) Archives Photographiques, France/Robert Harding Associates
127(TL) Alinari/Robert Harding Associates
127(CR), (B) Picturepoint, London
128 Scala, Florence
129(T) The Mansell Collection, London
129(B)–131 Scala, Florence
132 Giraudon
133(L) BBC Hulton Picture Library
133(TR) Giraudon
133(B) The Mansell Collection, London
134(T) Musée National d'Art Moderne, Paris/Photo Jacqueline Hyde
134(B) Musée National d'Art Moderne, Paris

135(T) Philadelphia Museum of Art: The Louise and Walter Arensberg Collection
135(B) Musée National d'Art Moderne, Paris
136(T) Collection Mrs. Walter Klein/Photo Hans Namuth
136(B) Hans Namuth
137(T) Perls Gallery, New York/Peter A. Juley & Sons/Robert Harding Associates © A.D.A.G.P., Paris
137(B) Hans Namuth
138(T) BBC Hulton Picture Library
138(C) Picturepoint, London
138(B), 139 The Henry Moore Foundation
140(T), (BR) The Tate Gallery, London
140(BL) Collection of the Whitney Museum of American History, New York
141(T) The Tate Gallery, London
141(B) Photo © Volz/Courtesy Annely Juda Fine Art, London
142 Popperfoto
144(T) Josef Muench
144(BL) Aldus Archives
144(BR) G. Heil/Zefa
145(T) David Moore/Colorific
145(B) Picturepoint, London
146(T) Georg Gerster/John Hillelson Agency
146(B), 147(T), (BL) Picturepoint, London
147(BR) Photo by courtesy of the Royal Netherlands Embassy, London
148(TL) Roger Wood, London
148(TR) The Mansell Collection, London
148(B) Picturepoint, London
149(T) Stephen J. Benson
149(CL) Picturepoint, London
149(BL) Rudolf Wittkower, *Architectural Principles in the Age of Humanism*, Alec Tiranti Limited, London
149(BR) Robert Harding Associates
150(T) Reproduced by permission of the Trustees of the British Museum
150(BL) John G. Ross
150(BR) Robert Harding Associates
151(TL) Photo Françoise Foliot
151(TR) Service de Documentation, Versailles
151(B) Robert Harding Associates
152(T) Michael Holford Library photo
152–153(CB) Nick Stournaras, Athens
153(TL) Laszlo Acs © Aldus Books
153(TR) Dan Bartush
153(BR) © Retoria, Y. Futagawa & Associated Photographers, Tokyo
154(T) Staatliche Museen, Berlin
154(BL) Picturepoint, London
154(BR) By courtesy of the Italian State Tourist Office, London
155(T) Deutsche Fotothek, Dresden
155(B) Picturepoint, London
156(T) Hedda Morrison
156(B), 157(T) Picturepoint, London
157(B) BBC Hulton Picture Library
158(T) Ferdinand Anton
158(B) Picturepoint, London
159(L) Lewis Mumford, *The City in History*, Harcourt, Brace & World, Inc., New York, and Martin Secker & Warburg Limited, London, 1961
159(R) Rapho
160(T) Courtesy Aage Struwing
160(B) The Chicago Architectural Photographing Company
161(T) Picturepoint, London
161(BL) Robert Harding Associates
161(BR) Milton Keynes Development

Corporation
163 Scala, Florence
164 Giraudon
165 Picturepoint, London
166–167 Scala, Florence
168(T) BBC Hulton Picture Library
168(BL) Mario Carrieri
168(BR) Scala, Florence
169 Mario Carrieri
170(T) A. F. Kersting
170(B) Picturepoint, London
171(T) A. F. Kersting
171(L) BBC Hulton Picture Library
171(B) Picturepoint, London
172(TL) The Mansell Collection, London
172(TR), (BL), 173(L) A. F. Kersting
173(TR) Picturepoint, London
174(T) Mario Carrieri
174(B) Scala, Florence
175 Mario Carrieri
176, 177(L) Bildarchiv Foto Marburg
177(R) A. F. Kersting
178(T) Victoria & Albert Museum, London/Photo John Freeman © Aldus Books
178(B) The Mansell Collection, London
179 A. F. Kersting
180(T) Salmer, Barcelona
180(B), 181 Andrew Vargo
182(T) Esto Photographics Inc., New York
182(B) John Donat
183(T) Retoria, Tokyo
183(CL) Photo courtesy of Johnson Wax
183(B) United States Information Service, London
184(C) Bilderdienst Süddeutscher Verlag
184(B) Wamel-Dorf über Soest, courtesy Fagus-Werk
185(T) Bilderdienst Süddeutscher Verlag
185(BL) Walter Gropius: courtesy of The Architects Collaborative Inc.
185(BR) Picturepoint, London
186(T) *Le Corbusier: 1910–60*, Editions Girsberger, Zürich
186(C) BBC Hulton Picture Library
186(B) Picturepoint, London
187(TL) Le Corbusier, *The Modular*, Harvard University Press, Cambridge, Mass., & Faber and Faber Ltd., London, 1961
187(R) Picturepoint, London
188 Museum of Finnish Architecture, Helsinki
189(T) Retoria, Tokyo
189(B) Finnish Embassy, London
190 Eddie Van der Veen/Colorific
192(T) UNESCO, Paris
192(C) David Paramor Picture Collection, Newmarket
192(B) The Mansell Collection, London/Photo John Freeman © Aldus Books
193(T) Paul Morand, *Majorca*, Editorial Noguer, Barcelona/Photo A. D. Arielli
193(B) Picturepoint, London
194(T) Rapho, Paris
194(CR) Reproduced by permission of the Trustees of the British Museum
194(BL) David Paramor Picture Collection, Newmarket
195(L) J. Bitsch/Zefa
195(R) B. Julian/Zefa
196(T) BBC Publicity photo
196(B) The Mansell Collection, London
197 Peter Warner © Aldus Books
198(T) Bibliothèque Nationale, Paris
198(BL) Reproduced by permission of the